The Louvre and the Masterpiece

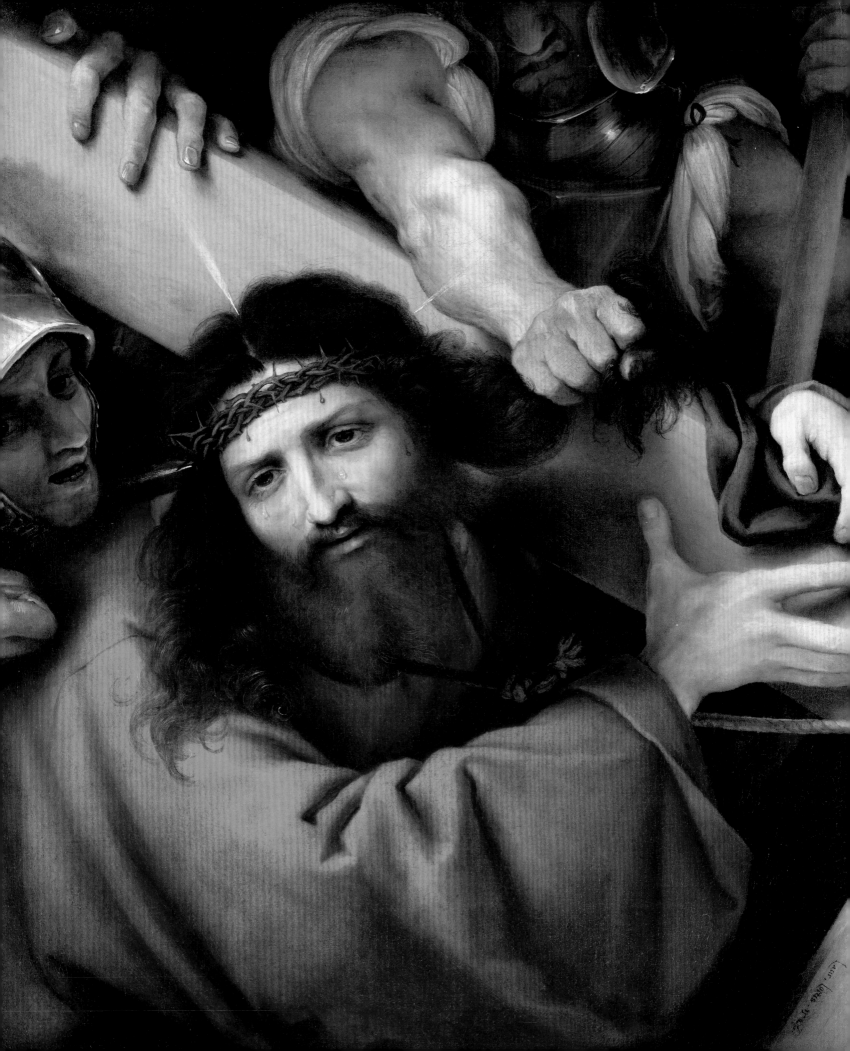

The Louvre and the Masterpiece

Isabelle Leroy-Jay Lemaistre and David A. Brenneman
Managing Curators

LOUVRE ATLANTA A collaborative project of the Musée du Louvre, Paris,
and the High Museum of Art, Atlanta

Published on the occasion of the exhibition *The Louvre and the Masterpiece*, organized by the High Museum of Art, Atlanta, and the Musée du Louvre, Paris.

LOUVRE ATLANTA

High Museum of Art
October 12, 2008–September 6, 2009

Minneapolis Institute of Arts
October 18, 2009–January 10, 2010

Library of Congress Cataloging-in-Publication Data

The Louvre and the masterpiece / Isabelle Leroy-Jay Lemaistre and David A. Brenneman, organizing curators ; [translation by Janice Abbott].

 p. cm.

"A collaborative project of the Musée du Louvre, Paris, and the High Museum of Art, Atlanta."

"Published on the occasion of an exhibition organized by the High Museum of Art, Atlanta, and the Musée du Louvre, Paris, which was held between Oct. 12, 2008 and Sept. 6, 2009"—T.p. verso.

Includes bibliographical references and index.

ISBN 978-1-932543-28-5 (hardcover : alk. paper)

1. Masterpiece, Artistic—Exhibitions. 2. Art—France—Paris—Exhibitions. 3. Musée du Louvre—Exhibitions. I. Lemaistre, Isabelle. II. Brenneman, David A. III. High Museum of Art. IV. Musée du Louvre.

N72.5.L68 2008

708.4'361—dc22 2008030669

Details

Cover: Johannes Vermeer, *The Astronomer*, 1668, plate 96
Back cover: Michelangelo Buonarroti, *"Ideal Head" of a woman*, early 1520s, plate 41
Cover spine: Female statuette known as *The Lady of Auxerre*, 7th century B.C., plate 68
Page 2: Lorenzo Lotto, *Christ Carrying the Cross*, ca. 1526, plate 95
Page 5: Attributed to Jean-Baptiste-Jules Klagmann, *Ewer*, ca. 1848, plate 24
Page 10: Jacopo Ligozzi, *Allegory of Lust*, ca. 1590, plate 48
Page 22: Antoine-Louis Barye, *Lion and serpent*, 1832–1833, plate 1
Page 34: Dish from the Boscoreale Treasure, 1st century A.D., plate 14
Page 68: Albrecht Dürer, *Knight, Death, and the Devil*, 1513, plate 58
Page 140: Johannes Vermeer, *The Astronomer*, 1668, plate 96
Page 198: Rubens Gallery, Musée du Louvre

For the High Museum of Art
Kelly Morris, Head of Publications
Heather Medlock, Assistant Editor
Rachel Bohan, Editorial Assistant

For the Musée du Louvre
Myriam Hely Hutchinson, Project Coordinator

Translation by Janice Abbott

Designed by Jeff Wincapaw
Proofread by Sharon Rose Vonasch
Indexed by Candace Hyatt
Color management by iocolor, Seattle
Produced by Marquand Books, Inc., Seattle
 www.marquand.com
Printed and bound by Mondadori, Verona, Italy

Contents

PATRON

Anne Cox Chambers

PRESENTING PARTNER

LEAD CORPORATE PARTNERS

FOUNDATION PARTNER

The Sara Giles Moore Foundation

ADDITIONAL SUPPORT

Forward Arts Foundation, Frances B. Bunzl, Tull Charitable Foundation
This exhibition is supported by an indemnity from the Federal Council on the Arts and the Humanities

PLANNING PARTNER

The Rich Foundation

The Louvre and the Masterpiece at the Minneapolis Institute of Arts
is presented by

with additional support from

and a generous gift from Ruth and John Huss.

Directors' Foreword and Acknowledgments

This catalogue documents and celebrates the third year of *Louvre Atlanta* exhibitions. The theme, the Louvre and the masterpiece, is a fitting finale since it allows us to look both backward and forward, to see the Louvre not only in historical terms, but to see it as a living, breathing institution engaged in today's and tomorrow's issues of art history and museology. The modern concept of the masterpiece, like the Louvre, was born during the age of enlightenment and revolution. Initially arising during the Middle Ages as a test of technical mastery, the masterpiece came to refer not only to a work of technical virtuosity, but, more importantly, to a work of artistic genius. As the distinguished American philosopher Arthur Danto has pointed out, this concept of the masterpiece has always been debated and contested.[1] In recent years, debate has focused on the validity of the concepts of mastery and genius, and ultimately of the validity of the concept of masterpiece itself, because these ideas are perceived by some to be elitist and exclusionary. Although we acknowledge the complexity of the debate and the arguments presented both for and against, we do not believe this to be the case.

It is important to note that the modern concept of the masterpiece coincided with the rise of the museum, specifically the Louvre. Moreover, as Danto pointed out, the creation of the Musée Napoleon represents a defining moment in the history of museums because it was the first time that anyone had attempted to bring all of the great masterpieces of Europe together in one place.[2] Napoleon put Dominique Vivant-Denon in charge of this endeavor and thus Vivant-Denon can fairly be called the first modern museum director. Although it was highly controversial and relatively short-lived, the Musée Napoleon made a profound and lasting impression. It established the modern notion of the museum as the dominant cultural authority in the visual arts, the place where works representing the highest pinnacle of human achievement—masterpieces—are brought together to edify and inspire the public.

The establishment of the Louvre, a place where a multitude of masterpieces could be seen and studied, and the rise of the modern concept of masterpiece unfortunately resulted in a great deal of anxiety for artists of nineteenth-century France. This anxiety informed two major works of nineteenth-century literature, Balzac's *The Unknown Masterpiece* (published in 1831) and Zola's *The Work* (published in 1886). In both books, fictional artists strive, and eventually fail, to produce masterpieces. The quest for the perfect or absolute work of art became, as the art historian Hans Belting has noted, a conundrum for modern art because it represented an unattainable ideal.[3] Part of the complexity today in dealing with the concept of the masterpiece is a result of the ongoing anxiety over its relevance for contemporary artists.

The Louvre today does not consider itself a "museum of masterpieces," but a place where the masterpiece can be seen and studied in the context of other works of art. Isabelle Lemaistre's essay on Barye (pp. 23–33) illustrates this point. Although the curatorial team began the project with the intention of answering the question "What is a masterpiece?" it became evident that it is extremely difficult, if not impossible, to articulate a definition of masterpiece that could be accepted universally. Instead, the efforts of the team focused on telling the story of the masterpiece and its changing meaning through time, using objects from the Louvre's incomparable collections. This is a fascinating story, and the objects carefully chosen for the exhibition each represent a revealing case study. The goal of the exhibition is to focus attention on the extraordinary works in the Louvre's collections through the historical lens of the masterpiece in order to reconsider their value as bearers of cultural, historical, and artistic meaning today. We hope that this exercise will

spark a healthy and reinvigorating debate on the subject of the masterpiece that will benefit not only the Louvre and the High Museum, but all art museums in the twenty-first century.

This exhibition was the most collaborative of any of the exhibitions presented during the three-year run of *Louvre Atlanta*, and we are grateful to all who participated in its creation and execution. Project team leaders were David Brenneman, Director of Collections and Exhibitions and Frances B. Bunzl Family Curator of European Art at the High, and Isabelle Lemaistre, the Louvre's chief curator of sculpture. At the High, we wish to acknowledge the efforts of Jody Cohen, Project Manager; Philip Verre, Chief Operating Officer; Rhonda Matheison, Chief Financial Officer; Susan Clark, Director of Marketing and Communications; Linda McNay, Director of Museum Advancement; Patricia Rodewald, Eleanor McDonald Storza Director of Education; Laurie Kind, Exhibition Coordinator; Cassandra Streich, Senior Manager of Public Relations; Julia Forbes, Head of Museum Interpretation; Virginia Shearer, Associate Chair of Education; Anne Hargaden, Manager of Membership; Mary Shivers O'Gara, Programming Manager; Kelly Morris, Manager of Publications; Heather Medlock, Assistant Editor; Rachel Bohan, Editorial Assistant; Jim Waters, Head Designer; Angela Jaeger, Head of Graphics; Frances Francis, Registrar; Amy Simon, Associate Registrar; Michele Egan, Senior Development Manager; Corinne Anderson, Manager of Government and Foundation Support; Jennifer de Castro, *Louvre Atlanta* Sponsor Manager; and Toni Pentecouteau, Executive Assistant to the Director. Special thanks go to Elisa Buono Glazer for her enthusiastic and highly capable assistance in preparing grant applications for this exhibition. Finally, we wish to thank Matthias Waschek, Director of the Pulitzer Foundation for the Arts in Saint Louis, for allowing us to translate and republish his excellent essay on the masterpiece as a "cultural phenomenon."

At the Musée du Louvre, we wish to acknowledge Didier Selles, Chief Executive Director; Catherine Sueur, Assistant General Administrator; Christophe Monin, Director of Cultural Development; Sophie Kammerer, International Development Manager; Sue Devine, Executive Director, American Friends of the Louvre; Myriam Hely Hutchinson, Project Coordinator; Aggy Lerolle, Chief of Communications; Catherine Guillou, Director of Visitor Services and Education; François Vaysse, Head of the Service of Educational and Cultural Activities; Jean-Marc Terrasse, Director of the Auditorium; and Violaine Bouvet-Lanselle, Chief of Publications.

This partnership has been made possible by numerous people from the Louvre, in particular the following curators from each of the eight departments of the museum, who have acted as coordinators and thus ensured the excellent collaboration we have enjoyed not only inside the Louvre, but above all between our two institutions: Elisabeth Antoine and Marie-Laure de Rochebrune, Decorative Arts Department; Nicolas Bel and Sophie Cluzan, Near Eastern Antiquities Department; Sophie Descamps-Lequime, Greek, Etruscan, and Roman Antiquities Department; Marc Etienne, Egyptian Antiquities Department; Guillaume Faroult and Olivier Meslay, Paintings Department; Gwenaëlle Fellinger and Sophie Makariou, Islamic Arts Department; Catherine Loisel and Carel van Tuyll van Serooskerken, Prints and Drawings Department; and Isabelle Leroy-Jay Lemaistre, Sculptures Department.

For their help in the organization of the exhibition behind the scenes, we thank: in the Near Eastern Antiquities Department, Norbeil Aouici, Anne Mettetal-Brand, and Nancie Herbin; in the Decorative Arts Department, Laurent Creuzet; in the Greek, Etruscan, and Roman Antiquities Department, Christelle Brillault, Christophe Piccinelli, and Brigitte Tailliez; in the Egyptian Antiquities Department, Catherine Bridonneau, Sophie Feret, and Geneviève Pierrat-Bonnefois; in the Paintings Department, Aline François, Brigitte Lot, and Aurélie Merle; in the Sculptures Department, Suzelyne Chandon, Frédérique Le Roux, Pierre Philibert, and Béatrice Tupinier; in the Islamic Arts Department, Hélène Bendejacq and Isabelle Luche; in the Prints and Drawings Department, Pascal Torres Guardiola, Christel Winling, Varena Forcione, Valérie Corvino, and Victoria Fernandez; in the Cultural Development Department, Juliette Armand, Myriam Prot-Poilvet, Patricia Kim, Eva Duret, Anne-Laure Ranoux, and Céline Rébière-Plé; in the Education Department, Célia Meunier and Alexandra Dromard for their hard work in the multimedia component of the exhibition, Magali Simon and Cyrille Gouyette for their faithful involvement in the Summer Teacher Institute, as well as Anne Krebs and Florence Caro. We also want to thank Isabelle Biron and the Centre de recherche et de restauration des musées de France for their collaboration in the gathering of scholarly information on The Blue Head (plate 66). Last but not least, we thank the catalogue translator, Janice Abbott.

At the Minneapolis Institute of Arts, an affiliate partner for this project, we wish to acknowledge Kaywin Feldman,

Director and President; Mikka Gee Conway, Assistant Director for Exhibitions and Programs; Matthew Welch, Assistant Director for Curatorial Affairs; Patrick Noon, Chair of Paintings and Modern Sculpture; Lisa Michaux, Acting Co-curator of Prints and Drawings; Pat Grazzini, Deputy Director; Laura DeBiaso, Administrator of Exhibitions and Curatorial Affairs; Joan Grathwol Olson, Director of Development; Anne-Marie Wagener, Director of External Affairs; Kristin Prestegaard, Interim Director of Marketing; Gayle Jorgens, Director of Design and Editorial Services; Kate Johnson, Chair of Education; Brian Kraft, Head of Registration; Jennifer Starbright, Assistant Registrar for Exhibitions; and Roxy Ballard, Exhibition Designer.

We also wish to thank our extraordinarily generous consortium of donors. The Honorable Anne Cox Chambers, the lead individual patron, supported the project from its inception. The Presenting Partner, Accenture—a global management consulting, technology services, and outsourcing company—provided technological expertise for interpretative tools to enhance the experience for Museum guests and members. They join other Lead Corporate Partners—UPS, Turner Broadcasting System, The Coca-Cola Company, Delta Air Lines, and AXA Art Insurance—who contributed critical financial support as well as the expertise of their most senior leadership and employees and in-kind assistance. We owe special thanks to Craig Ramsey and Mike Russell of Accenture; Mike Eskew and Scott Davis of UPS and Evern Cooper Epps and Lisa Hamilton of the UPS Foundation; Phil Kent, Mark Lazarus, and Louise Sams of Turner Broadcasting; Neville Isdell of The Coca-Cola Company and Ingrid Saunders Jones of The Coca-Cola Company Foundation; Gerald Grinstein, Lee Macenczak, and Richard Anderson of Delta Air Lines; and Christiane Fischer of AXA Art Insurance for sharing our vision. Foundation support was provided by the Forward Arts Foundation, The Sara Giles Moore Foundation, Tull Charitable Foundation, and The Rich Foundation, the latter as a planning partner. Additional individual support was provided by longtime patron Frances B. Bunzl. The *Louvre Atlanta* Teachers Institute received support from The Goizueta Foundation, French Cultural Services of the French Embassy, and the French Consulate in Atlanta. We are grateful to French Ambassador Pierre Vimont as well as the former French Ambassador to the United States, Jean-David Levitte, for their assistance and good counsel and to Philippe Ardanaz, Consul General in Atlanta, and his staff for championing the project in the United States and abroad. We also wish to acknowledge the significant support that the *Louvre Atlanta* project has received through an indemnity from the Federal Council on the Arts and Humanities.

Like the first two years of *Louvre Atlanta*, the third-year exhibition installation has been designed by our good friends at the Renzo Piano Building Workshop. We wish to thank Renzo and his associates Elisabetta Trezzani and Mark Carroll for sharing their considerable talents with us.

HENRI LOYRETTE
President Director, Musée du Louvre

MICHAEL E. SHAPIRO
Nancy and Holcombe T. Green, Jr. Director, High Museum of Art

NOTES

1. Arthur C. Danto, "Masterpiece and the Museum," in *Encounters and Reflections: Art in the Historical Present*, Berkeley, 1997, pp. 313–330. This is a republication of an essay that appeared in *Grand Street* magazine in winter 1990.

2. Ibid., pp. 319–321.

3. Hans Belting, *The Invisible Masterpiece*, London, 2001.

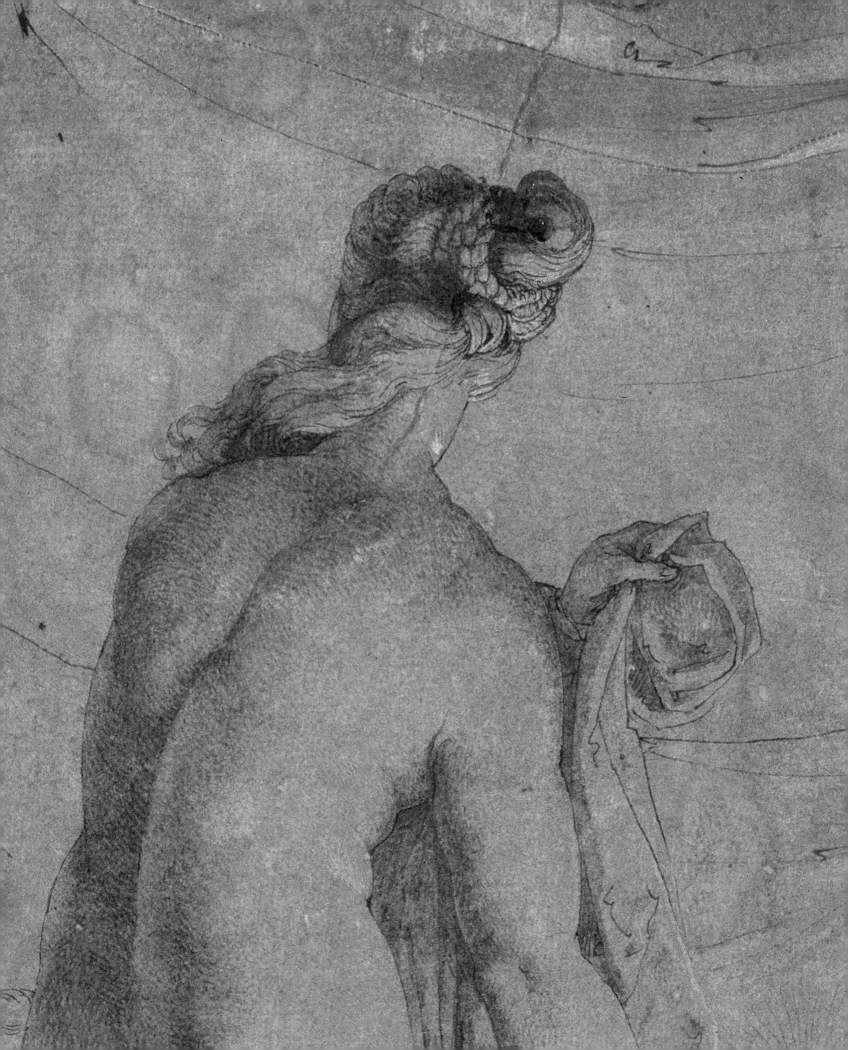

The Masterpiece: A Cultural Phenomenon

Matthias Waschek

The notion of the masterpiece evolved in medieval Europe, where craftsmen who wanted to run a workshop had to first submit a work of excellence.[1] This tradition has been transmitted to the modern world. In certain cases, such as the French *compagnons*, even aspects of lifestyle and codes of behavior have prevailed. As reflected in academic titles such as "Bachelor" and "Master," this system has been used outside the field of manual labor, and in modern language "masterpiece" also stands for major accomplishments: a bridge can thus be considered a masterpiece of engineering, bilateral agreements regarded as masterpieces of diplomacy, in certain cases even natural wonders may be described as masterpieces of Nature.

There is no exception to the usage of the word in the fine arts. A specific painting, a sculpture, or a work of architecture might be praised as a masterpiece within the oeuvre of an artist, the production of a period, or the culture of a country. However, this ranking is based on criteria that are not necessarily related to technical excellence. The judgment of connoisseurs and academics is as much determined by personal preference as it is by aesthetic, historical, and national ideals; none of these is free from the caprices of time. Since Romanticism, the question of the masterpiece has, at least in certain cases, escaped the control of a restricted circle of experts. As demonstrated by the long queues in front of the Louvre's *Mona Lisa*, the general public has chosen this particular work by Leonardo da Vinci (1452–1519) to be the museum's, if not the world's, absolute masterpiece. Even if experts were to pronounce themselves differently on this particular work, the impact on the museum visitors would be minor, at best. Like the judgment of the experts, that of the public is equally subject to change. This is prominently documented by *Luncheon on the Grass* and *Olympia*, both by Edouard Manet (1832–1883). Today, the Musée d'Orsay no longer needs to protect these works against angry visitors, who menaced both canvases with sticks and umbrellas in the past. On the contrary, specially assigned guards must protect the work against an overwhelming flow of visitors during the tourist season.

Philosopher Georg Wilhelm Friedrich Hegel (1770–1831) consequently defined true masterpieces as beyond the realm of a professional jury: these works are "immortal" and can be "enjoyed by all peoples and at all times."[2] *The Unknown Masterpiece* by Honoré de Balzac (1799–1850) illustrates how much the public's choice may escape the control of practitioners and experts: the story's protagonist, widely respected by his peers as an excellent painter and connoisseur, loses his mind over the painful realization that he is incapable of creating a masterpiece himself.[3] The question of the masterpiece could be discussed—or dismissed—as an element of art-historical thinking; in this context, the focus will be on the impact this notion has had, along with that of the arts, in the public sphere.

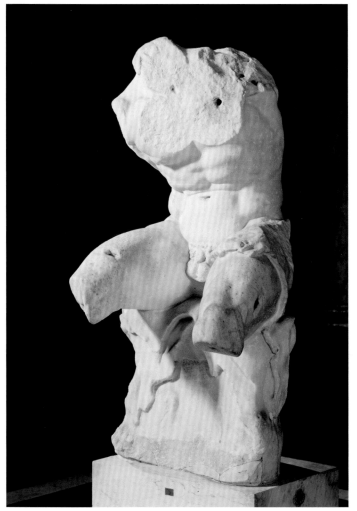

Before the notion of the masterpiece had an impact in the public sphere, it became an accepted value in the artistic domain, outside the specific context of excellence in craftsmanship. It seems that this process was initiated under the auspices of the term *chef d'oeuvre*, which is the French equivalent of the English *masterpiece* and the German *Meisterwerk* or "Meisterstück." One of the first documented examples of an art-specific acceptance of the term can be traced back to a manuscript from 1600 dedicated to the *Galerie d'Ulysse* at Fontainebleau, one of the French kings' most important residences of the time. In this text, Antoine de Laval combines different genres of literature: panegyrics (the praise of a hero), ekphrasis (the description of an artwork), and art criticism. After raising the question of how any painterly program could possibly do justice to the glory of the king of France, Laval highlights the excellence of the work, a painterly program based on Homer's *Odyssey*. "It is not that I do not honor, that I do not even adore (if I may so express myself) the excellence both of the poem and the painting illustrating it, for both are perfect masterpieces."[4] More than half a century later, Roland Fréart de Chambray (1606–1676) introduced the word for a different audience, his peers. It is interesting to note that his criterion, the confirmation of existing rules, does not differ from the one applied by juries from the craft guilds: "A learned Style, judicious Expression, particular and specific appropriateness for each figure of the subject treated."[5] It was the sculptor Gaspard Marsy (1624–1681) who defined the notion beyond the traditional framework of pre-established rules. In front of distinguished peers at the Académie royale des Beaux-Arts, he praised the *Belvedere Torso* (fig. 1) as an inimitable masterpiece of divine rather than human creation.[6] The obvious consequence of such a position is that excellence can only be "understood," not judged according to a set of man-made rules.

Marsy's definition, however, affected only a small circle of experts, who would still have been expected to combine professional expertise with personal sensibility. For the notion of the divine masterpiece to have its modern impact, the general public needed to be involved. In the seventeenth century, most of the modern institutions for viewing art existed only in embryonic forms. First attempts to regularly organize non-commercial art exhibitions started at the end of the seventeenth century, when the Salon Carré, situated in the Louvre, was made available. Once the French Revolution had overthrown the ancien régime, parts of the Louvre were converted into a public museum. The newly founded institution was the first to adopt art-viewing as a civic right, rather than a privilege granted by a powerful patron.[7] On 10 August 1793, when the Muséum central des Arts opened, citizens came in droves.[8] They were anxious to see the treasures amassed by generations of kings, but also what had been seized by the revolutionary armies from palaces and churches, both in the country and from all over conquered Europe.

Initially, the plundering had been undertaken without a rationale, and a great many cultural goods were destroyed and others were looted. However, a vast number of artworks could

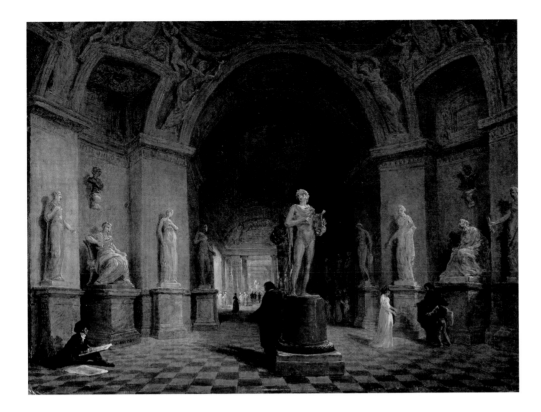

Fig. 2: Anonymous, *La Salle des Empereurs with a view of Laocoön*, 1812–1815, watercolor, Musée du Louvre.

be saved. An anecdote might demonstrate how much the opening of the Louvre actually contributed to a new awareness about the cultural importance of art. Citizens of Fontainebleau had decided to symbolically avenge the assassination of a revolutionary hero, Jean-Paul Marat (1743–1793), which had taken place some months before. The idea was to seize all portraits of the kings of France from the château and have Marat's image preside over their destruction by flames. A report shows that the actual ceremony did not go as smoothly as planned: "Soon the flames would have burnt to a cinder all that jumble of kings and queens ridiculously decked out as they were with fleurs-de-lys. But somebody noticed that one of the pictures portrayed that fool Louis XIII, and it transpired that the painting was a masterpiece by the famous Champaigne, whose other works now adorn the national Museum (the Louvre)."[9] The crowd thought they could separate the power of the ancien régime from the national heritage by removing one arm, and the limb was promptly cut off. In the end, however, "to everybody's satisfaction" the arm was "put back onto the body, from which it should never have been separated."[10] In other words, it was only through the sacrifice of Louis XIII that the admission of the painting as a masterpiece was possible. Once "freed" from its previous power, the portrait could be exhibited in the museum and thus contribute to the improvement of all people (as a leaflet of the period puts it) by "touching the hearts of the people, by speaking to their souls and improving their minds."[11] This emblematic rededication corresponds to the emergence of art as we know it today: divorced from traditional ceremonials, distinguished representatives are destined to be seen in public collections, where they contribute to a deeper understanding of artistic development.

The importance of this new concept to the French revolutionaries is reflected by the mise-en-scène of the Louvre's initial entrance, the Mars Rotunda, through which visitors reached the collections until the end of the nineteenth century. The initial presentation also included antique sculptures that had been seized by France's revolutionary armies from the papal collections in

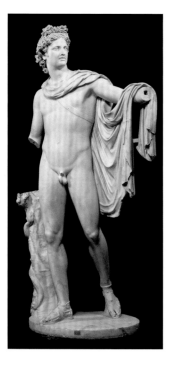

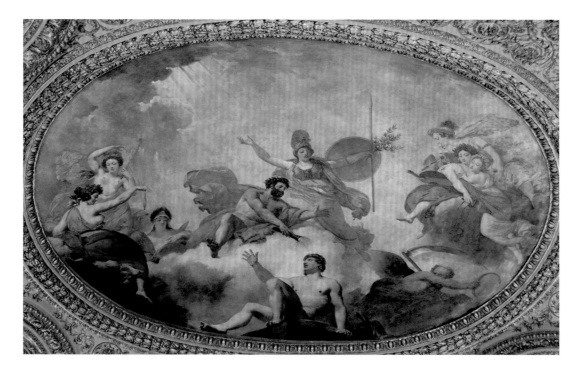

Fig. 3: *Apollo Belvedere*,
Hellenistic or Roman copy
of a Greek original from
ca. 350–325 B.C., marble,
88³⁄₁₆ inches high, Museo Pio
Clementino, Vatican City, Italy.

Fig. 4: Jean Simon Barthélemy
(French, 1745–1811), *Prometheus
Creating Man in the Presence of
Athena*, 1802, ceiling of Mars
Rotunda, Musée du Louvre.

Rome: *Laocoön* (fig. 2) was situated directly opposite the entrance and the *Apollo Belvedere*
(fig. 3) could be seen toward the right, on the way to the next floor. For centuries, both
works had been regarded by artists, connoisseurs, and patrons alike as supreme models of
artistic creation. Although France had to restitute most of its war booty, the ceiling decoration
of the entrance space still conveys the overarching message about the interaction of art and
mankind. The central medallion[12] shows Mankind receiving the divine gift of fire from Pro-
metheus (fig. 4). This scene is framed on one side by the three Fates spinning the thread of life
(and this time not cutting it) and on the other side by the three Arts: Painting, Sculpture, and
Architecture. Minerva, pictured here as the goddess of civic organization, watches over the
scene, whereas Kronos, the god of time, offers a snake biting its tail, the symbol of eternity. It
is not clear if the Arts revere any of the other allegorical figures in the painting or if they con-
template the fact that they have received, via mankind, the divine flame. No matter what the
viewer's interpretation may be, the stage for the masterpiece as an object of public interest has
been set.

The brave revolutionaries of Fontainebleau who donated the portrait by Philippe de Cham-
paigne to the Louvre had no access to further information about the painter. Art-historical
knowledge at the time was available only to a small elite who had the financial means to col-
lect, travel, and acquire books. It was only over the course of the nineteenth century that art
history reached a broader segment of the population, developing into an academic discipline.
Publications became increasingly available and more and more museums opened to an increas-
ing number of visitors. In spite of the careful preparation at the entrance of the revolutionary
Louvre, the understanding of most visitors would have probably been reduced to the sense
that this was a place for masterpieces. The general experience may have been similar to that
described by Emile Zola (1840–1902) in his novel *L'Assommoir*, set in the Second Empire. In
their search for inexpensive amusement, a wedding party explores Paris and decides to enter
the Louvre. First, the group walks through the Assyrian galleries ("they found all that very

ugly"), then they go up to the Apollo Gallery, where they expressed their admiration . . . for the shining parquet flooring. When they reached the Salon Carré (fig. 5), which had become the space dedicated to the most important masterpieces of the collection, "Gervaise wanted to know the subject of the *Wedding at Cana*; it was silly not to show the titles on the frames. Coupeau stopped in front of the *Mona Lisa*—and said he thought she looked like one of his aunts. Boche and Bibi-la-Grillade sniggered as they slyly pointed out to each other the pictures of nude women; Antiope's thighs in particular gave them quite a start." And worse still, the Gaudrons took the liberty of admiring Murillo's *Virgin* without the slightest background in the history of art: "They stood there, Gaudron with his mouth open, and his wife with her hands flat across her stomach, both agape, both softened with emotion, both staring ahead in stupid wonder."[13]

Zola used this fictional account of an uninformed viewing of paintings to emphasize the importance of the historical dimension of masterpieces. The platitudinous comments made by his characters had their origins in their immediate, everyday experience, whereas in the case of a so-called cultivated approach, it is precisely the dimension of the past that enables spectators to free themselves from the supposed banality of their everyday lives and to come into contact, via works of art, with an illustrious past. Such an encounter is famously described by Stendhal (1783–1842). In his account of a visit to Florence, the author describes the increasing intensity of his response to art and history at the church of Santa Croce. Upon contemplating the tombs and cenotaphs, particularly those of Michelangelo, Alfieri, Machiavelli, and Galileo, he is overwhelmed by a profound emotion: "it was almost piety." He then enters a chapel, where he kneels on a *prie-dieu* to admire the ceiling fresco: "I reached that point of emotion where the heavenly sensations provoked by the fine arts fuse with passionate feelings. When I left Santa Croce, my heart was beating, and as I continued on my way I was afraid that I would fall."[14]

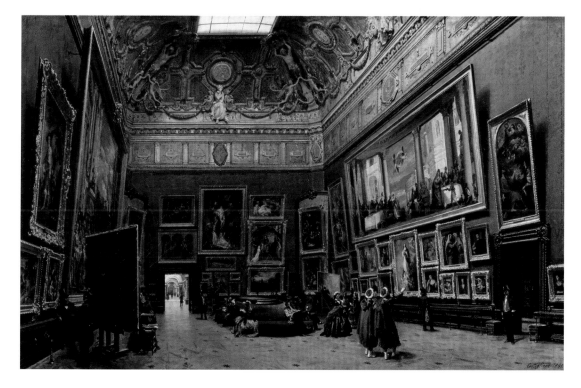

Fig. 5: Giuseppe Castiglione (Italian, 1829–1906), *The Salon Carré at the Louvre*, ca. 1861, oil on canvas, 27⅛ × 40½ inches, Musée du Louvre, Department of Paintings, RF 3734.

The Italian psychiatrist Graziella Magherini referred to this short passage from Stendhal when evoking the psychiatric problems of many hospitalized patients. Between 1978 and 1986 in Florence alone, about a hundred tourists had to be treated by the psychiatric service of the Santa Maria Nuova Hospital. Most were between twenty-five and thirty years old, and suffered from "intense separation anxiety, and a certain inability to put up with frustration and change."[15] Whereas Stendhal's crisis had been caused by an aesthetic shock and proved to be short-lived, patients suffering from "Stendhal syndrome" experienced obsessive projections leading to severe depression. They often reinterpreted a work of art in the light of a personal experience. Some were deeply upset by the sudden memory of a particular moment or mood experienced in their past, others by someone who had been very important to them and who re-emerged in the paintings or sculptures they looked at in Florence.[16] In this respect the reactions of these tourists are similar to those experienced by the guests at Gervaise's wedding. In both cases, the personal experience of the spectator became more important than the work itself. Sigmund Freud pointed out that the fusion between the personal history of a spectator and the historical aspect of a work of art can also lead to a kind of confirmatory satisfaction. As he exclaimed when he visited the Acropolis, "All this is just as we learned at school."[17]

What kind of knowledge is it exactly that the individual visitor needs to join Hegel's masses in their enjoyment of immortal masterpieces? As described by a British traveler of the eighteenth century, a certain form of information might lead to posturing rather than profound feelings: "I by no means pretend to be a connoisseur, either in painting or sculpture, but at the same time, they give me great pleasure; I believe some of my countrymen pretend to receive a great deal more pleasure than what is real, and wish to have the name of connoisseur, by praising the noted pictures, but before they begin, they have the good sense (in general) to enquire the name of the painter."[18] It seems that one of the main ingredients for the perception of a masterpiece is knowledge that stimulates the imagination. Those who are standing in line to see the *Mona Lisa* (fig. 6) may ignore the extensive literature and may be unaware of the fact that this portrait rose to its current level of fame only at the beginning of the twentieth century after it was stolen and publicized all over the world. However, they have an expectation, which is mainly constituted by clichés such as the enigmatic smile, the feminine beauty,[19] the stare which is supposed to follow the spectator, and so on.[20] On the basis of these preconceived ideas—one might also call them rudimentary elements of cultural awareness—the viewers are enabled to construct a work of art in their minds, even in the absence of the work itself.

For centuries, tourists have used travel guides to nourish their imaginations. The author of one of the early guides in Antiquity, Philon of Byzantium (ca. 280 B.C.–ca. 220 B.C.), takes an extreme position, claiming that words can replace the physical experience of traveling— in his case, to the Seven Wonders of the World. "Everybody has heard of the Seven Wonders of the World, but few have ever actually set eyes on them." This was hardly surprising given the traveling conditions in the third century B.C. and the considerable distances between the Kheops Pyramid and the Hanging Gardens of Babylon, the Temple of Artemis at Ephesus and the chryselephantine statue of Zeus at Olympia, the Mausoleum of Halicarnassus and the Colossus of Rhodes, and the Lighthouse of Alexandria. Philon goes on to explain that once the reader has acquired the cultural knowledge offered in the book he will no longer need to travel: "Culture brings beauty to the man in his home, by giving sight to his intelligence." He adds that even those readers who had already visited the different places described in his book could still profit from his descriptions: "Those who actually visit the monuments only see them for a moment, and once they have left they forget, for the details remain closed to them, and

they remember nothing precise. But those who have studied the texts and learned how these marvels were created, once they have thoroughly considered the subject . . . they retain an indelible memory of all the impressions left by each image." The author concludes that the extraordinary things seen by the traveler "have been seen with 'the eyes of the intellect.'"[21] This last remark is particularly pertinent, for the marvels of the ancient world had long disappeared when Philon wrote about them, completing the knowledge drawn from historical sources with his own imagination.

Until art history became an academic discipline, literature was full of references to works of art the authors knew only from written sources. A particular focus was on works from Antiquity. Fréart de Chambray, whom we mentioned in the context of the extended use of the word *chef d'oeuvre*, describes in one of his lectures a painting by Timanthus, which he in turn knew only from a text by Pliny the Elder (23–79 A.D.); here the masterpiece was the imaginary model to be followed. The same can be said of the painting of *The Calumny of Apelles* mentioned by Lucian (125–after 180 A.D.). This author's treatise "Slander, A Warning"[22] was rediscovered in the fifteenth century, and the painting described was subsequently used as an inspiration by painters such as Botticelli (1445–1510), Mantegna (1431–1506) (fig. 7), Raphael (1483–1520), and Dürer (1471–1528).[23] It has to be assumed that pre-romantic artists actually believed in the existence of their models, whereas those who described works in Antiquity often liked to maintain a certain degree of ambivalence. Philostratus (ca. 170–ca. 247), one of the protagonists of the ekphrastic genre, artfully reminds his readers that it is because of his words that the picture gallery he describes actually comes to life: he evokes the smell of the fruit depicted in one of the still lifes, he conjures up the image of a pastoral countryside when describing landscapes, and he also refers to different stories in history paintings.[24]

These ekphrastic texts admittedly were addressed only to a small circle of scholars, patrons, and painters, but they raise the question of how our appreciation of a work of art can be conditioned by the way the work is described. Since paintings executed in Antiquity could no longer be seen, descriptions were particularly important for stimulating the imagination, and it was for this reason that ekphrasis lost its evocative power in the late eighteenth century, when the archaeological discoveries made at Pompeii and Herculaneum corrected and even bridled the spectators' imagination. In his *Laocoon: An Essay on the Limits of Painting and Poetry*,[25] Gotthold Ephraim Lessing (1729–1781) compared the images evoked by the writings of the Ancients with archaeological reality and concluded that the physical reality of works was very different from descriptions of them. His book caused a furor, and he had to justify his hypothesis. When asked by one of his university colleagues, "How could the Ancients have written about something that did not exist, and praise a painting for a quality that nobody could see?" the philosopher replied that the Ancients "praised what they saw, but their approval does not mean that they saw something which we also would consider worthy of praise."[26]

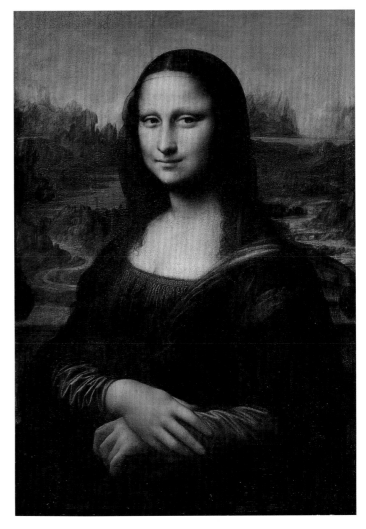

Fig. 6: Leonardo da Vinci (Italian, 1452–1519), *Portrait of Lisa Gherardini, wife of Francesco del Giocondo*, called *Mona Lisa*, *La Gioconda*, or *La Joconde*, ca. 1503–1506, oil on poplar, 30 × 21 inches, Musée du Louvre, Department of Paintings, INV 779.

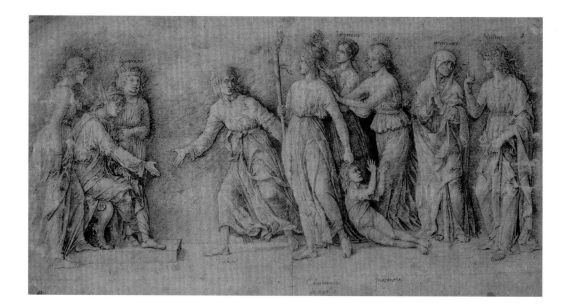

Fig. 7: Andrea Mantegna
(Italian, 1431–1506), *The
Calumny of Apelles*, 1504–1506,
pen and brown ink with white
heightening, 8⅛ × 14⅞ inches,
British Museum, London,
INV 18.600.616.85.

The phenomenon of disappointment is the same in the case of more easily accessible works. Although erudite writings and travel guides prepared spectators for their encounter with pictures, sculpture, and architecture, numerous travelers recount the disappointment they felt when they actually saw, for example, the ruins of ancient Rome. It is even more interesting to note the disillusionment experienced by spectators when confronted with contemporary works that followed the rules of the greatest models of the time. The comments made by English aristocrats completing the Grand Tour in the seventeenth and eighteenth centuries provide us with a veritable mine of information. Adam Walker devotes a long passage to Raphael's *Ecstasy of Saint Cecilia with Saints* (fig. 8), now in Bologna. After contemplating the picture for a quarter of an hour, the Englishman realized that he felt nothing, although he would have loved "to fall down on his knees in admiration." On the contrary, the more he looked at the picture the more he disliked it. "All I can see in it is a girl trying to sell the organ she holds in her hands to three insipid-looking people. . . . Saint Peter [it is actually St. Paul] seems to be wondering whether the instrument is worth buying . . . while the Holy Virgin and the person standing beside her look as though they are waiting to hear a few notes before giving up the negotiation."[27] Walker's imagination had probably been stimulated by writings and engravings. His fellow Englishman Jonathan Richardson (1665–1745), the author of *A Treatise on Painting and Sculpture*—one of the most highly regarded reference guides in the eighteenth century—had already noted that Marcantonio Raimondi's (1480–1534) engraving of the Saint Cecilia was much better than the picture itself.[28]

In fact, writings on art and reproductions of works create a certain anticipation in the spectator, and depending on what they have read or seen previously, viewers assume that the original will live up to their expectations, which can result in disappointment. The Comte de Caylus (1692–1765) wrote that he preferred descriptions of works to reproductions—engravings at that time—for he considered that the spirit was more "heated" in descriptions.[29] This shows that spectators quickly chose between written descriptions and reproductions, so as to avoid being disappointed when they actually saw the work. Those who, like Caylus, preferred descriptions, apparently accepted such disappointments since they knew that, in exchange, their imaginations would be greatly enriched by the descriptions. On the other hand, those who favored

reproductions categorically refused the idea that their appreciation could be deepened by any source other than the original work itself, and they believed that the original (or, in the absence of the work itself, a reproduction of it) should be the sole material support of their pleasure.

August Wilhelm Schlegel (1767–1845), for example, emphasizes the importance of immediate visual contact with a work of art without the peripheral help of any description: "What I know with certainty is that the impression is never but the shadow of a picture or statue. And how imperfectly do words describe the impression we feel—something in fact that is impossible to express."[30] This kind of attitude is rooted in the cult of unprepared viewing which still haunts our literature. Walter Benjamin (1892–1940) stresses how important it is to have direct contact with a work of art and concludes that, in the absence of such immediacy, the "aura" of the work will not be revealed. In his opinion, hand reproduction, "which in general bears the mark of simplification," does not endanger the authority of the original, whereas photography (and more recent reproduction technology) devalue this authority. "One thing is missing even from the most perfect reproduction, and that is the here and now, the unique existence of the original in one place." After a lengthy discussion on the question of reproduction, the author concludes that photography— a reproduction method quite independent of the human hand—had perhaps, even more than other techniques, "replaced a unique presence by a massive presence."[31] He thus shows himself to be deeply romantic in his condemnation of the photographic reproduction of old works. The now-obsolete controversy concerning the artistic value of photography reveals that reproduction on an industrial scale is aimed at subjectivity in the same way as engravings. In his *Musée imaginaire*, André Malraux (1901–1976) even associated the imagination with photographic reproductions of works of art.[32] To conclude, we can refer to one of the most paradoxical cases in this respect—the *Mona Lisa*. It is the most frequently reproduced work of art in the world and should therefore either occupy pride of place in our "musée imaginaire" or be totally excluded from it, since the innumerable duplications made of it would deprive it of that aura so essential for a masterpiece. This would indicate that Walter Benjamin was right . . . at least in this case.

When the concept of the masterpiece emerged under the auspices of technical excellence, works such as cathedrals were created that have continued to capture the imagination ever since. Irrational magic, however, was mainly expected to be residing in objects that had been animated by forces other than those of man. Miraculous depictions of the Virgin Mary, for example, were not traced back to an individual artist but to a divine creator. This changed gradually when painters, sculptors, and architects began to aspire to a more prominent position in

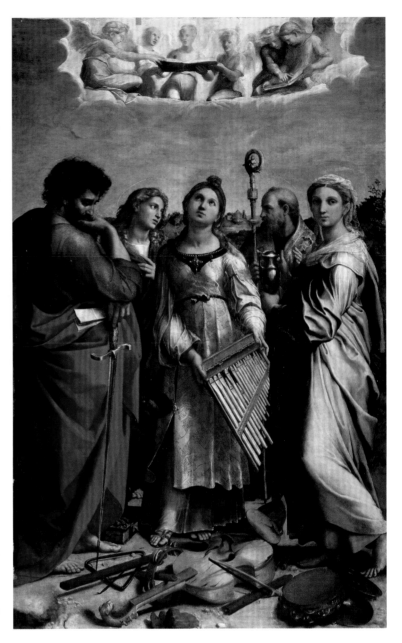

Fig. 8: Raphael Sanzio (Italian, 1483–1520), *The Ecstasy of St. Cecilia with Saints*, 1514, oil transferred from panel to canvas, 86⅝ × 53½ inches, Pinacoteca Nazionale, Bologna, Italy.

society. Parallel to the technical excellence of the craftsman appeared a new form of excellence, that of the artist, who supposedly invested his own work with magical power. For this power to be activated, a captive audience was needed, which has grown ever since Romanticism. Toward the end of the nineteenth century this general audience had fully developed, as had, in that public's imagination, the notion of the absolute masterpiece. At that moment, Georg Simmel (1858–1918) published an essay titled *The Tragedy of Culture*, in which he basically stated that every form inherited from the past needed to be reloaded with new and relevant meaning by every new generation.[33] At first sight, this melancholic conclusion seems to be contradicted by the ever-increasing number of visitors queuing to get a glimpse of the Louvre's *Mona Lisa*, the Vatican's Sistine Chapel, and the British Museum's Elgin Marbles. However, none of these works enjoyed the same degree of fame throughout history, and in the same way that they were even forgotten in certain periods, the public's eye will ultimately turn to other inherited forms that seem to attract projections in a more meaningful way. Even the modern notion of the masterwork is not destined to be eternal.

NOTES

1. W. Cahn, *Masterpieces, Chapters on the History of an Idea*, Princeton, 1979; M. Stürmer et al., *Der Herbst des Alten Handwerks, Meister, Gesellen und Obrigkeit im 18. Jahrhundert*, Munich, 1986.

2. G. W. F. Hegel, *Vorlesung zur Ästhetik*, Berlin, 1835, vol. I, part 1.

3. H. de Balzac, *Le chef-d'œuvre inconnu*, Paris, 1831.

4. A. de Laval, "Des peintures convenables aus Basiliques et Palais du Roy, meme à sa Gallerie du Louvre à Paris" (date of dedication 20 September 1600), quoted in J. Thuillier, "Peinture et politique: une théorie de la Galerie royale sous Henri IV," *Etudes d'art français offertes à Charles Sterling*, Paris, 1975, p. 196.

5. R. Fréart de Chambray, *L'Idée de perfection de la peinture démontrée par les principes de l'art*, Le Mans, 1662. The entry for *capolavoro* in *Dizionario dei termini artistici* (ed. L. Grassi and M. Pepe, Turin, 1994, p. 151) refers to this particular text as one of the first to extend the use of the term "masterpiece."

6. T. Hedin, *The Sculpture of Gaspard and Balthasar Marsy*, Columbia, 1983, pp. 238–239. The author refers to a lecture given by Gaspard Marsy on the torso of the *Belvedere Hercules*, 7 December 1669.

7. E. Pommier, *L'art de la liberté. Doctrines et débats de la Révolution française*, Paris, 1991.

8. J. Galard, *Visiteurs du Louvre*, Paris, 1993.

9. It was generally accepted that the portrait in question was of Louis XIII (INV 1167). However, this attribution has been put into question by B. Dorival, *Philippe de Champaigne 1602–1674. La vie, l'oeuvre, le catalogue raisonné de l'oeuvre*, Paris, 1976, vol. II, no. 183, pp. 103–104.

10. *Archives parlementaires*, vol. LXXVII, 1910, pp. 648–651, quoted in E. Pommier, *Théories du portrait. De la Renaissance aux Lumières*, Paris, 1998, pp. 426–427.

11. *Essai sur la méthode à employer pour juger les beaux-arts du dessin et principalement ceux qui sont exposés au Salon du Louvre*, Paris, 1790, quoted in E. Pommier, *L'art de la liberté*, 1991, pp. 18–19.

12. The fresco was painted by Jean-Simon Barthélemy in 1802 and was repainted by Jean-Baptiste Mauzesse in 1826. See also the commentary by H. Belting, "La conception du chef d'œuvre," in *Histoire de l'histoire de l'art*, ed. E. Pommier, vol. I, Paris, 1995, pp. 347–368.

13. E. Zola, *L'Assommoir* [1877], Paris, 1983, pp. 88–92.

14. Stendhal, *Rome, Naples et Florence*, Paris, 1987, pp. 270–272 (Florence, 22 January 1817).

15. G. Magherini, "La folie du passé," in *Autrement, 'Toscane, le balcon de la vie,'* special issue, no. 31, May 1988, pp. 222–226.

16. See G. Magherini's description of a large number of cases in *Le syndrome de Stendhal*, Paris, 1990.

17. Ibid., p. 148.

18. J. Black, *The British and the Grand Tour*, Beckenham (Kent), 1985, p. 221, letter from Andrew McDougall to his friend Keith, Florence, 27 January 1782.

19. W. Pater, *Studies in the History of the Renaissance*, London, 1873, p. 316.

20. See F. Zöllner, *Leonardo da Vinci. Das Portrait der Lisa del Giocondo, Legende und Geschichte*, Frankfurt am Main, 1994; A. Chastel, *L'illustre incomprise, Mona Lisa*, Paris, 1988; and J.-P. Guillern, *Tombeau de Léonard de Vinci. Le peintre et ses tableaux dans l'écriture symboliste et décadente*, Lille, 1981.

21. J.-P. Adam and N. Blanc, *Les Sept Merveilles du monde*, Paris, 1992, pp. 47–48.

22. "Slander, A Warning," *The Works of Lucian of Samosata*, trans. H. W. Fowler and F. G. Fowler, Oxford, 1905, vol. 4.

23. J. M. Massing, *La Calomnie d'Apelle*, Strasbourg, 1990.

24. Philostratus, *Imogines*, trans. A. Fairbanks, New York, 1931. The still lifes are described in Book 1.31 and Book 2.26.

25. G. E. Lessing, *Laokoon oder die Grenzen von Malerei und Poesie*, Berlin, 1776.

26. Ibid.

27. A. Walker, *Ideas suggested on the spot in a late excursion*, London?, 1790, pp. 188–189, trans. and quoted in J. Black, *The British and the Grand Tour*, 1985, p. 222.

28. J. Richardson, *Traité de la peinture et de la sculpture par Messieurs Richardson*, vol. III, Amsterdam, 1728, pp. 43–44.

29. Ch. Michel, "De l'ekphrasis à la description analytique: histoire et surface du tableau chez les théoriciens de la France de Louis XIV," in *Le Texte et l'œuvre d'art: la description*, conference proceedings, ed. R. Recht, Strasbourg-Colmar, 1988, p. 52.

30. A. Schlegel, *Les Tableaux* [1799], translated from the German by A.-M. Lang, Paris, 1988, p. 43. See also E. Décultot, *Peindre le paysage. Discours théorique et renouveau pictural dans le romantisme allemand*, Tusson, Charente, 1996, p. 44. In the chapter "Les fondements de l'ekphrasis," pp. 265–278, the author quotes and provides a commentary on Schlegel and other sources in order to discuss the complex attitude toward description held by German theoreticians of the period.

31. W. Benjamin, "Das Kunstwerk im Zeitalter seiner technischen Reproduzierbarkeit," in *Gesammelte Schriften*, I:2, ed. Tiedemann and Schweppenhäuser, Frankfurt, 1980, pp. 471–508. The essay was published in an abbreviated version in 1936.

32. A. Malraux, *Psychologie de l'art, le musée imaginaire*, Geneva, 1947.

33. Georg Simmel, "On the Concept and Tragedy of Culture" and "The Conflict in Modern Culture," in *The Conflict in Modern Culture and Other Essays*, trans. P. Etzkorn, New York, 1968, pp. 27–46 and 11–26.

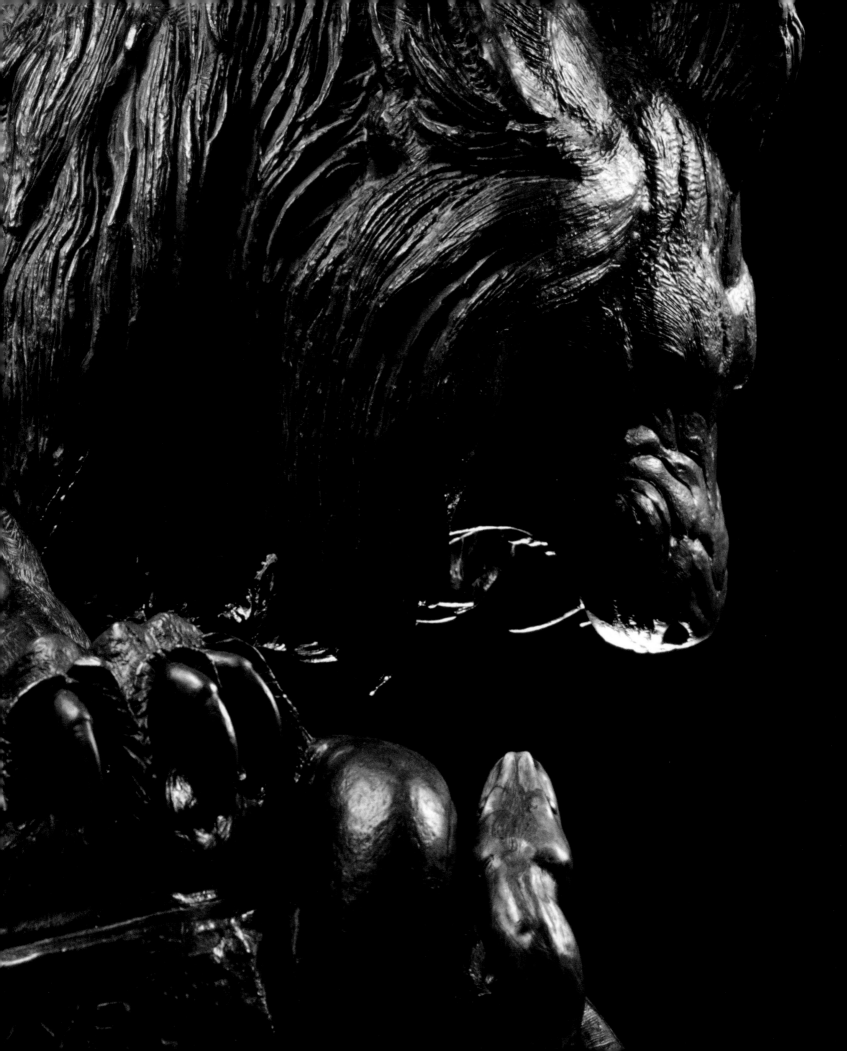

Barye's *Lion and serpent*: A Masterpiece in Context

Isabelle Leroy-Jay Lemaistre

On account of its monumental size and unusual subject, Antoine-Louis Barye's *Lion and serpent* was from the beginning designed to be an exceptional work. It rapidly became the recognized masterpiece of Romantic sculpture, and numerous reproductions were produced and distributed. Barye began his career working for the goldsmith Fauconnier, his employer and landlord in the Rue du Bac in Paris, where he chiseled the decoration on military uniform buttons and soup tureens. In this early part of his career, Barye also spent several years trying to win the famous Grand Prix de Rome, but he never succeeded in rising higher than second place. The animals he sculpted at the beginning of his career were very small; the first outstanding sculpture he produced, the celebrated *Tiger devouring a gavial* for the 1827 Salon, is only about half life-size. In light of this, it is clear that Barye was taking a considerable risk when envisioning a life-size version in plaster (fig. 1). The model presented at the 1833 Salon was a difficult and extremely costly undertaking, but the work was almost immediately hailed as outstanding, not only by the government, but by critics and art lovers alike. The work was not therefore an unknown masterpiece, one that was suddenly revealed or which was only recognized later. Like Géricault's *Raft of the Medusa* (see plate 23), painted just a few years before, the group was considered exceptional by its creator.

When commissioning the group, the government originally stipulated that it should be carved in marble.[1] Although the choice of marble showed the importance attached to the commission, it was in contradiction to the spirit of the work. We have no trace of Barye's discussions with the government,[2] but we can assume that it was Barye who insisted that the group be executed in bronze (plate 1) rather than marble. Works in marble require a simplified and synthetic approach, whereas bronze statues are cast from the wax model worked by the sculptor. With bronze, it is possible to represent the smallest details, the tiniest asperities, and the minutest traces left by tools or fingers that worked the material, for they are directly transferred from the wax to the bronze.

From sketch to bronze

We know that Barye began by modeling sketches in wax or clay—*Bull attacked by a lion* (plate 9) is an example. He then made a plaster model in the same size as the final work (fig. 1). This model was composed of different fragments assembled together and propped up on all sides, much like a boat under construction. In this way Barye was able to continue to modify his composition, and it was only at the very end of this first stage that he finally joined together the fragments of the three-dimensional puzzle he had constructed. Even when the plaster model was cast, he could still continue to change the surface of his composition by either reworking the still-wet plaster or by adding reworked wax. As shown by the group *Panther attacking a stag*

I

Antoine-Louis Barye
French, 1795–1875

Lion and serpent, also known as *The Lion of the Tuileries*,
1832–1833

Bronze, cast by Jean-Honoré Gonon (1780–1850) and Sons
53⅛ × 70¹⁄₁₆ × 37¹³⁄₁₆ inches (135 × 178 × 96 cm)
In front: BARYE / *1832*; on the back: CAST BY HONORÉ GONON /
AND HIS TWO SONS / *1835*; near the lion's tail, in a square: AD.
Department of Sculptures, LP 1184

HISTORY: Commissioned by the king following the 1833 Salon;
exhibited at the 1836 Salon; placed in the Tuileries gardens

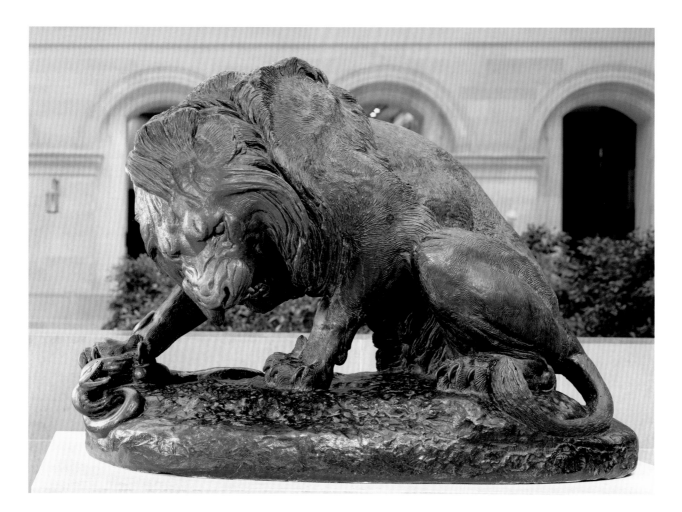

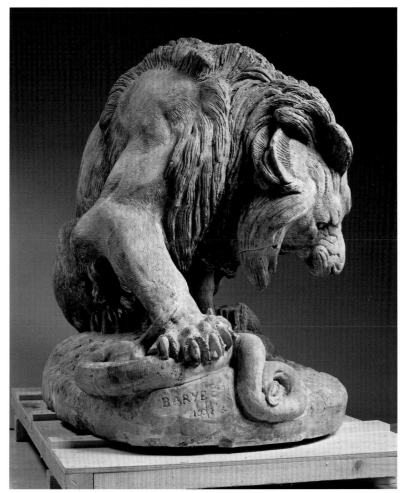

Fig. 1. Antoine-Louis Barye, *Lion and serpent*, plaster model, signed *Barye/1832*, Salon of 1833, Musée des Beaux-Arts, Lyon.

(plate 8), Barye was not averse to patinating the surfaces of his plaster works to make them look as though they were bronze.

The *Lion and serpent* was cast in bronze by Honoré Gonon. He was the best lost-wax founder of the period and had carried out many experiments and tests to determine the qualities necessary in both the bronze alloy and the refractory mold, or "investment," for the surface of the bronze to be as close as possible to the wax model. Gonon described his workshop as being "specialized in difficult shapes." The presence of Gonon's signature proudly placed on the bronze is a guarantee of the founder's own satisfaction with his work: the transfer of the model is so faithful to the original that even the ridges left by the tool used for digging furrows in the wax are visible all along the lion's back. The bronze *Lion and serpent* was presented at the Salon of 1836 and then installed in a prominent position in the gardens of the Tuileries palace, where everyone could see it. The work thus quickly became famous and elevated animal subjects to an unprecedented position in public sculpture.

An immediate success

In 1833 the group was seen as an emblem of the accession of King Louis Philippe to the French throne, for he had come to power in the month of July—under the Zodiac sign of the lion. When the bronze *Lion and serpent* was presented three years later at the Salon of 1836, and then installed in the Tuileries, it was praised by the critics not only for the quality of the bronze, but also because of the novelty of the subject, the realistic treatment, and the vigor of the combat portrayed. The traditional Greek heroes in marble had been dethroned by wild animals. The Romantics recognized themselves in this portrayal of the forces of Nature, in the "ferocity of this taut backbone, curved like a bow,"[3] and in the desperate combats like those depicted by Delacroix in his paintings. The poet Alfred de Musset described the group as "terrifying as nature. . . . This lion roars, this snake hisses. . . . Where on earth did Mr. Barye manage to pose such models? Is his workshop an African desert or a forest in Hindustan?"[4] Another critic, disapproving but pertinent, went even further: "Since when have the Tuileries become a menagerie?" Barye's lion was indeed very different from previous models, which had not been true to nature and were frequently very stylized and represented "with marble wigs."[5] We might indeed ask ourselves how Barye came to imagine this kind of realistic scene, for he had never left the Paris region and had never been in a position to see such an outlandish combat.

"Geometry for the skeleton and passion for the envelope"[6]

In order to model a lion so true to life that it frightened the young ladies walking in the Tuileries Gardens, Barye must have had the opportunity to observe actual lions. He had certainly seen live ones in traveling menageries; we know that he went to the Saint Cloud fair

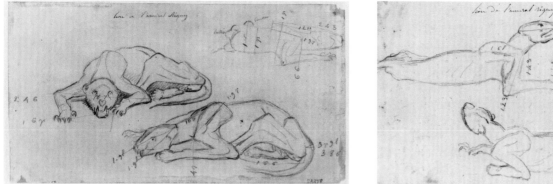

in 1827 with Delacroix, and that the two artists drew the lions in the menagerie there.[7] But it was principally at the Museum that he came into contact with all sorts of animals, and it was here that he made the sketches that he used in the decoration of soup tureen handles for Fauconnier. The Museum gardens had been considerably enlarged since the Revolution, and after French troops took the town of Algiers on 5 July 1830, the number of lions increased significantly. On 4 November 1830, five lions and eight lionesses from Africa entered the Museum Menagerie.[8] All of Barye's biographers note that the Museum keepers knew him well, for the artist would spend hours standing in front of the lion cages and always asked to be informed if one of them died.[9] The dead animals were taken as rapidly as possible to the anatomy laboratory, where they were dissected by veterinary surgeons and artists interested in the anatomy of the animals. It was in this way that Barye and Delacroix together dissected and drew several lions, including the famous one donated by the Admiral de Rigny,[10] the lion Delacroix was referring to when he wrote to his friend Barye: "The lion is dead, gallop over here where I'll be waiting for you; with this weather we need to act fast, affectionate regards, today Saturday." The museum inventory records clearly indicate that the lion died on Saturday, 19 June 1829, and that it was "carried to the Laboratory" the same day. Barye and Delacroix immediately proceeded to draw the animal. We can follow the work carried out by the two artists: from the lifeless, but complete animal, for which Barye made a precise topographic study (ENSBA 54),[11] to the skinned carcass hung up by one or two of its legs. The lion is also shown in particularly expressive attitudes (figs. 2 and 3), or in a dynamic pose, or as the noble animal (figs. 4, 5, and 6), an attitude portrayed by both artists. They drew and they measured.

Barye was able to study lion anatomy very precisely in the period 1831–1832, during which six lions died (the life expectancy of the museum lions was not much more than one or two years). The anatomical drawings show that Barye systematically measured the skinned carcasses of the animals—the muscles, bones, and tendons—and then compared these measurements with those he found published in different contemporary scientific treatises, for we know that Barye was a frequent visitor to the Museum's library, first opened to the public in 1823. He then noted the measurements on the large comparative tables hung on the walls of his studio. In one drawing (fig. 7), Barye compares the facial angles of a number of felines ranging from lions to cats. Such meticulous preparation explains in part why even today Barye's works continue to appear so realistic. We are now used to amazingly realistic productions, such as the work of artists like Duane Hanson or Ron Mueck, yet it is the veracity of Barye's monumental lion which makes

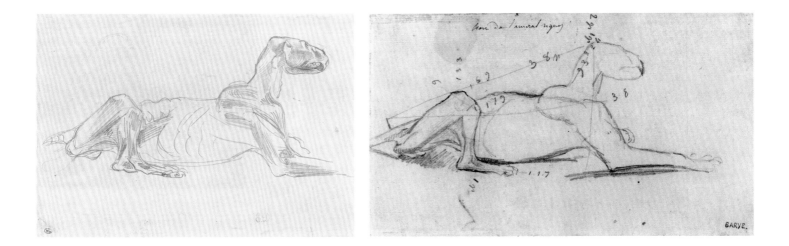

it a masterpiece that overshadows all other animal sculptures, including the Debay group (see page 205), which was also exhibited at the 1833 Salon and placed next to Barye's lion at the Louvre.

This realism so skillfully calculated by Barye was then meticulously transposed into bronze by Gonon and used in the depiction of an imaginary combat. For Barye does in fact recreate reality: his majestic, vigorous lion has little in common with the sad animals of the zoos, with their dull, lusterless coats and flabby muscles. It is possible that there was something of Barye himself in this savage violence; as a critic suggested in 1836, he might himself have been "a bit of a lion or tiger" in a previous life.[12] He had turned up disguised as a Bengal tiger at Alexandre Dumas's famous costume ball, and it is also true that he used this type of ferocious combat as a theme for the majority of works he made for his own artistic pleasure, in contrast to those he produced for sale. When working on this kind of sculpture, Barye played upon the contrast between different kinds of surfaces and revealed his virtuosity in the association of claw and tooth, hair and scale, and the shiny skin of the boa with the lion's dramatic coat.

Fig. 4. Eugène Delacroix, *Study of a skinned lion*, 1829, graphite on paper, Musée du Louvre, Department of Graphic Arts, RF 9694, recto.

Fig. 5. Antoine-Louis Barye, *"The Lion of Admiral Rigny" as a sphinx, with measurements*, 1829, graphite on paper, École Nationale Supérieure des Beaux-Arts, Paris, INV EBA 62.

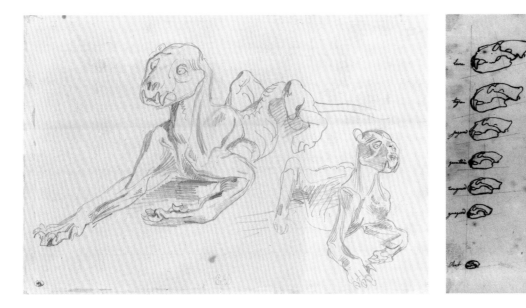

Fig. 6. Eugène Delacroix, *Two skinned lions*, 1829, graphite on paper, Musée du Louvre, Department of Graphic Arts, RF 9692, recto.

Fig. 7. Antoine-Louis Barye, *Feline skulls*, pen, ink, and graphite on tracing paper, École Nationale Supérieure des Beaux-Arts, Paris, INV EBA 11.

2

Antoine-Louis Barye
French, 1795–1875

Lion and serpent, 1832

Bronze foundry model
4¾ × 6¹³⁄₁₆ × 4⅛ inches (12 × 17.3 × 10.4 cm)
Department of Sculptures, OA 5740

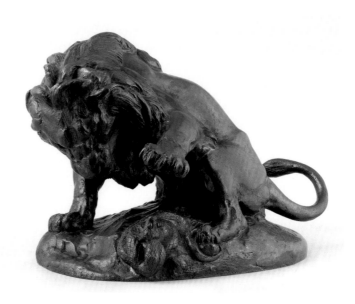

3

Antoine-Louis Barye
French, 1795–1875

Lion and serpent, mid-19th century

Bronze chief model with patina
6⅞ × 8⅛ × 3¹³⁄₁₆ inches (17.5 × 20.6 × 9.7 cm)
Department of Sculptures, OA 5743

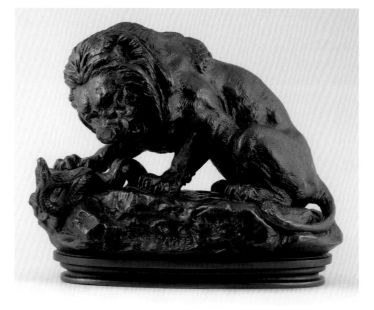

4
Antoine-Louis Barye
French, 1795–1875

Lion and serpent, mid-19th century

Bronze model with patina
9¼ × 13¾ × 6¹¹⁄₁₆ inches (23.5 × 34.9 × 17 cm)
Department of Sculptures, OA 5741

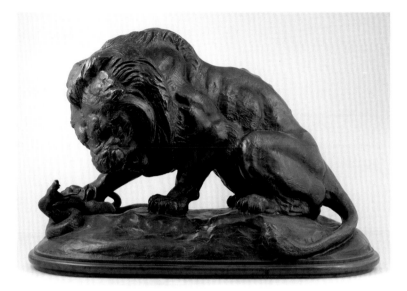

5
Antoine-Louis Barye
French, 1795–1875

Lion and serpent, mid-19th century

Bronze with yellow-brown patina
6⅞ × 8⅛ × 3¹³⁄₁₆ inches (17.5 × 20.6 × 9.7 cm)
Department of Sculptures, OA 5742

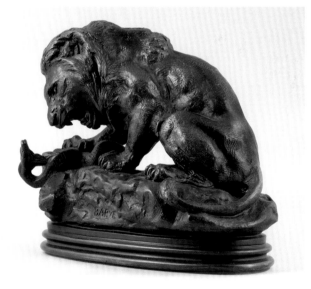

Collection
VILDIEU-BARYE

Fig. 8. Antoine-Louis Barye,
Sketches of a lion, 1832, graphite
on paper, The Walters Art
Museum, Baltimore, 37.2248.

The unique and the multiple

The first studies by Barye show a lion lifting its paw to crush a boa constrictor (fig. 8). This is the group that was finally entitled *Lion and serpent* (plate 2). The final group was more powerful and more majestic. The sketch was only reproduced in very small sizes. Barye quickly produced his large group in several sizes, and this composition was widely distributed and copied. We have here an illustration of one of the criteria defining a masterpiece—that it becomes well and widely known. Barye had a family to support and, up to 1855, he had serious and recurrent financial problems. He therefore decided to sell small bronzes, and began advertising them in catalogues. It should not be forgotten, however, that when he designed the smaller version of this group, Barye did not resort to the reduction machine he would use when making the small head of the plaster *Lion and serpent* (plate 7). On the contrary, he modeled new groups. These smaller versions display differences of detail from the original and their composition is slightly modified. The shape of the rock and the mane are both new creations (plate 3), and even on those versions that seem to be closer to the original group, there are variations in the position of the lion.

Barye represented the *Lion and serpent* in several watercolors (fig. 9), but it was the composition of the Louvre bronze which proved to be the most successful. We have a number of examples in the original size—including those now in Philadelphia, Prague, and Copenhagen, many of which were cast by Barbedienne—as well as thousands of others throughout the world, for which the quality of the casting ranges from the very good to the mediocre. The Louvre has one of the most important collections of Barye's works. The other major ensemble

6

Antoine-Louis Barye
French, 1795–1875

Lion and serpent, mid-19th century

Bronze with brown patina on oval base
5¹⁄₁₆ × 6⅞ × 4½ inches (12.9 × 17.5 × 11.4 cm)
Department of Sculptures, OA 5744

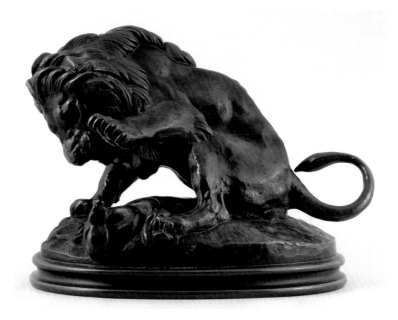

7

Antoine-Louis Barye
French, 1795–1875

Lion and serpent, 1852

Patinated plaster reduction
5¾ × 4⁵⁄₁₆ × 4⁵⁄₁₆ inches (14.6 × 11 × 11 cm)
Department of Sculptures, RF 1569

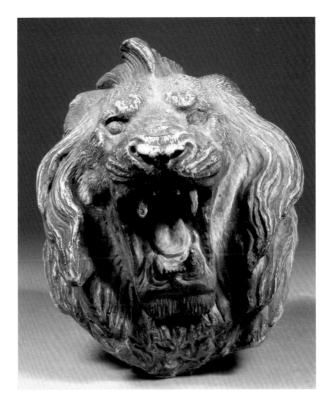

8

Antoine-Louis Barye
French, 1795–1875

Panther attacking a stag,
mid-19th century

Patinated plaster model with wax
additions
14⅞ × 23⅜ × 9⁵⁄₁₆ inches
(37.8 × 59.4 × 23.7 cm)
Department of Sculptures, RF 1572

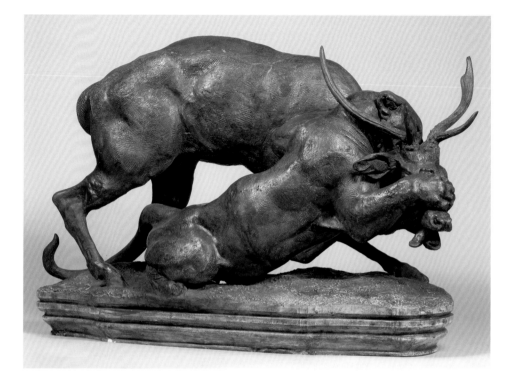

9

Antoine-Louis Barye
French, 1795–1875

Bull attacked by a lion,
mid-19th century

Terracotta sketch
8¹³⁄₁₆ × 13⅛ × 7⁵⁄₁₆ inches
(22.4 × 33.3 × 18.5 cm)
Department of Sculptures, RF 2593

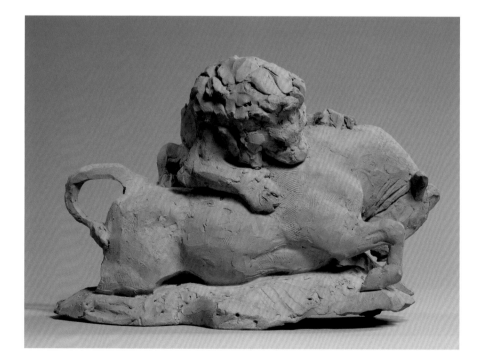

is owned by the Walters Art Gallery, which was founded by Henry Walters, one of the earliest collectors of Barye's bronzes.[13] But the original, cast by Gonon under Barye's personal supervision, remains unique and unequalled, and is not only a masterpiece of French sculpture, but one of the greatest *chefs d'oeuvre* of animal sculpture in the world.

Fig. 9. Antoine-Louis Barye, *Lion and serpent*, watercolor, Musée Fabre, Montpellier, INV 876.3.95.

BIBLIOGRAPHY

William R. Johnston and Simon Kelly, *Untamed: The Art of Antoine-Louis Barye*, exhibition catalogue, Baltimore, 2006; Isabelle Leroy-Jay Lemaistre and Béatrice Tupinier Barrillon, *La griffe et la dent, Antoine-Louis Barye (1795–1875), sculpteur animalier*, Paris, 1996.

NOTES

1. In June 1833 the government asked a number of suppliers to provide an estimate of the marble necessary for the sculpture. Louvre archives, S.30, 24 June 1833.

2. R. Ballu, *L'oeuvre de Barye*, Paris, Maison Quantin, 1890, p. 52, tells us that the decision to execute the group in bronze was made in 1834.

3. T. Gautier, *Les Beaux-Arts en Europe*, Paris, 1855, tome 2, p. 180.

4. A. de Musset, "Salon de 1836," in *La Revue des Deux Mondes*, Paris,

15 April 1836, reprinted in Alfred de Musset, *Oeuvres*, Paris, Charpentier, 1867, p. 681.

5. T. Gautier, *L'Illustration*, 18 May 1863.

6. A. Alexandre, *Les artistes célèbres, Antoine-Louis Barye*, Paris, 1889, p. 34.

7. The year 1827: no. 194c, two drawings of a seated lioness executed "in the company of Barye at Saint Cloud in one of the first travelling menageries that came to France." Annotated catalogue of the works of Delacroix by Robaut. A. Robaut, *L'oeuvre complet de Eugène Delacroix, Peintures, dessins, gravures, lithographies, 1813–1863*, Paris, 1885.

8. Record of entry of mammals to the Menagerie, 1807–1849.

9. E. Guillaume, "Barye et la théorie anatomique," lecture given at the Collège de France, 1883–1884, published in *Notices et discours*, Paris, 1884, p. 214.

10. F.-R. Loffredo clearly establishes this date and presents some of the drawings by Delacroix which are now in the Louvre. "Des recherches communes de Barye et de Delacroix au Laboratoire d'anatomie du Muséum d'Histoire Naturelle," in *Bulletin de la Société d'Histoire de l'art français*, Paris, 1984, p. 147.

11. Ibid., p. 148.

12. A. Barbier, 1835 Salon, pp. 114–115: "One would almost have to have had a little of the lion or tiger about one . . . and to have retained a kind of intuitive vision from this previous life. . . . Mr. Barye examines himself so carefully . . . and realizes that he still has memories of the time he once paced the desert . . . and took a gazelle as his prey."

13. This collection was created in the 1860s with the direct help of Barye himself.

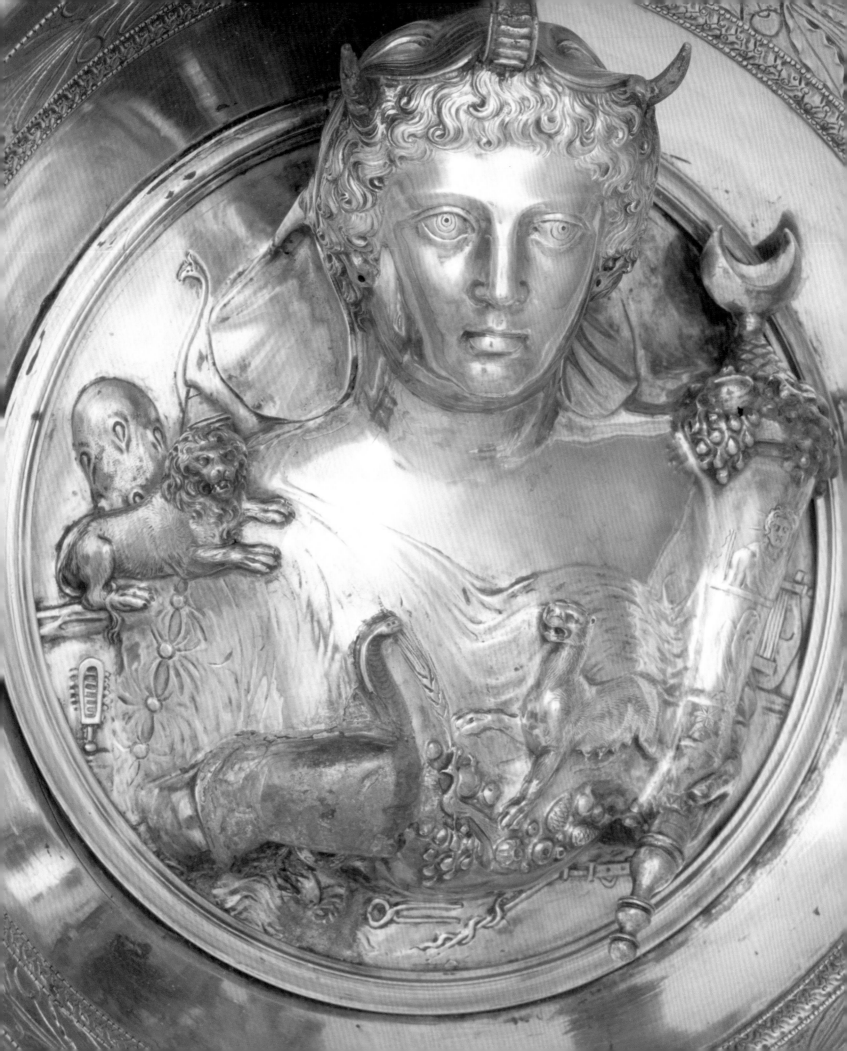

Changing Historical Definitions of Masterpiece

David A. Brenneman

The English term "masterpiece" and its French equivalent *chef d'oeuvre* have their roots in the Middle Ages. The concept of the masterpiece did not exist in Antiquity. Nevertheless, key qualities associated with the masterpiece—the production of a work of art that is a tour de force of technical skill and the identification of certain works of art as representing artistic perfection—appeared in ancient art and suggest a long history of human preoccupation with the idea that some works of art are so special that they belong to a separate, higher category of achievement.

Two remarkable objects in this exhibition that help explain the prehistory of the masterpiece are the ancient Greek bronze weight in the shape of an anklebone (plate 13), dating from between 522 and 486 B.C., and an even older bronze *aryballos*, or votive perfume jar (plate 12), dating from the late seventh century to the first half of the sixth century B.C. Both objects are unassuming to modern eyes, yet in ancient Greece they were considered masterpieces worthy of the gods by the artists who made them. We know this because both artists left inscriptions on their respective masterpieces identifying themselves as the makers. About the size of a golf ball, the *aryballos* was inscribed, "Chalkodamas dedicated me to the gods [Castor and Pollux] as a very beautiful object." In this case, the artist not only identified himself as the maker, but rendered the qualitative judgment that his offering was "very beautiful."

The French term for masterpiece, *chef d'oeuvre*, is older than its other European equivalents (*Meisterwerk* or *Meisterstück* in German; *capodopera* or *capolavoro* in Italian). Although the term must have been used in spoken language well before it appeared in written form, *chef d'oeuvre* made its first documented appearance in a book regarding trades in Paris in the late thirteenth century,[1] where it was used to refer to a special work that showed mastery of a given trade. In the medieval system, a guild was made up of experts or masters in their field of production, such as carpenters, stonemasons, painters, and even barbers and cooks. The same guild brought together painters, sculptors, engravers, and illuminators. It defended its members against peddling, clandestine sales, and competition from similar trades. It organized group activities and ensured the apprenticeship of its members.

Before an artisan could be called a master and join the guild, he had to go through a rigorous period of apprenticeship. After several years of experience in a master's workshop, an apprentice could take a test which involved the production and submission of a masterpiece. There were usually specific requirements for the production of the masterpiece, including the amount of time needed to complete the work. After acceptance into a guild, members could identify themselves as masters (using the Latin term *Magister*) and could open workshops and take on apprentices. Although we know that there must have been many masters during the Middle Ages, self-identification as a master was an uncommon occurrence. Thus, the enameled

ciborium (container for communion wafers, plate 15) made in Limoges before 1200 and inscribed "Magister G. Alpais me fecit lemovicarum" ("Master G. Alpais from Limoges made me") is a rarity as a testament to the medieval system that gave rise to the masterpiece.

Islamic civilization also had guilds, the earliest of which was for papermaking. During the thirteenth and fourteenth centuries, the period when the Mamluks governed Egypt and Syria, Islamic artists took metalworking to new heights. Like the Master Alpais, who proudly signed the Limoges ciborium, the master metalworker Muhammad ibn al-Zayn signed his masterpiece, now known as the *Baptistère de Saint Louis* (plate 18).

In 1648 Louis XIV created the Royal Academy of Painting and Sculpture, the purpose of which was to protect the interests of the king's artists, but also to train student artists and establish the principles to be applied. Chief among the reasons to establish the Academy was a desire to raise the fine arts—painting, sculpture, and architecture—above the level of craft and artisanship. There was also a desire to break the grip of the guilds, which were commercially powerful organizations. But after 1663 the Academy became a machine for governing the arts. Membership in the new academic system also required the production of a work that would demonstrate mastery, but the term "masterpiece," associated with the guild system, was replaced by "reception piece" (*morceau de réception*). Unlike the guild masterpiece, where the emphasis was almost exclusively on the work's technical aspects, the academic reception piece required the candidate to demonstrate knowledge of history and literature.

The reception piece of the Rococo painter François Boucher, which was submitted to the Royal Academy in 1734, is typical in its choice of subject matter, a scene from Renaissance literature, its complex composition featuring the human body in a variety of poses, and the artist's virtuoso display of his ability to represent a variety of different materials and surfaces. Boucher's *Rinaldo and Armida* (plate 22) is certainly not his best painting and cannot be considered a masterpiece in the modern sense of the term, but it did serve its intended purpose, which was to showcase the artist's outstanding talent.

In sculpture, the first reception pieces were oval medallions like the *Mater Dolorosa* by François Girardon. Gradually a new kind of reception piece emerged, still in the form of an oval medallion but now depicting an allegorical scene, such as the relief by Pierre Hutinot (plate 20). Subsequently several reliefs illustrated the glory of the king and his exploits, an example being *Hercules crowned by Glory* by Martin Desjardins (1671). A few busts were sculpted in the 1670s, such as the one of *Mansart* by J. B. Lemoyne, which was exhibited at the High Museum in 2005–2006. The fashion for small marble statuettes began in 1700 and was to last until the Revolution.

The modern meaning of the masterpiece, discussed thoughtfully at the beginning of this catalogue by Matthias Waschek, arose only at the end of the eighteenth century and the beginning of the nineteenth, the same time as the birth of the museum. It was during this period that the masterpiece began to be seen not merely as a work of technical mastery, but also as the result of creative genius. As such, the production of masterpieces was no longer the domain of the guild and the academy, which operated under rules and regulations. Genius is above and beyond rules; in fact, the artist genius creates masterpieces that break the rules. These new concepts of the masterpiece and the artist genius ushered in a new age in which artists struggled against convention, against the academy. The artistic heroes of the past that emerged from this new conception of masterpiece included Michelangelo, Raphael, and Leonardo da Vinci, all artist geniuses who paved their own ways to artistic greatness.

One of the first artists to epitomize this new approach was the French Romantic painter Théodore Géricault, whose monumental painting *The Raft of the Medusa* created a sensation when it was first exhibited in 1819. The final painting, which resides in the Louvre and cannot travel because of its massive size, was shocking because it depicted a controversial contemporary maritime disaster, the sinking of the *Medusa* and the subsequent abandonment of the crew by the ship's officers (see plate 23). The subjects of such large, ambitious paintings had previously been limited to edifying subjects from Christianity, Classical history, and even contemporary history, but no artist had ever attempted to paint on a grand scale such a gut-wrenching scene. As the art historian Hans Belting reported: "Géricault's preparations showed that he was planning an extraordinary work. He transformed his studio into the scene of the catastrophe: not having experienced it himself, he wanted to re-create it as though on a stage. He even induced the *Medusa*'s carpenter, who was one of the survivors, to build him a scale model of the raft. On this he positioned wax models of the figures, while sketches of dead bodies were hung on the studio walls."[2]

In setting out to make this painting, Géricault clearly intended to follow the lead of his Renaissance idol, Michelangelo, and break the rules of the art establishment. In doing so, he is credited with creating one of the first modern masterpieces, a work that, despite its origins in the contemporary reportage of the early nineteenth century, continues to inspire and fascinate visitors to the Louvre.

NOTES

1. W. Cahn, *Masterpieces: Chapters in the History of an Idea*, Princeton, 1979, p. 4.

2. H. Belting, *The Invisible Masterpiece*, London, 2001, p. 89.

10
Vase

Egypt, Nagada I period, ca. 3800–3500 B.C.
Basalt
14⅝ × 5 inches (37.1 × 12.8 cm)
Department of Egyptian Antiquities, E 23449

HISTORY: Acquired by the Louvre in 1938, gift of L., I., and A. Curtis

This very sober and surprisingly modern-looking vase could well have been produced by a contemporary artist, but it dates from late Egyptian prehistory. Similar vases were found in tombs from the first phase of the Nagada era, which takes its name from a site in southern Egypt that shows cultural characteristics typical of ancient human occupation. In such tombs, a group of clay and stone vases was found beside the body, which was not routinely mummified during this period. Some of the most characteristic objects from this era are vases made from basalt, an extremely hard volcanic stone. The Louvre vase is a masterpiece, not only because its manufacture constituted a veritable tour de force, but also on account of its large size.

Variants of this kind of vase, with more or less bulbous bodies, do exist, but the general type displays the same characteristics: small handles beneath the neck, a spindle-shaped body, and a conical foot. These features suggest that the vase could have been used in two ways: either suspended or transported by means of a string placed round the neck and passed through the handles, or dug into the ground. The foot would have been too small to ensure stability for fixing in the ground, yet the vase is stable when vertical, thanks to the great skill used in its manufacture. The opening of the vase was created by boring the vase with a piece of stone as hard as basalt, fixed to a shaft. The ensemble was then rotated by using the equivalent of a bow: the shaft was attached to the string and held at its top end by the sculptor. The opening was bored by moving the bow back and forth, much in the way drills are used today. Throughout the first dynasties, hard-stone vessels remained prestige items among the funerary wares of both royalty and high-ranking personages and officials.

MARC ETIENNE

11
Statuette of a worshipper bearing an offering

Susa, Iran, Middle Elamite period, 12th century B.C. (?)
Gold alloy (statuette) and copper (plinth)
2⅞ inches (7.5 cm) high
Department of Near Eastern Antiquities, Sb 2758
Atlanta only

HISTORY: Discovered during the J. de Morgan excavations on the
Acropolis of Susa at the placement known as "Trouvaille de la statuette
d'or," 22 February 1904.

BIBLIOGRAPHY: Roland de Mecquenem, "Trouvaille de la statuette d'or,"
in *MDP (Mémoires de la Délégation en Perse)* VII, p. 132, pl. XXIV: 1;
Edith Porada, *The Art of Ancient Iran: Preislamic Cultures*, New York, 1965,
pp. 132–134; Pierre Amiet, *Elam*, Auvers-sur-Oise, 1966, fig. 319; Agnès
Spycket, *La statuaire du Proche-Orient ancien*, Leyde and Cologne, 1981,
p. 309, note 79, pl. 200; Françoise Tallon, *The Royal City of Susa*,
exhibition catalogue, Metropolitan Museum of Art, 1992. French
version of the catalogue *La Cité royale de Suse*, RMN, Paris, 1994,
no. 89, pp. 146–148.

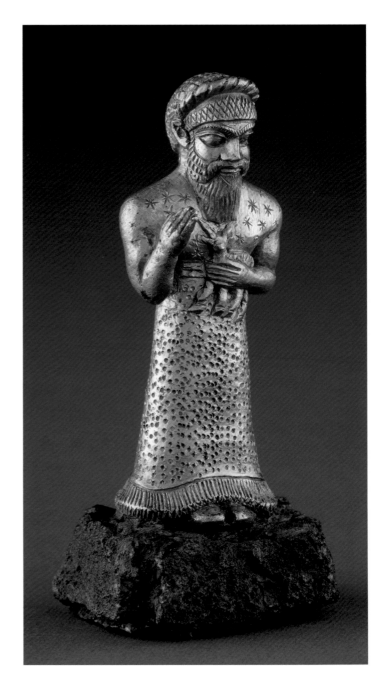

This small statuette was the most important piece found in
a deposit that was subsequently named after the figure, the
"Trouvaille de la statuette d'or" (place of the gold statuette). The
deposit, consisting of approximately fifteen objects[1] dating from
the Middle Elamite period—probably the twelfth century B.C.—
was found in the sacred quarter of the Acropolis of the town of
Susa. The fact that the objects were discovered on a pavement
of glazed bricks suggests that they were not burial objects but
instead constituted a royal offering to a temple.[2] The gold statu-
ette was accompanied by eleven other statues of worshippers,
including one in silver and ten in frit. All the figures are repre-
sented in a pious attitude, in keeping with their function of
perpetuating their worship through their effigies.

The statuette represents a man raising his right hand in the
nishqati gesture of reverence for the deity.[3] With his left arm he
clasps against his chest the baby goat he has brought as an offer-
ing. The animal, which looks straight ahead at the spectator, is
well rendered, with attention paid to all details such as the small
hooves and woolly fur. Worshippers in the second millennium
at Susa offered either small four-legged animals or birds to their
local god Inshushinak, the major deity of the Susian plain.[4] The
man wears a seamless skirt tied at the waist by a double belt.

The embroidery work of spangles decorating the material is represented by a dotted pattern. The bottom of the robe is fringed, and we can see from the part of the garment which is raised over the feet that there are three rows of fringes.

The upper part of the torso is naked, the left nipple is shown prominently, and there is no trace of clothing on the back. We can conclude from this that the numerous small eight-pointed stars engraved on the bust do not represent the embroidered pattern on a piece of clothing worn by the worshipper, nor the hair on his skin, but are most probably religious tattoos on the body. The practice of tattooing in this period in the Marlik civilization is attested by marks on anthropomorphic ceramic vases and also on the hands of a male bust in gold.[5] Another deposit, explicitly dedicated to Inshushinak, now in the Louvre, contains many pendants crafted in precious materials and shaped like eight-pointed stars.

The worshipper's hair appears to be enclosed in a kind of net or skullcap kept in place by a twisted headband, which corresponds to a thick net or a twisted braid of material, or may even represent a diadem similar to the one on a statue of the Prince of Marlik.[6] Whatever the case, this kind of hairstyle is unique, since most worshippers either had their heads shaved or wore their abundant hair piled up high above the forehead in a hairstyle known as the caplike Elamite coiffure. The long beard is carefully executed and divided into two parts and resembles those worn by kings and gods. The treatment of the face is extremely delicate, in particular the continuous eyebrows and the fleshy lower lip.

The statuette, made from a gold alloy composed of 6.5% silver and 1% copper, is heavy (weighing 6½ ounces or 185 grams). It was cast in the lost-wax process, and the absence of a central core is surprising. It is connected to the copper plinth, which is hollow, by an anchor-shaped endpiece. A similar statuette in silver (fig. 1) was also found in the deposit. The two statuettes are almost exactly the same except that the animal held by the worshipper in silver is small enough to fit into his hand. The personage represented here is not a commoner; he differs from ordinary representations of praying figures in his distinctive hairstyle and beard, in his tattoos, and even in the kind of shoes he wears. The fact that the piece is executed in solid gold without the use of a clay core—implying that there was no need to limit expense— supports the hypothesis that this statuette represents a royal personage.[7] Mesopotamian texts suggest that statues can help with

Fig. 1. A similar statuette in silver, found in the same deposit.

the dating of reigns, and they also indicate that two different statues were sometimes crafted for the same person: one in gold and one in silver.[8] Our statuette could be an example of such a practice.

AGNÈS BENOIT

NOTES

1. For a presentation of the deposit, see F. Tallon, *The Royal City of Susa*, exhibition catalogue, New York, 1992, pp. 145–146. It consisted of two statuettes, one in silver and one in gold, and about ten statuettes of worshippers in frit, a whetstone, with a gold lion's head at the end, a small bull's head in lapis lazuli with a gold bull-ring, a large dove in lapis lazuli studded with gold, a small lion, a bead made from agate inscribed with the name of Kurigalzu (cat. nos. 89–99), and a bead necklace.

2. Subsequently confirmed by Roland de Mecquenem, who discovered the deposit.

3. The same gesture as the one made, for example, by King Hammurabi of Babylon standing before Shamash, the god of Sun and Justice, on the stele inscribed with Hammurabi's law code.

4. In 2006–2007 the Department of Near Eastern Antiquities of the Louvre lent a large alabaster statuette of a worshipper carrying a baby goat to the High Museum, Atlanta. However, this kind of offering was exceptional in the context of the third millennium. A. Benoit, *The Louvre and the Ancient World*, exhibition catalogue, Atlanta, 2007, no. 35, p. 102.

5. E. O. Negahban, *A Preliminary Report on the Marlik Excavation. Gohar Rud Expedition. Rudbar 1961–1962, Joint Publication of the Iranian Archaeological Service and the Institute of Archaeology, University of Tehran*, Tehran, 1964, pl. X, and *Marlik. The Complete Excavation Report*, Philadelphia, The University Museum, 1996, vol. 2, fig. 11, nos. 70–72, pl. 32, nos. 70–72, and pl. 35, no. 82.

6. Although in the case of the Prince of Marlik statue, the diadem goes right around the prince's head, ibid., fig. 12, no. 82.

7. This is in spite of the fact that the royal hairstyles for this period consist of two long tresses ending in curls.

8. This was the case for the last king of the first dynasty of Babylon, Samsuditana, J. J. Finkelstein, "The year dates of Samsuditana," in *JCS (Journal of Cuneiform Studies)* 13, 1959, p. 47.

12
The Chalkodamas *aryballos*

Sparta, late 7th century–first third of 6th century B.C.
Argian production
Bronze
1⅝ × 1⅜ inches (4 × 3.6 cm); weight: 2.5 oz. (70 g)
Department of Greek, Etruscan, and Roman Antiquities, Br 2918

HISTORY: Acquired by the Louvre in 1884.

BIBLIOGRAPHY: P. A. Hansen, *Carmina Epigraphica Graeca. Saeculorum VIII–V A. CHR. N.*, Berlin and New York, 1983, pp. 193, 194, 268, 291.

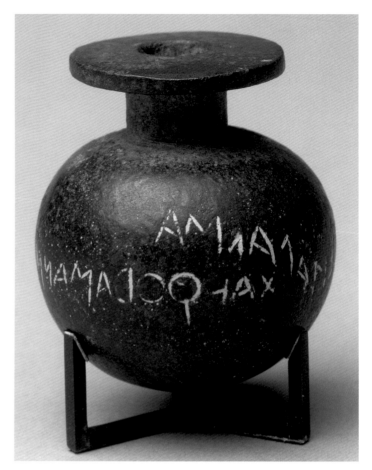

This view of the *aryballos* shows the name Chalkodamas and the last word of the dedication, *agalma* ("beautiful object"), inscribed in the Argian alphabet.

This small utensil with a spherical body, high neck, and flat mouth once had a ribboned handle that was manufactured separately. The upper part of the handle, which is now lost, was bent at a right angle so that it could be fitted horizontally into a wide slit in the rim. The remains of soldering can be seen where the handle was originally attached to the body.

Metal *aryballoi* are much rarer than those made of clay. Corinthian pottery workshops produced numerous vases of this type for export, and they were considered particularly precious on account of the perfumed oils they contained. By studying the figured scenes and the decorative motifs used to embellish the walls of clay *aryballoi*, we can see how these vases evolved typologically and establish a relative chronology. It is now thought that globular *aryballoi* with no foot were produced mainly in the late seventh century and the first third of the sixth century B.C.[1]

The Louvre *aryballos* may appear very modest to the modern eye, but the dedicatory inscription it bears shows that it was considered a masterpiece during Antiquity. The inscription engraved on the body in Argian letters[2] is in reverse—i.e., it is to be read from right to left—and encircles the entire body of the *aryballos* (figs. 1–3). For lack of space, the last letters of the inscription were placed above the first word:

Χαλκοδάμανς με ἀνέθεκε θιιοῖν περικαλλὲς ἄγαλμα

As was usual in such cases, the ex-voto expresses itself in the first person and speaks to those who can read the inscription: *Chalkodamas dedicated me to the gods as a very beautiful object*. The *aryballos* was dedicated to several deities (θιιοῖν), and although no names are specified, the gods were probably the Dioscuri, Castor and Pollux, who were worshipped at a number of sanctuaries in the Peloponnese.

It is from the last two words of the inscription that we learn that the *aryballos* was considered an outstanding work: ἄγαλμα (*agalma*), meaning a "beautiful object," an "object which pleases," an "object whose beauty delights the gods." This "beautiful object" is described as being περικαλλὲς (*perikallès*), that is, "very beautiful."[3]

The dedicator calls himself Chalkodamas, the literal translation of which is "tamer of bronze"; in other words, his name was derived from his outstanding expertise and skill in working bronze. It thus seems highly probable that he was not only the donor, but also the artist who made the *aryballos*. The dedication thus expressed the pride of a master craftsman, who was undoubtedly a precursor capable of producing a tour de force at a time when the processes of lost-wax hollow casting were still evolving. The other examples of globular *aryballoi* that have come down to us and are in good enough condition to be analyzed were not manufactured using the same technique. In those cases,

Fig. 1. If the *aryballos* is turned slightly from left to right, the end of the name Chalkodamas (*damans*) can be read, as well as the dedicatory formula: *me anetheke*: "dedicated me."

Fig. 2. If the *aryballos* is turned more to the right, the words *Thiioin* ("to the gods") and *perikallès* ("very beautiful") can be seen.

Fig. 3. Transcription of the dedicatory inscription (after L. H. Jeffery, *The Local Scripts of Archaic Greece*, Oxford, 1961, pl. 26.3).

the body is divided horizontally in the middle and consists of two semi-circular parts soldered together.[4]

It is unlikely that Chalkodamas would have chosen for his *aryballos* a shape which had gone out of fashion. Moreover, the writing used for the dedicatory inscription corresponds to the most ancient form of the Argian alphabet. Everything then seems to support the hypothesis that this ex-voto was produced well before the middle of the sixth century B.C. This means that the tiny Louvre vessel could bear the oldest known signature of a Greek bronzeworker engraved on its surface.[5]

In Greece the first signatures by artists[6]—or, to be more precise, of *dèmiourgoi* (those who create with their hands)—date from the late seventh century B.C. However, they are rarely accompanied, as here, by an inscription which shows that the dedicator was the creator of the "beautiful object" and, moreover, that he was conscious of the fact that he had produced a masterpiece approved by the gods.

SOPHIE DESCAMPS-LEQUIME

NOTES

1. D. A. Amyx, *Corinthian Vase-painting of the Archaic Period*, Berkeley, Los Angeles, and London, 1988, p. 441.

2. L. H. Jeffery, *The Local Scripts of Archaic Greece*, Oxford, 1961 (reprinted with suppl. A. W. Johnston, 1990), no. 3, pp. 156, 168, 405, 444, pl. 26.3.

3. The expression περικαλλὲς ἄγαλμα (*perikallès agalma*) disappeared in about 530 B.C.: C. Karouzos, ΠΕΡΙΚΑΛΛΕΣ ΑΓΑΛΜΑ, Athens, 1941 (reprinted 1982), p. 18.

4. F. Brommer, "Aryballoi aus Bronze," in *Opus Nobile. Festschrift zum 60. Geburtstag von Ulf Jantzen*, Wiesbaden, 1969, nos. 2, 7, 16, 17, 18, pp. 17–19. The same technique of making the body in two parts was also employed in the production of iron and bronze *aryballoi*.

5. The Susa anklebone weight (plate 13), cast (ἔχεε) by the bronzeworker Pasikles, a small wheel discovered at Camiros in Rhodes produced by the "bronze hammerer" (χαλκοτύπος) Onesos, and an *aryballos* shaped like a helmet made by the bronzeworker Koios are dated to the third quarter of the sixth century B.C.

6. There is no equivalent for the words "art" and "artist" in ancient Greek.

13
Weight shaped like an anklebone

Made in Ionia (present-day Turkey), third quarter of the
6th century B.C.
Bronze
10¹³⁄₁₆ × 15⅜ × 9⅜ inches (27.5 × 39 × 24 cm); weight: 206½ lb.
(93.7 kg)
Department of Near Eastern Antiquities, Sb 2719
Atlanta only

HISTORY: Discovered during French excavations at Susa in Iran,
conducted by Jacques de Morgan, 1901.

BIBLIOGRAPHY: Béatrice André-Salvini and Sophie Descamps-Lequime,
*Actualité du département des Antiquités grecques, étrusques et romaines
no. 10*, exhibition catalogue, Musée du Louvre, Paris, 12 February–
30 June 2003; Béatrice André-Salvini and Sophie Descamps-Lequime,
"Remarques sur l'astragale en bronze de Suse," in *Studi micenei ed
egeo-anatolici*, vol. XLVII, 2005, pp. 15–25.

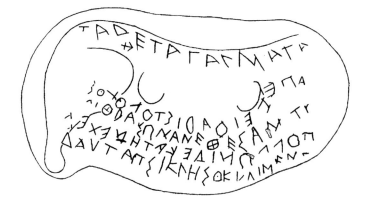

Fig. 1. Transcription of the dedicatory inscription.

This monumental bronze anklebone weight was discovered
in 1901 during the excavations conducted by Jacques de
Morgan at Susa in Iran, one of the most important sites of
ancient Iran and a capital of the Persian Achaemenid Empire.
The shape of the letters of the inscription engraved on the upper
side, however, indicates that the object originally came from
an Ionian city of eastern Greece, on the west coast of Anatolia,
and that it was dedicated in the third quarter of the sixth cen-
tury B.C. The name of Apollo included in the dedication most
likely refers to the god of the oracular sanctuary of Didyma, a
sanctuary that was dependent upon the city of Miletus. The
anklebone constitutes an exceptional testimony to the Greco-
Persian wars opposing the Persian Empire and the league of
Greek city-states. After the pillage of Miletus by Darius's Persian
army in 494 B.C., the anklebone was taken as war booty, along
with the most precious ex-votos from the sanctuary of Didyma,
to be presented on the Acropolis of Susa, in accordance with a
tradition dating back to the second millennium B.C.

The object perfectly imitates a talus, or anklebone; two
handles were attached, one to the side and one to the top. The
inscription (fig. 1) reads: "These beautiful objects [products of]
the tithe on the harvest, Aristolochos and Thrason have conse-
crated to Apollo. P[a]siklès, son of Kydimen[eus], cast them."

Before it was dedicated to Apollo, the anklebone was used
as a standard weight in the city of Miletus (206½ lb. or 93.7 kg,
equivalent to 6,645 Milesian staters). It represents a feat of
technical prowess: not only did an enormous amount of metal
have to be cast in the lost-wax process for solid metal, but the
operation also necessitated the utmost precision, involving
extremely complex calculations—even the weight of metal
that would be lost in the cold-finishing process (trimming
and polishing) had to be precisely calculated in advance. The
Persians recognized this use of weights, and the anklebone was
placed at Susa alongside other monumental bronze weights.

The amount of metal and the great skill needed to produce
the weight explains why it was dedicated to Apollo of Didyma.
The inscription indicates that it was accompanied by another
"beautiful object" (*agalma*), for which we have no other informa-
tion. The bone-shaped weight was considered a veritable master-
piece from the very beginning, as shown by the signature of the
bronzecaster who made it: "P[a]siklès, son of Kydimen[eus]," a
person important enough to be mentioned in the dedicatory
inscription.

NICOLAS BEL

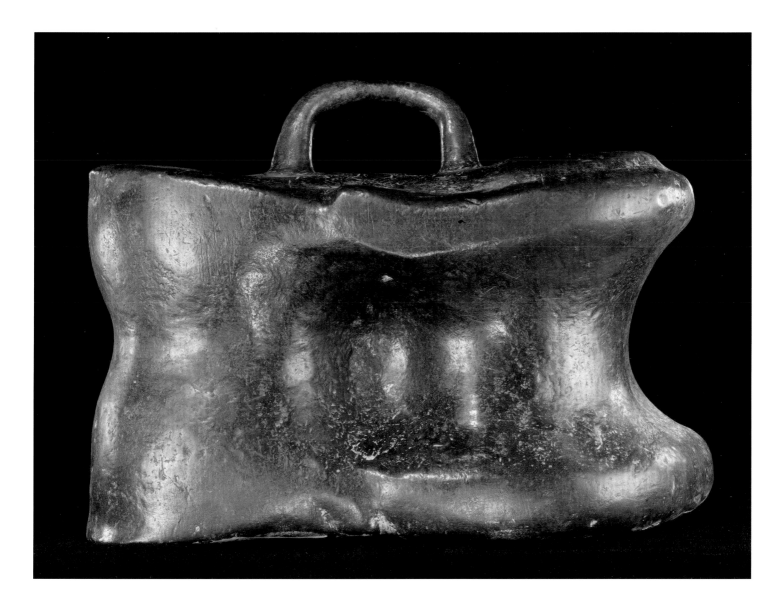

I4
Dish from the Boscoreale Treasure

First half of 1st century A.D.
Partially gilt silver
2⅝ × 8⅞ inches (6.7 × 22.7 cm); weight: 2 lb. (934.7 g)
Department of Greek, Etruscan, and Roman Antiquities, Bj 1969

HISTORY: Discovered in the Boscoreale Villa near Pompeii (Italy), in 1895; given to the Louvre by Baron Edmond de Rothschild, 1895.

BIBLIOGRAPHY: A. Héron de Villefosse, "Le trésor de Boscoreale," in *Monuments Piots* V, 1899, pp. 39–43, pl. I; A. Linfert, "Die Tochter, nicht die Mutter. Nochmals zur 'Afrika' Schale von Boscoreale," in Bonacasa and di Vita, eds., *Allessandria e il mondo ellenestico-romano. Studi in onore di Achille Adriani*, Rome, 1984, pp. 351–358; F. Baratte, *Le trésor d'orfèvrerie romaine de Boscoreale*, Paris, 1986, pp. 77–81; S. Walker and P. Higgs, eds., *Cleopatra of Egypt. From History to Myth*, exhibition catalogue, British Museum, London, 2001, pp. 312–313.

Fig. 1. Detail of decorations on the band, including plait motifs, pearl borders, and vegetal bands.

Fig. 2. Detail of the panther's hide.

Fig. 3. Detail of gold leaf on the crescent moon.

This dish decorated with an *emblema* is undoubtedly one of the most famous and exceptional pieces from the Boscoreale Treasure. Since its discovery, it has been considered a masterpiece of Roman silverware. This large dish with affixed embellishment (*emblema*) served no useful function but was simply intended to be admired by guests. It was a ceremonial piece, the formal, technical, and iconographic qualities of which were intended to reflect and enhance its owner's status.

The techniques used in its fabrication illustrate the technical virtuosity of the master artisans skilled in toreutics—the art of chasing precious metals—active in Campania at the end of the Roman Republic and in the beginning of the Empire. One of the major reasons for considering this dish as outstanding is the variety of techniques employed in its manufacture. The dish itself and the ring foot were probably cast in one piece. Both were then worked on the wheel: the foot was decorated with concentric circles, and the interior and exterior of the plate were embellished with delicate bands. The insides of these bands were then decorated with a variety of designs, including plait motifs, pearl borders, and vegetal bands (fig. 1). This ornamentation was entirely executed using a chasing point and chasing chisel. The background scrolls of myrtle and olive tendrils were smoothed by light hammering and then gilded with gold leaf by means of heating and burnishing. The central medallion, which was made separately and then fixed to the main piece, is framed and kept

in place on the base of the dish, to which it was soldered by a solid silver ring molded on the wheel. Although most of the decoration was executed in repoussé—a technique of hammering the sheet of silver from the reverse side—all the additional details were chased onto the surface of the metal sheet using points and *ciselets* (chasing chisels). The outlines of the gods' attributes, the lion's and the panther's hides (fig. 2), and the eagle's plumage are all highlighted or represented by short, delicate lines traced with a chasing chisel. Many different kinds of points were used to execute the details, such as the pupils of the eyes, the nostrils, the curls of hair, and the center of some of the fruit that fills the horn of abundance. Certain parts of the decoration, such as the tunic and the elephant hide, were highlighted with gold leaf (fig. 3)—now much deteriorated—by means of heating and burnishing.

The female bust which emerges from the dish is problematic. The elephant hide worn by the figure has led to her being interpreted as a personification of Africa or of the town of Alexandria. The many attributes surrounding the bust evoke the principal deities of the Greek pantheon—a bow and quiver for Artemis, a dolphin for Poseidon, a panther for Dionysios, pincers for Hephaistos, a caduceus for Hermes, a club for Herakles, and a lyre for Apollo—and those assimilated into it (the sistrum of the Egyptian goddess Isis). This woman is dressed in a chiton and has one shoulder bared; she holds a cornucopia

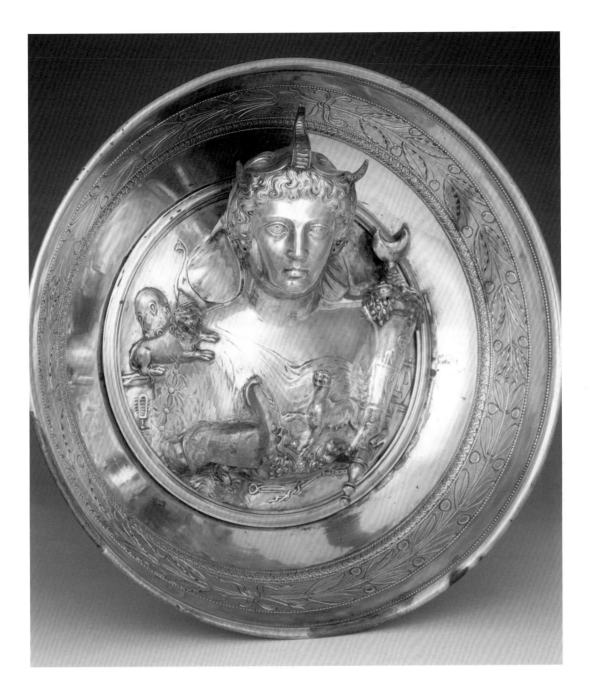

filled with fruit, from which emerges a pinecone surmounted by a crescent moon. The horn itself is adorned with a representation of Helios, a deity personifying the sun, as well as an eagle and the caps of the Dioscuri, Castor and Pollux. There is such a profusion of symbols that it is not easy to understand the meaning of the decoration. However, the realistic and individualized treatment of the face weakens the argument that it should be considered a personification. Although such personifications were greatly appreciated in Roman art, they were generally represented with idealized features. The bust should perhaps rather be seen as a portrait of Cleopatra Selene II,

the daughter of Cleopatra VII and Mark Antony, who died in 4 B.C.

Apart from the technical and iconographical qualities which make this work a masterpiece, two other considerations need to be emphasized. First of all, the dish belongs to one of the most important surviving treasuries of Roman silverware which have come down to us, as the result of exceptional circumstances. Secondly, the dish is in excellent condition, and we can thus appreciate the extremely high technical standard attained by Roman artisans in the domain of toreutics.

CÉCILE GIROIRE AND MARIE-EMMANUELLE MEYOHAS

15
The Alpais ciborium

Limoges, France, ca. 1200
Copper: stamped, champlevé, enameled, engraved, chased, and gilded
Enamel: lapis, medium and lavender blue, turquoise, dark and light green, yellow, red, and white. Glass cabochons and enameled beads
11 ¹³⁄₁₆ × 6⅝ inches (30.1 × 16.8 cm)
Signature on the inside of the cup: + *MAGI[s]TER : G : ALPAIS : ME FECIT : LEMOVICARUM* (Master G. Alpais from Limoges made me)
Department of Decorative Arts, MRR 98
Atlanta only

HISTORY: Formerly in the Revoil Collection; acquired by the Musée du Louvre in 1828.

BIBLIOGRAPHY: *Enamels of Limoges 1100–1350*, exhibition catalogue, The Metropolitan Museum of Art, New York, 1996, pp. 246–249, with extensive bibliography.

Fig. 1. Angels on top of finial.

Fig. 2. Artist's name engraved around medallion inside cup.

The ciborium of the Alpais Master is one of the most famous works in the Department of Decorative Arts of the Louvre. The elegant shape, perfect execution, and excellent state of conservation of this masterpiece all compel the spectator's attention. The full, round shape, which may have been inspired by Oriental metalwork, is reminiscent of the kind used for pagan drinking bowls, but the iconography of the decoration leaves no doubt that this object was used for religious purposes—to keep the consecrated hosts for the sacrament of Holy Communion. The knob on the lid is in fact adorned with the busts of four angels in half relief, holding hosts in their veiled hands (fig. 1).

The decoration is repeated symmetrically on the lid and the cup and constitutes one of the finest examples of enamelwork produced during the Middle Ages. A lozenge-shaped network studded with glass cabochons encloses a series of haloed busts emerging from clouds. The busts are left in reserve and stand out against the blue enameled background, which is embellished with gold scrolls and dots. Figures of saints clasping books in the manner of apostles stand within the central lozenge shapes on both the lid and the cup. There are sixteen figures in all—more than the usual number of twelve apostles. Since none of the figures holds any attribute other than a book, it is difficult to identify them. However, we might suggest the following identifications for the four "extra" saints: Saint Paul, who was frequently associated with the apostles in the Middle Ages; Saint Martial,

"the apostle of the Limousin"; and the two Evangelists who were not apostles, Saint Luke and Saint Mark. On either side of the lozenge shapes, angels standing within triangles seem to be keeping guard over the hosts in the ciborium, frequently referred to in medieval theology as the "bread of angels" (*panis angelorum*). The metalwork here—in particular, the engraving of the figures in reserve and the small heads made in a classicizing style—attains an unusual degree of perfection. On the rim of the cup is an inscription in pseudo-Kufic characters, a decorative motif that was in fashion and frequently used in Limoges works around 1200. The decoration ends with the openwork motifs on the foot, where small figures seem to pursue fantastic animals amid intermingled scrolls in a naturalistic atmosphere typical of the "1200 style."

Although the formal and technical qualities of the ciborium clearly make it one of the great masterpieces of medieval art, it is because of the inscription on the inside of the cup that the object has become famous. The inscription "Master G. Alpais from Limoges made me"—the signature of the artist—can be seen inside a medallion engraved around the figure of an angel, who gives a blessing with one hand and holds a book in the other (fig. 2). The name of a certain G. Alpais does in fact appear several times in the consular registers and other accountancy sources of Limoges dating from the first quarter of the thirteenth century. Artists' signatures are rare in medieval gold- and silver-

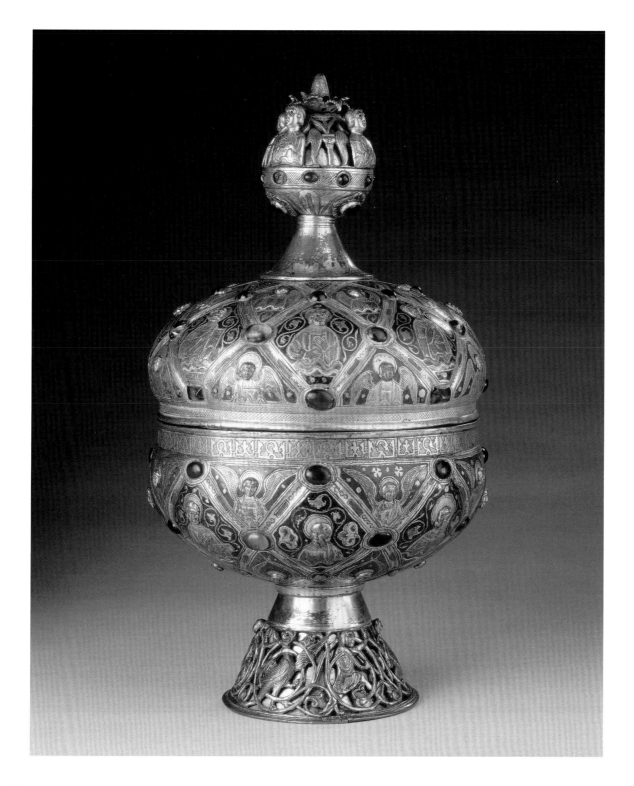

work, and even more unusual for works made in Limoges. The exceptional appearance of the artist's signature on the ciborium could be related to the outstanding quality of the object and may express the artist's pride in the quality of his work.

The exquisite shape of the ciborium, the superb craftsmanship employed in its execution, and the fact that it bears the extremely rare signature of the artist all contribute to making this object a great masterpiece of medieval art. Since it entered the Louvre in 1828 it has been mentioned and illustrated in every publication concerning medieval goldsmiths' work and in many general works on medieval art.

ELISABETH ANTOINE

16
Saint Matthew

Limoges, France, ca. 1220–1230
Copper: champlevé, enameled, engraved, chased, and gilded
Appliqué figure in copper: repoussé, engraved, chased, and gilded
Enamel: dark blue, lapis blue, medium blue, turquoise, white, green,
yellow and red. Eyes inset with dark blue enamel beads. Blue and
turquoise enamel beads, blue and dark red glass cabochons.
11⅜ × 5½ inches (29 × 14 cm)
Inscription: S[anctus] *MATEUS*
Department of Decorative Arts, MR 2650

HISTORY: Probably comes from the frontal of the high altar of the abbey church at Grandmont, near Limoges; previously in the Edme Durand Collection; acquired by the Musée du Louvre in 1825.

BIBLIOGRAPHY: *Enamels of Limoges 1100–1350*, exhibition catalogue, Metropolitan Museum of Art, New York, 1996, pp. 218–222, with extensive bibliography.

This impressive figure of Saint Matthew was not originally an isolated piece but belonged to a larger ensemble which formed part of a liturgical work such as an altarpiece or altar frontal. Art historians now agree that it probably comes from the frontal of the high altar of the abbey church of Grandmont (destroyed in 1790) in the Limousin region. The frontal was probably produced in about 1220–1230 and was decorated with a Christ in Majesty surrounded by Evangelists and a group of thirteen apostles that included the "Limousin apostle," Saint Martial. The six figures of apostles, now divided among different museums—the Louvre and the Petit Palais in Paris, the Hermitage in Saint-Petersburg, the Bargello in Florence, and the Metropolitan Museum in New York—appear to be the vestiges of what was one of the major examples of *opus lemovicense* produced by Limousin metalworkers.

Saint Matthew is identified by an enamel inscription on the arched plaque. He is shown seated on a throne, holding a book, and with his bare feet resting on a pedestal. He is dressed in classical drapery that falls smoothly down his body in fine, fluid folds. His long face and huge eyes contribute to the figure's sense of monumentality. The magnificent gilt-copper appliqué figure was worked in repoussé, then engraved and chased. The engraving and chasing of the clothes is especially careful, as shown by the coat, which opens to show a fur lining with a vair design, and

by the book-binding adorned with glass beads simulating precious stone cabochons. The sober gilt-appliqué figure stands out against the enameled background, which, with its decoration of tendrils ending in fleshy palmettes, provides an exuberant ornamental surround for the figure of the saint.

This appliqué figure of Saint Matthew is characteristic of the renewed art of Limousin metalwork in the thirteenth century, a period when large-scale gilt copper (but not enameled) figures were associated with the plaques enameled with colored motifs for which the region had become famous in the late twelfth century. The figure is also a representative example of the "1200 style," influenced by the renewed interest in the art of Antiquity and widely adopted by artists at the end of the twelfth century and the beginning of the thirteenth. This masterpiece of Gothic metalwork, with its monumental frontal pose, powerful face, and penetrating stare, is imbued with great sculptural majesty. It evokes certain sculptures from Chartres Cathedral, especially the *Coronation of the Virgin* in the central tympanum of the north transept. If we are to fully appreciate the great impression this work must have made on the faithful, we must imagine thirteen similar figures delicately highlighted by the play of light and shadow coming from the flickering light of candles.

If the hypothesis of a Grandmontain provenance is correct, the group of apostles from Grandmont illustrates a curious paradox—that a monastic order vowed to poverty should have commissioned the best artists of the time to create a sumptuous decoration for the altar where the relics of their founding saint were displayed. Connoisseurs of all eras have appreciated the great quality of the figures from the Grandmontain altar. The collector Edme Durand probably acquired the Saint Matthew shortly after the altar was destroyed, and the figure of the apostle entered the Louvre as early as 1825, when Durand donated his collection to the museum.

ELISABETH ANTOINE

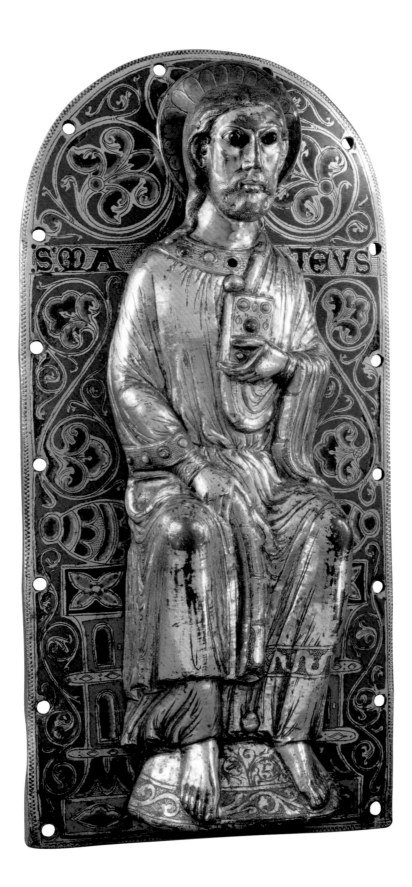

17

Ahmad al-Dhakî (al-Mawsilî)

Basin in the name of the Ayyubid Sultan al-ʿAdil II Abû Bakr

Syria, 1238–1240
Hammered copper alloy inlaid with silver, gold, and black paste
7½ × 18⅝ inches (19 × 47.2 cm)
Department of Islamic Arts, OA 5991
Minneapolis only

HISTORY: Gift of Félix Doistau, 1905.

BIBLIOGRAPHY: David S. Rice, "Inlaid Brasses from the Workshop of Ahmad al-Dhakî al-Mawsilî," in *Ars Orientalis* II, 1957, pp. 283–326; Gaston Wiet, *Répertoire Chronologique d'Epigraphie Arabe* XI, Cairo, 1941, no. 4164; *The Arts of Islam*, exhibition catalogue, London, Hayward Gallery, 1976, no. 198; *L'Exposition des Arts Musulmans au Musée des Arts Décoratifs*, exhibition catalogue, Paris, 1903, pl. 13; *Arts de l'Islam des origines à 1700 dans les collections publiques françaises*, exhibition catalogue, Orangerie des Tuileries, Paris, 1971, no. 150; *L'Orient de Saladin, l'art des Ayyoubides*, exhibition catalogue, Institut du Monde Arabe, Paris, 2001, no. 42.

This basin has been known for a long time; it was first published in 1869, by which time it was already in France. In 1903 it was exhibited at the first important exhibition in Paris of "Muslim art," as the still-developing domain of Islamic art was called then, and became one of the prize pieces of the Louvre collections shortly thereafter.

The basin is one of the finest examples of the very particular art of inlaid metal. We know that the techniques of inlaying a copper alloy support with precious metals were first practiced in the middle of the twelfth century in eastern Iran, and that in the first half of the thirteenth century the art subsequently spread to Jezireh—in the north of present-day Iraq—as well as to Syria. It was here, with the works of artists of the Mosul school, that "painting on metal" reached its apogee. We know this from the signatures the artists left on the metalworks they crafted, signatures which always ended with the words *al-Mawsilî*, or "from Mosul." The painters of this school not only revolutionized the art of inlaid metal, but also fundamentally changed its status, for with such scenes engraved on them, the metal objects now became veritable supports for pictures and calligraphy. Moreover, the use of gold, silver, and red copper in the making of such pieces transformed them into precious objects. They became outward signs of the power and prestige of their owners and were often commissioned by the aristocratic elite.

A long silver-inlaid inscription to the glory of the Ayyubid Sultan al-ʿAdil (who reigned between 1238 and 1240) occupies the lip of the basin. The artist's signature is also inlaid with silver, but it is placed in the center of the basin's outside wall, in the vegetal band which structures the composition of the exterior decoration, and is therefore not immediately visible.

The organization of the exterior decoration is particularly striking: each of the thirty quatrefoils, which are arranged in two superposed registers against a background of geometric design adorned with vegetal friezes, encloses a figured scene. The movements of the persons and the animals portrayed are adapted to the shape of the lobes, and the constraints imposed give rise to lively scenes full of movement. Hunters, fighters, acrobats, and dancers are depicted alongside mythical species such as sphinxes and griffins, as well as real animals like monkeys, lions, tigers, and birds. The interior decoration, which is unfortunately less well conserved, differs from the vignette organization of the exterior composition, and the spectator is first struck by the profusion of detail. Pictures are represented on the inside of the basin, particularly high up on the sides, where four extraordinary hunting scenes seem to encapsulate all the skill and research of the workshop master al-Dhakî who crafted the basin, and of whose work we have two other signed examples. He depicted the hunting scenes on several planes and used many foreshortenings in his representation of the horses, thus creating depth in the composition. The skillful arrangement of the horsemen, who seem to be directing their mounts in all directions, puts a final touch on the composition of the scenes—a perfect example of well-organized disorder.

ANNABELLE COLLINET

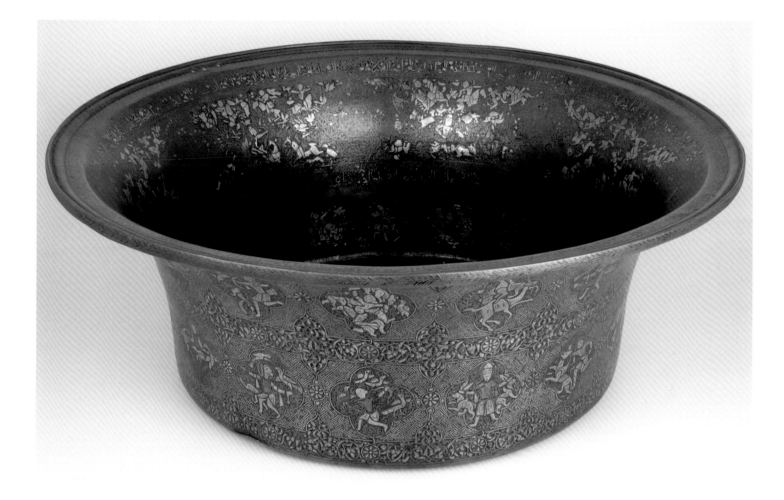

18

Muhammad ibn al-Zayn

Basin known as the *Baptistère de Saint Louis*

Egypt or Syria, second quarter of the 14th century
Hammered copper alloy inlaid with engraved silver, gold, and
black paste
8¾ × 19¾ inches (22.2 × 50.2 cm)
Department of Islamic Arts, LP 16
Atlanta only

HISTORY: Kept in the Treasury of the Sainte-Chapelle of Vincennes;
entered the Louvre in 1793; returned to the Sainte-Chapelle of
Vincennes in 1818; returned to the Louvre in 1832 and listed in the
inventories of King Louis-Philippe.

BIBLIOGRAPHY: Doris Behrens-Abouseif, "The Baptistère de Saint-Louis:
a reinterpretation," in *Islamic Art* 3, 1989, pp. 3–29; David Storm Rice,
Le Baptistère de saint Louis, Paris, 1951; Rachel Ward, "The Baptistère de
saint Louis, a Mamluk Basin made for Export to Europe," in *Islam and
the Italian Renaissance*, London, 1999, pp. 113–132.

This basin, known as the *Baptistère de Saint Louis* (the baptismal font of Saint Louis), is regarded as one of the Louvre's major masterpieces for reasons that go beyond the fact that it is in almost perfect condition. It is an exceptional and emblematic work of Mamluk art, one which still holds many secrets from us. The important Mamluk dynasty, a military caste of slave soldiers who had converted to Islam, reigned over Egypt, Syria, and Palestine from the middle of the thirteenth century to the beginning of the sixteenth century. The power of this dynasty was based on its military status, and most of the objects commissioned by the Mamluk emirs and sultans bear evidence of military training in the monumental inscriptions which gradually replaced the figured decoration.

Under the circumstances, this basin is an exceptional object, embellished with a monumental and entirely figured decoration of bands punctuated by circular medallions and inlaid with silver plaques, which are themselves engraved with a multitude of details. Some elements, such as the lotus blossom, are very close to the decoration of metalworks dated to the reign of Sultan Muhammad ibn Qalaun in the first half of the fourteenth century, suggesting that the basin could be dated to this period—i.e., much later than the reign of Saint Louis (1226–1270). The

name of the basin was in fact given very late, probably during the eighteenth century, when it had already been in France for several centuries.

On the exterior, two small friezes portraying running animals and punctuated by roundels frame the principal register. The latter is embellished with hunting scenes, processions, depictions of military exercises, and a host of anecdotal scenes, all interspersed with a series of circular medallions portraying mounted huntsmen. All sorts of birds and animals lie hidden in the profuse background foliage. The scenes have been interpreted in different ways by art historians, who have tried to link them with historical events such as a royal ceremony or an ambassadorial visit.[1] However, it is difficult to connect the scenes with any actual event; most of the somewhat stereotyped images appear instead to evoke the *furusiya*—the training exercises undergone by the military elite (fig. 1). (Another basin, with an unfinished decoration which might be the work of the same artist,[2] displays almost identical scenes; it is organized in a similar fashion and adopts a style which is very close.) The inside base of the basin (fig. 2) is decorated with a fishpond inhabited by a host of aquatic animals—frogs, crocodiles, waterbirds, tortoises, snakes, and even people bathing. This design is a clue to the original function of the basin as a container for water.

Another exceptional feature of this basin is that it bears the artist's signature. Not only are signatures rarely found on medieval objects—Western or Eastern—but the *baptistère* is the only known example of a work signed six times. The master coppersmith not only placed his principal silver-inlaid signature under the rim, but also signed his name five other times in the figured decoration—on three bowls and on the sides of two royal thrones within the medallions on the inside of the basin. Muhammad ibn al-Zayn is also known to have crafted other objects, including a small basin decorated in much the same way as the *baptistère*,[3] a mirror,[4] and possibly a window grill from a *khanqa*[5] dated to 1359. Although we have no precise information about the artist's origin and role, it would seem that he was the owner of an important atelier and that he worked during the first half of the fourteenth century, probably in the Syria-Palestine region.

We also know nothing about the person who commissioned the object. The remains of a rampant lion or a key are still visible on each of the coat of arms on the roundels adorning the small exterior friezes. These designs might have provided a clue as to the identity of the patron, but they were subsequently covered

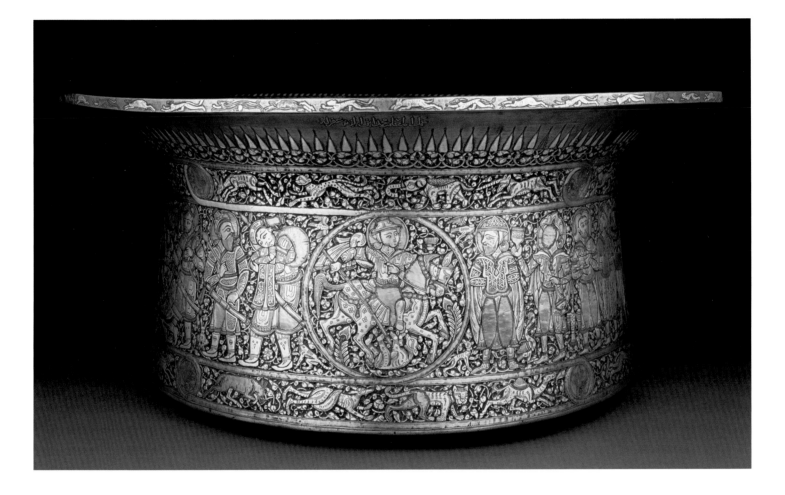

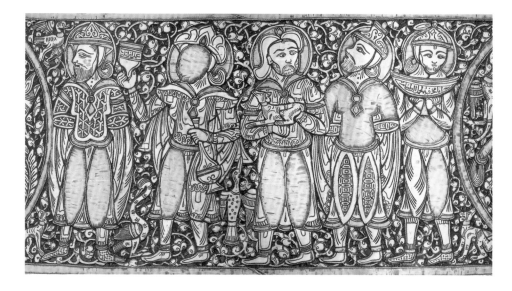

Fig. 1. A procession.

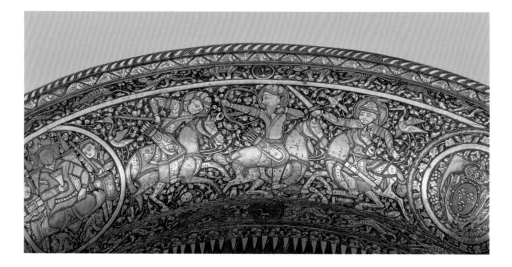

Fig. 2. Detail of marine scenes inside the basin.

Fig. 3. Detail of the design on the interior rim.

with a fleur-de-lys. It is possible that the patron who commissioned the basin was a European or a descendant of the Crusaders living in the Orient.[6] In this respect, it is interesting to note that a rampant lion forms part of one of the coats of arms of the Lusignans, a French family who reigned over Cyprus under the title "King of Jerusalem" long after the fall of Acre in 1284.[7]

The exceptional condition of the *baptistère* is due in part to its history. It was brought to the West during the Middle Ages, probably at the end of the fourteenth century or the beginning of the fifteenth, and was then kept in the Treasury of the Sainte-Chapelle of Vincennes, where it was used for presenting the holy water during Easter celebrations. It was subsequently employed as a baptismal font for the royal children, notably in 1606 for the christening of the Dauphin, the future King Louis XIII, and in 1856 for that of the Imperial Prince Napoleon-Eugène, the son of the Emperor Napoleon III. It escaped being pillaged during the Revolution and entered the Musée du Louvre in 1793. It was returned to the Sainte-Chapelle of Vincennes in 1818 by order of Louis XVIII, before being definitely placed to the Louvre in 1832. Two European coats of arms bearing the royal French fleur-de-lys were added to the interior of the basin in the eighteenth or nineteenth century (fig. 3), probably in an attempt to strengthen the object's connection with the French monarchy and to give credit to the otherwise fanciful idea that the object had once belonged to Saint Louis.

The baptistery merits its status as a masterpiece on several accounts: because of its superb craftsmanship, because it bears six signatures by the artist—an indication of the pride the latter felt in the object he had created—and by virtue of its symbolic history and reuse by the kings of France, who made it a royal symbol.

GWENAËLLE FELLINGER

NOTES

1. See D. S. Rice, *Le Baptistère de Saint Louis*, Paris, 1951; E. Knauer, "Einige trachtgeschischtliche Beobachtungen am Werke Giottos," in *Scritti in onore de Roberto Salvini*, Florence, 1984, pp. 176–177; and D. Behrens-Abouseif, "The Baptistère de Saint-Louis: a reinterpretation," in *Islamic Art* 3, 1989, pp. 3–29.

2. This basin is at the L. A. Mayer Memorial, Jerusalem (acc. no. M58); see J. Bloom, "A Mamluk Basin in the L. A. Mayer Memorial Museum," in *Islamic Art* 2, 1987, pp. 19–26.

3. Musée du Louvre, Department of Islamic Arts, MAO 331.

4. Signed by the "master Muhammad," Topkapi Saray; see M. AGA-OGLU, "Ein Prachtspigel im Topkapu Sarayi Museum," in *Pantheon*, 1930, vol. III, pp. 457 sq.

5. A *khanqa* is a meeting room for Sufi brotherhoods. See J. Allan, "Muhammad ibn al-Zain: Craftsman in Cups, Thrones and Window Grilles," in *Levant* 28, 1996, pp. 199–208.

6. See R. Ward, "The Baptistère de saint Louis, a Mamluk Basin made for Export to Europe," in *Islam and the Italian Renaissance*, London, 1999, pp. 113–132, and J. Folda, *Crusader Art in the Holy Land*, Cambridge, 2005, p. 470.

7. D. S. Rice, "Arabic Inscriptions on a Brass Basin Made for Hugh IV de Lusignan," in *Studi orientalistici in onore di Giorgio Levi Della Vida*, Rome, 1956, pp. 390–402.

19

Bartolomé Esteban Murillo

Spanish, 1617–1682

Christ at the Column with Saint Peter

Paint on obsidian
13¼ × 12 inches (33.7 × 30.7 cm)
Department of Paintings, INV 932
Atlanta only

HISTORY: Justino de Neve, Seville (1685); Nicolas Omazur, Seville; his sale, Brussels, 1738; The Elector of Cologne, Clemens Augustus of Bavaria; his sale, Bonn, 1764; with Neveu, art dealer, Paris; Comte de Vaudreuil; his sale, Paris, 1784, no. 14; bought by the King.

BIBLIOGRAPHY: Olivier Meslay, "Murillo and Smoking Mirrors," in *Burlington Magazine*, February 2001, pp. 73–79.

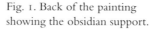

Fig. 1. Back of the painting showing the obsidian support.

Fig. 2. Bartolomé Esteban Murillo, *Christ in the Garden of Olives*, Musée du Louvre, Department of Paintings, INV 931.

This painting is most extraordinary. It is neither the subject matter nor the high quality of the finish that makes it so unusual and intriguing, but rather the support on which it was painted—a large rectangle of obsidian, one side of which is perfectly polished, while the reverse was left in its original rough, coarse state (fig. 1). The most various materials have been employed by artists as supports, including copper, slate, and lapis lazuli, but obsidian is one of the rarest. However, perhaps the most surprising aspect of this piece of mirror-like obsidian is its origin. This *flagellation* is one of a series of three pictures painted by Murillo on obsidian; the second in the series, *Christ in the Garden of Olives* (fig. 2), is also in the Louvre, while the third, a *Nativity*, is in the Museum of Fine Arts, Houston.

These obsidian plates were most likely ancient representations of the Aztec god Tezcatlipoca. They were known as "smoking mirrors," the English translation of *Tezcatlipoca*, the name of the deity they embodied. Tezcatlipoca was a complex deity, the god of sorcerers, chiefs, and warriors, harbinger of both devastation and good fortune. In ancient times he was depicted with a circular mirror above his head, whereas in more recent periods he is represented with a leg consisting of a snake emerging from a foot in the shape of an obsidian mirror. He was closely linked with warfare, and came to be of paramount importance for the Aztecs.

"Smoking mirrors" can be either rectangular or circular, the circular ones being more common. Although many remain in Mexico, some were acquired by Europeans fascinated by their rarity and their mysterious aura. One of the most famous smoking mirrors is the *Devil's Mirror* now in the British Museum and formerly used by John Dee (1527–1608), the Elizabethan mathematician, astrologer, and magician. Working with the medium Edward Kelly, Dee used the round obsidian mirror to communicate with the spirits of the dead.

The tremendous emotional appeal of Murillo's painting alone makes it a great work of art, and the remarkable use of obsidian to represent night constitutes a technical tour de force. But the most striking aspect of the work is that it illustrates in the most astonishing way the meeting of two civilizations and the coming together of two histories and two religions. Few objects bear witness to the great fractures of history with such force.

OLIVIER MESLAY

20

Pierre Hutinot
French, 1616–1679

Time revealing Truth and the Love of the Arts, 1667

Marble
32⁵⁄₁₆ × 26⅜ inches (82 × 67 cm)
Department of Sculpture, MR 2730

HISTORY: Reception piece for the Royal Academy of Painting and Sculpture, 3 September 1667.

21

François Barois
French, 1656–1726

The Death of Cleopatra, 1700

Marble
19⅛ × 39⅞ × 11⅝ inches (48.5 × 101.5 × 29.5 cm)
Department of Sculptures, MR 1756

HISTORY: Reception piece for the Royal Academy of Painting and Sculpture, 30 October 1700.

Artists who wished to enter the Royal Academy of Painting and Sculpture had to submit a *morceau de réception* or "reception piece." They often followed a drawing provided by a master, but sometimes the subject was related to their specialty. In theory, artists had three years to complete the work, but many took longer. Once they had submitted their *chef d'oeuvre*—the term used by the Academy in its early years—they could take their place among the other Academy members.

Reception pieces gradually came to illustrate essentially allegorical themes, the first example being the *Union of Painting and Sculpture* by Jacques Buirette in 1663 (the same subject was treated again by Jacques Prou in 1682). Hutinot's *Time revealing Truth and the Love of the Arts* (plate 20) was received in 1667. This theme was admirably suited to the Academy, and they commissioned the same subject from René Frémin, who submitted his reception piece in 1701. Pierre Franqueville had already executed a large marble group on this theme for King Henri IV which at the time was in the Tuileries gardens. Bernini also sculpted a figure of *Time and Truth*, but never finished it.

Hutinot's model was submitted in 1665 but was unjustly criticized and only finally presented on 3 September 1667. It shows an old man with wings—a kind of Saturn or image of Father Time holding his scythe—who pulls aside a curtain to reveal Truth bearing a sun. At their feet the little genie of the Arts stands and presents the instruments of various arts: a square and a compass are depicted in front, a palette and brushes behind.

The *Polyphemus* submitted by Corneille Van Clève in 1681 was the first example of a statuette presented as a reception piece. A few years later the sculptor Robert Le Lorrain was asked to depict the figure of Galatea, the nymph loved by Polyphemus, and the artist submitted it for his reception in 1701. Marble statuettes became fashionable at the turn of the century, and on 30 October 1700, François Barois submitted *The Death of Cleopatra* (plate 21) to the Academy. The Egyptian queen is shown lying down, a terrified expression on her face. She clutches in her hand the asp she has deliberately hidden close to her with the intention of letting it bite her, but at the last minute she recoils from such a painful death. This kind of dramatic statuette was later to become the fashion of the period, when movement and emotion were favored above all; as with the theatre and opera, art had to move the spectator. Dynamism and expression are the key words of a style that has been called Baroque, and in representing death, the sculptor could reveal both his skill and his capacity to touch the emotions. Examples of this style include *The Death of Meleager* by René Charpentier (1713), *Dido on the funeral pyre* by Augustin Cayot (1711), and *Titan struck down* by François Dumont (1712).

But reception pieces could also illustrate lighter subjects, as in the *Leda and the Swan* by Jean de Thierry (1717) and *Mercury fastening his heel-wings* by Pigalle (1744), one of the rare artists to present a personal work whose subject had not been assigned. All the reception pieces were kept at the Academy in the Louvre until the Academy was suppressed during the Revolution and its collections confiscated. Most pieces are now exhibited at the Louvre, where they constitute a homogenous series illustrating the evolution of academic art.

GENEVIÈVE BRESC-BAUTIER

22

François Boucher
French, 1703–1770

Rinaldo and Armida, 1734

Oil on canvas
53⅛ × 66¹⁵⁄₁₆ inches (135 × 170 cm)
Department of Paintings, INV 2720

HISTORY: Presented by Boucher to the Royal Academy of Painting
and Sculpture on 30 January 1734, and subsequently transferred to
the Musée du Louvre.

BIBLIOGRAPHY: Alastair Laing, *François Boucher 1703–1770*, exhibition
catalogue, Galeries Nationales du Grand Palais and Réunion des Musées
Nationaux, Paris, 1986, pp. 164–166, no. 26; William McAllister Johnson,
Les peintres du roi 1648–1793, exhibition catalogue, Musée des Beaux-Arts,
Tours; Musée des Augustins, Toulouse; and Réunion des Musées
Nationaux, Paris, pp. 150–152, no. 30.

The French painter François Boucher enjoyed an exemplary
and distinguished career, one crowned by the supreme suc-
cess of being appointed by Louis XV to the exalted post of First
Painter to the King, a position he held from 1765 until his death
in 1770. Boucher was extremely talented and ambitious, deter-
mined to mount the steps in the ladder of success, the *cursus hon-
orum* reserved for painters of the period. In eighteenth-century
France, only the most talented artists could aspire to become
members of the prestigious Royal Academy of Painting and
Sculpture, originally founded in 1648 (though its rules had been
continually modified ever since). Candidates were required to
pass a series of discriminating tests and competitive examinations
before being admitted to the venerable institution, a *sine qua non*
for those artists who wished to obtain the most prestigious royal
commissions and have the right to exhibit their works publicly
at the Salon Carré in the Louvre. This was particularly true from
1737 to the outbreak of the French Revolution in 1789.

On 30 January 1734, Boucher (only thirty years old) pre-
sented his painting *Rinaldo and Armida* to the exacting judgment
of the Academy in the hope that he would be admitted and
given full membership to the institution. The painting was
well received and hung alongside other "reception pieces"
of Academy members. Boucher was anxious to cut as fine a

figure as possible alongside all the finest examples of French
painting. He was careful to choose a distinguished subject taken
from the highly esteemed *Jerusalem Delivered*, the epic poem by
the Italian poet Torquato Tasso (1544–1595), in which the sorcer-
ess Armida uses her charms to captivate Rinaldo, the valorous
Christian chevalier, and dissuades him from the battle he intends
to wage against the infidels. This subject not only offered the
advantage of illustrating a distinguished literary work, but also
allowed the artist to demonstrate his talent in a difficult picto-
rial representation. He depicted a great accumulation of subtle
elements, including fabrics and draperies of different textures,
flowers, waterfalls, clouds, and curving architecture seen in
perspective, and he used all the means at his disposal to display
his virtuosity. With its sinuous, supple lines, its palette of pastel
colors with pearl grays, pinks, and blues dominating, and its
erotic undertones, the painting is a magnificent example of
Rocaille, the dominant style among French artists at the time.
With this virtuoso painting, Boucher sought to present a master-
piece, an exceptional painting, one that would convince both his
contemporaries and posterity of his wide range of talents and
the sensual quality of his inspiration.

GUILLAUME FAROULT

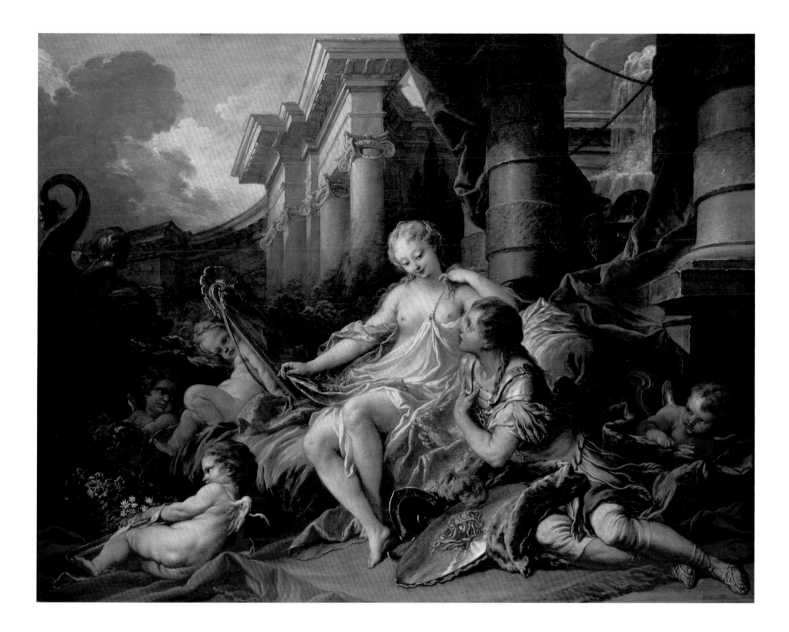

23

Théodore Géricault
French, 1791–1824

Study for The Raft of the Medusa, 1819

Oil on canvas
14¾ × 18⅛ inches (37.5 × 46 cm)
Department of Paintings, RF 2229

HISTORY: Acquired by the Musée du Louvre in 1824 at the posthumous sale of Géricault's works through the intermediary of his friend Pierre-Joseph Dedreux-Dorcy.

BIBLIOGRAPHY: Lorenz Eitner, *Géricault, His Life and Work*, London, 1983; Bruno Chenique, "*Le Radeau de la Méduse* ou l'avenir du monde," in *FMR* XX, July–August 2007, pp. 6–40.

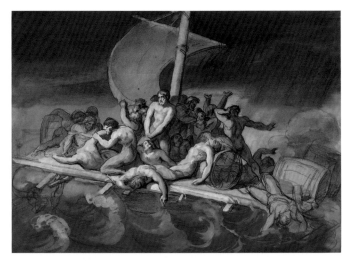

Fig. 1. Théodore Géricault, *Scene of Cannabalism on the Raft of the Medusa*, Musée du Louvre.

The painting presented here is the study for Théodore Géricault's masterpiece *The Raft of the Medusa*, one of the major works in the Louvre—less on account of its considerable size (16 × 23½ feet; 4.91 × 7.16 meters) than because of its importance in the history of painting. Just as Jacques-Louis David's *The Oath of the Horatii* heralded the beginning of Neoclassicism in 1784, or Eugène Delacroix's *Liberty guiding the People* that of Romanticism in 1830, *The Raft of the Medusa* appeared in 1819 as the expression of a revolution in painting and secured a new status for the artist. Its originality lay in the fact that it broke the rules of historical painting in a spectacular fashion—by its modern and totally new subject matter and by the energetic and innovative style. Earlier large-scale works—usually painted with a smooth finish—had always been devoted to heroic subjects drawn from ancient history or mythology or, since the Empire, from the Napoleonic epic. In this picture the heroes are anonymous, the drama they experience concerns a contemporary event, and the pictorial execution is dark, violent, and contrasted.

In 1816, following the fall of Napoleon and the restoration of the French monarchy with the beginning of the reign of Louis XVIII (the brother of Louis XVI, guillotined in 1793), a military expedition was sent to Africa to retake Senegal. The expedition was led by the frigate *La Méduse*, commanded by a captain who had emigrated during the Revolution and had not navigated for twenty-eight years. The frigate ran aground on a sandbank off the African coast and could not be refloated. When the passengers tried to escape, it rapidly became clear

there were insufficient lifeboats for them all, and the decision was taken to build a large raft from what was left of the boat. The approximately 150 survivors who crowded onto the raft were of course those of very modest class—mostly soldiers, together with a few officers. They were left to fend for themselves and drifted over the sea for thirteen days. There was a shortage of food, but not wine, which only increased the violence on board. A mutiny erupted but was bloodily repressed; there were even scenes of cannibalism (fig. 1). When one of the other boats of the expedition, the *Argus*, finally arrived to pick up the survivors, only fifteen men were still on the raft.

When the disaster was recounted by the surgeon Savigny and the engineer Corréard and published in the press, there was a public outcry, directed in particular against Louis XVIII's government. The Bonapartists and liberal opposition parties exploited the scandal to their own ends. The minister of the Navy was held responsible for having nominated as captain a royalist faithful to the regime rather than a competent sailor, and he was forced to resign. The captain himself was judged guilty and condemned.

Géricault was twenty-seven years old when he chose this contemporary tragedy as the subject of his next painting. He was practically unknown to the public, for only two of his paintings had been exhibited at the Paris Salons of 1812 and 1814: the *Officer of the Imperial Horse Guards charging* and *The wounded cuirassier*. He had been trained by Carle Vernet, with whom he shared a passion for horses, and by Pierre Guerin, a history painter reputed to be classical but whose atelier turned out to

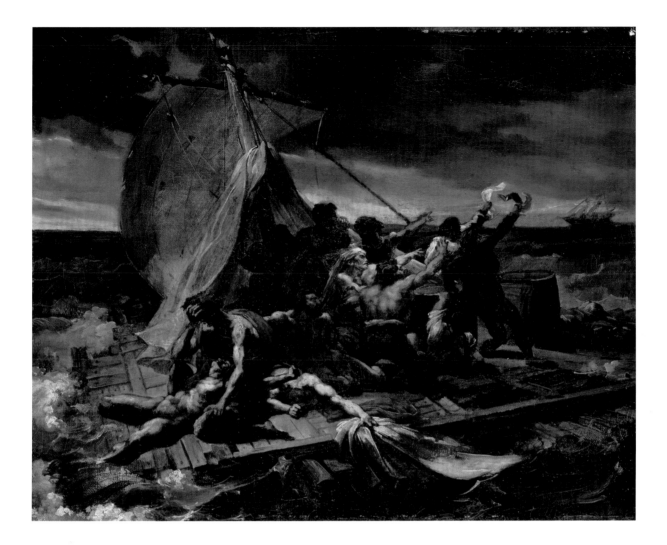

be one of the breeding grounds of Romanticism. Above all, Géricault had studied the great masters of painting in the Musée Napoleon (the Louvre), which at the time contained masterpieces plundered from the whole of Europe. Géricault's two years in Italy were a revelation: he came into contact with the works of Antiquity, with Michelangelo, Raphael, and Caravaggio, and acquired a taste for everyday subjects.

Upon his return to France Géricault realized that in order to be recognized as a painter he would have to do something special—"surprise the world," as he was to say. Without receiving a commission, he decided to undertake the painting of a picture whose sheer size would put it out of the reach of any private buyer. Géricault could only count on its being purchased by the State and displayed in the recently opened Luxembourg Museum, which in 1818 had been inaugurated as a museum devoted to the works of living artists. The founder of the museum, the Count of Forbin, was a painter himself and a fervent admirer of the new generation of painters. In the 1819 Salon, Géricault's picture was presented under the banal title of *Scene of a Shipwreck*, but nobody was fooled, for it was evident that behind the depiction

of a tragedy at sea lurked the evocation of a political scandal. However, in spite of the king's complimentary remark— "Monsieur Géricault, we have here a wreck, something which cannot be said of you"—and although the jury appeared to appreciate the painting and even awarded Géricault a medal, the picture was not sold. It was later exhibited in London but was still in the artist's studio when he died prematurely in 1824. Indeed, it only escaped being cut up thanks to the opposition of Géricault's friends, one of whom later acquired the painting and arranged for it to enter the Louvre almost immediately afterward.

Géricault only exhibited three major paintings at the Salon, and when he died—still a young man—he was convinced that he had only painted studies. But in those early years of the nineteenth century his audacious style was to agitate the world of painting and profoundly influence such later artists as Delacroix, Courbet, and Manet.

SYLVAIN LAVEISSIÈRE

24

Attributed to Jean-Baptiste-Jules Klagmann
French, 1810–1867

Ewer

Paris, ca. 1848
Cast and chased silver worked in repoussé
39¾ × 18⅛ inches (101 × 46 cm)
Department of Decorative Arts, OA 11741

HISTORY: Previously in the Mme. Bro de Commères Collection; Roland Poncet Collection; donated to the Musée du Louvre in lieu of death duties, 1994.

BIBLIOGRAPHY: Henri Bouilhet, *L'Orfèvrerie française aux XVIIIe et XIXe siècles*, Paris, 1908–1912, vol. II, pp. 227–231; Anne Dion-Tenenbaum, "Une dation récente: un important ensemble d'orfèvrerie des XIXe et XXe siècles," in *Revue du Louvre*, 1996, no. 1, pp. 82–84.

Fig. 1. Side of the vase depicting Bacchus and Ariadne.

This large ewer is particularly noteworthy for its elaborate and profuse decoration related to the theme of wine. The foot is decorated with bunches of grapes, two children sitting astride a swan and a griffin, and two nymphs riding dolphins. The continuous frieze that takes up most of the body of the vase is filled with a profusion of figures after the antique, forming a composition with little volume to it and which clearly draws its inspiration from Bacchic Roman sarcophagi. On one side of the vase, various figures surround the central composition of Bacchus bearing his thyrsus and Ariadne treading on a panther skin (fig. 1). The other side is decorated with a Dionysiac scene featuring bacchants, satyrs, and the god Pan playing his flute. Beneath the spout, a child seated on a tortoise brandishes a club. The handle is shaped in the figure of Ganymede, the future cup-bearer of the gods, who was carried off by Jupiter metamorphosed into an eagle.

This ewer was exhibited at the Universal Exhibition held in Paris in 1900 alongside another monumental ewer which seems to have been its pair. At the time, both vases belonged to Mme. Bro de Commères, the daughter of the arms manufacturer Henri Lepage (1792–1854). The other ewer, which is decorated with the battle between the Centaurs and the Lapiths, was commissioned by Lepage in about 1847–1848 from the metalworker Vechte, and it is most likely that Lepage commissioned

the Ganymede ewer at about the same date. According to Bouilhet, who published the vase on the occasion of the 1900 Exhibition, the model for the Ganymede ewer was provided by the sculptor Klagmann, an attribution which seems likely in view of the ornamental exuberance of the sculptor's works. However, we know nothing about the metalworker who transcribed Klagmann's model with such virtuosity. Certain parts of the vase were worked in *repoussé*, a technique that had fallen into disuse during the Neoclassical period and which came back into favor in France under the July Monarchy of Louis Philippe (1830–1848), along with the renewed taste for the Renaissance.

Because of its size and the virtuosity of its making, this vase is a spectacular work of art and an excellent example of the kind of masterpieces favored by nineteenth-century artists, who sought to surpass the great achievements of the Renaissance with their presentation of such monumental works at the Industrial Exhibitions and at the Universal Exhibitions.

ANNE DION-TENENBAUM

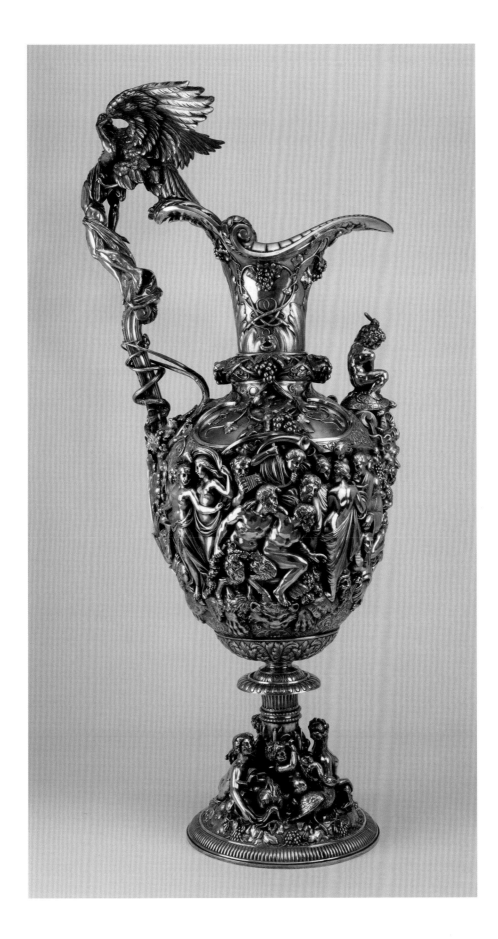

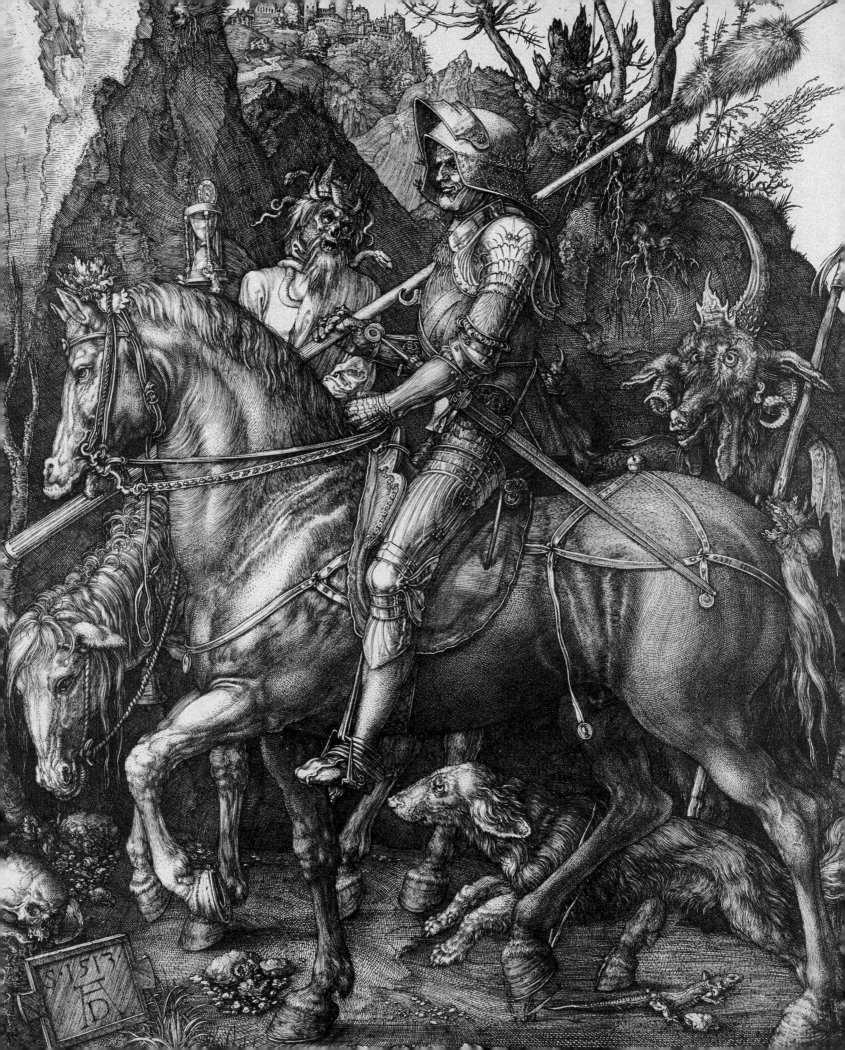

Connoisseurship, or Knowing a Masterpiece When You See One

David A. Brenneman

How do you know a masterpiece when you see one? What are the criteria, if any, that allow us to distinguish works that are great from works that are merely good? In the art world, the process of distinguishing authentic works from fake ones, and between good art and great, is called connoisseurship. Although "connoisseurship" sounds pretentious, many people are probably more familiar with the concept than they realize. For example, Malcolm Gladwell's bestselling book *Blink* (2005) opens with a compelling case study in connoisseurship focused on the Getty *Kouros*, an archaic Greek sculpture of a young man purchased by the J. Paul Getty Museum in the early 1980s. Gladwell used the process of showing the sculpture to be a fake as a means to prove his concept of the "power of thinking without thinking." Although the Getty had conducted extensive scientific analyses on the object, a number of important scholars could not accept the sculpture as genuine based on their "intuitive revulsion." Initially hailing it as the rediscovery of an ancient masterpiece, the Getty was eventually forced to concede that the sculpture might be a modern forgery. Many Americans have also become familiar with the basics of connoisseurship through public television's *Antiques Roadshow*, where experts lead lay participants through visual analyses of the objects that they have brought for valuation.

The discussion of connoisseurship, derived from the French term *connoisseur*, began to appear in English texts of the eighteenth century. One of the first writers to treat the subject at some length was the artist and art theorist Jonathan Richardson, who argued that the process of determining who had painted a given work of art could be arrived at through a rational process of building on solid attributions and understanding the stylistic development of individual artists.[1] Scholars at the end of the nineteenth century even sought to transform connoisseurship into a discipline with scientific rigor. Giovanni Morelli believed that while an artist focuses on capturing the individuality of the most important parts of a subject—let's say the sitter's eyes, nose, and mouth in a portrait—the artist unconsciously relaxes his or her guard when painting secondary parts, like ears and hands, and slips into a unique habit of representation. Thus by knowing how an artist paints ears and hands, a connoisseur trained in the Morellian method can discern the master's style. Morelli's system was challenged as being too narrowly focused on details, making it possible to miss the big picture in determining a work's authorship, and it eventually fell out of favor. Although connoisseurship is a rational process that can be carried out with rigor and some degree of precision, it is generally accepted that it is not a science and that its conclusions will always be subject to further scrutiny and potential revision.

In the twentieth century, connoisseurship has been aided by scientific techniques that provide information regarding the materials and techniques with which art is made. The use of such techniques as X-ray, infrared reflectography, and spectrum analysis has provided scholars

with a powerful arsenal of investigative tools. However, it is acknowledged, as in the case of the Getty *Kouros*, that these analytic techniques can provide more information but not necessarily definitive answers to questions of authorship and authenticity. This has proven to be the case with the Rembrandt Project, an ongoing effort led by art historians and conservation scientists whose goal has been to produce a definitive corpus of Rembrandt's paintings. To date, this process has resulted in the controversial de-attribution of two of Rembrandt's most famous paintings, *The Polish Rider* in the Frick Collection and the *Man in the Golden Helmet* in Berlin's Gemäldegalerie. However, as the art historian Peter Sutton noted in an article on the Rembrandt Project, the current members of the project team recognize that decisions of previous members, who relied heavily on scientific analysis, may need to be reevaluated and have begun to reassess Rembrandt's body of work with a renewed emphasis on connoisseurship, thus opening up the possibility that these works may be returned to the master's hand.[2]

Although analytic techniques can be extremely helpful, and even definitive in some cases—such as in the case of the Louvre's Egyptian Blue Head (plate 66)—they certainly cannot address questions of quality, which is another important aspect of connoisseurship. While it is possible to bring a certain amount of scientific rigor to the process of deciding whether or not a work of art is authentic or by a given artist, deciding on questions of quality is bound up with the concept of taste, which unfortunately carries with it connotations of snobbery, whim, and fashion. As the philosopher Arthur Danto has pointed out, "taste is something that functions in the abeyance of rules, and rules are there precisely for those who do not possess taste."[3] It is somewhat easier to discern between works of art that are merely good and those that are great. One can see, for example, in the Louvre's peacock dish (plate 37), that the complexity of the composition, the skill with which the forms are rendered, and the brilliance of the glazed colors place this example far above other pieces of sixteenth-century Iznik ceramics—but is this work a masterpiece? Perhaps it is in the medieval sense of the term, but is it also an expression of genius? If so, how can we judge?

In his book *What Is a Masterpiece?* Kenneth Clark set forth his understanding of the concept of the masterpiece.[4] He disagreed that the determination of whether or not a work is a masterpiece is subject to taste because the masterpiece symbolizes something larger and more universal. In his opening sentence, Clark claims, "Although we may disagree about a theory, the impact of a masterpiece is something about which there is an astonishing degree of unanimity." He went on to provide a number of examples of masterpieces and presented criteria for deciding whether or not a given work is a masterpiece. Among these criteria, he asserted that masterpieces exhibit a density of memories and emotions, a "human element," a "devotion to truth," a "dramatic situation," and "imaginative power." Clark's slim text, based on a lecture, gives the impression that these criteria are somewhat arbitrary. In addition, all of Clark's examples were taken from European Renaissance painting through the early twentieth century, and it is not clear that Clark would have considered an example of Islamic art such as the peacock dish a masterpiece. Thus it is difficult to agree with Clark that there is an "astonishing degree of unanimity" regarding the judgment and recognition of masterpieces. In the end, reading Clark's text makes us realize that connoisseurship can take us only so far. While it is possible to reach a degree of unanimity in deciding that works of art are either fake or authentic, that they are by certain makers, and that some works of art are better than others, deciding whether or not a work of art is the result of genius will continue to be a contested process.

NOTES

1. P. C. Sutton, "Rembrandt and a Brief History of Connoisseurship," in *The Expert Versus the Object*, ed. Ronald D. Spencer, Oxford and New York, 2004, pp. 31–32.

2. Ibid., pp. 29–38.

3. A. Danto, "Masterpiece and the Museum," in *Encounters and Reflections: Art in the Historical Present*, Berkeley, 1997, p. 326.

4. K. Clark, *What Is a Masterpiece?* London, 1979.

25
Cylinder seal: The sun-god rising

Mesopotamia, beginning of the Akkadian
period, ca. 2330–2284 B.C.
Serpentine
1⅝ × 1 inch (4 × 2.6 cm)
Department of Near Eastern Antiquities,
AO 2261

HISTORY: Acquired in 1893.

BIBLIOGRAPHY: L. Delaporte, *Catalogue des
cylindres orientaux du Musée du Louvre*, Paris,
1920–1923, no. A136; Rainier M. Boehmer,
*Die Entwicklung Der Glyptik Während Der
Akkad-Zeit*, Berlin, 1965, no. 986, fig. 411.

Cylinder seals are emblematic of the ancient Near Eastern civilization, but because of their small size, they often go unnoticed beside more monumental works. Yet some of these "minute monuments" are veritable masterpieces. It was toward the end of the fourth millennium B.C. that these roll-shaped seals first appeared in Mesopotamia (present-day Iraq). They are closely linked with the first developments in the invention of writing on clay, and indeed these two innovations went hand-in-hand with the setting up of a new political and social organization that was to result in the emergence of the first towns. Cylinder seals were rolled out on clay *bullae* bearing accountancy records or impressed upon the clay sealings used to close the bales of food provisions or to secure warehouse doors. These seal impressions reveal the identities of the participants in the expanding commercial exchanges of the period. At a later epoch the use of cylinder seals became linked with the development

of cuneiform writing on clay tablets, which had its origins in Mesopotamia and subsequently spread throughout the Near East. When this writing fell into disuse in the first millennium B.C., the cylinder-shaped seals were also abandoned and replaced by stamp seals.

Over the three thousand years during which the seals continued to be produced, their style, iconography, and the materials from which they were made all varied. One of the most brilliant periods of glyptic art is that of the Akkadian Empire in the late third millennium B.C. The images on the seals of this period depict—sometimes in a most dramatic way—a rich mythology evoking the world order, the cosmic powers, and the eternal cycle of nature. The seal impression in plate 25, for example, depicts the crucial moment of daybreak that announces the return of the sun-god. Two minor gods act as acolytes of the great god and open the doors of the East, while the Sun, an

26
Cylinder seal: Contest scenes

Mesopotamia, beginning of the Akkadian
period, ca. 2330–2284 B.C.
Green porphyry
1⅜ × ⅞ inch (3.5 × 2.4 cm)
Department of Near Eastern Antiquities,
AO 22307

HISTORY: Former De Clercq Collection;
gift of de Boisgelin, 1967.

BIBLIOGRAPHY: Louis De Clercq, *Collection de
Clercq, catalogue méthodique et raisonné. antiquités
assyriennes, vol. 1, cylindres orientaux*, Paris, 1888,
no. 59; Henri Frankfort, *Cylinder seals*, Lon-
don, 1939, pl. XVI-d; R. M. Boehmer, *Die
Entwicklung Der Glyptik Während Der Akkad-
Zeit*, Berlin, 1965, no. 54; Pierre Amiet, *L'art
d'Agadé au Musée du Louvre*, Paris, 1976; *Bas-
reliefs imaginaires de l'Orient ancien*, Paris, 1973,
no. 222.

impetuous, conquering deity, begins his daily rise above the
mountains, symbolized here by a scale motif. He emerges in a
burst of flames, a symbol of the implacable fiery furnace which
would continue to burn in the sky throughout the coming day.

The iconography of seal AO 2261 reveals the rich imagina-
tion of Akkadian engravers, but the style is dry, almost awkward,
and totally different from the mastery with which the decoration
of seal AO 22307 is crafted (plate 26). This second seal depicts a
scene of combat between human heroes, fantastic creatures, and
wild animals, a theme which appeared at the beginning of the
third millennium and reached its apogee during the Akkadian
period, when it was portrayed on artworks produced in the royal
ateliers working for high dignitaries in the administration and for
those close to the royal family.

These combat scenes illustrate the primeval mythology of a
world ruled by supernatural and threatening forces which man
must confront and tame in order to survive. They evoke the
conflict between the civilized world and the powerful, mysteri-
ous forces of nature—the combat between order and chaos. On
the right a bull-man, the traditional ally of humans, stabs a lion,
the greatest of the predators, while on the left two human heroes
each master a human-headed bull; this strange creature, modeled
perhaps on a bison, has the face of a bearded man and probably
represents a benevolent earth spirit. The uncluttered composi-
tion is divided into three balanced duels and gives the impression
that these conflicts have now been quelled. Could this be the
image of the order imposed by the strong new monarchic power,
which, for the first time, had united under its sway the hitherto
rival cities of Mesopotamia?

The same motif appears again several hundred years later in
the nineteenth century B.C., but this time the treatment is differ-
ent. The two human-headed bulls are barely recognizable in the

27
Cylinder seal: Contest scenes

Mesopotamia
Isin-Larsa period, 2000–1800 B.C.
Hematite
¾ × ⅜ inch (1.9 × 1.1 cm)
Department of Near Eastern Antiquities,
AO 6250

HISTORY: From the original collections of
the Musée du Louvre.

BIBLIOGRAPHY: L. Delaporte, *Catalogue des
cylindres orientaux du Musée du Louvre*, Paris,
1920–1923, no. A107.

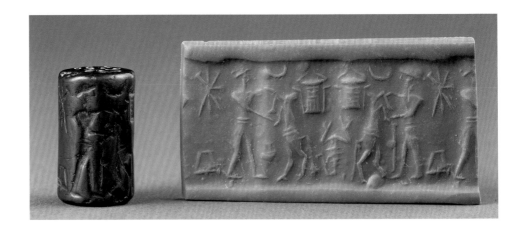

dislocated creatures that constitute the center of the decoration of seal AO 6250 (plate 27). The two heroes who overcome them are engraved rather summarily with little attempt at modeling, and the filling elements—a scorpion, a rod of justice, and a small vase—clutter the field and confuse the reading. The clumsily engraved inscription includes the name of the god Shamash but not that of the seal's owner. We have here the work of a provincial workshop, which showed little originality or talent in its reproduction of the motifs of the Akkadian period.

Nothing could be more different from the splendid seal of Ibni-sharrum, the scribe of Shar-kali-sharri, the last sovereign of the Akkadian Empire, one of the most perfect masterpieces of Near Eastern glyptic art (plate 28). Two nude, hairy heroes kneel in symmetrical fashion. Buffaloes drink from the fresh water bubbling out of the vases they hold, while below, a river winds through mountains, symbolized by a scale motif. A cartouche held up by the buffaloes occupies the center of the composition. It frames the inscription: "O divine Shar-kali-sharri, Ibni-sharrum the scribe is your servant." The nervous, precise style of the engraving and the perfect polish of the hard diorite, the royal stone *par excellence*, emphasize the modeling of the figures. The technical mastery is admirably revealed in the realistic representation of the figure. The nude hero acts as the acolyte of the water god, master of the fresh waters, source of all life and symbol of fertility. At this period in Mesopotamia, buffaloes were exotic animals brought in by the monarchs from the country of Malluha, the present-day region of the Indus River. The association of the nude hero, the spirit of fresh water, with the buffalo, an animal that spent its time lazing in muddy water, would probably have seemed obvious to the artists. They must indeed have

28
Cylinder seal: Contest scenes

Mesopotamia
End of Akkadian period, reign of King
Shar-kali-sharri, ca. 2217–2193 B.C.
Diorite
1½ × 1 inch (3.9 × 2.6 cm)
Department of Near Eastern Antiquities,
AO 22303

HISTORY: Former De Clercq Collection,
gift of de Boisgelin, 1967.

BIBLIOGRAPHY: Louis De Clercq, *Collection de
Clercq, catalogue méthodique et raisonné. antiquités
assyriennes, vol. 1, cylindres orientaux*, Paris,
1888, no. 46; Henri Frankfort, *Cylinder seals*,
London, 1939, pl. VIII-c; R. M. Boehmer,
*Die Entwicklung Der Glyptik Während Der
Akkad-Zeit*, Berlin, 1965, fig. 232, no. 724;
Pierre Amiet, *L'art d'Agadé au Musée du
Louvre*, Paris, 1976, no. 73; Dominique Collon,
*First Impressions, cylinder seals in the ancient
Near East*, London, 1987, no. 529; *Bas-reliefs
imaginaires de l'Orient ancien*, Paris, 1973,
no. 231; *De Sumer à Babylone*, Paris, Louvre,
1979, p. 101.

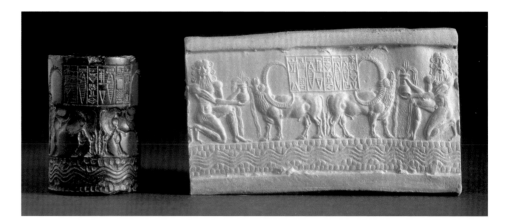

been intrigued and interested in these hitherto unknown animals,
now kept in the royal parks, much as we today keep our exotic
wild animals in zoos.

 The calm equilibrium of the composition, based on horizon-
tal and vertical lines, gives a classical monumentality to this tiny
relief. Seals of this quality were reserved for those close to the
royal family, and certain engraving ateliers worked exclusively
for the elite. The lapidaries recruited by such ateliers may well
have been trained in the royal sculpture workshops, for they
engraved cylinder seals with a sense of modeling never again to
be equaled.

FRANÇOISE DEMANGE

29
Head of Amenhotep III

Egypt, New Kingdom, 18th Dynasty (1391–1353 B.C.)
Granodiorite
12¹³⁄₁₆ × 11¹³⁄₁₆ × 9⅞ inches (32.5 × 30 × 25.3 cm)
Department of Egyptian Antiquities, A 25

HISTORY: Previously in the Drovetti Collection; acquired by
the Louvre in 1827.

BIBLIOGRAPHY: Christophe Barbotin, *Les statues égyptiennes du Nouvel
Empire. Statues royales et divines*, Paris, 2007, vol. 2, book 1, note 16,
pp. 54–55, 58, 61; Betsy M. Bryan, *Egypt's Dazzling Sun, Amenhotep III
and His World*, exhibition catalogue, Cleveland and Fort Worth, 1992–
1993, note 10, pp. 164–165; Bernadette Letellier, *Treasures of Egyptian
Art from the Louvre*, exhibition catalogue, Cleveland, 1996, note 12,
pp. 56–57.

The reign of Amenhotep III was one of the most prosperous and favorable periods in the history of Egypt. For thirty-eight years, from 1391 to 1353 B.C., the Valley of the Nile enjoyed a veritable state of grace, an era of radiant prosperity favored by the peaceful relations the country enjoyed with its neighboring countries, which in the first half of the fourteenth century B.C. had been subjugated by Amenhotep's predecessors, Tutmose III and Amenhotep II, and obliged to pay taxes. During this period, Pharaonic Egypt constituted the most important empire in the Near East, extending from the fourth cataract of the Nile in the south through central Mesopotamia and up to Anatolia in the north. The apogee enjoyed by the Egyptians under Amenhotep III was modest but had a firm foundation, and it was in this extremely favorable context that the artistic production of the period flourished. The period is thus considered by art historians as a particularly splendid one.

The many monuments and statues which survive help us appreciate the elegance, harmony, and refinement of the period. Although now surrounded by other constructions, the great court of the Luxor Temple in Upper Egypt, lined on three sides with a double colonnade, is a place where one still senses the grace and beauty that permeates the work of the architects and sculptors of the reign of Amenhotep III and their desire to convey a sense of perfect equilibrium. This was a time when the gigantic and the beautiful came together in perfect fusion—as can be clearly seen in the statues recently discovered during excavations on the site of the Colossi of Memnon on the left bank of Luxor conducted by Dr. Hourig Sourouzian for the German Institute of Cairo, in collaboration with the Supreme Council of Archaeology of Egypt. The discoveries included several colossal 50-foot (15-meter) royal statues, as well as a gigantic statue of the wife of Amenhotep III, Queen Tiy, measuring almost 12 feet (3.62 meters); the queen is represented smiling gently but is nevertheless imbued with an air of imperious authority.

One might justifiably expect these statues to be the routine works of an almost mass-production system organized to turn out as many colossal statues as possible. On the contrary, the extremely fine execution of the statues of the pharaoh and his queen strikes the viewer, and in particular the precise and realistic rendering of the features of the royal couple shown on not just one or two statues, but on all of them. The Louvre head is particularly expressive, and undeniably constitutes one of the finest portraits of the king. It is carved from granodiorite, an extremely hard, dark stone which seems to have been the pharaoh's favorite—to our knowledge, there are nearly a thousand statues in this black granodiorite dating from the reign of Amenhotep III—and exploits all the qualities offered by the stone. The size of the head suggests that it originally formed part of a very large statue. The surface of the helmet still has the rough, dull quality of the stone from which it was carved, whereas the face is polished to an almost shiny brilliance. This helmet is in fact the ceremonial crown, or *khepresh*, decorated on the front with the *uraeus*, the formidable cobra, a symbol of royal power. The face beneath is a youthful one, with full, smooth cheeks and the characteristic almond-shaped eyes that so clearly distinguish portraits of Amenhotep III from all others. The eyes, bordered with thick protruding lines of makeup and emphasized by prominent eyebrows, stretch out and slightly upward toward the temples. It is perhaps this oblique look which gives Amenhotep III his air of gentleness and sensuality, an expression that is further accentuated by the well-defined lips. Historians have often described Amenhotep III as being indolent, a personality trait taken advantage of by the ambitious and authoritarian Queen Tiy. The origin of this reputation for affability could stem from the calm and good-natured expression shown in these admirable portraits of the king, so strikingly different from the energetic and determined qualities expressed in the iconography traditionally used for representing the pharaohs.

GUILLEMETTE ANDREU

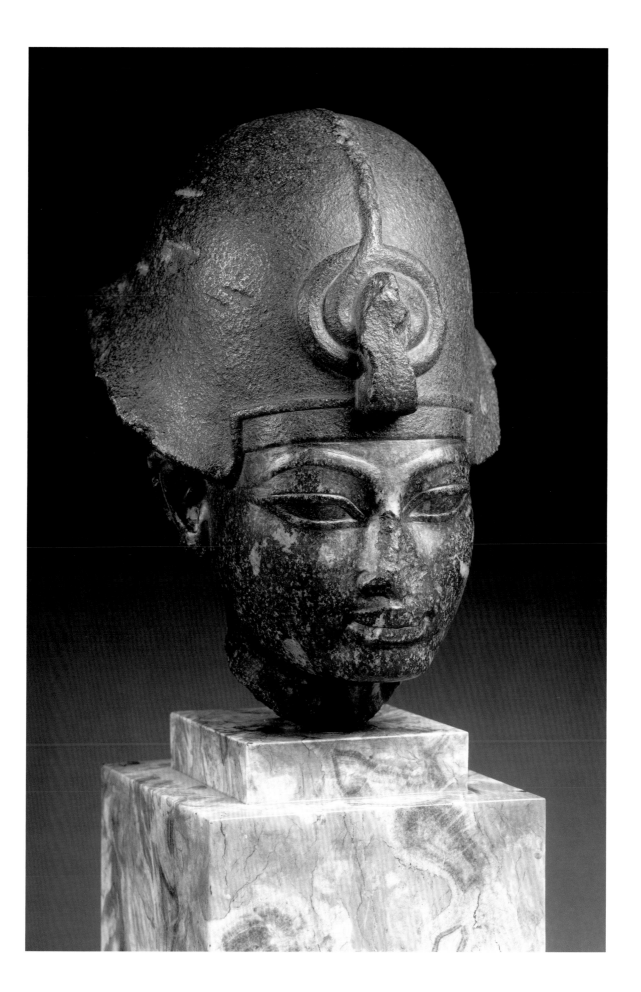

30
Lévy *oinochoe*

Greek, ca. 630 B.C.
Clay
15½ inches (39.5 cm) high
Department of Greek, Etruscan, and Roman Antiquities, E 658
Atlanta only

HISTORY: Acquired in Rome by the painter E. Lévy in about 1855; then by the Musée du Louvre in 1891.

BIBLIOGRAPHY: Edmund Pottier, *Vases antiques du Louvre* I, 1901, p. 9; *Mer Egée, Grèce des îles*, Paris, 1979, no. 78; Martine Denoyelle, *Chefs-d'oeuvre de la céramique grecque*, 1994, p. 24; John Boardman, *Early Greek Vases*, 1998, p. 143, pl. 287; Michael Kerschner and Udo Schlotzhauer, "New classification of East Greek Pottery," in *Ancient West and East* 4, 2005, p. 25.

The Lévy *oinochoe* is the finest example of the Milesian "Wild Goat" style. This animal-frieze style, which originated in Asia Minor during the seventh century B.C., reflects the eastern Greek fascination for the Orient during this period, as shown in the depiction of mythical animals such as sphinxes and griffins, the use of repetitive animal friezes, and the employment of floral bands of lotus chains. However, it should be remembered that in the field of ceramics, as in other domains of art, the Greeks did not simply imitate the foreign influence, but adapted it to their own particular style. In the area of monumental sculpture, for example, the Greeks completely rethought the Egyptian models from which they drew their inspiration. By doing away with the supporting back pillar, they inscribed their statues in space, transforming a borrowing into a true creation. In the same way, Orientalizing pottery is in itself an innovative transposition, for painted pottery, uncommon in the art of the Orient, became a Greek speciality.

Unlike works of the preceding Geometric period, Orientalizing pottery did not develop autonomously but integrated a number of foreign influences. This can be seen in the way shapes and pictorial techniques were renewed. The carinated body, the trefoil mouth, the delicately modeled rib under the lip, and the structure of the handle all indicate that the Lévy *oinochoe* took its inspiration from a luxury prototype in metal. The handle in particular reveals this inspiration: it is composed of five small rods and is flanked by wheels and a rectangular plaque, which

on metal vessels was designed to conceal the upper rivet. Both the plait motifs depicted on the plaque and the neck, and the guilloche design painted between the friezes, are also frequently found in the decoration of metal objects. The aesthetic of the Lévy *oinochoe* also owes much to the art of textiles. The use of outline and reserve drawing—the great pictorial technique of the Orientalizing period—evokes the oriental fabrics and tapestries we no longer have through its supple, vaporous style, its combination of lustrous colors, and the profusion of filling ornaments.

A number of workshops contributed to the diffusion of the Wild Goat style, but on the basis of recent excavations and laboratory analyses of clay, it is now thought that the Miletus atelier was one of the earliest and most active. The three vases presented here with the Lévy *oinochoe* (plates 31–33) illustrate the Milesian version of the Wild Goat style and enable us to measure over a period of fifty years the distance separating a masterpiece (the Lévy *oinochoe*) from the general production.

A number of exceptional features account for the great celebrity of the Lévy *oinochoe*. This shape of vase, used as a jug for serving wine, was widespread in both Miletus and eastern Greece in general. The size, however, especially the imposing breadth of the body, was most unusual. Great care was taken in the polishing of the vase, and the color and brilliance of the slip evoke ivory. The attraction of the vase lies most of all in the great refinement of the decoration which spreads out over the surface in miniature

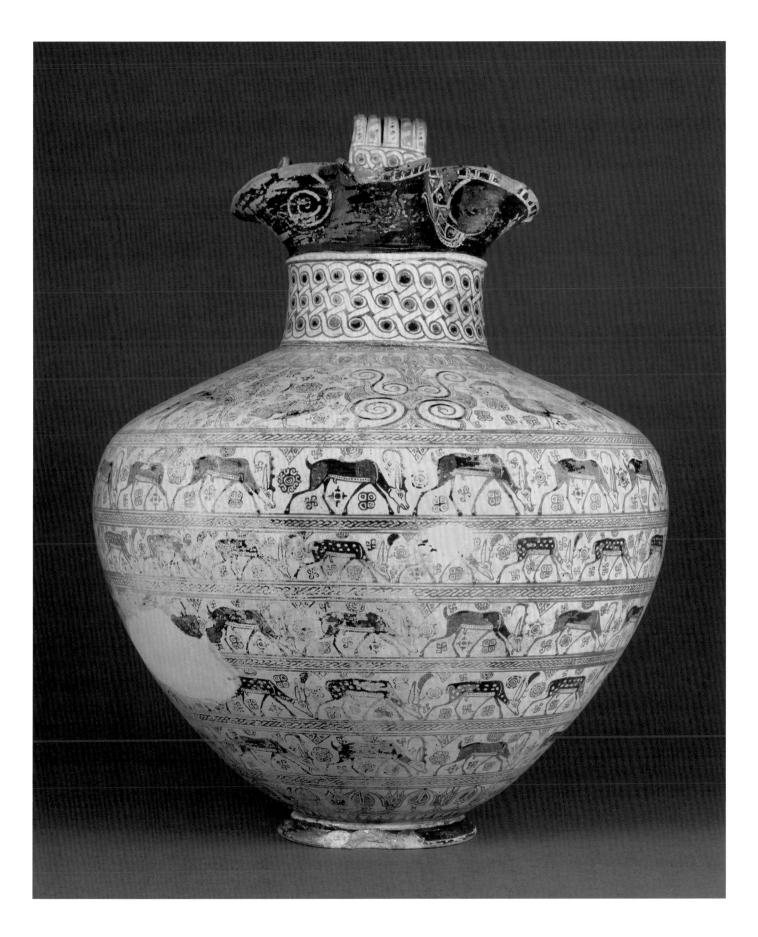

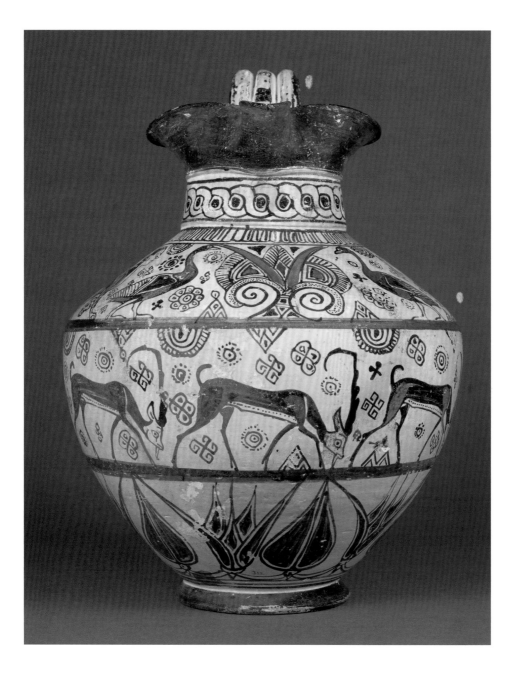

31

Oinochoe

Greek, ca. 625–600 B.C.
Clay
12 × 8⅝ inches (30.5 × 22 cm)
Department of Greek, Etruscan, and Roman Antiquities, A 312
Atlanta only

HISTORY: Acquired by the Louvre in 1864; Salzmann excavations
in Rhodes.

Fig. 1. Detail of sphinxes and griffins.

Fig. 2. Detail of deteriorated fox above leftmost deer.

friezes. The decoration on the varnished mouth was painted in outline in the light creamy color of the slip. The floral motifs, which are better conserved to the right of the pouring spout, are each composed of a lotus flower flanked by volutes alternating with concentric circles surrounded by Ts, the central branch of which is pointed toward the exterior. The most voluminous motif—arabesques in a corolla around a lotus flower with short round petals—echoes the components of the decorative scheme chosen for the large central ornament embellishing the shoulder, around which the main frieze is organized.

Here, animals are positioned symmetrically on either side of the central floral: a goose and a griffin turn toward the center, while a sphinx and deer look outward. Although the composition is symmetrical, the animals are of different sizes. On the right, the goose spreads out, whereas the deer is somewhat cramped—its muzzle comes up against the vertical frame and its leg rubs against those of the sphinx behind (fig. 1). These anomalies indicate that the painter worked from left to right and from the center toward the exterior. On the left half of the frieze, the painter also progressed from left to right and from the edge inward; he began with the deer and did not leave enough space for the goose. The drawing of the griffin on the left confirms the direction in which the painter moved, for the back of

the animal is more voluminous than the compact front. The red highlights decorating the surface are well conserved on the griffin and the sphinx on the right. Many details are almost hidden in the great variety of filling ornaments, and the viewer who looks carefully can discover the much-deteriorated little fox (or is it a ferret?) on a long oblique tongue above the left deer (fig. 2), or the five swallows suspended among the filling ornaments or perched on the tails of the animals.

The five animal friezes on the body consist of three processions of wild goats alternating with two friezes of spotted deer. The dense, homogeneous filling elements play a unifying role here; each of the triangles hanging from the upper line frames an animal, and the backs of the animals are surmounted with concentric semicircles and hemmed with petals. This meticulously executed structure reinforces the impression of great mastery, which is also seen in the multiplication of astoundingly identical animal vignettes. Here order and beauty reign, but there is nothing rigid, nothing overly systematic or mechanical in this superb minute decoration. The centered composition of the shoulder, for example, is only approximately in line with the axis determined by the spout, and the height of the animal friezes varies, even if they all measure just more than an inch (about 3 cm). The way in which the painter closes his compositions by bending the

32
Oinochoe

Greek, ca. 600 B.C.
Clay
14 × 8¾ inches (34.5 × 22.2 cm)
Department of Greek, Etruscan, and Roman Antiquities, A 314
Atlanta only

HISTORY: Acquired by the Louvre in 1864; Salzmann excavations
in Rhodes.

33
Oinochoe

Greek, ca. 600–570 B.C.
Clay
13⅜ × 8⅝ inches (34 × 22 cm)
Department of Greek, Etruscan, and Roman Antiquities, A 319
Atlanta only

HISTORY: Acquired by the Louvre in 1864; Salzmann excavations
in Rhodes.

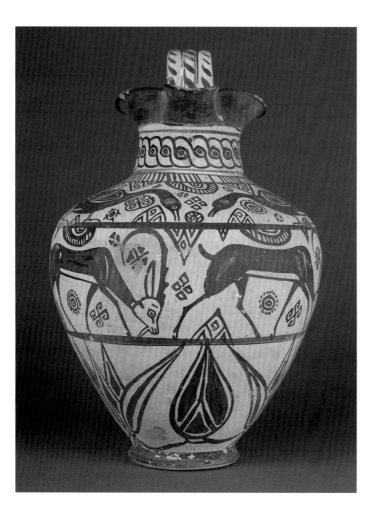

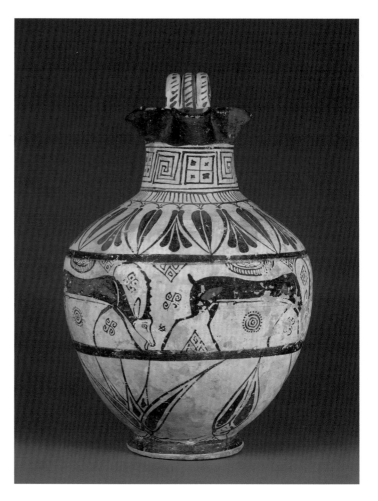

Fig. 3. Third frieze, featuring ibexes and another animal.

Fig. 4. Swallow motif in detail of A 312.

figure of the pacing ibex is particularly skillful. In the first zone, to the left, beneath the griffin on the shoulder, an ibex turns its head. On the third frieze (fig. 3), the remaining space is so limited that the painter introduces two variants: he turns the head of the ibex and mingles its feet with those of the animal preceding it. The anomalies on the left half of the vase indicate where the two parts of the decoration come together, showing how the painter started in the middle zone of the vase and moved from left to right, and how his mastery of drawing—controlled but free—enabled him to improvise where necessary. The freedom of the drawing, which points to the primacy of line drawing—a celebrated characteristic of Greek pottery—was one of the great achievements of the seventh century B.C., and in particular the technique of outline and reserve drawing, which the painter of the Lévy *oinochoe* so brilliantly exploited.

If we compare the Lévy *oinochoe* with three more recent Milesian jugs, the outstanding quality of the former becomes strikingly evident. The first jug (plate 31) retains a number of features inherited from its prestigious forerunner, notably the carinated shoulder, the heraldic composition of the main frieze centered around a floral, and the swallow motif (fig. 4), incorporated within the filling elements. The second (plate 32) illustrates the late animal-frieze style of the workshop, where the animals are more elongated—a tactic used by the painters to save time and which clearly points to the break with the miniaturist

spirit of the Lévy *oinochoe*. The third vase (plate 33) uses a bilingual style that reveals the transition from the late Wild Goat style to the Fikellura style, a new phase in the Milesian production. One of the distinguishing features of the Fikellura style is the use of an elegant floral frieze, which appears here on the shoulder of the vase. The last three vases were discovered in tombs on the island of Rhodes, which led to the whole group being referred to as Rhodian pottery for many years. The provenance of the Lévy *oinochoe*, however, is uncertain. It was purchased by the painter E. Lévy in Italy toward the middle of the nineteenth century—that is, before the excavations carried out in Rhodes—and it may have come from a tomb in Italy. Throughout the Archaic period, the finest examples of Greek vases were imported by the Etruscans to place in the tombs of aristocrats, and such a context would explain the exceptional quality of the Lévy *oinochoe*.

ANNE COULIÉ

34
Roman copy of the statue type known as "The Leaning Aphrodite"

Roman, 1st or 2nd century A.D.
After a lost Greek original by the sculptor
Alkamenes, ca. 420 B.C.
Marble
46½ inches (118 cm) high
Department of Greek, Etruscan, and Roman
Antiquities, INV Ma 414 (cat. MR 298)

HISTORY: Collection of Cardinal Mazarin;
entered the collections of Louis XIV in 1665
(?); entered the Tuileries Palace in 1669;
seized at Versailles in 1798.

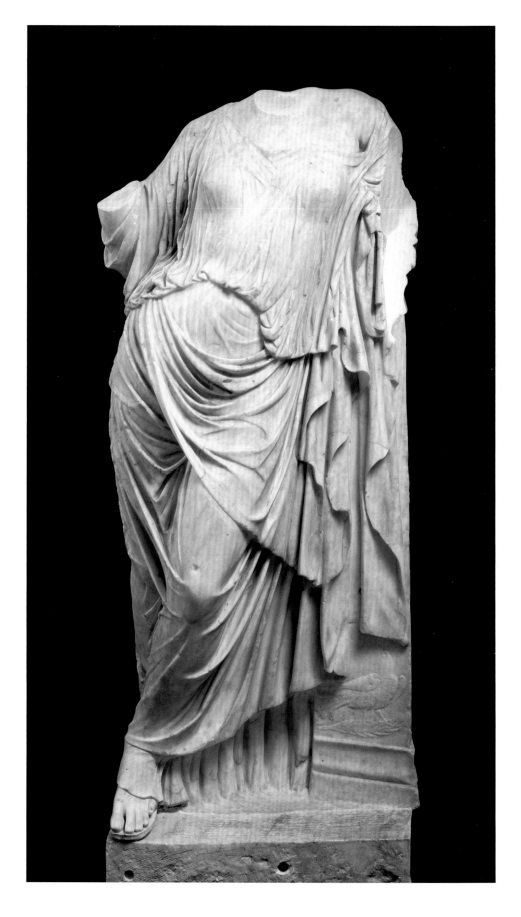

35
Roman copy of the statue
type known as "The Leaning
Aphrodite"

Roman, 1st or 2nd century A.D.
After a lost Greek original by the sculptor
Alkamenes, ca. 420 B.C.
Marble
48⅜ inches (123 cm) high
Department of Greek, Etruscan, and Roman
Antiquities, INV Ma 420 (cat. MR 181)

HISTORY: Borghese Collection; purchased by
Napoleon from his brother-in-law in 1807.

BIBLIOGRAPHY: Alain Pasquier in *La Vénus
de Milo et les Aphrodites du Louvre*, Paris,
1985, p. 51; Ilaria Romeo, "Sull''Afrodite
nei giardini' di Alcamene," in *Xenia Antiqua*,
1993, pp. 31–44; Jean-Luc Martinez, ed.,
Les Antiques du Louvre, Paris, 2004, p. 53,
figs. 51–52, and p. 223, n. 33; Jean-Luc
Martinez, *Les antiques du musée Napoléon.
Edition illustrée et commentée des volumes V
et VI de l'inventaire du Louvre de 1810*, Paris,
2004, nos. 210–211, pp. 130–131; *Greek
Masterpieces from the Louvre*, exhibition
catalogue, National Museum of Singapore,
2007, p. 123, no. 120; Jean-Luc Martinez
in *100 chefs d'œuvre de la sculpture grecque au
Louvre*, Paris, 2007, p. 96.

Fig. 1. Sculpted relief on pillar of Ma 414.

The bronze statuary of the ancient Greeks has almost entirely disappeared, partly as a consequence of the ravages of wars and pillaging, and partly because the alloy was frequently melted down to make weapons and tools. The loss is somewhat attenuated, however, by precious evidence we have dating from Antiquity. Indeed, we know of certain famous Greek statues—now lost—through descriptions written by Greek and Latin authors and also because we have reproductions made during Antiquity—images on reliefs, coins, and precious stones, as well as terracotta statuettes and marble replicas. The Romans in particular were great lovers of Greek art and commissioned many "copies" for the decoration of their public buildings (temples, baths, and porticos) and private buildings (villas and gardens), thus translating into marble the bronze statues which had been molded and distributed in the form of plaster models.

Most of these replicas date from the first or second century A.D. They are absolutely fundamental for our knowledge of Greek artists and also give us information on the choice, taste, and skill of Roman artists. By comparing and contrasting these different sources, we can discover the location and attribution of the lost original Greek bronzes, and try to find an echo of them in the numerous marble replicas which have come down to us. This method, known in German as *Kopienkritik*, a veritable discipline in the study of art history, seeks to bring together and compare ancient replicas of the same statuary type—the jargon used for expressing the idea we have of a lost original.

A comparative analysis of the two replicas of the so-called "Leaning Aphrodite" constitutes a good example of the *Kopienkritik* method. It is not only useful in the definition of a common prototype, but also contributes to our appreciation of the talent of both copyists and helps us distinguish the masterpiece replica from the more mediocre production. Today both statues are reduced to the ancient body; they no longer have the arms bearing a mask or flute, which were added during the modern era to make them into representations of the Muses.

Both statues clearly copy the same lost original, though with variations. A series of ancient replicas (including others at Naples, INV 6396, and at Heraklion, INV 325) reproduce the same female figure wearing a tunic attached at the shoulder and a woolen himation which cuts diagonally across the back and is brought back in apron form over the thighs to be finally held in position under the left arm. The figure stands leaning on a pillar, with

the left leg placed forward and across the right leg, thus accentuating the tilt of the silhouette. A relief from Daphni, near Athens—and bronze elements of the fifth century B.C. depicting this figure in association with Eros—prove that the figure portrayed can be identified with the goddess Aphrodite and that the statue was probably located in Athens. Moreover, this type of statue is also shown on reliefs that reproduce the bases of cult statues—attributed to Alkamenes—in the Temple of Hephaistos in Athens. This suggests that we have here a reproduction of the *Aphrodite in the Gardens* by Alkamenes—a statue which, according to Pausanias (1, 19, 2), a Greek writer of the second century A.D., was at Athens in the Athenian sanctuary situated beside the River Ilissos. The style could correspond to what is known of Alkamenes's work in the second half of the fifth century B.C.; the Museum of the Acropolis of Athens has an original group by him, and he is also thought to be the sculptor of the famous caryatids of the Erechtheion.

Whatever the case, the break in the balance, the exaggerated treatment of the drapery, and the sensual baring of the left shoulder are all characteristic of what is known as the "Rich Style." This style seems to have originated on the East pediment of the Parthenon with the so-called K., L., and M. figures, which probably represent Aphrodite and two other divinities. Only the replica from the French Royal Collections (plate 34) shows the unveiling of the left armpit and the sensual baring of the top of the arm, whereas on the replica from the former Borghese Collection (plate 35) almost the whole top part of the arm is covered. The same difference of sensitivity can be seen in the treatment of the drapery over the abdomen: the sculptor of Ma 414 reveals the navel and the swelling of the abdomen beneath the material, whereas the sculptor of replica Ma 420 places his folds rather mechanically and completely conceals the female body. He does not seem to have understood that this part of the abdomen is covered only by the tunic and not by the coat, which forms a triangular pleat at the level of the pubis and the top of the left thigh. Similarly, the folds emphasizing the tautness over the advanced left knee are more marked on replica Ma 414, whereas they have practically disappeared on the other copy.

Finally, there is the most significant detail of all: the sculptor of Aphrodite Ma 414 decorated the bottom of the pillar with the motif of a crow and the side of the pillar with a laurel branch (fig. 1). How can we interpret these differences? Should we associate skill with faithful copying and assume that the more

delicate and sensitive replica is the closest to the lost original? The presence of the bird and the branch—supposedly evoking the Sanctuary of Aphrodite on the River Ilissos—has been explained in this way. However, although the surface quality of the Borghese Collection replica is the work of a less skillful artist, it displays features—such as the oblique folds beginning from the left breast and the bunching folds beneath the left armpit—which are found on other replicas and which seem to faithfully reproduce the original composition. The sculptor of Ma 414 was probably a more skillful artist, but also one who showed more independence from the original.

JEAN-LUC MARTINEZ

36
Eros, known as *The Winged Genius* or *The Genius Borghese*

Roman, 1st or 2nd century A.D. (?)
Marble
39¹³⁄₁₆ inches (101 cm) high without plinth
Department of Greek, Etruscan, and Roman Antiquities, INV MR 140
(cat. Ma 545)

HISTORY: Borghese Collection; purchased by Napoleon from his
brother-in-law in 1807.

BIBLIOGRAPHY: Johann Joachim Winckelmann, *Histoire de l'Art dans
l'Antiquité* (1764), trans. D. Tassel, Paris, 2005, p. 159; Johann Joachim
Winckelmann, *De la description* (1759), trans. E. Décultot, Paris, 2006,
pp. 57–61, figs. 27–28; Jean-Luc Martinez in *Praxitèle*, exhibition
catalogue, 23 March–18 June 2007, Musée du Louvre, Paris, no. 93,
pp. 352–353.

The history of this statue of Eros, known as *The Genius
Borghese*, reveals how the tastes in art of the European elite
have changed and evolved, sometimes in the most startling way,
since the eighteenth century. Over the last two hundred years,
the work has been viewed in four radically different ways, reveal-
ing first the late eighteenth-century European admiration for
Neoclassicism, as well as its scarcely ambiguous veneration of the
male nude, then the characteristic nineteenth-century fascination
for the great artists of Antiquity, followed in the twentieth cen-
tury by the rejection of Academic art in favor of the fascination
for fragments which became so fashionable in the 1930s, and
finally the recent renewed interest in antiquities and in the his-
torical restoration of antiques.

In the first edition of his *History of Ancient Art* (1764),
J. J. Winckelmann had nothing but praise for the statue:

I wish I were capable here of describing this object of
beauty, which could only have been created with the
greatest of difficulty by the human hand: it is a winged
genius from the Borghese Villa, and resembles a tall, well-
built youth. Let us suppose that the imagination, having
in mind the different beauties of nature, and occupied
with contemplating that beauty which comes from God
and leads to God, let us suppose that it dreams of an
angel whose face is lit up by the divine light and whose

form seems to originate in the most harmonious source:
it is in this way that the reader should see this beautiful
statue.

This veneration on the part of Winckelmann, one of the great
high priests of Neoclassicism, says much about his psychology.
Nineteenth-century scholars went even further and added to the
reputation of the statue by attributing it to one of the most pres-
tigious artists of Antiquity. When the work was purchased by

Napoleon from his brother-in-law Camille Borghese along with the greatest collection of antiques in private hands at that time, it quickly achieved unrivaled celebrity at the Louvre. The statue was almost immediately attributed to Praxiteles, the famous Athenian sculptor of the fourth century B.C., on the grounds that it was probably a Roman copy of the *Eros* from Parium, a statue attributed to Praxiteles, one of the masters most praised by the authors of Antiquity. Pliny, the Latin author of the first century A.D., for example, mentions a naked *Eros* sculpted by Praxiteles and dedicated to Parium, a city in the region of Propontis in the Hellespontus, and tells how this *Eros* was as famous as the *Aphrodite of Cnidus* and had suffered the same outrage committed by an excessively ardent admirer (Pliny, XXXVI, 22). If we are to believe Pliny, the original statue must have been in bronze, for Pliny refers to it in his treatise on that metal. It is probably the same statue reproduced on coins from Parium, minted during the second and third centuries A.D. These coins bear the inscription *Deo Cupidini* and show a naked Eros standing with his weight on his right leg and his hips and shoulders at a considerable tilt. There are numerous similarities between the Eros on the coins and *The Genius Borghese*, particularly the flexed position of the body, the hairstyle, and the large drapery worn on the left. *The Genius Borghese* of the Louvre was thus thought to evoke one of the most admired creations of Praxiteles. This admiration of the statue reached its culmination in 1895 when A. Furtwängler gave it pride of place in his masterly study on Greek art.

But soon after, Greek sculpture began to be confused with the most sterile of Academic art, and the enthusiasm for the statue gave way to doubts and even downright rejection. The attribution to Praxiteles was questioned, and scholars started to murmur that the strange knot of hair kept in place by a narrow band, the strands of hair tied over the ears, the narrowness of the chest in relation to the pelvis, and the slack, rather flabby torso could go no farther back than the Hellenistic period (third to first century B.C.) and seemed instead to indicate a work from the early years of the Roman Empire (first to second century A.D.). When the draped tree trunk, which had been the major point of comparison with the Parium coins, was proved to be entirely modern, the statue could no longer be attributed to Praxiteles. During the twentieth century the statue was viewed as mediocre, and after 1935 it was de-restored and reduced to a torso with a head (fig. 1). The final disgrace came with its

Fig. 1. De-restored torso.

relegation to the museum's storerooms. This was a period when the admiration for antique fragments resulted in numerous Greek and Roman sculptures being de-restored, sometimes to excess. The twentieth-century taste for creations depicting fragments led to the removal of modern additions, with the result that it became even more difficult to present the mutilated antiquities.

It was only recently, in 2004, that the different fragments of the statue were traced and a new restoration carried out, incorporating all the modern additions. We now know that only one fragment dates to Antiquity. This fragment, the head attached to the torso, constituted the main part of the statue. The torso is conserved down to the middle of the thigh and the top part of the right arm, but the end of the nose, the legs and feet, the support and its drapery, the two arms, and even the wings are all additions, probably dating to the seventeenth century. The antique fragment still has its nose (which is exceptional) and is not broken at the level of the neck and is therefore not without interest. But the real value of *The Genius Borghese* lies in what it teaches us about changes in taste. Two hundred years after being celebrated by Winckelmann, this statue was mutilated and relegated to storage before being allowed to return once again to the limelight in the Musée du Louvre.

JEAN-LUC MARTINEZ

37
Peacock dish

Iznik, Turkey, ca. 1550
Stonepaste with underglaze painting over a slip coating
3⅛ × 14¾ inches (8 × 37.5 cm)
Department of Islamic Arts, K 3449

HISTORY: Acquired by the Louvre through the Koechlin bequest, 1932.

BIBLIOGRAPHY: *Soliman le Magnifique*, exhibition catalogue, Paris, Grand Palais, 1990, no. 197; *Istanbul, Isfahan, Delhi, Three Capitals of Islamic Art*, exhibition catalogue, Sakib Sabanci Museum, Istanbul, 2008, no. 26; Nurhan Atasoy and Julian Raby, *Iznik*, London, 1989.

During the second half of the nineteenth century, European artists seeking new sources of inspiration, as well as lovers of exotic objects and art historians wishing to trace the evolution of non-European artistic traditions, rediscovered the productions of the Muslim Orient. Ceramics collectors began to show interest in a category of vessels and tiles now attributed to the town of Iznik, the main production center of the Ottoman Empire from the end of the fifteenth century to the seventeenth. At the beginning of the twentieth century and in the context of this craze for Islamic ceramics, the eminent collector and donor Raymond Koechlin, one of the founding members of the Society of Friends of the Louvre, came upon the peacock dish in the window of a Parisian art gallery located, strangely enough, in the Rue de Constantinople.

The dish has a foliated flange and is executed in a subtle and harmonious color scheme characteristic of the years 1540–1555, where two shades of blue (turquoise and ultramarine) are associated with pale mauve and sage green. A spray, consisting of a combination of different species of natural and imaginary flowers interspersed with elongated and serrated leaves, spreads out over the surface. We have here the elements of the two vegetal repertoires constituting the Ottoman classical style. On the one hand, the saz mode, distinguished by its use of a fantastic and invasive plant decoration, had been brought to the fore in the second decade of the sixteenth century by the designer and ornamentalist Shah Kulu. On the other, the employment of an assortment of garden flowers (violets, tulips, and carnations) became increasingly present in Ottoman art toward the middle of the century under the influence of the illuminator Kara Memi.

The vegetal bouquet theme was endlessly employed on Iznik dishes in an almost infinite variety of ways. The effects produced can be very diverse. On the two other dishes presented here, the spray of flowers is restricted to the cavetto, whereas on the peacock dish it is allowed to expand onto the flange, betraying no sense of rupture but, on the contrary, creating a visual unity between the curve of the well and the flat flange. Another outstanding feature of the peacock dish is the extreme clarity of the composition and the balance between the different masses, an equilibrium sustained by the tripartite and almost symmetrical arrangement of the stems. An artichoke flower or stylized tree stands out boldly in the middle of the dish and centers the composition. It is flanked by two diverging stems, each bearing flowers with two corollas. The left one, with a small carnation, branches out along the edge of the dish, then curves over and terminates in a long, serrated leaf. On the opposite side, what seems to be the extension of the stem rising up near the "flower-tree" pierces the latter and then follows a course symmetrical to the one followed by the left stem.

On the two other dishes presented here, the stems unfurl more diffusely, producing a less contrasted and accentuated effect. On the first (plate 38), this impression of relative uniformity is emphasized by the regular arrangement of simple, rather stiffly drawn flowers dotted over the surface. On the second piece (plate 39), the stems diverge and disperse without coming together around a strong axis, and the different flowers (rose, tulip, crocus, or Manisa tulip) do not communicate the same impression of opulence and variety conveyed by the peacock dish. On the latter, the robust quality of the flower-tree contrasts with the fragility of the delicate violets, and the surface is enlivened by corresponding forms, such as the curve created by the body and train of the bird, which perfectly counterbalances the movement of the two flanking leaves. Finally, the unusual presence of the peacock, a symbol of beauty and royalty, gives the measure of this disproportionate and luxuriant vegetal world.

CHARLOTTE MAURY

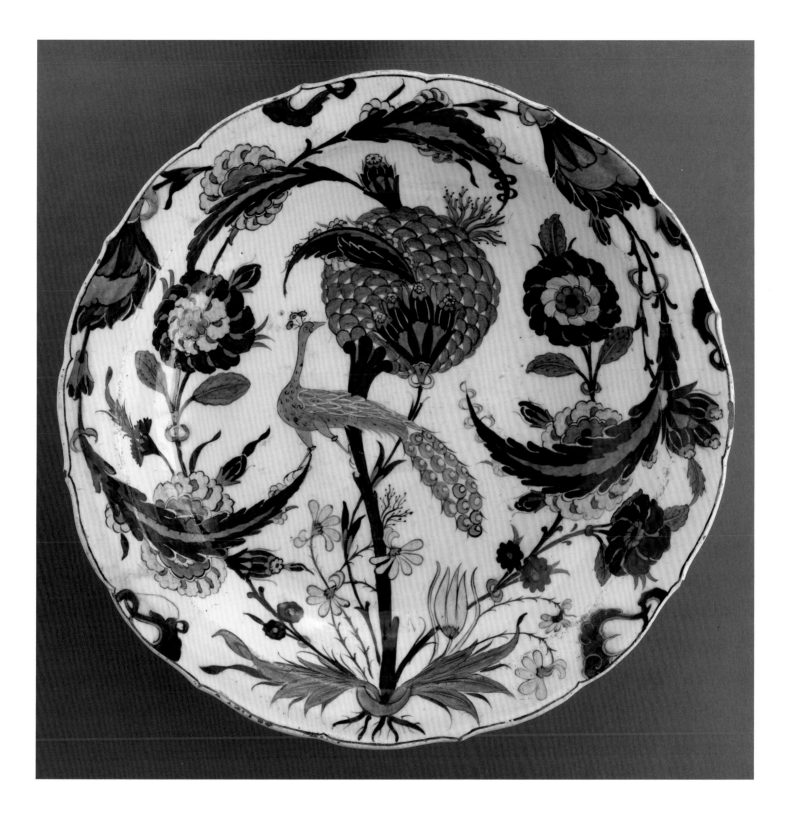

38
Dish with floral spray

Iznik, Turkey, ca. 1550–1560
Stonepaste with underglaze painting over a slip coating
3⅛ × 14¾ inches (8 × 37.5 cm)
Department of Islamic Arts, on deposit from the Musée des Arts
Décoratifs, Madame T. B. Whitney bequest, 1931, INV 27701

39
Dish with floral spray

Iznik, Turkey, late 16th–early 17th century
Stonepaste with underglaze painting over a slip coating; traces of gilding
2³⁄₁₆ × 11³⁄₈ inches (5.5 × 29 cm)
Department of Islamic Arts, on deposit from the Musée des Arts
Décoratifs, gift of Tournière-Jouassain, 1902, INV 10148

40

Leonardo da Vinci
Italian, 1452–1519

Drapery study

Tempera on linen
12⅗₆ × 8⅗₆ inches (31.9 × 21.8 cm)
Department of Graphic Arts, RF 41905
Minneapolis only

BIBLIOGRAPHY: Françoise Viatte, in *Léonard de Vinci, dessins et manuscrits,* exhibition catalogue, Paris, 2003, cat. 7.

Executed by Leonardo when he was in his late teens, this sheet is part of a group of six drapery studies in the Louvre. Scholars believe that they were produced during the artist's apprenticeship in Verrocchio's workshop in Florence, not preparatory for any specific work but rather as an obligatory exercise for a young aspiring painter to train his hand and eye. Sixteenth-century sources describe how a fine cloth dipped in wet clay and draped over a mannequin to dry was then depicted using only black and white tempera applied with a brush. In fact, the sheet could be said to be a painting because of the technique of brushing tempera onto linen.

A Leonardo drapery study is an icon in Western art. The monochrome tempera produces an image of pure abstraction, at the same time suggesting a seated figure underneath. We are faced with the ambiguity of perception. Is it a "portrait" of folds or the image of an inhabited drapery? The whites are applied with an extremely fine brush on the ridge of the folds, to obtain a sequence of cascading folds with the precision of a calligrapher. The study of light as it glides over the inner and outer parts of the fabric is masterly, and the beauty of the composition goes beyond virtuosity of execution.

VARENA FORCIONE

41

Michelangelo Buonarroti
Italian, 1475–1564

"Ideal Head" of a woman, early 1520s

Red chalk
12⅜ × 9½ inches (31.5 × 24.1 cm)
Department of Graphic Arts, INV 12299
Atlanta only

BIBLIOGRAPHY: Paul Joannides, *Musée du Louvre, Musée d'Orsay, Département des Arts Graphiques. Inventaire Général des Dessins Italiens. VI. Michel-Ange, élèves et copistes*, Paris, 2003, no. 28.

Michelangelo drew the red chalk *Head of a woman* (plate 41) in the early 1520s. It is an early example of his so-called "Ideal Heads," drawings of female and (occasionally) male heads, which seem to have no other purpose than to give shape to the artist's notions of ideal beauty and to demonstrate his mastery as a draftsman. He clearly took great pleasure in endowing the Ideal Heads with complex hairdos, including long plaits and fantastic headdresses. In this case, the presentation is still relatively natural and straightforward, but in later versions, including the *Cleopatra* copied by Giulio Clovio (plate 43), the coiffures take ever more bizarre forms.

Even in Michelangelo's lifetime, these Ideal Heads were recognized as consummate masterpieces. He seems to have given such drawings to a few favored friends as a mark of his esteem; thus, he presented the original of the *Cleopatra* to Tommaso de' Cavalieri in the early 1530s. The drawing later entered the collection of Duke Cosimo de' Medici and is now in the Casa Buonarroti in Florence. Several copies of *Cleopatra* are known, attesting to its celebrity. The one attributed to the celebrated illuminator and miniature painter Giulio Clovio (1498–1578) is a very faithful copy, including even the occasional hesitations and changes of mind that can be seen in the original.

Another Ideal Head is, quite literally, at the basis of the splendid *Head of a satyr in profile* (plate 42). An anonymous draftsman, possibly one of Michelangelo's pupils, painstakingly copied in red chalk a drawing by the master of a female head that is known through one other version. Michelangelo intervened and, taking over the sheet, drew over the copy the grotesquely ugly, goitered satyr's head in pen and ink; the tresses and braids are all that remain visible of the woman's profile. The artist may have felt that, since the inept copy failed to do justice to the ideal beauty of his original invention, he would demonstrate his mastery by creating an "ideal" of ugliness in a virtuoso display of penmanship.

CAREL VAN TUYLL VAN SEROOSKERKEN

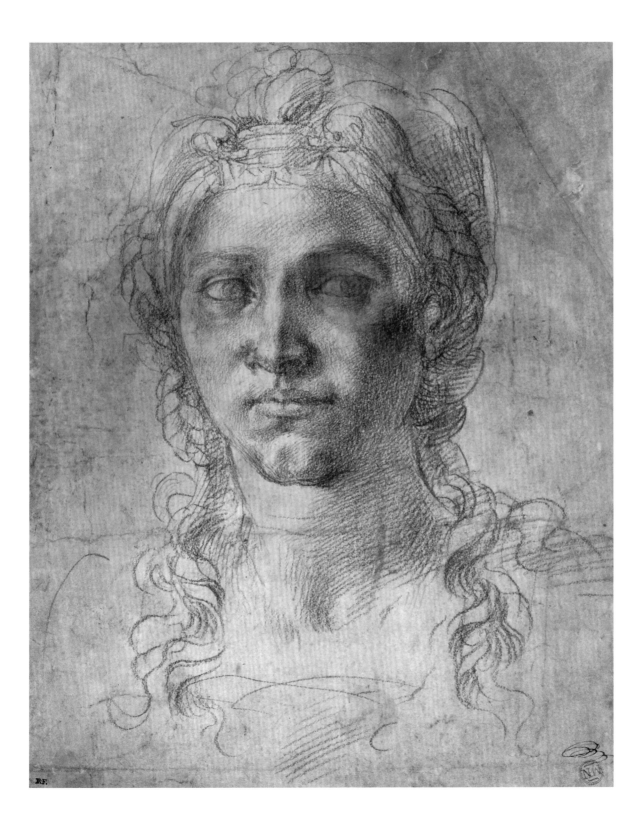

42
Michelangelo Buonarroti
Italian, 1475–1564

Head of a satyr in profile,
1520–1525

Pen and ink for the satyr's head; red chalk
for the female head underneath
10⅞ × 8⅜ inches (27.7 × 21.3 cm)
Department of Graphic Arts, INV 684
Atlanta only

BIBLIOGRAPHY: Paul Joannides, *Musée du
Louvre, Musée d'Orsay, Département des Arts
Graphiques. Inventaire Général des Dessins
Italiens. VI. Michel-Ange, élèves et copistes*, Paris,
2003, no. 29.

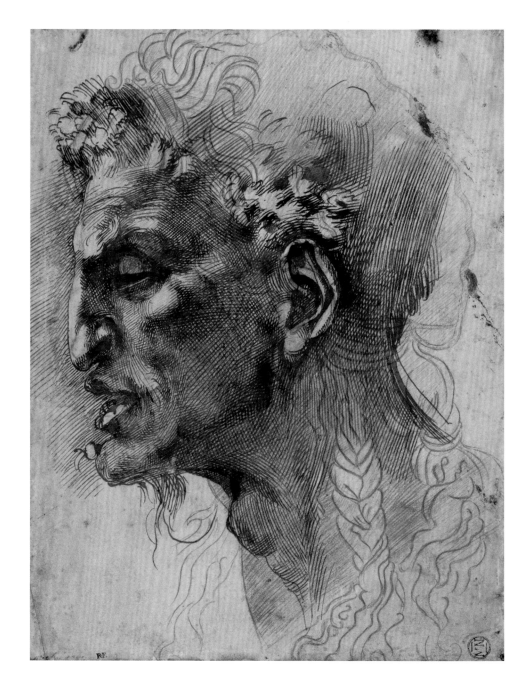

43
Giulio Clovio
Italian, 1498–1578

Bust of Cleopatra, copy after
Michelangelo

Black chalk and stumping
9¹³⁄₁₆ × 7¾ inches (25 × 19.7 cm)
Department of Graphic Arts, INV 733
Atlanta only

BIBLIOGRAPHY: Paul Joannides, *Musée du
Louvre, Musée d'Orsay, Département des Arts
Graphiques. Inventaire Général des Dessins
Italiens. VI. Michel-Ange, élèves et copistes,*
Paris, 2003, no. 115.

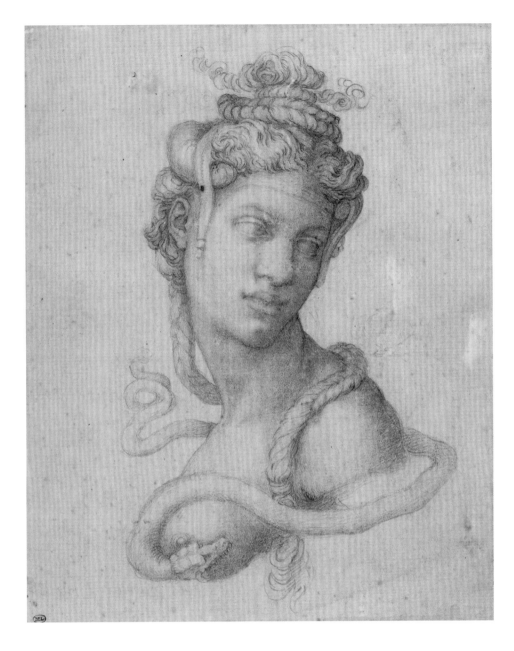

44

Michelangelo Buonarroti
Italian, 1475–1564

*Virgin and Child with Saint Anne, study of a male nude,
head in profile*

Pen and ink, brown wash, and black chalk
12¾ × 10¼ inches (32.4 × 26 cm)
Department of Graphic Arts, INV 685
Minneapolis only

BIBLIOGRAPHY: Paul Joannides, *Musée du Louvre, Musée d'Orsay,
Département des Arts Graphiques. Inventaire Général des Dessins Italiens. VI.
Michel-Ange, élèves et copistes*, Paris, 2003, no. 16.

In the main study on this early sheet, a *Virgin and Child with
Saint Anne*, Michelangelo was obviously thinking of a famous
composition by Leonardo da Vinci (1452–1519) which included
the same three figures. The young artist was trying to emulate
the older master and perhaps even surpass him; the annotation
to the right of the group—which translates as "Who would ever
have said that I made this with my hands"—is indicative of his
youthful ambition. The standing male figure and the profile head
were probably added later.

The skillful pen-and-ink technique used in this sheet is typi-
cally Florentine and reflects Michelangelo's apprenticeship with
the painter Domenico Ghirlandaio (1449–1494). However, in his
masterful treatment of infinitely varied hatching to evoke light,
shade, and form, he brought it to a level of sophistication and
subtlety that became a standard for future generations.

CAREL VAN TUYLL VAN SEROOSKERKEN

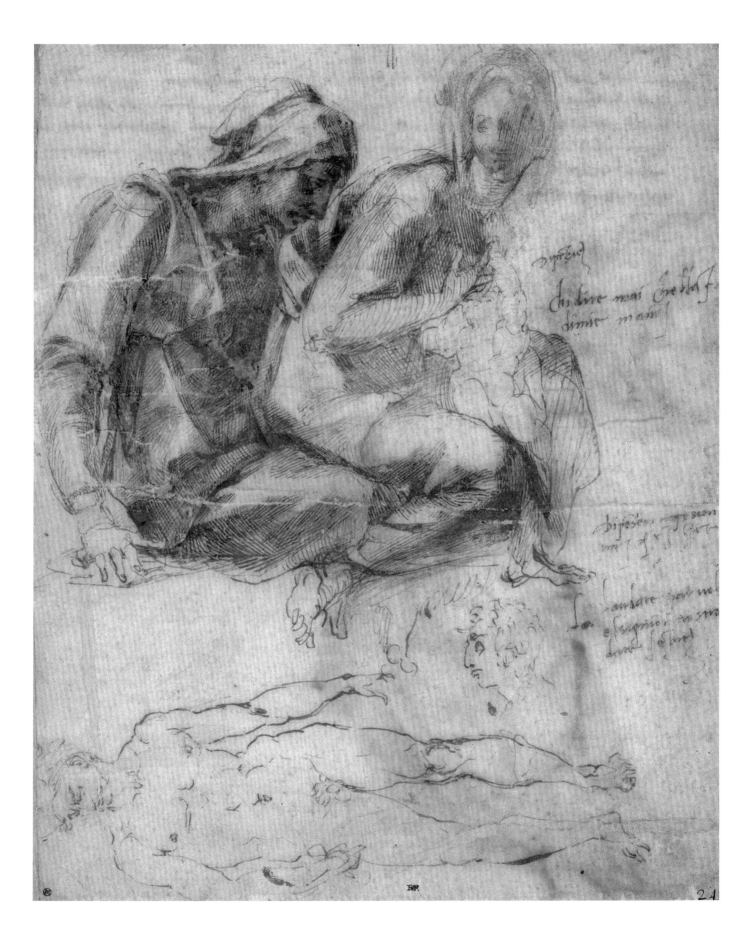

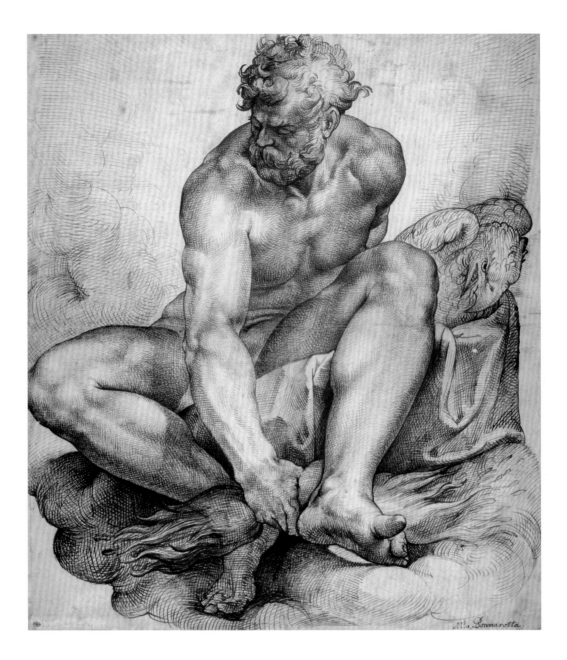

45

Bartolomeo Passarotti
Italian, 1529–1592

Jupiter seated on clouds

Pen and ink over a black chalk preparatory drawing
17⅜ × 15 inches (44.1 × 38.1 cm)
Department of Graphic Arts, INV 8463
Minneapolis only

BIBLIOGRAPHY: Dominique Cordellier in *Il Cinquecento a Bologna. Disegni dal Louvre e dipinti a confronto*, Bologna, 2002, cat. 100.

One artist who was particularly influenced by the pen style perfected by Michelangelo was the Bolognese painter Bartolomeo Passarotti, who imitated Michelangelo's manner to the point that later connoisseurs often mistook Passarotti's drawings for those by the Florentine master. For example, the *Jupiter seated on clouds* was annotated in the eighteenth century with Michelangelo's name. It is, however, a typical drawing by Passarotti, who reused the figure in his large pen drawing (plate 46) showing an episode from the life of the Greek poet Homer.

CAREL VAN TUYLL VAN SEROOSKERKEN

46
Bartolomeo Passarotti
Italian, 1529–1592

Homer and the sailors

Pen and ink over a black chalk preparatory
drawing
20�5/16 × 14¹⁵/16 inches (51.6 × 37.9 cm)
Department of Graphic Arts, INV 8469
Minneapolis only

BIBLIOGRAPHY: Catherine Loisel in *Disegni di
una grande collezione: antiche raccolte estensi dal
Louvre e dalla Galleria di Modena*, Sassuolo,
1998, cat. 45.

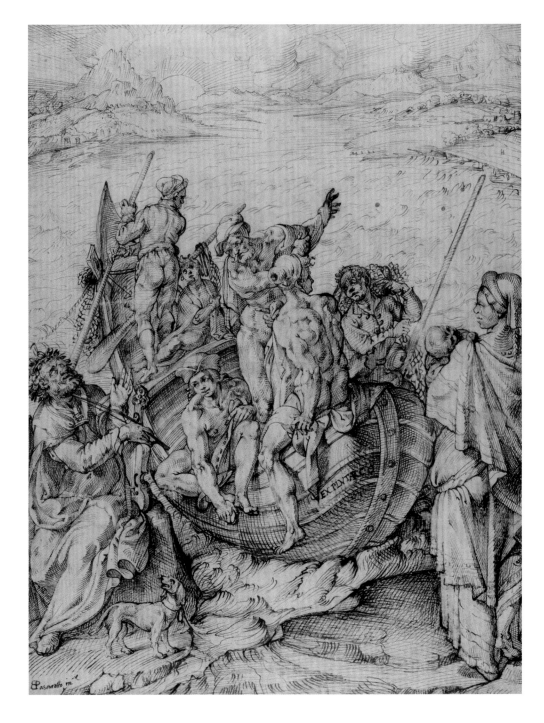

47

Jacopo Ligozzi
Italian, 1547–1627

Allegory of Sloth, ca. 1590

Pen and brown ink, brown wash, gold
highlights on paper covered with beige wash
11¹⁵⁄₁₆ × 7¹³⁄₁₆ inches (30.3 × 19.8 cm)
Department of Graphic Arts, INV 5037
Atlanta only

BIBLIOGRAPHY: Lucilla Conigliello, *Ligozzi*,
Paris, 2005, no. 8.

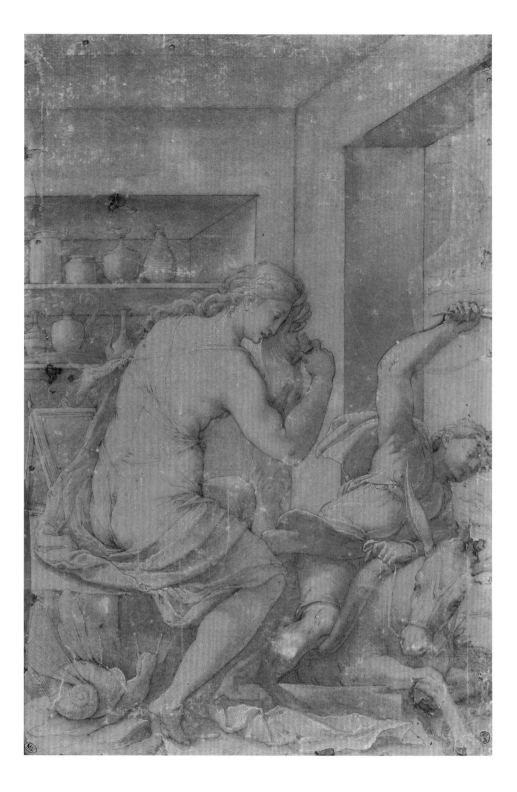

A native of Verona, Jacopo Ligozzi was a foreigner in Florence when he arrived in 1577 to be at the service of the Grand Duke Francesco I de' Medici. He had worked for the Hapsburg court, thus bringing with him a Northern taste for naturalism, attention to detail, and an extreme refinement of execution combined with strange set-ups, full of hermetic meaning reserved for a narrow circle of amateurs.

The two sheets chosen for the exhibition belong to a 1590s series dedicated to the seven deadly sins, which are (according to Catholic belief) envy, greed, gluttony, sloth, wrath, lust, and pride.

48

Jacopo Ligozzi
Italian, 1547–1627

Allegory of Lust, ca. 1590

Pen and ink, brown wash, gold highlights
on paper covered with brown wash
11⅞ × 7¹³⁄₁₆ inches (30.1 × 19.8 cm)
Department of Graphic Arts, INV 5032
Minneapolis only

BIBLIOGRAPHY: Lucilla Conigliello, *Ligozzi*,
Paris, 2005, no. 6.

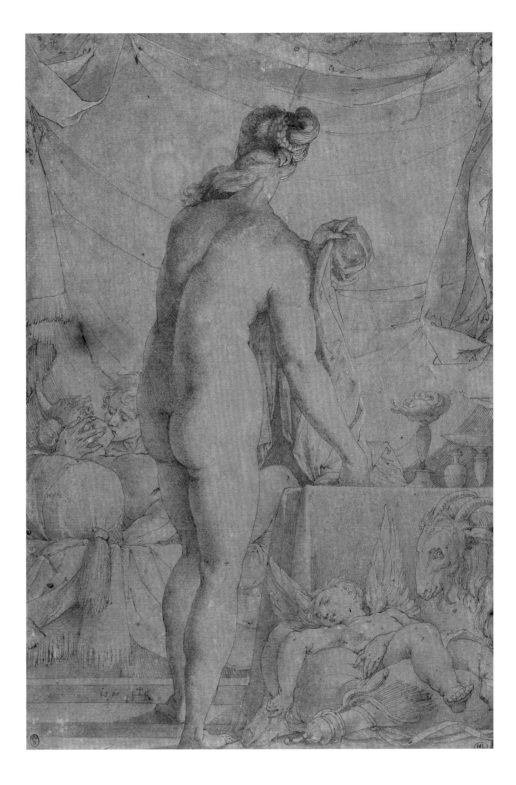

Both drawings are highly representative of the artist's superb
capacity to exploit his chosen technique, that of pen, ink, and
brown wash, with spectacular golden highlights. The personifica-
tions of the sins are accompanied by their emblematic animals
and other attributes, in interior environments stacked with
objects. The donkey being whipped and the winged snail allude
to Sloth, the goat and the slouched figure of Eros to Lust. The
atmosphere is at the same time erotic and mysterious, well in
tune with the taste of the Court that employed the artist.

VARENA FORCIONE

49

Alexandre-Isidore Leroy de Barde
French, 1777–1828

Exotic shells, 1804

Watercolor and gouache on paper glued onto canvas
49 × 31¹¹⁄₁₆ inches (124.5 × 80.5 cm)
Department of Graphic Arts, INV 23689
Atlanta only

BIBLIOGRAPHY: Yves Le Fur, *D'un regard l'autre. Histoire des regards européens sur l'Afrique, l'Amérique et l'Océanie*, exhibition catalogue, Paris, cat. 164.

Alexandre-Isidore Leroy de Barde came from a family of royalists who left France for England during the French Revolution. He settled in London and at the age of twenty-two started showing his watercolors at the Royal Academy as an amateur. He was possibly self-taught. He returned to France only when the monarchy was reinstated after the defeat of Napoleon.

The two trompe-l'oeil works exhibited here (see plate 50) are part of a series of six acquired for the Louvre by King Louis XVIII. The other works—*Exotic birds, Foreign birds, Royal tiger being strangled by a boa constrictor*, and *Greek vases*—reproduce the curiosities exhibited in cases in William Bullock's London Museum on Piccadilly, engraved by Thomas Bewick and published in the 1814 museum catalogue. Bullock was a member of the Linnean Society, a group devoted to the study of natural history, and was one of the most important collectors in early nineteenth-century England. The large-scale reproductions by Leroy de Barde are in the spirit of the Age of Enlightenment. The remarkable technique of watercolor and gouache on paper glued onto canvas follows the purest eighteenth-century tradition of French artists employing gouache, such as Nicolas Pérignon, Jean-Pierre Houël, and Jean Pillement.

The astonishing precision of representation, almost to a photographic degree, combines a scientific interest with an artistic one, creating a poetic image where forms, colors, and shapes are particularly harmonious.

VARENA FORCIONE

50
Alexandre-Isidore Leroy de Barde
French, 1777–1828

Crystalized minerals, 1814

Watercolor and gouache on paper glued onto canvas
49⅝ × 31½ inches (126 × 80 cm)
Department of Graphic Arts, INV 23690
Atlanta only

BIBLIOGRAPHY: Bert C. Sliggers and M. H. Besselink, eds., *Het verdwenen museum. Natuurhistorische verzamelingen, 1750–1850*, Blaricum, 2002, p. 12.

The Rothschild Collection

When the heirs of Baron and Baroness Edmond de Rothschild donated the famous Edmond de Rothschild Collection to the Louvre in 1935, the Museum acquired at one stroke a group of masterpieces that were both unique and remarkably preserved. The gift demonstrated once more the generosity of the Rothschild family toward the Louvre and was also proof of the Baron's aesthetic and historical discernment, exercised over the course of an entire lifetime devoted to the quest for beauty. As the media of the day pointed out, the Louvre was the beneficiary of nothing less than a totally new "Museum of the Print." More than 40,000 prints, covering the entire history of this artform from its origins to the first years of the Empire, and more than 3,000 drawings, selected for their historical and artistic merit, were added to the Louvre's graphic arts collections. The works exhibited in Atlanta have been selected to show masterpieces created by anonymous artists from the beginning of printmaking as well as by famous artists in later times, all the way to the eighteenth-century artists who invented the practice of color printing.

5 I

Anonymous Artist
French, end of 14th century

The Bearing of the Cross

Block-book incunabula, woodcut
10½ × 15⅜ inches (26.7 × 39 cm)
Department of Graphic Arts, Collection Edmond de Rothschild, I LR
Atlanta only

BIBLIOGRAPHY: Jean Mistler, *Epinal et l'imagerie populaire*, Paris, 1961, repr. p. 13.

The Bearing of the Cross from the Rothschild collection is one of only two prints of this image without color known in the world—the other being in the Registry of the Chancellery of Emperor Sigismund (1368–1437), in the Albertina in Vienna. The image shows Simon of Cyrene helping Christ carry the cross to the top of Golgotha. The women of Jerusalem lament and follow them, along with the Roman soldiers who are leading the two thiefs crucified with Christ.

The important similarity with a work called the *Bois Protat* in the Bibliothèque Nationale de France that dates to the end of the fourteenth century suggests the origins of the present woodcut in Burgundy rather than southern Germany. The sheet is the oldest in the Rothschild Collection and is one of the oldest known woodcut prints. The acquisition of such an exceptional work by Edmond de Rothschild is a result of the collector's belief that the origins of printing should be placed in France.

CHRISTEL WINLING

52

Anonymous Artist

German, 15th century

The Death of the Virgin, ca. 1460

Woodcut print with hand coloring
7⅞ × 10¹³⁄₁₆ inches (20.2 × 27.4 cm)
Department of Graphic Arts, Collection Edmond de Rothschild, 4 LR
Atlanta only

BIBLIOGRAPHY: Pascal Torres Guardiola, *Masters of Invention: The Edmond de Rothschild Collection*, exhibition catalogue, Madrid, 2004, cat. 2.

This woodcut represents the Twelve Apostles gathered around the bed of the dying Virgin. Christ receives her soul, depicted as a female figure, in his arms. Saint Peter holds a book of prayers of absolution and a holy water sprinkler while behind him Saint Andrew holds the censer. In the foreground, between the two seated Apostles, two angels hold up long candles. The twelve Apostles are marked by haloes, with Judas represented only by the top of a halo in the upper left corner.

The present print, heightened with brown, yellow ochre, green, pink, and red varnish, is a unique impression, though it can be related to other prints, such as the famous *Last Judgment*.

A print now in Munich of *The Death of Mary* depicts the same subject treated very differently. The expressions of the Apostles, the extreme rigidity of their gestures, as well as the way the figures occupy the space, make the Rothschild print a more sophisticated composition than the Munich one, which predates it by some decades. The green bedcover is halfway between the tradition of ornament and the type of motif printed in woodblock on textiles. It occupies the center of this composition and is a key element in dating the print, which cannot be much later than the first half of the fifteenth century.

PASCAL TORRES GUARDIOLA

53

Tommaso d'Antonio, called Maso Finiguerra
Italian, 1426–1464

The Baptism of Christ, ca. 1460

Niello print, unique impression
3½ × 2¹³⁄₁₆ inches (8.9 × 7.1 cm)
Department of Graphic Arts, Collection Edmond de Rothschild, 137 Ni
Atlanta only

BIBLIOGRAPHY: Pascal Torres Guardiola, *Masters of Invention: The Edmond de Rothschild Collection*, exhibition catalogue, Madrid, 2004, cat. 7.

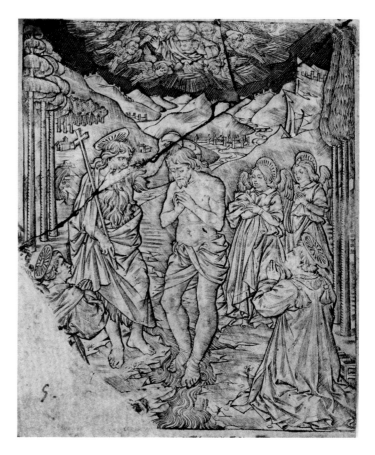

Christ stands in the center of the composition, his hands together and his feet covered by the graceful arabesque of the River Jordan. He receives baptism from Saint John's left hand—proof that this paper is the counter-impression taken from a nielloed plaque. The Baptist is also standing on the bank of the river. Kneeling in the foreground are Saint Stephen, the first martyr, dressed as a deacon, and on the left is Saint Francis in his habit. Behind Stephen, two angels hold Christ's clothes. In the sky in the center of the composition we see God the Father and the dove of the Holy Spirit within a glory of angels. The landscape framed by yew and pine trees includes a mountain range through which the Jordan peacefully flows, while the hills are dotted with castles and the lower ground features several churches.

Maso made a clay mold of the metal plate and used it to make a sulfur print. From this sulfur print he printed the impression on paper, resulting in a reversed image of the original. This impression on paper may well have been used by the artist as an intermediary proof to check his work as he proceeded. The defects in the impression—the diagonal line, the blank area in the lower corner, restitution from an ancient restoration—are the direct results of having been printed from a sulfur base: the sulfur breaks due to the pressure of the printing, and the impression suffers as a consequence.

It is surprising that this niello print has been little mentioned until now, but it is hoped that the Atlanta exhibition will highlight its importance and exceptional quality.

PASCAL TORRES GUARDIOLA

54

Martin Schongauer

German, ca. 1450–1491

Christ carrying the Cross, ca. 1475–1480

Engraving with burin
11³⁄₁₆ × 16¹³⁄₁₆ inches (28.5 × 42.7 cm)
Department of Graphic Arts, Collection Edmond de Rothschild,
204 LR
Atlanta only

BIBLIOGRAPHY: Pascal Torres Guardiola, *Masters of Invention: The Edmond de Rothschild Collection*, exhibition catalogue, Madrid, 2004, cat. 18.

The dramatic expressiveness of this *Christ Carrying the Cross*, Schongauer's most famous print—along with his *Saint Anthony*—may derive from a now lost painting by Jan van Eyck. Between 1466 and 1469, Schongauer studied with Caspar Isenmann, from whom he acquired his interest in Flemish art, while from 1469 to 1470 he traveled to Burgundy and the Low Countries. He was particularly influenced by the paintings of Rogier van der Weyden, clearly echoed in his early prints.

The way in which the artist conveys the effect of a large crowd, brilliantly organized within the picture space (with five horses around the figure of Christ); the landscape with Jerusalem on the right and Golgotha in the distance on the left; and the pathetic figure of Christ looking directly at the viewer, are all brilliant iconographic elements that make this print one of the most admired within his graphic oeuvre.

Schongauer's fame was surpassed only by Dürer's, while the elegance of his art earned him the nickname of "Beau Martin." The first of the great masters of engraving, he took the medium to a new level of artistic expression. He was the son of Caspar Schongauer, a goldsmith who settled in Colmar in 1440. Martin's remarkable skill and precision with the engraving tool was undoubtedly derived from his father's craft tradition, in a way comparable to that of the earliest fifteenth-century Florentine engravers.

PASCAL TORRES GUARDIOLA

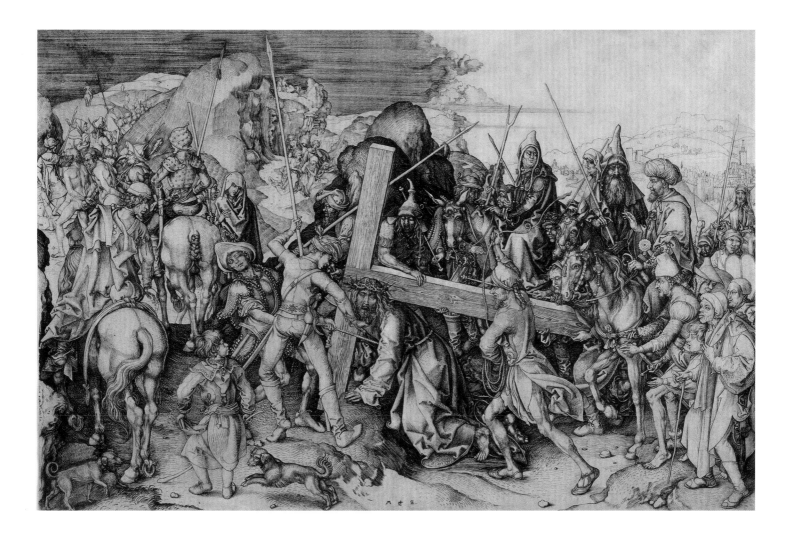

55

Antonio Pollaiuolo

Italian, ca. 1432–1498

The Combat of the nude men, ca. 1470–1480?

Engraving with burin in the broad manner
15¹³⁄₁₆ × 23⅝ inches (40.2 × 60 cm)
Department of Graphic Arts, Collection Edmond de Rothschild,
6813 LR
Atlanta only

BIBLIOGRAPHY: Pascal Torres Guardiola, *Masters of Invention: The Edmond de Rothschild Collection*, exhibition catalogue, Madrid, 2004, cat. 14.

There is a wealth of literature on this first masterpiece of engraving. It is undoubtedly the most famous and celebrated image of any Italian print. A unique work engraved by Pollaiuolo, it is considered exceptional, and this splendid example of intaglio printmaking heralds the future development of the art of the print. *The Combat of the nude men* is the first great image to have emerged from the workshop of a printmaker. For both the format and the monumental nature of the figures, Pollaiuolo elevates the art of the burin to a major artform.

The distribution of Renaissance models was of key importance to the greatest artists of the day for two reasons: on the one hand, the circulation of models allowed for an illustration of the new theoretical concepts; on the other, the dissemination of a particular master's style could reach potential patrons far removed from Florence (hence the presence of the artist's signature on this work). *The Combat of the nude men*, a key work in the history of printmaking, gives unique witness to Pollaiuolo's contribution to the history of the medium.

PASCAL TORRES GUARDIOLA

56
Workshop of the Master of the Arms of Cologne

Pietà, ca. 1480

Stipple engraving, burin and punches, very lightly colored, unique
impression
10 × 7⁵⁄₁₆ inches (25.3 × 18.5 cm)
Department of Graphic Arts, Collection Edmond de Rothschild, 45 LR
Atlanta only

BIBLIOGRAPHY: Pascal Torres Guardiola, *Masters of Invention: The Edmond
de Rothschild Collection*, exhibition catalogue, Madrid, 2004, cat. 4.

The Virgin supports Christ on her knees, tenderly caressing
his beard, while her eyes express sorrow. The corpse-like,
rigid pose of Christ's body forms an exact diagonal across the
composition and can be compared to the work of Rogier van
der Weyden and Dieric Bouts, both of whom were very influen-
tial in workshops in the Rhine area, where this sheet undoubt-
edly originated. The background combines floral motifs set into
rosettes with the instruments of the Passion. The cross—above
which nails hold up the instruments of the Flagellation—closes
the upper space of the composition. The wide border is followed
by a white band and a second frame decorated with a garland of
roses, a symbol of the Virgin. Each corner has Christ's monogram.

This devotional image, imbued with the emotional expres-
siveness typical of artists of this region, is a key reference point
in the development of printmaking. The stippling technique is
here used with notable rigor and elegance. The regular punching
follows the diverging and interconnecting curves and gives the
Virgin's robe the modeling of a painted composition with chiaro-
scuro. The regular stars that border her cloak, produced by the
same punch, are flatter. This short-lived technique, which would
soon be replaced by intaglio, reached a high degree of perfection
in a short period, producing an austere beauty that attains a clas-
sical equilibrium.

PASCAL TORRES GUARDIOLA

119

57

Cristofano di Michele Martini,
called Cristofano Robetta

Italian, 1462–reported active to 1535

Allegory of the power of Love, ca. 1510

Engraving with burin
12⅛ × 11⅜ inches (30.9 × 28.9 cm)
Department of Graphic Arts, Collection Edmond de Rothschild,
3834 LR
Atlanta only

BIBLIOGRAPHY: Pascal Torres Guardiola, *Masters of Invention: The Edmond
de Rothschild Collection*, exhibition catalogue, Madrid, 2004, cat. 16.

In this sensual print Robetta explores the complexity of a
Renaissance allegory. Each character has a specific meaning,
and the composition as a whole reads as an interpretation of
love. The three putti are clearly identifiable: Cupid is tying a
young man to a tree, symbolizing the attachment to physical
love. The two other putti could be Hypnos, son of Night (on
the left, holding two flowers on his brow), and his twin brother
Thanatos, stepping on a skull. The embracing couples are linked
to an androgynous figure on the left, the only unaccompanied
figure, who holds a piece of drapery weaving through the whole
group and tying them together. The drapery flows at the level
of the sexual parts of the characters, which explains the second
title given sometimes to this engraving: *Allegory of Physical Love*.

Robetta seems to be responding to the famous Dürer
print of *Adam and Eve*, as both prints have common elements.
The exceptional model followed by the master in this print is
Pollaiuolo's *The Combat of nude men* (plate 55), here focusing on
physical love rather than the conflict of brutal masculine forces.
For engravers, Pollaiuolo's print remains the major reference.
This learned dialogue between Quattrocento and Cinquecento
engravers underlines the erudite nature of the print and its
role as a graphic interpreter of art theory.

PASCAL TORRES GUARDIOLA

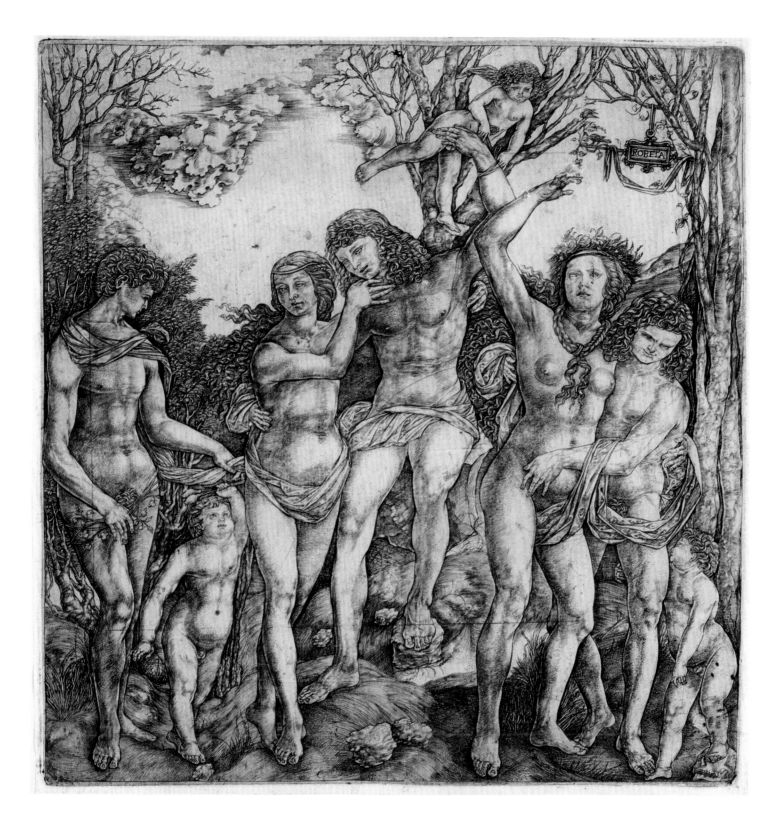

58

Albrecht Dürer

German, 1471–1528

Knight, Death, and the Devil, 1513

Engraving with burin
9⅝ × 7⅜ inches (24.4 × 18.9 cm)
Department of Graphic Arts, Collection Edmond de Rothschild,
594 LR
Atlanta only

BIBLIOGRAPHY: Erwin Panofsky, *La Vie et l'Art d'Albrecht Dürer*,
Paris, 1987.

In 1513–1514 Dürer worked exclusively on engraving with the burin, leaving aside painting and woodcut printing. Three burin engravings out of the thirteen executed during these two years are considered *Meisterstiche*, his masterpieces: *Knight, Death, and the Devil, Melencolia I,* and *Saint Jerome in his cell.* It is not a trilogy, but rather a formal and spiritual ensemble. According to the early art historians Wöllflin and Panofsky, the knight shown by Dürer is the victor over his traditional enemies of Death and the Devil.

Melencolia I is certainly the most personal and enigmatic image the artist created. Contrasting meanings and images are spread throughout the composition: the figure is winged, yet seated; the crown cannot hold the figure's thick hair; and the clothing is sumptuous but worn in a slovenly manner. Even the expression shows both fatigue and tension. It is possibly the personification of one of the four humors believed to compose human bodies (sanguine, choleric, phlegmatic, and melancholic) or Geometry, one of the Seven Liberal Arts of the Renaissance—hence the presence of a compass in the right hand. Renaissance artists, constantly trying to perfect their technique through the development of subjects of celestial inspiration and eternal ideas, found themselves facing their own human condition, unable to go beyond the limitations of the intellect. Panofsky even suggests that "*Melencolia I* is, in a certain sense, the spiritual self-portrait of Dürer."

CHRISTEL WINLING

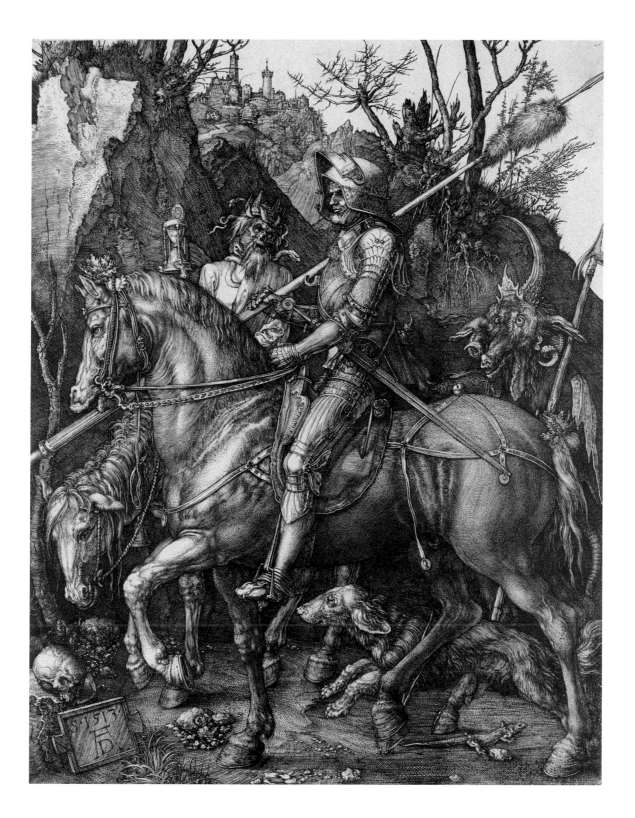

59

Albrecht Dürer

German, 1471–1528

Melencolia I, 1514

Engraving with burin
9⅜ × 7⁵⁄₁₆ inches (24 × 18.6 cm)
Department of Graphic Arts, Collection Edmond de Rothschild,
574 LR
Atlanta only

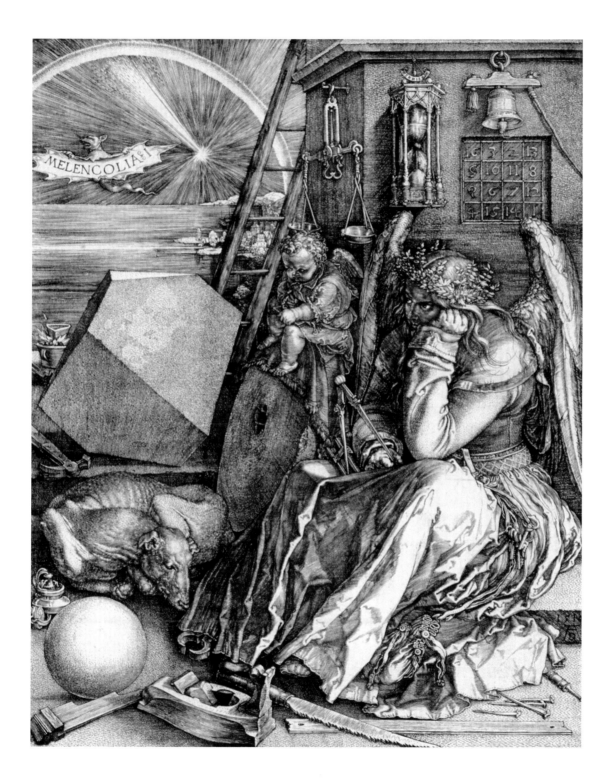

60

Rembrandt Harmensz. van Rijn
Dutch, 1606–1669

The Three Crosses, 1653

Etching with drypoint and burin, third state
15¼ × 17⅞ inches (38.8 × 45.6 cm)
Department of Graphic Arts, Collection Edmond de Rothschild,
2518 LR
Atlanta only

BIBLIOGRAPHY: Pascal Torres Guardiola, *Masters of Invention: The Edmond de Rothschild Collection*, exhibition catalogue, Madrid, 2004, cat. 63.

To achieve this dramatic composition, a masterpiece of his printed oeuvre, Rembrandt worked directly on the copper plate with drypoint, after having sketched only a few details on paper, without any other preparatory study.

The apocalypse between the sixth and the ninth hour and the darkness covering the world are rendered by Rembrandt by means of the violent contrast of blackness falling onto the side of the bad thief, on the living, like a veil of obscurity. In the fourth state of the print, the gloom of darkness is intensified and several characters are erased to heighten the intensity of drama: the world swallowed into nothingness. The only part of the composition which does not vary from one state to the other and which stands out from the first to the last state, is the cross. Vertical, in the center of the plate, it is also the pivoting point of light, obtained by the whiteness of the paper itself.

The Three Crosses emphasizes a particular fact that is unique to Rembrandt's concept of printing, in which the narration of a dramatic event is read through the various states. The evolution of the composition from the first to the last state (the moment when the artist puts the copper plate aside) shows the real meaning of the art of printmaking according to Rembrandt—it justifies his creative process. A concept must develop progressively, according to the rules of the theatre, by successive acts, to deliver its essence. The final state of the plate was hinted at—already present in the first impression of 1653—in the space left untouched in the copper, as if it were a transcendental concept.

PASCAL TORRES GUARDIOLA

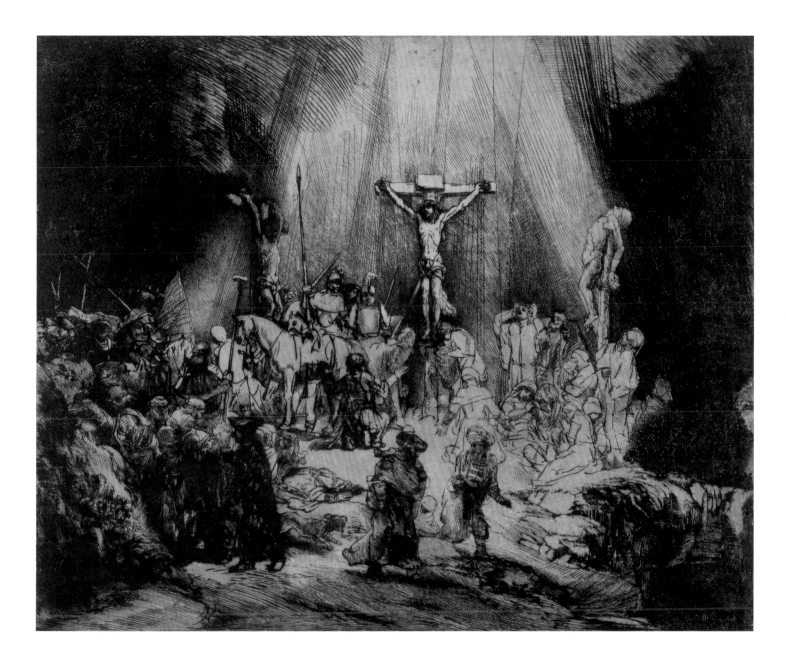

61

Jean-François Janinet
French, 1752–1814

After François Boucher
French, 1703–1770

The Toilet of Venus, 1783

Engraving with aquatint and mixed technique, printed in colors
from several plates
19⁵⁄₁₆ × 15⅛ inches (49.1 × 38.5 cm)
Department of Graphic Arts, Collection Edmond de Rothschild,
6431 LR
Atlanta only

BIBLIOGRAPHY: Pascal Torres Guardiola, *Masters of Invention: The Edmond de Rothschild Collection*, exhibition catalogue, Madrid, 2004, cat. 77.

François Boucher painted *The Toilet of Venus* in 1751. The painting, now in the Metropolitan Museum of Art, was probably commissioned by Madame de Pompadour and hung in the Château de Belleville, where she lived from 1751 to 1764. Tradition states that *The Toilet of Venus*, as well as its pair, *Venus consoling Love*, were intended for her bathroom in the château.

The impression exhibited here, which is particularly fresh and strong, was acquired by Edmond de Rothschild in April 1876. A manuscript annotation in the sale catalogue states that the Baron decided on a price of 300 francs and that Lacroix was able to secure it on his behalf for 200. Edmond de Rothschild's taste for eighteenth-century colored prints long preceded the revival of interest in this genre heralded by the Goncourt brothers.

The Baron acquired the second state of the four known states—the first state was printed without letters, and the second with the signatures. The third has the coat of arms and the fourth shows the image with the cupid (since erased) arranging Venus's hair. A masterpiece of color printing, this work by Janinet was one of his most famous creations and one of his greatest successes, along with his engravings after Nicolas Lavreince and Pierre-Antoine Baudouin.

PASCAL TORRES GUARDIOLA

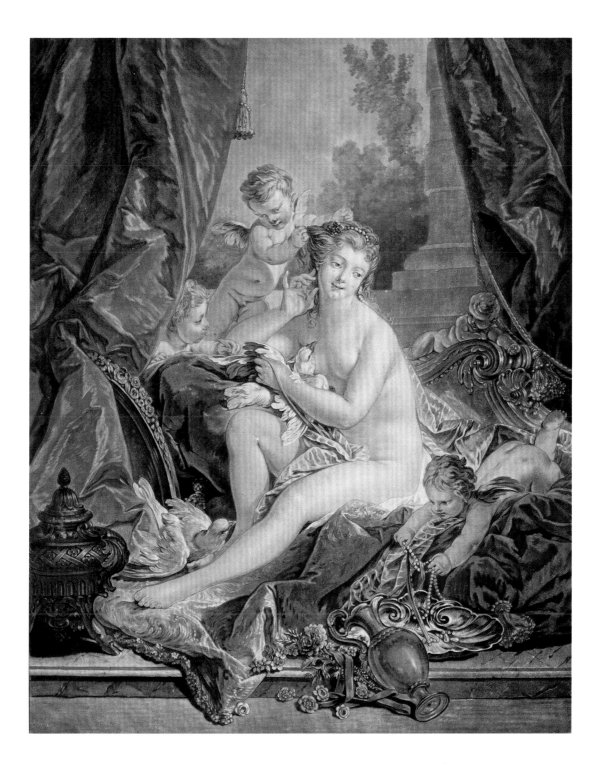

62

Philibert Louis Debucourt
French, 1755–1832

The Wedding in the Château, 1789

Etching and aquatint, impression printed in black, hand-colored
with watercolors
14⅛ × 10¼ inches (35.8 × 26.1 cm)
Department of Graphic Arts, Collection Edmond de Rothschild,
6144 LR
Atlanta only

BIBLIOGRAPHY: Pascal Torres Guardiola, *Masters of Invention: The Edmond
de Rothschild Collection*, exhibition catalogue, Madrid, 2004, cat. 79.

Debucourt should be compared in some ways with Hogarth
for their shared alertness to ironic details and their interest
in the rendition of characters that reveals particular sensibilities
and the mood of the times. This work is particularly telling in
that respect. A masterpiece of color printing, this was Debu-
court's fourth print using the technique promoted by Janinet.

The impression on display here is printed in black and hand-
colored by the artist in watercolor. The reverse of the sheet has
a typically vibrant black-crayon drawing reflecting Debucourt's
constant aim of conveying the movement of his figures. This
search for a sense of reality is in complete contrast to the formu-
laic type of landscape found in *Wedding in the Château*. Nonethe-
less, this landscape still serves to emphasize the realistic nature of
the figures and acts essentially as an artificial theatrical backdrop.
Debucourt conveyed with almost unparalleled brilliance the chil-
dren's games and the timid reaction of the young groom who is
invited to open the dance with the mistress of the château.

PASCAL TORRES GUARDIOLA

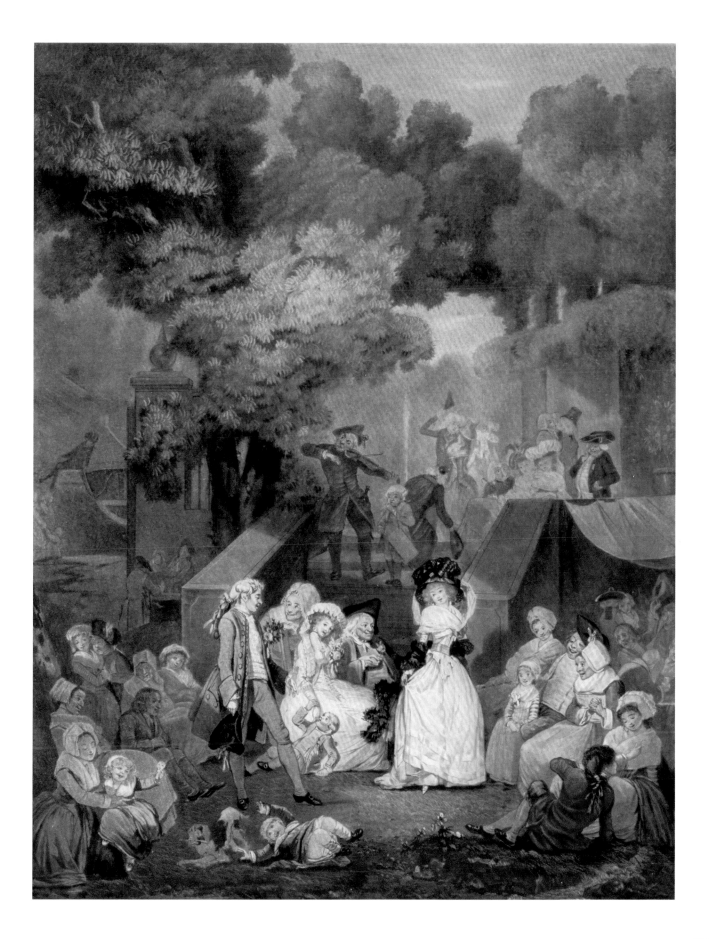

63

Reinhold Vasters

German, 1827–1909

Incense boat

Aachen, Germany, last quarter of the 19th century
Lapis, gold, silver gilt, gilt brass, enamel, emeralds, rubies, pearls
7⅛ × 8½ × 4⅜ inches (18 × 21.5 × 11.2 cm)
Department of Decorative Arts, OA 5556

HISTORY: Bequest of Baron Adolphe de Rothschild, 1901.

BIBLIOGRAPHY: Émile Molinier, *Donation de M le baron Adolphe de Rothschild*, exhibition catalogue, Paris, 1902, no. 6, pl. VII; R. Gallo, "Reliquie et Reliquiari Veneziani," in *Rivista mensile della citta di Venezia*, May 1934, pp. 201 and 205; Yvonne Hackenbroch, "Reinhold Vasters," in *Metropolitan Museum Journal* 19/20, The Metropolitan Museum of Art, New York, 1986; Norbert Jopek, "Notizen zu Vasters," in *Festschrifft für Peter Bloch zum 11. Juli 1990*, Mainz am Rhein, 1990, pp. 378–381, figs. 9–11; Miriam Krautwurst, *Reinhold Vasters—ein niederrheinischer Goldschmied des 19. Jahrhunderts in der Tradition alter Meister*, Trier, 2003, pp. 684–685.

64

Leather box

Italy (?), 15th century
Embossed leather
7⅜ × 9 × 5⁵⁄₁₆ inches (18.7 × 23 × 13.5 cm)
Department of Decorative Arts, OA 5557

HISTORY: Bequest of Baron Adolphe de Rothschild, 1901.

This spectacular vessel of hard stone richly ornamented with gold reliefs, enamels, and precious stones and fitted in a black embossed leather box was thought to be a rare Venetian object from the fifteenth century. It was considered one of the highlights of the collection of early silver and jewelry bequeathed to the Louvre by the famous connoisseur Baron Adolphe de Rothschild. Such early examples of hard stone vases or bowls embellished with valuable metal and jewels were indeed among the most precious objects kept in the grandest medieval treasuries, such as that of San Marco in Venice or the Basilique Saint-Denis in France.

However, a closer examination reveals disturbing aspects: the design and the craftsmanship of the elaborate gold mounts are totally unorthodox for the work of a fifteenth-century goldsmith, particularly the way multicolored enamels—white, translucent red, and green—are applied under the scrolls in low-relief, and dark blue enamel imitating lapis is used on the stem. Furthermore, lapis was not the kind of stone brought to Europe in medieval times.

It is now quite clear that this vessel is a rare achievement of one of the most skilled nineteenth-century forgers, the goldsmith Reinhold Vasters, who worked in Aachen. This piece is a brilliant fake made at a time when such rarities were in high demand. The corresponding preparatory drawing and watercolor that survive in the Vasters archives of London's Victoria and Albert Museum indicates only minor changes in the final work.

What makes this fake so interesting is that it is a complete reinterpretation suggested by the shape and size of the fine leather box—decorated with leaves, scrolls, fantastic animals, and the monogram YHS in a medallion on the cover—which is undoubtedly a genuine late fifteenth-century work. Italian incense boats of this type survive, usually in silver gilt or enameled copper, but only one other example is known, carved in a softer stone with a silver-gilt setting, in the treasury of San Marco. Vasters instead took his inspiration from objects kept in German treasuries—the delicate gothic arches on the stem, for instance, appear on the base of an early sixteenth-century silver reliquary of the Virgin and Child belonging to the Ratsilber in Lüneburg. The winged dragons at each end of the cover—which do not correspond exactly to Vasters's design and which display different shades of enamel—might be elements salvaged from an earlier piece.

MARC BASCOU

65

Israel Rouchomowsky
Russian, active late 19th century

Tiara of Saïtapharnèse

Gold
6⅞ × 7⅛ inches (17.5 × 18 cm); weight: 15.6 oz. (443 g)
Department of Greek, Etruscan, and Roman Antiquities, Bj 2357

HISTORY: Purchased in 1896.

BIBLIOGRAPHY: M. Collignon, "Tiare en or offerte par la ville d'Olbia au roi Saîtapharnès," in *Monuments Piot* VI, 1899, pp. 5–57; Gérard Nicolini, "Considérations techniques sur un faux célèbre La 'Tiare de Saïtapharnès,'" in *Les Ors des Mondes Grec et "Barbare,"* Actes du Colloque de la Sociètè d'Archéologie Classique du 18 novembre 2000, Paris, 2006, pp. 247–261, pls. XIII–XVIII; Mark Jones, ed., *Fake? The Art of Deception*, exhibition catalogue, London, The British Museum, 1990, no. 4, p. 55; Chantal Georgel, ed., *La jeunesse des Musées. Les Musées de France au XIXe siècle*, exhibition catalogue, Paris, Musée d'Orsay, 7 February–8 May 1994, pp. 300–313; *Israel Ruchomowsky*, exhibition catalogue, Jerusalem, Israel Museum, 25 February–31 December 1997 (*Israel Museum Journal* XV), pp. 95–114.

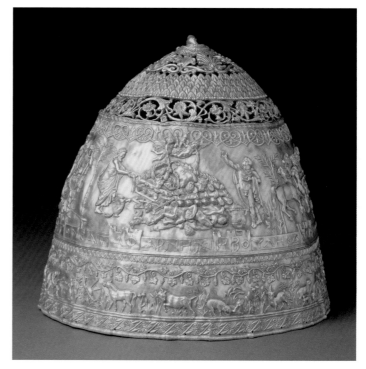

Fig. 1. The funeral pyre of Patroclus.

This exceptional object made entirely of gold entered the Louvre in 1896. When it was acquired, everything seemed to suggest that it was an exemplary masterpiece, yet only a few years later doubts of its authenticity began to arise. The ceremonial helmet is in the shape of a high conical cap made up of two main sections soldered together at the level of the small figured scenes. The profuse and complex decoration is separated into a number of superposed bands and consists of two principal scenes and several decorative zones, all executed in various techniques. The main zone is decorated with scenes executed in repoussé illustrating episodes from the *Iliad*, Homer's epic poem that relates the story of the hero Achilles during the Trojan War. One of the principal scenes depicts canto XIX of the *Iliad*—the moment when Agamemnon, the leader of the Greek armies, returns the captive slave-girl Briseis to Achilles. The hero occupies the center of the composition, seated on a ceremonial chair and flanked by an old man and a young man in armor. The gifts from Agamemnon—including different shaped vases, a tripod, a rhyton, a bowl, and gold ingots—lie at his feet. Achilles turns toward the Greek king, who stands to his left.

Behind Agamemnon two men prepare to sacrifice a pig on an altar. The figures on the other side of the central scene include the veiled Briseis being led forward by Ulysses and a group of four young women with birds. Another scene showing a man holding two groups of horses by the bridle may illustrate canto X, in which Ulysses seizes the horses of Rhesus, the King of Thrace.

On the other side of the tiara, the funeral of Achilles's friend Patroclus (*Iliad*, canto XXIII) is given less space than the Briseis episode (fig. 1). The central part of this scene shows a monumental funeral pyre bearing the body of Patroclus lying face down on a pile of sacrificed animals. The corpses of Trojan prisoners lie in a heap alongside dead animals at the bottom of the pyre, while to the right Achilles raises his arm and invokes the west and north winds: Zephyrus lowering a torch and Boreas blowing a conch to fan the fire. A large vase for Patroclus's ashes stands at Achilles's feet. On the other side of this part of the scene, Agamemnon stands making a libation in front of a group of figures, one of whom is a female mourner. Below this figured band is a frieze of town walls and a dedicatory inscription in Greek characters:

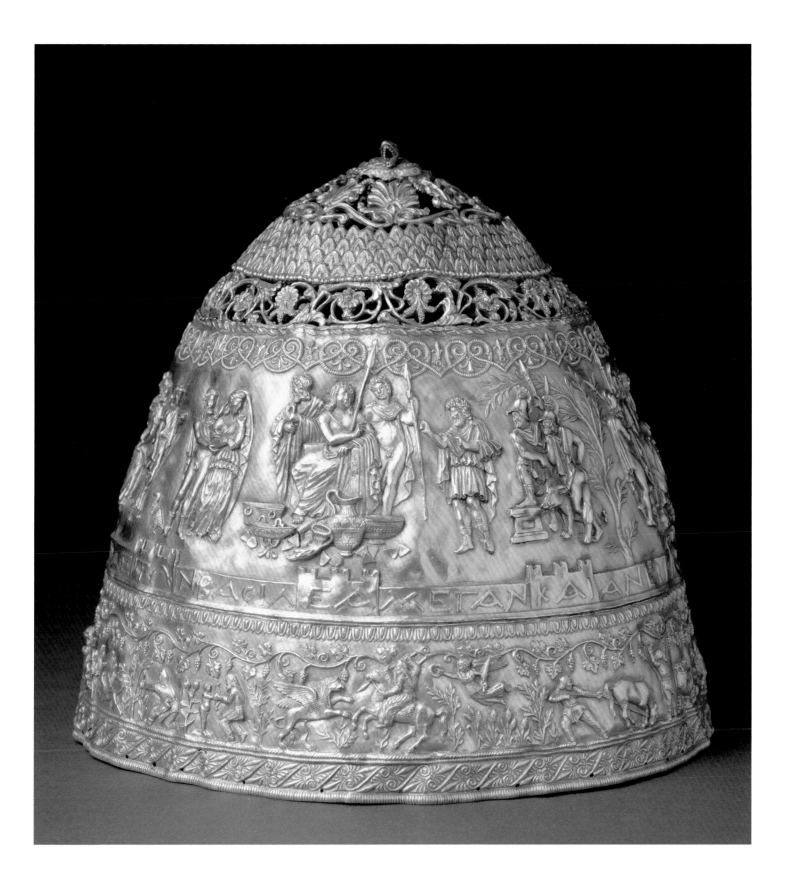

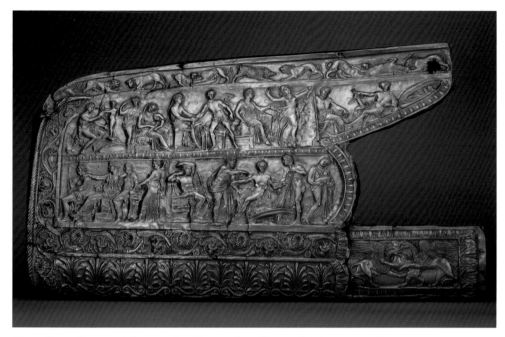

Fig. 2. Goryt (bow case) from the Scythian tomb at Chertomlyk (ca. 400 B.C.) showing scenes from the life of Achilles, State Hermitage Museum, St. Petersburg.

"*The Council and the citizens of Olbia to the great and invicible king, Säitapharnèse.*"

Several decorative motifs, including a vine scroll, introduce the second zone, which depicts small pastoral scenes showing animals in combat or simply walking along, as well as shepherds and hunters whose clothes and arms indicate that they are Scythian. This part of the tiara seems intended to illustrate the customs of the Scythian peoples living on the shores of the Black Sea as described by Herodotus, who wrote his *Histories* in the fifth century B.C. The top of the tiara, which is adorned with several decorative bands, an acanthus scroll, and a zone of scales, is crowned with a small curled-up snake.

Such was the appearance of this exceptional object when it was acquired (at considerable expense) by the Louvre in 1896. It should be remembered that this was the period when news was beginning to reach Europe of the increasing number of archaeological discoveries being made in the Crimea on the borders of the Black Sea (see fig. 2). N. Kondakov and L. Tolstoï's *Russkija drevnosti* (*Russian Antiquities*) was published in 1889 in St. Petersburg, and the French translation of the book—completed almost

immediately afterward in 1891 under the aegis of Salomon Reinach, a curator at the Musée d'Antiquités Nationales at Saint-Germain-en-Laye—caused a sensation. The acquisition of the marvelous tiara from the Crimea seemed to be an ideal way of enriching the Louvre's collections, but no sooner had the tiara been purchased than doubts about its authenticity began to surface, including those of the German scholar A. Furtwängler. Experts were soon hotly debating the issue, and the battle was also taken up by the press. It gradually emerged that forgeries were being produced in the Crimea, particularly in the area around Odessa, a region where the Hochmann brothers, dealers in grains and antiquities, were in the habit of commissioning artworks from local artisans.

The complicated and somewhat fantastic history of the scientific debate concerning the tiara, the details of which have been widely discussed and published over the last twenty years, reached its culminating point in 1903, when a certain Elina, an artist from Montmartre, claimed that he had crafted the "tiara." The ensuing scandal was so great that news of it reached Russia, and a goldsmith called Israel Rouchomowsky declared that he

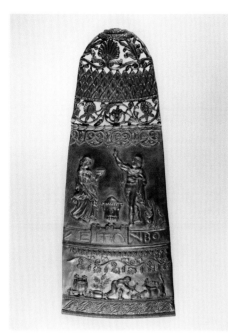

Fig. 3. Fragment executed by Rouchomowsky at Paris in 1903.

had been commissioned by S. Hochmann to produce the tiara, which, as he had been led to believe, was intended to be given as a gift to a professor at Kharkov University for his jubilee. Rouchomowsky added that he was prepared to go to Paris to prove his claim.

Rouchomowsky arrived in Paris and was questioned at an inquiry headed by Charles Clermont-Ganneau, a teacher at the Collège de France. He produced the drawings he had used to execute the decoration and declared that he had been provided with sourcebooks from which he had drawn the motifs of the figured zones. He even claimed that he could produce a vertical section of the tiara (fig. 3). After careful examination, the tiara was declared a forgery.

The tiara is therefore no longer considered a masterpiece of Greek metalwork from the Scythian world but rather a virtuoso demonstration of skill by a late-nineteenth-century Russian metalworker who brilliantly exploited the sources of inspiration with which he had been provided. Indeed, all the models for the *Iliad* scenes depicted in the Greek zone of the tiara can be found in Ludwig Weisser's *Bilderatlas zur Weltgeschichte*, a book published in 1860 and 1885 containing drawings that faithfully reproduced monuments of different civilizations of Antiquity. By copying, modifying, and mixing motifs from Greek and Roman art, Rouchomowsky succeeded in creating a "Greco-Scythian" artwork. As for the Scythian scenes, they can all be found in *Russkija drevnosti*, and here once again the Russian goldsmith chose and exploited his sources in the most convincing way. The name Säitapharnèse, taken from an authentic Greek inscription found in the Olbia region, was used to provide a historical context for the tiara—the third century B.C.

When the tiara was purchased by the Louvre, there was every reason to believe that it was a masterpiece. A century later it is easy to wonder why it was not recognized as a fraud. But our knowledge has increased greatly, and we have at our disposal more accurate ways of examining objects than at the end of the nineteenth century. Nevertheless, the troubled history of the tiara, which continues to intrigue, leads us to reflect upon the subjective notion of what constitutes a masterpiece—a changeable notion which can vary at different periods and alter with the passing of time.

CATHERINE METZGER

66
The Blue Head

20th-century forgery in the style of the late 18th Dynasty
Blue glass
3½ inches (9 cm) high
Department of Egyptian Antiquities, E 11658

HISTORY: Purchased by the Musée du Louvre in 1923.

BIBLIOGRAPHY: Georges Bénédite, "A propos d'une petite tête royale en pâte de verre," in *La Revue de l'Egypte ancienne* I, Paris, 1925–1927, pp. 1–4; Geneviève Pierrat-Bonnefois and Isabelle Biron, "La tête égyptienne en verre bleu: la conclusion d'une enquête," in *La Revue du Louvre et des Musées de France* 3, 2003, pp. 27–37; Isabelle Biron and Geneviève Pierrat-Bonnefois, "La tête égyptienne en verre bleu du musée du Louvre: de la XVIIIe dynastie au XXe siècle," in *Techne* 15, 2002, pp. 30–38.

Fig. 1. *Head of a harp*, twentieth century, rengas wood, 7¾ inches (19.7 cm) high, Musée du Louvre, Department of Egyptian Antiquities, purchased in 1932, E 14255.

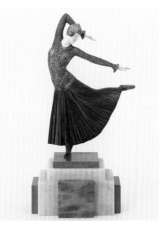

Fig. 2. Dimitri Chiparus (Romanian, 1888–1950), *Ayouta*, gold-painted gilt bronze and ivory, private collection.

This head in blue glass, purchased by the Musée du Louvre in 1923 and presented ever since in the museum's Egyptian collections, has everything of the masterpiece about it. It is a head sculpted in the round, the kind of florid piece favored by aesthetes that combines the artistic style and sense of humanity which distinguish all good human representations. It is characteristic of that period of Egyptian art much favored in the early twentieth century—the late Eighteenth Dynasty (ca. 1450–1300 B.C.), when the pharaohs Amenhotep IV (Akhenaten) and Tutankhamun ruled Egypt. The head embodies the sophisticated academism of this period but also suggests the emotional intensity that had characterized the so-called "Amarnian" revolution, when the pharaoh Amenhotep IV-Akhenaten overturned the established order. Finally, it is entirely made of glass in two shades of blue—a feature in keeping with the innovative style of artists of the period, who were versed in the art of composite statues made from different materials. It was inevitable that the head should be associated in the public's mind with the treasures discovered in Tutankhamun's tomb in 1922, and the piece immediately became a "star" of the Louvre collections—until just a few years ago, there were record sales of postcards and models reproducing it.

But mystery surrounded the head. Nothing was known of its origin (as is often the case for archaeological objects) nor whom it represented. Was it a portrait of one of the princess daughters of Amenhotep III? Did it represent the adolescent King Tutankhamun? Could it be Nut, the goddess of the sky, who was frequently depicted on the sarcophagi of the period in a glass inlay of two different shades of blue? Or was it quite simply an anonymous figure for the decoration of a piece of furniture? These mysteries, as well as certain features of the head—such as the narrow wig resembling a helmet on the nape of the neck—might have put the authenticity of the piece in doubt. But the fascinating beauty of the head was its major advantage, and in the absence of any conclusive evidence there was no question of rejecting such a striking and unusual object.

Nevertheless, in the second half of the twentieth century doubts continued to grow. It transpired that other heads—in stone or wood (fig. 1) but displaying the same style—were fakes produced in the first decades of the century. Finally, in 2002 the Louvre curators decided to have the glass analyzed by the Center for Research and Restoration of French Museums. The technique used for the analysis was the non-destructive method known as PIXE (Particle Induced X-ray Emission). It was proved beyond doubt that the glass was modern: the cobalt oxide was not the same as the one used by the ancient Egyptians, and the chemical component employed to opacify the glass was unknown during Antiquity. Once the results of the laboratory analysis were published, this very attractive piece had to be placed firmly in the category of fakes produced with the express intent of deceiving.

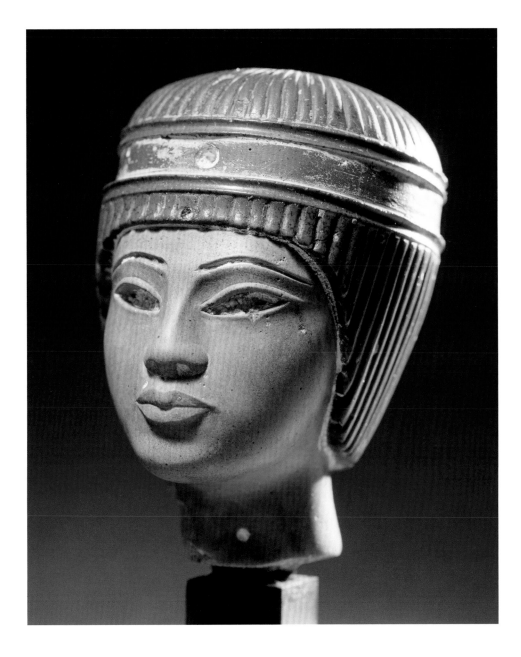

It is not surprising that specialists and art lovers were so fascinated and attracted by the blue head—for it was created with
exactly this in mind. It never represented anyone in particular,
but was simply a work of art conceived by a twentieth-century
artist for his contemporaries. Today it should be seen in this
context, as a masterpiece born of modern fascination with
ancient Egypt, but which also betrays hints of Art Deco style,
particularly evident in the strange blue helmet that seems to
come straight out of the Russian ballet and figurines of the
1920s (fig. 2).

GENEVIÈVE PIERRAT-BONNEFOIS

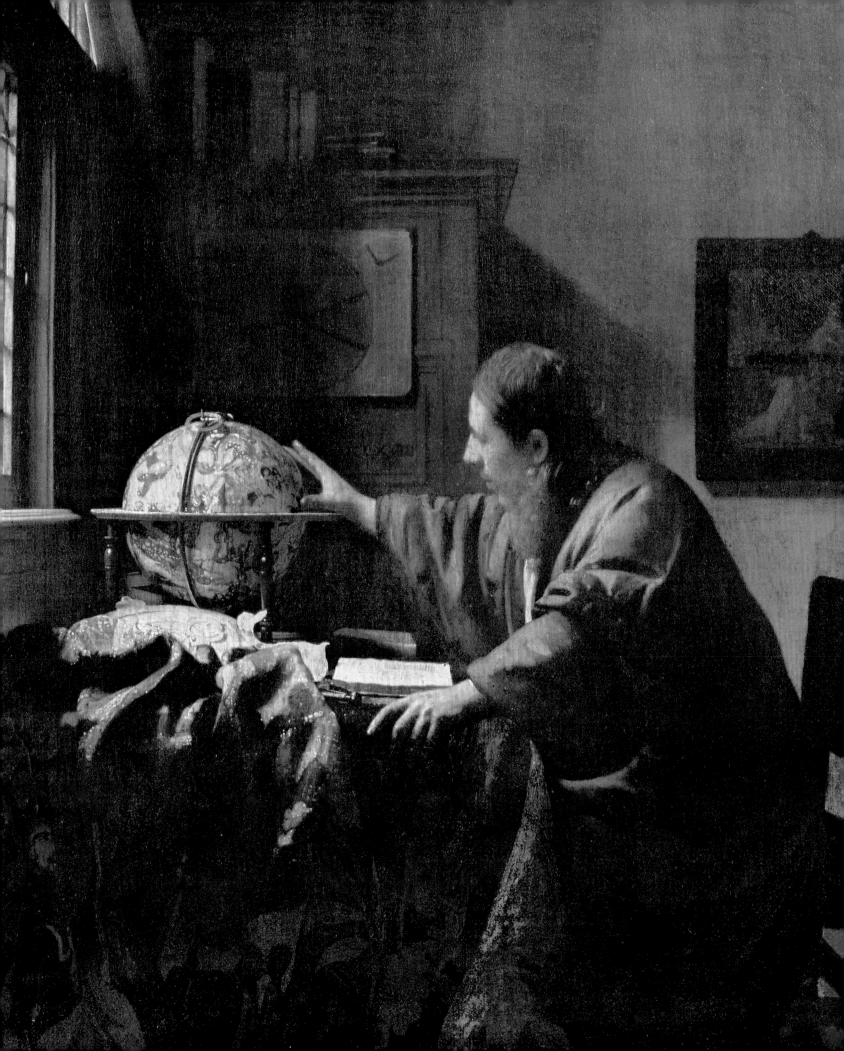

Taste and the Evolution of Knowledge

David A. Brenneman

In his fourteenth *Discourse on Art*, Sir Joshua Reynolds, the President of the Royal Academy in London, eulogized his academic colleague and competitor Thomas Gainsborough. Reynolds observed that although Gainsborough did not practice the highest form of academic art, history painting, he nevertheless did exhibit genius. As such, his works would pass on into posterity, whereas the works of his Italian competitors—namely, Pompeo Batoni and Anton Raphael Mengs—would "fall into the rank of Imperiale, Sebastian Concha, Placido Constanza, Masuccio, and the rest of their immediate predecessors; whose names, though equally renowned in their lifetime, are now fallen into what is little short of total oblivion."[1] Embedded in Reynolds's judgment is an important assumption: tastes change, but true genius will always rise to the top.

In thinking about Reynolds's judgment, with which certain scholars and critics both then and now would disagree, it is also possible to observe that art and politics go hand-in-hand. One of the main items on Reynolds's agenda was to advance the interests of the English School. In telling the history of art and deciding which artists are masters and which works are masterpieces, it is important to keep in mind that nationalism has played an important (if not always readily apparent) role.

The fact that a true masterpiece will stand the test of time makes it possible for masterpieces to be "rediscovered," an adjective used tentatively because it is not always a matter of true rediscovery, but often of reevaluation based on changing circumstances. These changes might be due to an increased knowledge of a certain artist or historical period or to a general shift in taste. The Louvre possesses many masterpieces that were "rediscovered" or "reevaluated." Some of these case studies are very well known; others are not.

The best-known examples of rediscovered masterpieces are by two masters whose reputations were revived in the late nineteenth and early twentieth centuries—Johannes Vermeer and Georges de La Tour. In both cases, shifts in taste prompted a new appreciation for these artists and their works. During his own lifetime, Vermeer (plate 96) was well known to fellow artists, and his works were avidly sought by collectors. In the following centuries, his work was known but did not make much impact on the art world, in part because of the extremely small number of works that he produced (current estimates place his output at around thirty-five paintings) and because his distinctive, almost photographic style did not fit the prevailing tastes. In fact, his paintings were almost completely unknown and unrecognized by art historians and collectors before the last half of the nineteenth century. Prior to 1870, the year that *The Lacemaker* entered the Louvre, there were no Vermeers in public collections in France. Both the advent of Realism in painting and literature in France and Vermeer's reappraisal by Théophile Thoré-Bürger, an

important French critic and writer, sparked a new interest in Vermeer's remarkable pictorial achievements.

The same is essentially true of the work of the seventeenth-century French painter Georges de La Tour, who painted the Louvre masterpiece *The Card-Sharp with the Ace of Diamonds* (plate 97). Both King Louis XIII and Cardinal Richelieu were patrons and collectors of the artist's work, but his reputation did not fare as well under Louis XIV. Whereas the previous regime had embraced La Tour's Caravaggesque approach, the new regime, led by such personalities as the painter Charles Le Brun, favored a more elegant Italianate style. Like Vermeer, La Tour's output is extremely small—around sixty paintings. La Tour resurfaced only in the first decades of the twentieth century when a German scholar named Hermann Voss recognized him as a major talent. An important turning point in La Tour's reappraisal in France was the 1934 Paris exhibition *Painters of Reality*. Organized by two Louvre curators, Paul Jamot and Charles Sterling, the exhibition presented a survey of seventeenth-century French artists that was well received, especially by critics and contemporary French artists, including Picasso, Matisse, and Balthus, all of whom found something profoundly modern in the unpretentious work of La Tour and his contemporaries. It is not surprising to learn that all six paintings by La Tour in the Louvre's collections were acquired in the twentieth century—the first in 1926 and the most recent in 1988.

Perhaps an example of a truly rediscovered masterpiece occurred in 1907, when a Louvre curator, Maxime Collignon, visited the storeroom of the museum of the city of Auxerre, where he found a limestone statue depicting a woman. He immediately recognized the stylized and rigid manner in which the human body is depicted as deriving from the Minoan period of Greek sculpture of the seventh century B.C. Realizing that he had come upon an extraordinarily rare and early example of Greek figural sculpture, he arranged an exchange of artworks with the city of Auxerre and was able to add this work, now known as *The Lady of Auxerre* (plate 68), to the Louvre's collections, where it is today considered one of the great masterpieces of the museum's extensive holdings of Greek art. Among the work's many admirers was Henri Matisse, who made several sketches of it during his forays into the Louvre.

Artists and works of art have also been rediscovered through study and the accumulation of knowledge that has accompanied the rise of art history as a professional discipline. This has taken the form of reattribution, or reassigning authorship from one artist to another. A Renaissance sculpture depicting the head of the young Saint John the Baptist is an example of a reattributed masterpiece. It was collected by the Louvre in the nineteenth century as the work of Donatello, a leading Florentine sculptor of the Renaissance. The stone base on which it was shown had even been inscribed with the name of Donatello. Only later, as scholars began to learn more about Donatello and the circle of artists around him, was Donatello's authorship questioned and a new name suggested, that of Desiderio da Settignano, a contemporary and close collaborator of Donatello's. Today, the sculpture (plate 94) is recognized as the work of Desiderio, and it was featured in the first retrospective exhibition devoted to Desiderio's work held in 2007 at the Bargello Museum in Florence, the National Gallery in Washington, D.C., and the Louvre.

Another artist who has been rediscovered through the evolution of connoisseurship is Pisanello, an artist at the forefront of the Renaissance whose remarkable drawings inaugurated new emphasis on the study of nature. In the mid-nineteenth century, the Louvre acquired an album containing 482 drawings believed to be by Leonardo da Vinci. It was subsequently discovered that most of the drawings were not by Leonardo, but by his unknown predecessor

Pisanello. It was in the 1880s that the artist was resurrected by the Italian art historian Adolfo Venturi, and only in the 1990s that an exhibition and exhaustive catalogue of the Louvre's treasure trove of Pisanello drawings finally appeared.

The Louvre is now attempting to compensate for a nationalistic historical bias by acquiring works by artists from other European schools that are underrepresented in the Louvre's collections. John Martin's *Pandemonium* (plate 103) represents a spectacular addition to the Louvre's meager holdings of English School paintings, while the acquisition of Franz Xaver Messerschmidt's character head (plate 102) represents the Louvre's first eighteenth-century sculpture by an artist from a German-speaking country. It is exciting to think that there are more masterpieces waiting their turn to be rediscovered and to find their place in the Louvre.

NOTE
1. Sir Joshua Reynolds, *Discourses on Art*, ed. Robert R. Wark, New Haven and London, 1975, pp. 248–249.

67

Fragmentary bas-relief dedicated to the female divinity Nin-sun

Mesopotamia, Neo-Sumerian period, ca. 2119–2004 B.C.
Diorite
5½ × 2⅜ inches (14 × 6 cm)
Department of Near Eastern Antiquities, AO 2761

HISTORY: Telloh (ancient Girsu), Mesopotamia; purchased on the art market, Brimo, 1898.

BIBLIOGRAPHY: André Parrot, *Sumer*, Paris, 1960, fig. 208, p. 235; Horst Steible, *Die Neusumerischen Bau- und Weihinschriften. Teil 1: Inschriften der II. Dynastie von Lagaš*, Stuttgart, 1991, Freiburger Altorientalische Studien; Band 9.1, p. 368.

Although fragmentary, this bas-relief is of very high quality. Made from diorite, a rare black stone imported into Sumer for the crafting of royal commissions, it is bordered by a regular double frame, and the execution of the sculpture is particularly delicate and supple. The fragment represents a woman seated on a chair with a low back. Her long flounced dress (*kaunakes*) completely covers her body, except for the right forearm, which is left bare. The features of the face are rounded, and the expression is gentle but grave. Her long, wavy hair, held in place by a band worn around the forehead, falls down her back. She wears a necklace made from six hard rings. Her left hand is closed, but her right hand might have been held out in the gesture for blessing a worshipper or could have held an object. This is suggested by a very similar statuette of a neo-Sumerian divinity in alabaster (fig. 1), in which the goddess holds a small globular *aryballos* in her hands.

During the Neo-Sumerian period, this kind of iconography was reserved for goddesses. The very fragmentary inscription at the top of the bas-relief clearly identifies the goddess as Nin-sun, the mother of Gilgamesh, the mythical king of Uruk. Nin-sun had originally been chosen as the "divine mother" by Prince Gudea of Lagash and subsequently by the kings of the third dynasty of Ur, and she occupied a very important place in the Neo-Sumerian pantheon.

The bas-relief of the goddess Nin-sun suggests the ways in which taste and political ideology changed between the period of the Akkadian Empire (ca. 2340–2150 B.C.) and the Neo-

Sumerian period (ca. 2119–2004 B.C.). During the Akkadian period, representations of the pantheon were being structured and codified, and royal commissions tended to emphasize the warlike and dynamic side of the gods—reflecting the political history of the empire. In the Neo-Sumerian period, on the other hand, the gods were portrayed as the protectors and intercessors for man; the royal statues and objects of this epoch reflect the new relationship between gods and men. They depict scenes of intercession and are crafted in a style which is softer, more serene, and more reserved. This was a period when royal power was characterized by wisdom and piety.

NICOLAS BEL

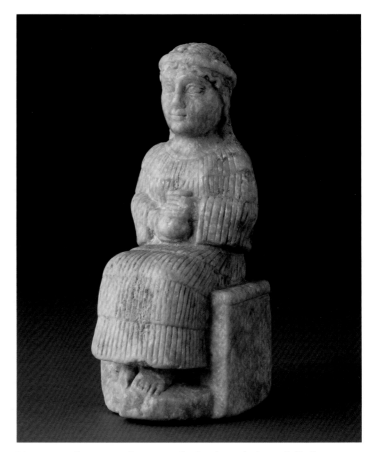

Fig. 1. Female statuette known as the "Lady with the *aryballos*," Mesopotamia, Neo-Sumerian period, ca. 2119–2004 B.C., alabaster, 7⅞ inches high, Musée du Louvre, Department of Near Eastern Antiquities, AO 23995.

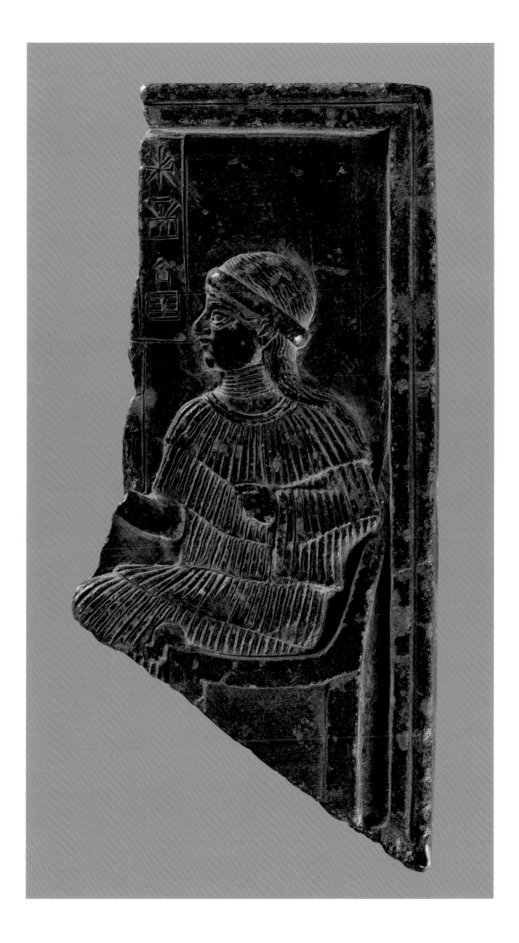

68

Female statuette known as *The Lady of Auxerre*

Crete, second half of the 7th century B.C.
Limestone
29½ inches (75 cm) high
Department of Greek, Etruscan, and Roman Antiquities, Ma 3098

HISTORY: From Eleutherna (Crete)?; acquired by the Musée du Louvre as part of an exchange with the Museum of Auxerre, 1909, entry no. MND 847.

BIBLIOGRAPHY: Jean-Luc Martinez, *La Dame d'Auxerre*, Musée du Louvre publication, "Solo" Collection, no. 16, Paris, 2000; Marianne Hamiaux, *Les sculptures grecques I: des origines à la fin du IVe siècle avant J.-C.*, Paris, rev. ed., 2001, no. 38, pp. 43–45; Nicolaos Christos Stampolidis, *Eleutherna. Poli, Akropoli, Nékropoli*, exhibition catalogue, Museum of Cycladic Art, Athens, Greece, 2004, no. 253, pp. 236–237.

This limestone statuette represents a standing draped woman, slightly less than half life-size, on a plinth 3⅞ inches (10 cm) high. She stands upright, her head in line with her body, her left arm close to her side with the palm lying flat against the thighs, her right arm folded against her chest. The heavy mass of hair divides on the shoulders; five tresses on each side conceal the ears—four when viewed from the front and one deep when seen from the side. The shoulders and arms are covered with a sort of shawl, the edge of which can just be seen along the arms and running along the back at the level of the right elbow. The collar on the bodice is decorated with a key pattern, and the bodice itself is dotted with incised scale motifs, which (like other parts of the statue) were probably originally painted. The waist is cinched with a wide belt, and the skirt is decorated with a vertical band, a sort of *paryphe* (border) consisting of interlocked rectangles. The statue is carved from a yellowish, shelly limestone that is extremely fragile, which might explain the numerous abrasions and chips on the surface, including a large crater that disfigures the left part of the face. The base, which may have been made of another material, is also missing. The high plinth has a chamfered edge and bears traces left by a facing hammer.

The composition is striking in the way that the head is given so much importance compared to the relatively small torso, and for the hieratic stance of the body. Although the sculptor did not entirely manage to release the statuette from the block of stone from which it was carved, he did succeed in portraying certain volumes—the slightly bent back (fig. 1) and the full breasts—and in showing, if only timidly, the movement from one plane to another. The work took its inspiration from Near Eastern models and is the best example we have of the evolution of Greek sculpture in the seventh century B.C. as expressed in the Orientalizing style, which broke with the geometric schema of the preceding centuries in the importance it accorded to the head. The Greeks often took ideas from other cultures, such as the gesture of the statuette's right hand on the chest and the hair resembling a stepped wig (fig. 2)—elements borrowed from the nude goddesses of Syria and Phoenicia—or the use of a heavy belt, which came from far-off Phrygia and Urartu. They then used these borrowings in their own development of the *kore*, the portrayal in stone of a draped young woman, primarily intended to represent a mortal in prayer. The island of Crete was situated on the routes linking the Levantine coast with Greece via Rhodes and the Cyclades, and thus played an important role in the trade between these different areas. The absence of marble on the island explains the use of limestone in sculpture production.

Attempts have been made to date the Louvre statuette more precisely. In his celebrated work of 1936, *Dedalica*, R. J. H. Jenkins used a typology based on terracotta figurines from the regions where the Dorian dialect was spoken in order to trace how the faces of figures evolved during the seventh century B.C. This was the period of what is known conventionally as the "Daedalic style," named after the mythical Greek engineer Daedalus. According to Pliny and Pausanias, Roman and Greek authors of the first and second centuries A.D., the Daedalids (the descendants of Daedalus) were the creators of the very first statues. Based on Jenkins's theory of a supposed evolution reflected in the progressive widening of the jaw, it was estimated that *The Lady of Auxerre*—considered characteristic of the Middle 2 Daedalic phase—should be placed immediately after the Louvre's Proto-Corinthian *aryballos* (plate 12), dated to the middle of the century, ca. 645–640 B.C.

Such a degree of precision was probably illusory. Today, researchers tend to date the production of these statues to the period when different communities were beginning to produce their own individual styles. The excavations now being conducted at the necropolis of Orthi Petra on the site of Eleutherna in western Crete have brought to light objects of similar manufacture, dated to 620–580 B.C.—in particular, the fragment of a

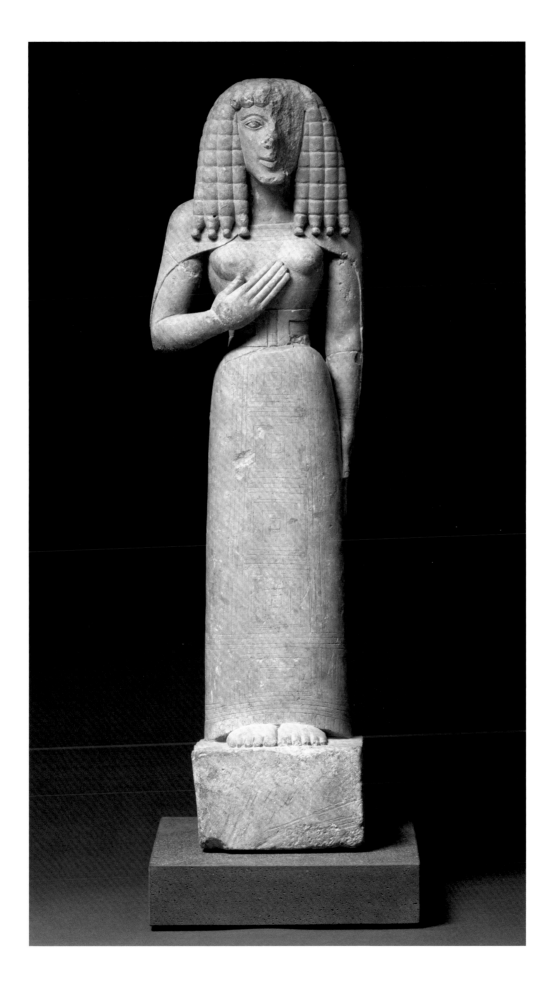

Fig. 1. Back view.

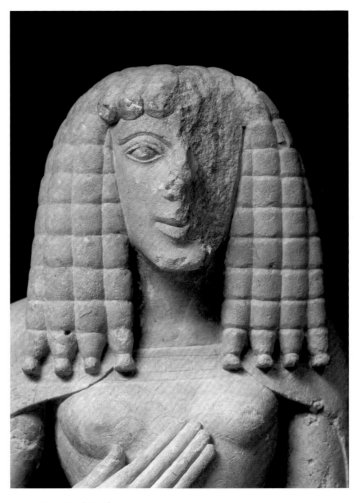

Fig. 2. Detail of the face.

limestone statuette and faces made from ivory, which have the same line incised above the eye. *The Lady of Auxerre* is in the same Eleuthernian style and could well have come from this necropolis.

This hypothesis helps dissipate the aura of mystery surrounding the origins of the statuette. It certainly adds one more episode to the incredible story of the sculpture's adventures in France and highlights one of the most surprising changes in taste in the history of art. This work—which during the twentieth century was to become prized as the consummate masterpiece of the beginnings of Greek sculpture and the prototype of the

Daedalic style—nearly disappeared at the end of the nineteenth century when its style was considered basely "primitive."

Indeed it is worthwhile to recall the fantastic story of the discovery of *The Lady of Auxerre*. During a visit to Auxerre, Maxime Collignon (1849–1917), a professor at the Sorbonne in Paris, noticed the statuette in the local museum. The sculpture was brought to Paris in 1907 and caused considerable surprise and interest. What had a Greek sculpture from the seventh century B.C. been doing in Burgundy? All sorts of hypotheses were advanced, including the most foolhardy—it was from a Gallic tomb; it had been brought back from Turkey by Burgundian workers working on the construction of a railway line; it was a fake. After an inquiry that took many surprising turns, the story was gradually pieced together and proved even more extraordinary than the early hypotheses. The statuette was probably acquired in Paris by the French sculptor Edouard Bourgoin, who transported it to his country home in Burgundy. It stayed there until the artist's death in 1895, when it was put up for auction along with the rest of his possessions. However, no one showed any interest in buying it at the public sale, and it was taken away for just one franc by the auctioneer's crier, who also happened to be the concierge of the town theatre in Auxerre. He used it as a prop, notably in the décor for the operetta *Galatée* by Victor Massé, but then got tired of it and stuffed it away in an old case. Here it was found and only just saved from being thrown away by some unknown person who took it to the Auxerre Museum. The museum caretaker was not at all impressed by the "broken old stone," as he termed it, and in the absence of any declared donor relegated it (without even bothering to register it) to the entrance hall of the museum, where, the story goes, it was used for a time as a hat stand. The renaissance of the statuette was due to the knowledgeable eye of Maxime Collignon—who at the time was studying the earliest examples of ancient Cretan sculptures recently discovered on the island—as was its transfer to the Louvre, the first step in its recognition as a masterpiece and the start of the enormous celebrity it has subsequently enjoyed.

How the sculpture originally turned up in Paris before 1895 remains a mystery, but we cannot fail to be amused by the ironic story of its transfer from the somber environment of a Cretan necropolis to the bright lights of the Louvre, via a season of stage appearances at the town theatre of Auxerre, perhaps a longer stay among the gutter stones of Burgundy, and a useful but obscure period in the vestibule of the Burgundy museum. However, the interest of the rediscovery of *The Lady of Auxerre* does not lie simply in the outlandish details of its travels. The rediscovery of this masterpiece of seventh-century B.C. Greek sculpture testifies to the change of taste which took place among Europeans in the early twentieth century, when the Classical canons of art were abandoned in favor of the fragmentary and the primitive. It is only within this context that we can begin to understand the taste for archaic Greek sculpture and the renown so quickly acquired by *The Lady of Auxerre*.

JEAN-LUC MARTINEZ

69
Stele of the scribe Tarhunpiyas

Southeastern Turkey, late 7th century B.C.
Basalt
29⅜ × 11⅛ × 6⅛ inches (74.6 × 28.3 × 15.6 cm)
Department of Near Eastern Antiquities, AO 19222

HISTORY: Acquired in 1936.

BIBLIOGRAPHY: Theodor Bossert, *Zur Geschichte von Karkamish*, Berlin, 1951, p. 27; Kurt Bittel, *Les Hittites*, Paris, 1976, p. 277, fig. 316; *Huit mille ans de civilisation anatolienne*, Paris, 1981; *La naissance de l'écriture*, exhibition catalogue, Paris, 1982, no. 276.

This bas-relief was carved from a thick slab of basalt and used as a funerary stele. The lower part for driving the stele into the ground was only roughly hewn. When it was acquired by the Louvre in the early twentieth century, it was believed to come from the site of Karkemish, but both the iconography and style link it instead with similar stelae discovered at Marash, the ancient city of Gurgum, in southeastern Turkey. Gurgum was the capital of one of the small Neo-Hittite kingdoms which developed on the eastern borders of Anatolia and in northern Syria after the fall of the Hittite Empire in about 1200 B.C. The very active school of sculpture which flourished in Gurgum toward the end of the eighth century B.C. produced a large number of funerary stelae representing the deceased either alone or accompanied by a family member.

On this stele a mother holds her son on her knees. The boy is already tall, almost a young man. He wears a long fringed tunic, a band around his forehead which keeps back his curly hair, and a calotte. With his left hand he holds a bird whose legs are tied together with a cord, and with his right he clasps a stylus to his chest. His writing desk is shown in front of him. Writing desks of this kind have been excavated; the most precious ones are made of wood or ivory and consist of two small plates hinged together so that they could be folded. They were used for writing something quickly, either by engraving the notes in wax spread over the plates or by writing in ink. The notes were then transferred onto rolls of parchment. These desks were first used in the Aramaean and Assyrian world from the beginning of the first millennium B.C., when alphabetic writing was beginning to replace the ancient cuneiform notation on clay tablets.

The child's name, Tarhunpiyas, is indicated above his head. It is written in Hittite hieroglyphs; these were used to transcribe the Luwian dialect that had been used in the Hittite Empire since the middle of the second millennium B.C. and continued to be employed in the small Neo-Hittite kingdoms. The decision to transcribe the name of the deceased in this way probably reflects the wish to emphasize the fact that he belonged to a very ancient lineage. It is also a reminder that Gurgum was the last of the small Neo-Hittite states to be conquered by the Assyrians. The writing desk and the bird of prey give us an idea of the everyday life of the young man. We learn that he was a scribe, and had therefore received a good education, and that his favorite pastime was falcon hunting. These two activities indicate that he belonged to a very well-off family, perhaps even a royal one.

FRANÇOISE DEMANGE

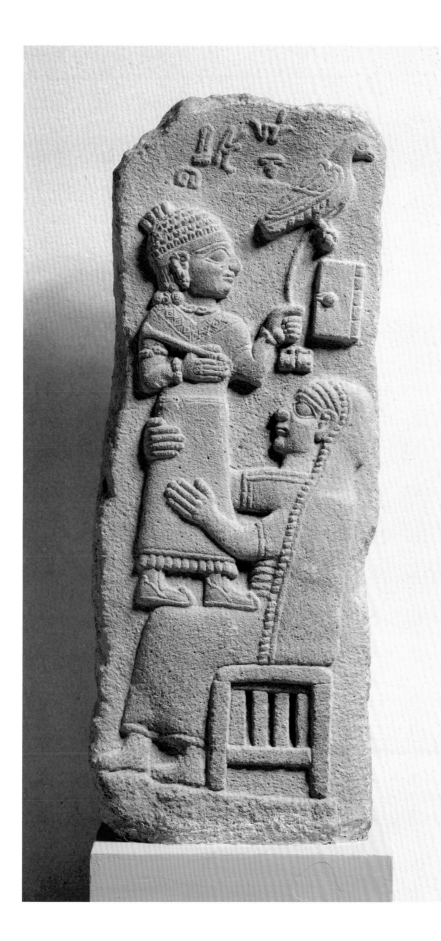

70
Fragment of a statue of a woman

Egypt
Porphyry, Ptolomaic period, 2nd–3rd century B.C.
11 × 4⅜ × 4⅛ inches (28 × 11.2 × 10.5 cm)
Department of Egyptian Antiquities, AF 12417

HISTORY: Provenance unknown; mode of acquisition uncertain
(first acquired by the Museum of Antiquities of Napoleon I?).

BIBLIOGRAPHY: Philippe Malgouyres, *Porphyre, La pierre pourpre des
Ptolémées aux Bonaparte*, exhibition catalogue, Musée du Louvre,
17 November 2003–2 February 2004, entry no. 3, pp. 45–46.

This fragment is what remains from a statue that was de-restored in 1998, when parts that had been added in the seventeenth and eighteenth centuries—legs, left arm, and head (fig. 1)—were removed, revealing the original fragment dating from Antiquity. This is an extremely rare example of the use of porphyry before the Roman period, and represents a woman holding a flexible object in her left hand, keeping her right arm flat against her side—an iconography well attested in Egyptian art, which first appeared during the New Empire (1550–1090 B.C.), when it was used for representing queens. The object held in the figure's hand is a flexible stick topped with feathers and embellished with a vegetal decoration, thought to be a fly whisk. On this statue the close-fitting dress is not figured, and there is no trace of the traditional three-part wig on top of the back pillar. This might suggest that the statue represents a woman of high rank rather than a queen. We do indeed have a number of well-dated statues of women from the Ptolemaic period—women of high rank but not of royal lineage—represented against a back pillar and holding a fly whisk.

This work, which might be a very early example of this kind of statue, shows how skillful Egyptian sculptors were in carving very hard stone. We know that in the thirtieth and last Egyptian dynasty (and during the Persian domination which followed), statues of high-ranking personages were executed in hard, colored stones quarried in the Arabian desert, not far from the porphyry quarries of the Gebel Dokkan massif, which were intensively exploited during the Roman period. Moreover, during the same period, the female wig was short, round, ball-shaped, and either flared or made up of a number of short

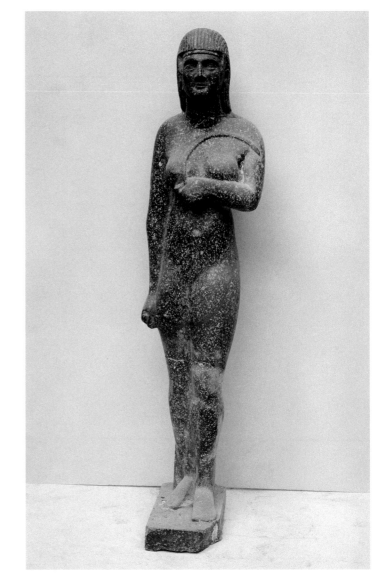

Fig. 1. Figure with added legs, arm, and head.

braids—which might explain the absence of wig-sections on our statue. The delicate modeling but clear demarcation of the limbs is also typical of works of this period. After being first carved out of the rock, the statue was carefully abraded, probably with another piece of rock such as sandstone, to give it its final finish —a technique mastered by Egyptian sculptors since the earliest dynasties.

MARC ETIENNE

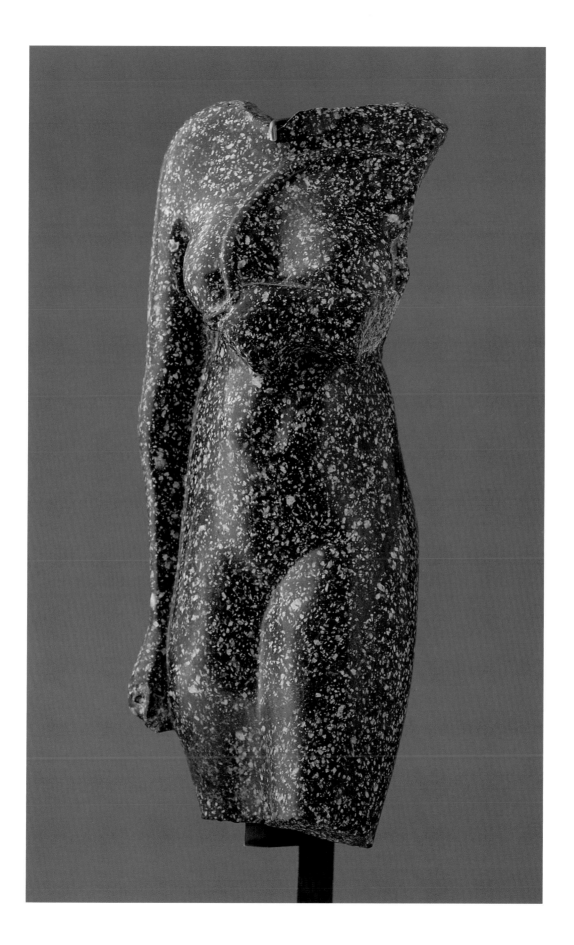

71

Capital: Daniel in the Lions' Den; acanthus leaves

Aquitaine (?) and Île-de-France, 6th century and first half of
12th century
Marble
19½ × 20⅞ × 20⅛ inches (49.5 × 53 × 51 cm)
Department of Sculptures, RF 457

HISTORY: Basilica of the Apostles, Paris (later called the Basilica of
Sainte-Geneviève); Musée des Monuments Français, where it was
probably not exhibited, from 1808 to the Restoration of the Bourbon
monarchy; Abbey Church of Saint Denis.

BIBLIOGRAPHY: Louis Courajod, "L'ancien musée des Monuments
français au Louvre," in *Gazette des Beaux-Arts* 26.2, 1882, pp. 37–49;
Françoise Baron, *Musée du Louvre: Sculpture française*, vol. I, *Moyen Âge*,
Paris, 1996, pp. 26 and 41; Dany Sandron, "Chapiteau," in *Paris de Clovis
à Dagobert*, exhibition catalogue, Centre culturel du Panthéon, Paris,
1996, p. 36, no. 18; Jean-René Gaborit, *L'art roman au Louvre*, with
Danielle Gaborit-Chopin and Jannic Durand, Paris, 2005, pp. 11 and
95–96 (with previous bibliography).

During the first half of the nineteenth century this capital
was in the Abbey Church of Saint Denis, where it was used
as a plinth for a modern statue. In 1848 it was relegated to the
abbey's storerooms and stayed there until 1881, when it caught
the eye of L. Courajod, the indefatigable curator of the Louvre's
Department of Sculptures. Courajod reestablished the capital's
identity by publishing a letter dated 16 May 1808 written by
Alexandre Lenoir affirming that the capital came from the
Church of Sainte-Geneviève. Courajod subsequently rehabili-
tated the sculpture and confirmed its importance by ensuring
that it entered the Louvre, along with two other Romanesque
capitals—the first examples of Romanesque sculpture added to
the collections. At the time, such a consecration was far from
obvious. Although Courajod devoted pages of enthusiastic prose
to the sculpture he had rediscovered, even he was not totally
free of the prejudices of his century, an age when Romanesque
art was considered primitive. He described Daniel as a "stunted
ape with moronic, staring eyes" and was obliged to concede
that the style was "barbarous and crude" in order to better
emphasize "a certain delicacy of execution." In spite of these
reservations, the Daniel capital gradually became an icon and
was increasingly reproduced and discussed as Romanesque art

came to be appreciated, particularly in the second half of the
twentieth century.

However, the capital is not easy to interpret. The original
analysis proposed by Courajod is generally accepted—that it was
an isolated support capital created in the early Middle Ages and
reworked during the Romanesque period to become an engaged
support capital incorporating part of the original sculpture. Eco-
nomic reasons most likely lay behind this reuse; marble was an
expensive material, and during the Romanesque period it was
no longer imported into Paris. However, when deciding how he
would structure his new composition, the second sculptor was
influenced by the shape of the original vegetal capital: the lions'
heads are placed beneath the corner volutes and the head of
Daniel beneath the central rosette.

The iconographic theme chosen for the capital, Daniel in the
lions' den, is based on two passages from the Book of Daniel, and
it has been frequently noted that it was not only a theme com-
monly represented in Romanesque sculpture, but one that was
also very much in harmony with the spirit of the Gregorian
Reform, a movement which caused considerable upheaval in the
Church during this period. The image of the young prophet is
perhaps the most satisfactory reflection of the patience of the
clergy confronted with the encroaching power of the laity.

Two questions still need to be posed: the first concerns the
exact provenance of the capital, the second the date when it was
reused during the Romanesque period. When the Church of
Sainte-Geneviève was destroyed in 1807, only a few reports and
several very imprecise drawings were produced. It has been
assumed from the plan made of the building at the time of its
demolition that the capital came from the engaged half-columns
on the reverse of the façade of the nave; in this case the sculpture
would date from the end of the eleventh century or, more likely,
the beginning of the twelfth—a date proposed for the nave on
the basis of the stylistic analysis of the four enormous capitals
which crowned its main support columns and which are now
kept in the Cluny Museum. But it has also been pointed out that
the Louvre capital is stylistically very different from the massive
shapes of the capitals of the Cluny Museum, carved as they are in
two parallel planes. The stylistic dissimilarity could quite simply
be explained by the difference in the materials used and by the
progression in the construction of the building. Alternatively, the
Louvre capital might have come from the choir of the old abbey

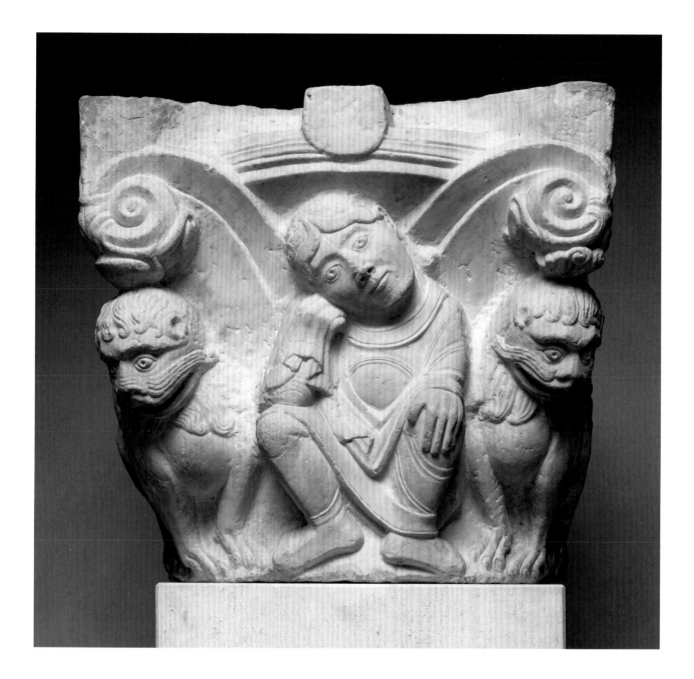

church. The sculptures from this church, which are also in the Cluny Museum and the Musée du Louvre, seem to date from the second quarter of the twelfth century. But this hypothesis casts doubt on the original positioning of the capital, since it would seem that there were no capitals resembling the Louvre example in the choir.

It is possible that insufficient attention has been paid to the fact that the sculpture was not completely finished in the Romanesque period. The sculptor carved neither the details of the tail, nor the top of the mane of the lion on the left, nor the vegetal motif beneath the corner volute on the same side.

Moreover, Daniel's hair was only vaguely indicated and the central rosette of the abacus given no more than a rough geometrical outline. Although it is possible that the capital was actually placed in position, we cannot be sure of this. All such problems of interpretation notwithstanding, the striking force of the composition makes the Daniel capital a masterpiece of Romanesque sculpture: the lions appear to be protecting the young prophet rather than menacing him, though the expression on Daniel's face leaning against his delicately veiled hand reveals all the anguish of the just assailed by the forces of evil.

PIERRE-YVES LE POGAM

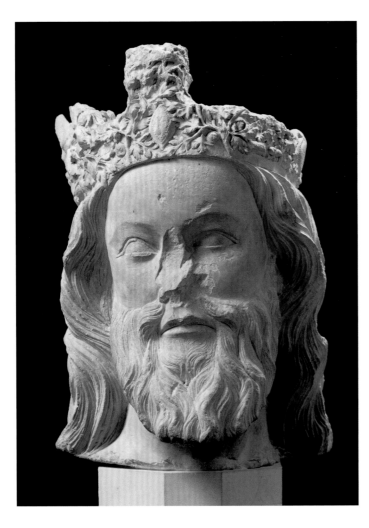

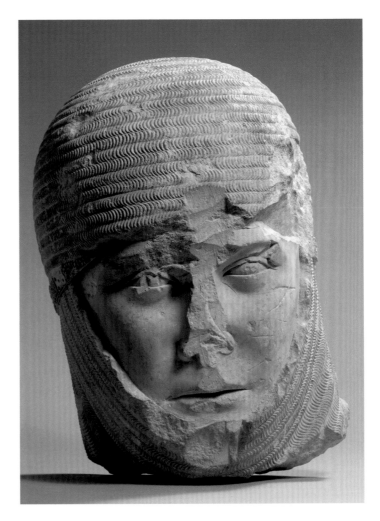

72
Workshop of the Master of Mussy
South Champagne or North Burgundy

Head of Christ crowned, ca. 1300

Tonnerre stone (limestone), identified in 2007, minute traces of polychromy
18¹¹⁄₁₆ × 13 × 11 inches (47.5 × 33 × 28 cm)
Department of Sculptures, RF 3526

HISTORY: Fontenilles Hospital at Tonnerre (founded in 1293 by Marguerite of Burgundy, the widow of Charles I of Anjou); gift of E. Bizot, 1981.

BIBLIOGRAPHY: Françoise Baron, *Musée du Louvre. Sculpture française*, vol. I, *Moyen Âge*, Paris, 1996; Françoise Baron, "Tête de Christ couronné" and "Tête de chevalier coiffé d'une cotte de mailles," in *L'art au temps des rois maudits. Philippe le Bel et ses fils, 1285–1328*, exhibition catalogue, Paris, 1998, nos. 62–63, pp. 115–117.

73
Workshop of the Master of Mussy
South Champagne or North Burgundy

Head of a chevalier in armor, ca. 1300

Tonnerre stone (limestone), identified in 2007
13⁵⁄₁₆ × 8½ × 7¾ inches (33.8 × 21.7 × 19.7 cm)
Department of Sculptures, RF 4217

HISTORY: Church of the Premonstrant canons of Saint Marien of Auxerre (probably a fragment of the recumbent figure of Jean de Seignelay, seigneur of Beaumont, died ca. 1293).

It is only for the more recent periods in the history of art that we have the names of the artists who created the works of art we now enjoy, whereas the names of those responsible for the works produced during most of Antiquity and the Middle Ages are largely unknown to us. This can be explained in several ways: we have few written sources to rely upon, certain artists were lesser known than others, the artworks we now have constitute but a fraction of what was produced, and quite simply, there are wide gaps in our knowledge. The exceptional quality of certain works has led art historians to adopt a reverse process, consisting of reconstituting the profile of the artist and, in the absence of any real name, endowing him with a conventional one.

Such is the case of the anonymous artist who carved these two sculptures. Since the 1960s his career and works have been reconstituted on the basis of a number of sculptures which are either still to be found in the southern Champagne region and in North Burgundy, or which originally came from these regions. Since a number of his sculptures—including a *Virgin and Child*, a *Descent from the Cross*, and a tomb—were found in Mussy-sur-Seine, previously called Mussy-l'Évêque, in Aube county, the sculptor was given the conventional name of the Master of Mussy.[1]

Art historians have based their grouping of these different works on a number of common characteristics, including the use of a particularly fine-grained stone—a limestone known as Tonnerre stone from the region of Tonnerre, but which was also quarried at Mussy-sur-Seine. This stone enabled the sculptor to obtain remarkable effects in the treatment of even the tiniest details—the individual links in the coat of mail; the strap of studded plaques that holds in place the head protection; the crown on the *Head of Christ*, where a few jewels seem almost lost in the profusion of foliage crafted in a very naturalistic manner; and finally, for the two faces, the subtle modeling of the flesh and the delicately highlighted eyes. It is tempting to deduce that such an approach was designed to produce "portraits" or that it was based on the use of living models. This hypothesis, however, cannot be confirmed. The different techniques were used in order to produce a decorative stylization, and the close similarity between the *Head of Christ* and the *Head of a chevalier*—probably Jean de Seignelay—shows that the sculptor was aiming at an ideal type.

This last point can only be advanced by considering the corpus as a whole. Up to and including the thirteenth century, sculpture was produced within the framework of architecture (monumental sculpture to embellish the interior and exterior of a building). However, the Master of Mussy seems to have produced primarily sculpture that was independent of any architectural framework—statues, reliefs, and recumbent figures—and only our *Head of Christ* appears to have come from the façade, or the reverse of the façade, of the great ward of the Tonnerre Hospital. However, it also seems clear that he frequently worked on monuments which had practically no architectural decoration, as though a kind of separation was occurring during this period between refined, independent sculpture on the one hand, and monuments notable for their modern character but distinguished by a particularly pronounced austerity (as seen in both the Collegiate Church of Mussy and the Tonnerre Hospital) on the other. It is perhaps not surprising that this kind of development should have been accelerated in the case under study by the inherent characteristics of Tonnerre stone.

However, it remains somewhat hazardous to establish a stylistic grouping. As we extend the corpus, the clear outlines of one individual artistic profile tend to fade, to merge with a myriad of more-or-less interconnected artistic tendencies which gradually reflect no more than the general characteristics of a given region and period. The statue of John the Baptist at Rouvres-en-Plaine, for example, has often been considered as typical of our artist's work—so much so, in fact, that he is sometimes referred to as the Master of *John the Baptist of Rouvres*—and yet this statue seems very different from his other productions, not simply because of where it was found, but principally on account of its striking expressivity in marked contrast to the balanced quality of the Mussy sculptures, for example. Bearing this in mind, it would seem wise to keep to the hypothesis sometimes advanced by critics that the concept of the Master of Mussy actually denotes a workshop. Attribution of the two superb Louvre sculptures to the workshop of the Master of Mussy does not imply that they were produced by a secondary artist distinct from the Master himself, but it does avoid the danger of constricting medieval productions by making excessively narrow and subsequently doubtful attributions.

PIERRE-YVES LE POGAM

NOTE

1. Other sculptures by the artist have been discovered in this region: A *Virgin and Child* was found in Bayel in Aube county (although this was probably not the original locale), the Louvre *Head of Christ* and a *Virgin with the Burning Bush* at Tonnerre in the Yonne department, the Louvre *Head of a chevalier* in Auxerre in the Yonne department, and a *John the Baptist* at Rouvres-en-Plaine in the Côte-d'Or county.

74

Antonio Pisanello

Italian, ca. 1395–1455?

Young boy with lowered head, seen from above

Pen and ink over a black chalk preparatory drawing
6½ × 8⅛ inches (16.5 × 20.6 cm)
Department of Graphic Arts, INV 2299
Atlanta only

BIBLIOGRAPHY: Dominique Cordellier, *Pisanello, le peintre aux sept vertus*, exhibition catalogue, Paris, 1996, cat. 173.

In 1856 Frédéric Reiset (1815–1891), curator of drawings at the Louvre, acquired from Giuseppe Vallardi (1794–1863), Milanese art dealer and collector, the so-called *Codex Vallardi*, a bound album with 284 pages onto which were glued 482 drawings attributed to Leonardo da Vinci (1452–1519). Of these, only seven are accepted today as being by the master himself. Among the others, about forty are attributed to the circle of Leonardo and to other sixteenth-century artists, the rest being by Pisanello.

Vallardi is still relatively unknown as a collector. Although he wrote about buying sheets from prestigious collections, recent scholarship has cast doubt on his activities. Included in the *Codex*, for instance, was a Leonardo sheet (Louvre, INV 2282) bearing a handwritten number found exclusively in the collections at Windsor Castle and at the Pinacoteca Ambrosiana in Milan. How did the sheet in question become separated from the initial group and find its way into Vallardi's hands?

Another more adventurous case is raised by two sheets (Louvre, INV 10706 and INV 10707) which were originally a single one. This latter had been confiscated from the Ambrosiana collection in 1796 by Napoleonic troops and brought to the Louvre, where it was duly registered with an inventory number. In 1815, after Napoleon's defeat and the Congress of Vienna, France was obliged to return the works of art it had seized to the original owners. The sheet in question went back to Milan, as attested by an annotation on the margin of the Louvre inventory. Its final trip back to Paris was in the *Codex Vallardi*, cut into two. How did Vallardi come into possession of the two parts, and did he separate the sheet?

The fact that Vallardi attributed all the drawings in his *Codex* to Leonardo does not necessarily imply that he knew that most of the 482 sheets were not autograph, but it certainly meant it acquired a higher value for sale. Nevertheless, connoisseurship of Leonardo's drawings was just beginning, and one can see from contemporary studies of Milanese collections that many erroneous attributions to Leonardo were made in good faith. The master had worked in Milan for eighteen years, his most famous fresco, *The Last Supper*, was still in place there, and the Ambrosiana conserved the celebrated *Codex Atlanticus*, a bound album with numerous drawings and writings. It was logical to attribute to Leonardo another series of magnificent drawings, as both Leonardo and Pisanello are among the greatest draftsmen of all time.

Pisanello, the "little Pisan," was virtually unknown by the 1850s. In his own time, he had been one of the most revered Italian artists. Poets described his works, and he was praised for his qualities as a man, a painter, and an executor of medals. He worked for the most important courts in Italy—the Visconti in Milan, the Este in Ferrara, the Gonzaga in Mantua, and for the King of Naples, Alfonso V of Aragon. Few of his works survive today, just four undisputed paintings, three frescoes, and the drawings. They show an inventive imagination and a talent for splendid coloring, combined with an acute observation of nature. His taste for precision, elegant sophistication, and beautiful firm line appeal to our modern taste. Yet his precision aims not at a faithful representation of nature (which would only come during the Renaissance), but rather at the conception of an emblematic,

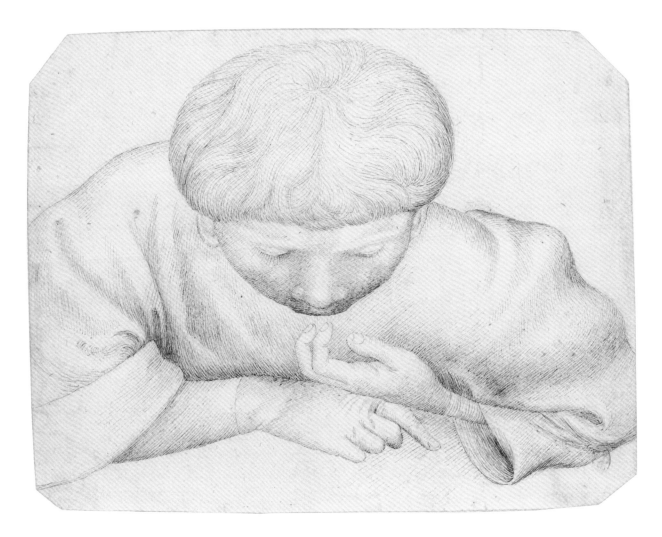

heraldic image, expressing through its minute details an allegory or an emblem.

His work was forgotten for more than 400 years, and it was around the 1880s that the Italian scholar Adolfo Venturi rescued the little Pisan from oblivion. In 1972 a large fresco by Pisanello was discovered in the Ducal Palace of Mantua; the excitement generated by the event spurred a renewed interest in the artist that continues to this day.

The choice of drawings made for this exhibition illustrates many aspects of the artist's technique, from the use of black chalk and metalpoint to the exploitation of color through washes and gouaches, usually on paper and occasionally on parchment. The studies of animals, birds, figures, and portraits show Pisanello's ability to reproduce movement and life. The decision to include sheets by other draftsmen was made to enable the public to appreciate the difference of hand and to show how the evolution of knowledge since the 1880s has allowed scholars to identify the autograph sheets.

VARENA FORCIONE

75
Antonio Pisanello
Italian, ca. 1395–1455?

Man seen from behind, draped in a cape and seated on a bench

Pen and ink over a metalpoint preparatory drawing
10¹⁵⁄₁₆ × 7¹¹⁄₁₆ inches (27.7 × 19.5 cm)
Department of Graphic Arts, INV 2332 verso
Atlanta only

BIBLIOGRAPHY: Dominique Cordellier, *Pisanello, le peintre aux sept vertus*, exhibition catalogue, Paris, 1996, cat. 174.

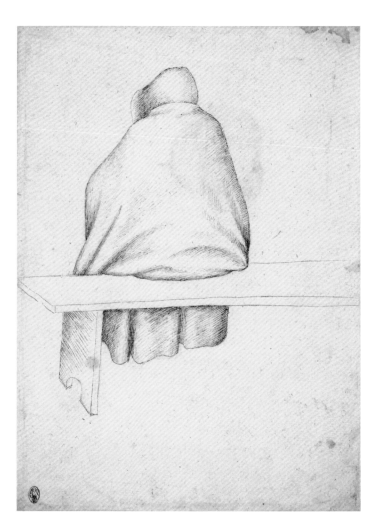

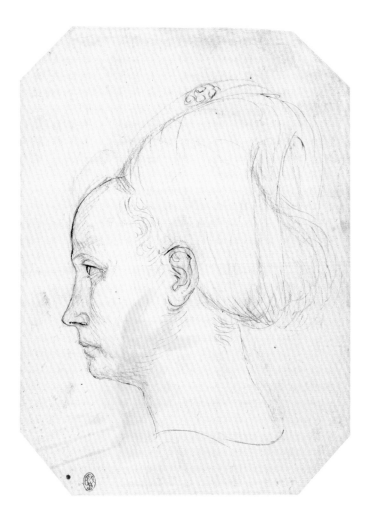

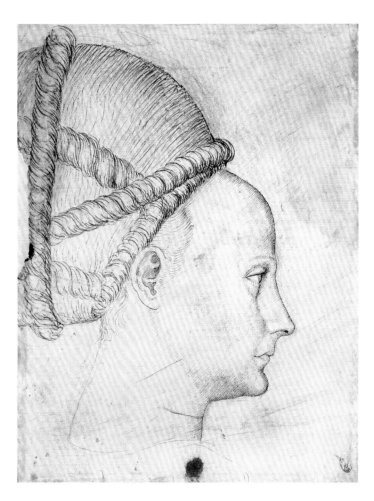

76

Antonio Pisanello

Italian, ca. 1395–1455?

Profile of a young woman to the left

Pen and ink over a black chalk preparatory drawing
9¹¹⁄₁₆ × 6¾ inches (24.6 × 17.2 cm)
Department of Graphic Arts, INV 2342 verso
Minneapolis only

BIBLIOGRAPHY: Dominique Cordellier, *Pisanello, le peintre aux sept vertus*, exhibition catalogue, Paris, 1996, cat. 188.

77

Workshop of Pisanello

Profile of a young woman to the right

Pen and ink over a black chalk preparatory drawing, with
a light red chalk wash
9⅝ × 7³⁄₁₆ inches (24.5 × 18.2 cm)
Department of Graphic Arts, INV 2343
Atlanta only

BIBLIOGRAPHY: Dominique Cordellier, *Pisanello, le peintre aux sept vertus*, exhibition catalogue, Paris, 1996, cat. 189.

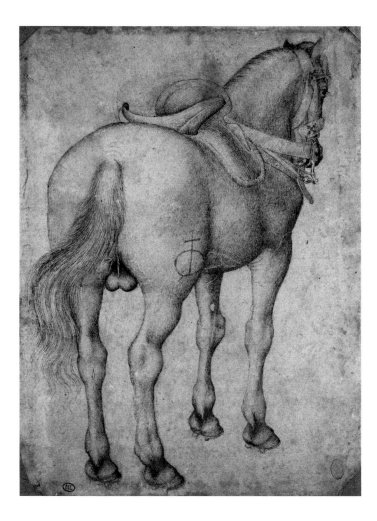

78

Antonio Pisanello

Italian, ca. 1395–1455?

Harnessed horse, seen from behind

Pen and ink over a black chalk preparatory drawing
8¹¹⁄₁₆ × 6⁵⁄₁₆ inches (22.1 × 16 cm)
Department of Graphic Arts, INV 2378
Atlanta only

BIBLIOGRAPHY: Dominique Cordellier, *Pisanello, le peintre aux sept vertus*, exhibition catalogue, Paris, 1996, cat. 143.

79

Antonio Pisanello

Italian, ca. 1395-1455?

Two harnessed horses' heads and details of a horse's snout

Pen and ink over a black chalk preparatory drawing
11⁷⁄₁₆ × 7¼ inches (29.1 × 18.4 cm)
Department of Graphic Arts, INV 2354
Minneapolis only

BIBLIOGRAPHY: Dominique Cordellier, *Pisanello, le peintre aux sept vertus*, exhibition catalogue, Paris, 1996, cat. 132.

80

Antonio Pisanello
Italian, ca. 1395–1455?

*Two harnessed horses, one seen from the front, the
other from behind*

Pen and ink, gray and brown wash, and white highlights over a black
chalk (or metalpoint) preparatory drawing
7¹³⁄₁₆ × 6½ inches (19.9 × 16.5 cm)
Department of Graphic Arts, INV 2468
Atlanta only

BIBLIOGRAPHY: Dominique Cordellier, *Pisanello, le peintre aux
sept vertus*, exhibition catalogue, Paris, 1996, cat. 116.

81

Antonio Pisanello
Italian, ca. 1395–1455?

Four egrets in flight

Pen and ink
6½ × 9¾ inches (16.5 × 24.7 cm)
Department of Graphic Arts, INV 2469
Atlanta only

BIBLIOGRAPHY: Dominique Cordellier, *Pisanello, le peintre aux sept vertus*, exhibition catalogue, Paris, 1996, cat. 153.

82
Antonio Pisanello
Italian, ca. 1395–1455?

Fourteen white herons

Pen and ink with green wash on parchment
7⅛ × 10⅝ inches (18.1 × 27 cm)
Department of Graphic Arts, INV 2472
Minneapolis only

BIBLIOGRAPHY: Dominique Cordellier, *Pisanello, le peintre aux sept vertus*, exhibition catalogue, Paris, 1996, cat. 158.

83

Antonio Pisanello
Italian, ca. 1395–1455?

*Seven seated monkeys. A peacock in
profile to the left*

Pen and ink; some red chalk wash
10³⁄₁₆ × 7³⁄₁₆ inches (25.9 × 18.2 cm)
Department of Graphic Arts, INV 2389
Atlanta only

BIBLIOGRAPHY: Dominique Cordellier,
Pisanello, le peintre aux sept vertus, exhibition
catalogue, Paris, 1996, cat. 197.

84

Antonio Pisanello

Italian, ca. 1395–1455?

Dead peewit with spread wings

Watercolor, white gouache partly oxidized, pen and ink over
a metalpoint preparatory drawing
6³⁄₁₆ × 11³⁄₈ inches (15.7 × 28.9 cm)
Department of Graphic Arts, INV 2465
Atlanta only

BIBLIOGRAPHY: Dominique Cordellier, *Pisanello, le peintre aux
sept vertus*, exhibition catalogue, Paris, 1996, cat. 234.

85

Antonio Pisanello

Italian, ca. 1395–1455?

Three views of a male titmouse

Watercolor, pen and ink, white highlights partly oxidized, on parchment
4⅝ × 6⅛ inches (11.8 × 15.5 cm)
Department of Graphic Arts, INV 2476
Atlanta only

BIBLIOGRAPHY: Dominique Cordellier, *Pisanello, le peintre aux sept vertus*, exhibition catalogue, Paris, 1996, cat. 230.

86

Antonio Pisanello
Italian, ca. 1395–1455?

*Hunting hawk hooded and perched on a gloved
left hand*

Pen and ink, brown wash and watercolor, white highlights, over
a black chalk preparatory drawing
9⅜ × 5⁵⁄₁₆ inches (23.7 × 15.1 cm)
Department of Graphic Arts, INV 2453
Minneapolis only

BIBLIOGRAPHY: Dominique Cordellier, *Pisanello, le peintre aux
sept vertus*, exhibition catalogue, Paris, 1996, cat. 166.

87

Antonio Pisanello
Italian, ca. 1395–1455?

Three studies of a cat's head. Eight studies of plants

Metalpoint on parchment
3¾ × 12 inches (9.5 × 30.5 cm)
Department of Graphic Arts, INV 2381
Atlanta only

BIBLIOGRAPHY: Dominique Cordellier, *Pisanello, le peintre aux sept vertus*, exhibition catalogue, Paris, 1996, cat. 205.

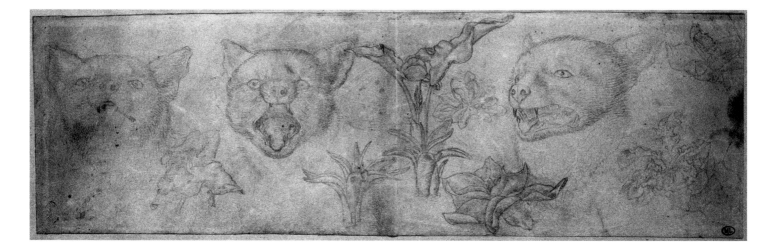

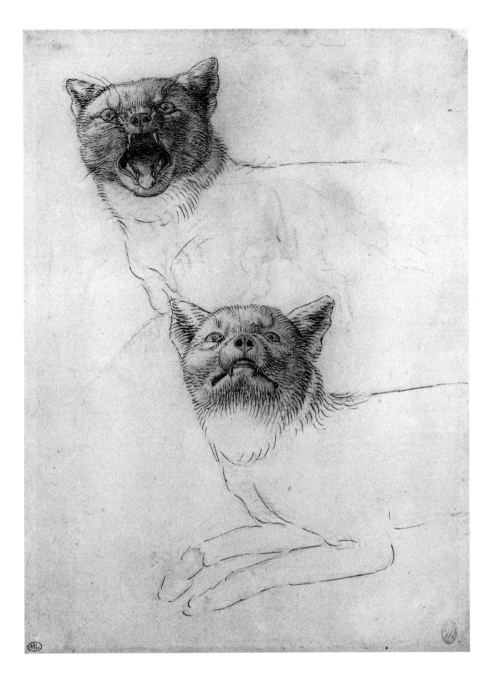

88

Workshop of Pisanello

*Two studies of a cat's head. Light sketch of a fox
in profile*

Pen and ink, brown wash over a black chalk preparatory drawing
9⅞ × 7 inches (25.1 × 17.9 cm)
Department of Graphic Arts, INV 2418
Atlanta only

BIBLIOGRAPHY: Dominique Cordellier, *Pisanello, le peintre aux
sept vertus*, exhibition catalogue, Paris, 1996, cat. 206.

89
Anonymous Lombard Artist
Lombardy, late 14th century

Three hunting dogs

Pen and ink, watercolor, and white highlights on parchment
10 × 6¹¹⁄₁₆ inches (25.3 × 17 cm)
Department of Graphic Arts, INV 2568
Atlanta only

BIBLIOGRAPHY: Dominique Cordellier, *Pisanello, le peintre aux sept vertus*, exhibition catalogue, Paris, 1996, cat. 181.

90
Antonio Pisanello, after a Lombard model sheet
Italian, ca. 1395–1455?

Three hunting dogs

Pen and ink with brown wash over a black chalk preparatory drawing
10¹¹⁄₁₆ × 7¹¹⁄₁₆ inches (27.2 × 19.5 cm)
Department of Graphic Arts, INV 2547
Atlanta only

BIBLIOGRAPHY: Dominique Cordellier, *Pisanello, le peintre aux sept vertus*, exhibition catalogue, Paris, 1996, cat. 182.

91

Antonio Pisanello

Italian, ca. 1395–1455?

Profile of a greyhound standing to the right

Watercolor, pen and ink over a black chalk preparatory drawing
7¼ × 9⅝ inches (18.3 × 24.5 cm)
Department of Graphic Arts, INV 2433
Minneapolis only

BIBLIOGRAPHY: Dominique Cordellier, *Pisanello, le peintre aux sept vertus*, exhibition catalogue, Paris, 1996, cat. 196.

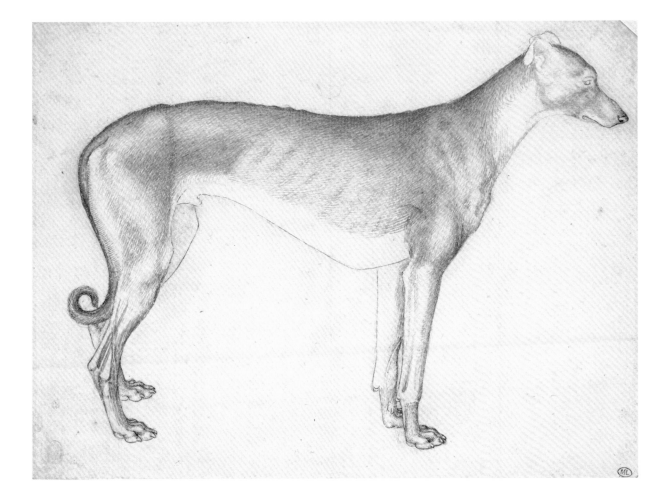

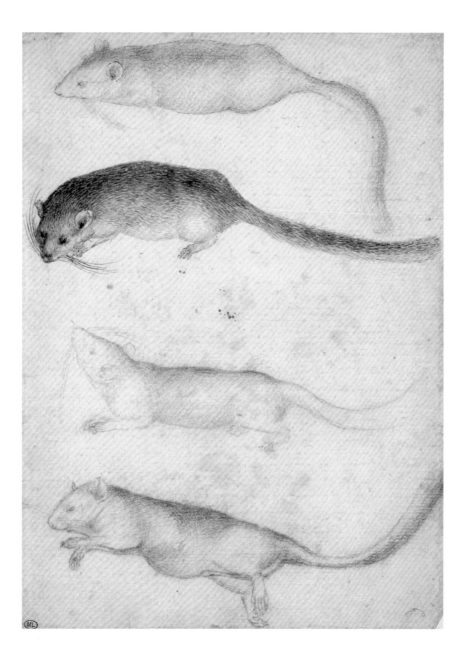

92

Antonio Pisanello
Italian, ca. 1395–1455?

Four views of a dormouse

Black chalk, pen and ink, pink wash, and oxidized white highlights
over a black chalk preparatory drawing
10¹⁄₁₆ × 7⅛ inches (25.5 × 18.1 cm)
Department of Graphic Arts, INV 2387
Minneapolis only

BIBLIOGRAPHY: Dominique Cordellier, *Pisanello, le peintre aux
sept vertus*, exhibition catalogue, Paris, 1996, cat. 250.

93
Antonio Pisanello
Italian, ca. 1395–1455?

*Design for a tapestry with an emblematic tree and
the Catalan motto "Guarden les Forces"*

Pen and ink with brown wash over a black chalk preparatory drawing
8⅜ × 11³⁄₁₆ inches (21.2 × 28.4 cm)
Department of Graphic Arts, INV 2538
Atlanta only

BIBLIOGRAPHY: Dominique Cordellier, *Pisanello, le peintre aux
sept vertus*, exhibition catalogue, Paris, 1996, cat. 309.

94

Attributed to Desiderio da Settignano

Italian, ca. 1430–1464

Saint John the Baptist, ca. 1455

Marble bust
19¾ × 15 × 8⅝ inches (50.2 × 38.2 × 22 cm)
Department of Sculptures, RF 679

HISTORY: Bequeathed by Albert Goupil in 1884, with a plinth in rosso levanto marble, decorated with bronze reliefs, and bearing the inscription: *DONATELLI OPVS* (Work of Donatello).

BIBLIOGRAPHY: *Desiderio da Settignano. Sculpteur de la Renaissance florentine,* exhibition catalogue, ed. Marc Bormand, Beatrice Paolozzi Strozzi, and Nicholas Penny, Paris and Milan, 2006, no. 3, pp. 132–137.

Fig. 1. Bust on plinth identifying it as the work of Donatello.

In the 1450s the representation of Saint John the Baptist as a child or adolescent became very popular in Florence, especially in the form of a bust. A particular type of devotion began to develop during this period that would lead to the production of a large number of youthful images of the patron saint of Florence. It is true that in the late nineteenth century some of these busts were associated with the sculptor Desiderio da Settignano (or with his contemporary Antonio Rossellino), but since the Renaissance most had been attributed to Donatello. The renown of the greatest sculptor of the fifteenth century had indeed almost never been eclipsed.[1]

The sixteenth century saw the beginning of art history with Vasari's *Lives of the Most Excellent Painters, Sculptors and Architects,* first published in Florence in 1550. Vasari accorded a large place to Donatello, describing him as "an unusually fine sculptor and marvellous statue-maker." Unlike many of his contemporaries, Donatello was never forgotten in the seventeenth and eighteenth centuries, and indeed there was a tendency to attribute almost all of the best sculpture of the first Florentine Renaissance to him. The publication of Leopoldo Cicognara's *History of Sculpture*[2] at the beginning of the nineteenth century opened a new period of glory for the great sculptor that would continue throughout the century. He was acclaimed for having attained the sublime through his combination of simplicity and expression. When Girolamo Torrini sculpted a Donatello for the outside décor of the Uffizi Gallery in Florence, he placed at the feet of the statue

the relief of *Saint John the Baptist as a Child.* This relief was in the Uffizi at the time, where it was attributed to Donatello (today in the Bargello Museum in Florence, attributed to Desiderio da Settignano).

During the Romantic period, Donatello was appreciated for the graceful style of his works, whereas in the second half of the nineteenth century, especially in France, more importance was attached to the psychological aspects of the artist's realism. In his 1885 monograph on Donatello, Eugène Müntz presented the artist as a creator who had been enabled through Christianity to emphasize the importance of moral beauty and to express emotions: "The gay, almost ironic tone is as familiar to Donatello as the serious, emotional note."[3] This contrast is well reflected in the pedestal of the bust of *Saint John the Baptist* (fig. 1). The motif of the two putti bearing garlands depicted on the front of the bronze relief between the rosso levanto marble moldings and on the sides reflects the grace and lightness of touch attributed to Donatello. The same qualities are also to be seen in the two *spiritelli* originally owned by Eugène Piot, who subsequently sold them to Edouard André in 1893 (Paris, Musée Jacquemart-André). This motif is therefore helpful in reassessing the spirit of the bust. Eugène Piot regretted that it presented "a naturalism sometimes taken to extremes, which gives no idea of the perfect grace and amiableness—if I may use this word—which distinguishes his works."[4] The 1880s proved to be a period in which Donatello's celebrity reached an apogee, culminating in 1886 with the five-hundredth anniversary of his birth, an event celebrated by numerous publications.

The Louvre bust continued to be attributed to Donatello until 1942, when Leo Planiscig suggested in his book on Desiderio da Settignano that it had been sculpted not by Donatello, but by his famous disciple.[5] In the recent exhibition on Desiderio, the bust was placed next to the great *Martelli Saint John the Baptist* (Bargello Museum, Florence), and the similarities in expression between the two works became obvious. Although we need to keep in mind the complexities of the *Martelli Saint*

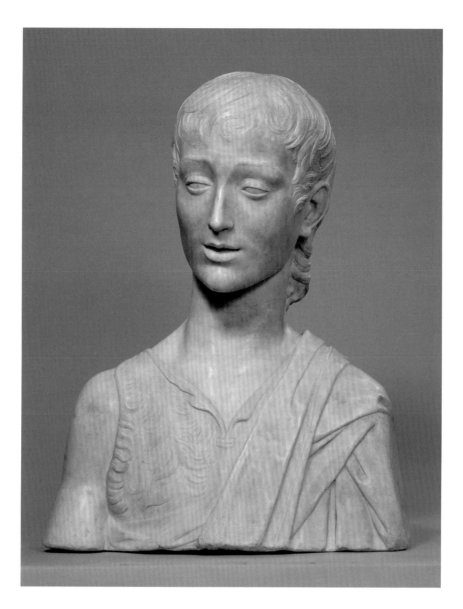

John the Baptist, which may have been started by Donatello and finished by Desiderio, it seems clear that the two busts share the same fleeting, melancholic expression—one that can also be detected on other sculptures by Desiderio, such as the *Young Hero*, now in the Musée Jacquemart-André in Paris. Rather than accepting the recently suggested attribution of the bust to Gregorio di Lorenzo, a follower of Desiderio's,[6] it seems more probable that the subtle expression, the particularly soft modeling of the face, and the delicate balance between the rigorous volumes and the supple underlying areas of the ascetic saint's flesh should encourage us to continue to attribute this bust to Desiderio da Settignano.

The existence of two copies in polychrome stucco and a third in stucco are testimony to the great celebrity of this work.

MARC BORMAND

NOTES

1. For the evolution of Donatello's reputation, see Giancarlo Gentilini, "Riflessioni sulla fortuna donatelliana," in *Donatello fra sette e ottocento*, Sala della Cortaccia, *Omaggio a Donatello 1386–1986. Donatello e la storia del Museo*, exhibition catalogue, Bargello National Museum, Florence, 19 December 1985–30 May 1986, ed. P. Barocchi, M. Collareta, G. Gaeta Bertelà, and B. Paolozzi Strozzi, 1985, pp. 365–389.

2. L. Cicognara, *Storia della Scultura dal suo risorgimento in Italia sino al secolo di Napoleone, per servire di continuazione alle opere di Winckelmann e di D'Agincourt*, Venice, vol. II, 1816.

3. E. Müntz, *Donatello*, ed. J. Rouam, Librairie de l'art, Paris, s.d. [1885], p. 112.

4. E. Piot, "Exposition universelle: la sculpture à l'exposition rétrospective du Trocadéro," in *Gazette des Beaux-Arts*, vol. XLIII, December 1878, p. 583.

5. L. Planiscig, *Desiderio da Settignano*, Vienna, 1942.

6. A. Bellandi, lecture given at the conference on Desiderio da Settignano, Florence, 10 May 2007, Kunsthistorisches Institute, and book in press.

95

Lorenzo Lotto
Italian, ca 1480–1556

Christ Carrying the Cross, ca. 1526

Oil on canvas
26 × 23⅜ inches (66 × 60 cm)
Signed and dated on lower right: *Laur. Lotus 1526*
Department of Paintings, RF 1982-50

HISTORY: Purchased by the Musée du Louvre in 1982.

BIBLIOGRAPHY: André Chastel, "*Le Portement de croix* de Lorenzo Lotto," in *Revue du Louvre* 4, 1982, pp. 266–271; Sylvie Béguin, "Le Christ portant sa croix," in *Le siècle de Titien: l'âge d'or de la peinture à Venise*, Galeries Nationales du Grand Palais, Paris, 9 March–14 June 1993, no. 153, pp. 148–149; Peter Humfrey, "*Christ Carrying the Cross*," in *Lorenzo Lotto: Rediscovered Master of the Renaissance*, National Gallery of Art, Washington, D.C., 2 November 1997–1 March 1998, New Haven, 1997, no. 27, pp. 157–160.

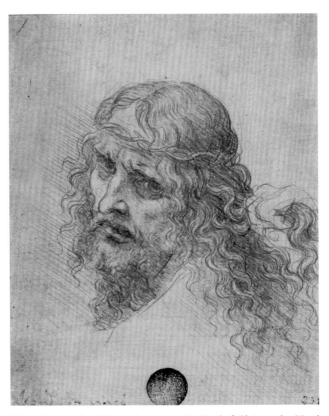

Fig. 1. Leonardo da Vinci (1452–1519), *Head of Christ and a Hand Grasping His Hair*, pen and ink, Accademia Gallery, Venice.

The unexpected reappearance of Lotto's *Christ Carrying the Cross* in the early 1980s occurred in the most remarkable circumstances. The forgotten painting lay stacked away in the attic of the Convent of the Congregation Saint Charles Borromée until it was purchased by an antique dealer at a ridiculously low price. When the new owner, a restorer of antique furniture, proceeded to clean the layers of dirt on the canvas, he discovered a signature and date: *Laur. Lotus 1526*. This was the authentic mark of the Venetian master, who frequently signed his paintings between 1520 and 1530, and the work was thus established as a masterpiece of Italian painting. Despite the enormous interest provoked by the discovery, the Louvre did not immediately purchase the painting, and it was only in 1982 that the *Christ Carrying the Cross* became part of the museum's prestigious collection of Venetian paintings.

The position of the inscription, strangely directed toward the figure of Christ, is the artist's pious homage and affirms his lifelong devotion to Catholicism. His particular attachment to the spirituality of the Dominicans undoubtedly permeated his understanding of the Passion, which was one of the most important themes for the Order. When he returned to Venice in 1525 after a twelve-year absence, Lotto stayed in the Dominican convent of Santi Giovanni e Paolo. This Road to Calvary painting depicts the moment when Jesus was beaten by his executioners and fell under the weight of the cross. The resignation, pain, and exhaustion shown in Christ's expression contrast with the violence and brutality of the Roman soldiers. Though the humanity of the Savior is clearly evoked, the effects of shadow and light as well as the three rays of light around his face suggest his divine nature.

Though the tight framing of the composition is unusual, it was not an innovation of the Cinquecento. This half-figure representation—a popular mode in both northern Italy and Lombardy—accentuates the drama in the image and reinforces its emotional impact. Many artists subsequently adopted this type of composition, and it was widely diffused through block engravings. Lotto drew much inspiration from Leonardo da Vinci (fig. 1), from whom he borrowed the hand gripping Christ's hair and Christ's tormented expression. But Lotto reinterpreted the motif and made it his own, thus creating a dramatic and moving effect. Lotto's painting differs from contemporaneous versions by Andrea Solario (Galleria Borghese, Rome) and Titian (Scuola di San Rocco, Venice), and is more strongly influenced by the style of Northern painting: the soldiers' deformed faces reflect those

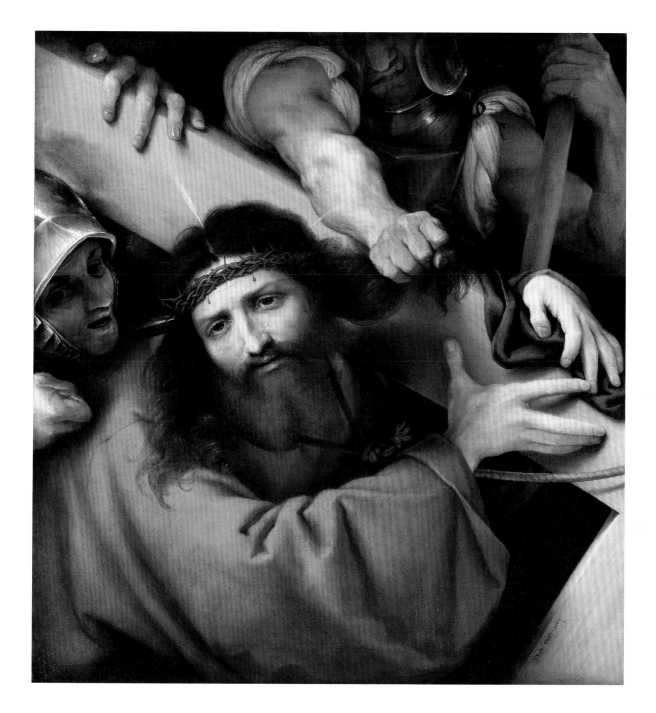

of the Flemish artist Hieronymus Bosch, the attention to detail shows Lotto's admiration for Rogier van der Weyden, and the drapery is directly inherited from Albrecht Dürer.

Lorenzo Lotto made a significant contribution to Renaissance art, setting himself apart from the movement largely dominated by Titian. The particularity of his work derives from his ability to combine and adapt different influences without attaching himself to any one style. The distinct characteristics of his approach—the use of contrasting light and shade, saturated colors, and affected attitudes—position his art between tradition and modernity. Although he was highly thought of by his patrons in northern Italy, Lotto did not enjoy the same celebrity in Venice. Through his rediscovery in the nineteenth century by the art historian and collector Bernard Berenson, and retrospective exhibitions devoted to him in Venice (1953) and Washington (1997), Lotto now occupies the place he deserves in the pantheon of Venetian artists.

STÉPHANIE LARDEZ

96

Johannes Vermeer
Dutch, 1632–1675

The Astronomer, 1668

Oil on canvas
Signed and dated
19¹¹⁄₁₆ × 17¾ inches (50 × 45 cm)
Department of Paintings, RF 1983-28

HISTORY: Acquired by the Louvre in 1983.

BIBLIOGRAPHY: Jacques Foucart, "*L'Astronome de Vermeer: Musée du Louvre, département des Peintures*," in *Revue du Louvre* 33 (1983), pp. 280–281; JoLynn Edwards, "*La curieuse histoire de L'Astronome de Vermeer et de son 'pendant' au XVIIIᵉ siècle*," in *Revue du Louvre* 36 (1986), pp. 197–201; Walter Liedtke, *A View of Delft. Vermeer and his Contemporaries*, Zwolle, 2000, p. 320; Klaas van Berkel, "Vermeer and the Representation of Science," in *The Cambridge Companion to Vermeer*, Cambridge, 2001, pp. 131–139.

The Astronomer is a work from the Delft master's mature period that reveals the new approach he brought to the previously employed treatment of a specific genre scene, that of a scholar at work—as illustrated, for example, in numerous German and Italian Renaissance representations of Saint Jerome in his study, not to mention Rembrandt's etching of *Faust*. Vermeer's painting depicts a well-proportioned, dark-haired man manipulating a celestial globe at a table covered with a heavy, ornate rug or *verdure*, a tapestry with a floral motif. Although the scene takes place in a room lit by the clear day-light coming through a window on the left, the viewer can only guess at the accessories and different objects in the room—books, a map, dividers, a painting on the wall and an astrolabe. The atmosphere emanating from the picture is one of delicately fused contemplation, mystery, and industry.

The elusive profile of the person represented (many attempts have been made to identify the sitter but the mystery pervading the work remains), the stained-glass window masked by a piece of furniture, the view of the metal instrument on the table obscured by the folds of the rug, and the painting on the wall cut off by Vermeer's compositional artistry all contribute to the enigma of the work. This enigma, it is true, is compounded by

two historical phenomena: the strange fascination exercised by Vermeer, a painter who had more or less fallen into oblivion until his rediscovery in the nineteenth century, and the para-doxical situation of a work manifestly intended to form a pair with *The Geographer* (fig. 1), from which it is now separated.

We could easily be misled by the celebrity the painting now enjoys. It is true that Vermeer was never totally forgotten, but it would be no exaggeration to say that the idea which eighteenth- and early-nineteenth-century art lovers (and even historians) had of his art was, to say the least, extremely vague. Though the Dutch themselves justifiably maintain that the resurgence of Vermeer's reputation first began in the artist's own country as early as the 1810s, the honor of bringing the artist back into the forefront must nevertheless be attributed to a Frenchman, Théophile Thoré (*alias* William Bürger). This great connoisseur (fig. 2) and author of numerous articles and commentaries on the private and public collections he visited in France and thoughout Europe became a fervent defender of Vermeer. With his 1866 monograph on the painter, *Van der Meer de Delft*, he set his seal to the master's rediscovery.

The reasons behind Thoré's enthusiasm for a painter whose name would have only raised the eyebrows of his contemporaries

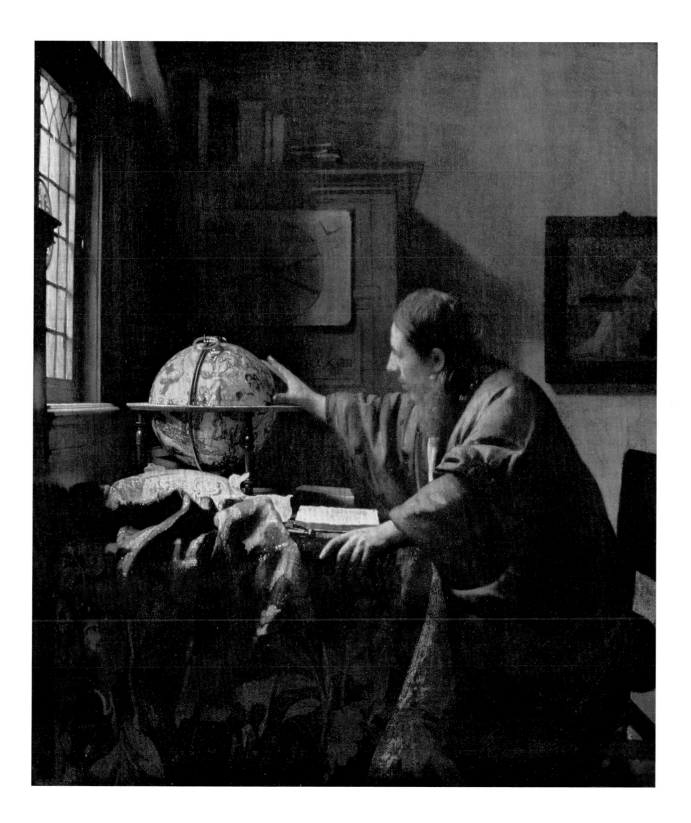

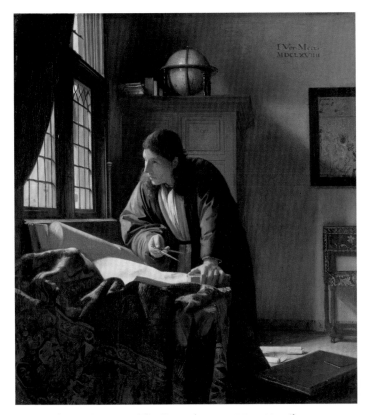

Fig. 1. Johannes Vermeer, *The Geographer*, ca. 1668–1669, oil on canvas, 20⁵⁄₁₆ × 17⅞ inches (51.6 × 45.4 cm), Städelsches Kunstinstitut, Frankfurt am Main.

Fig. 2. Portrait of Théophile Thoré (William Bürger)

are significantly different from those underlying the admiration surrounding Vermeer's paintings today. Thoré was a convinced republican and had been forced into exile in 1849, following the period of revolutionary unrest in Europe known as the "Spring of Nations." Thoré saw in Vermeer's art the dignified and humane depiction of humble people carrying out their daily tasks. He believed that Vermeer's quality lay in his capacity to render in all its nobility the lives of those who had to be content with their mundane lot. The characteristics we now most often associate with the Dutch painter's work—the sense of mystery, an elusive enigmatic quality that infuses an innate sense of purity, a form of discreet but masterly restraint that bestows a unique flavor on all Vermeer's paintings—were seen by Thoré as drawing their profound quality from an ennobling vision of the human condition.

With the passing of time, Thoré's intuitive appreciation of Vermeer has been reduced to its just proportions, and today appears more as evidence of the preoccupations of a man living under the Second Empire of Napoleon III than a reflection of the ideas harbored by an inhabitant of seventeenth-century Delft. Nevertheless, Thoré not only accomplished the extraordinary feat of bringing to the public's attention one of the greatest artists of the Dutch Golden Age, but also sparked the subsequent

French interest in Vermeer during the nineteenth century that led to an unprecedented development in taste for the Dutch school of painting. It is indeed one of the great paradoxes of art-collecting history that the furor and excitement caused in Europe by the rediscovery of Vermeer was to result in the transfer to the United States of the last of the artist's masterpieces still available on the European market.

It is precisely due to the hazards of the art market that Vermeer's *Astronomer* and *Geographer* are now in two different European countries. At the end of the eighteenth century, the two paintings were presented to the Comte d'Angiviller, the King's Directeur-Général des Bâtiments, with a view to their entering King Louis XVI's art collection. The importation of these works from Holland would have enabled France to purchase two great masterpieces by Vermeer. Today it would be unthinkable to let slip such an opportunity. However, the two paintings in the manner of a diptych were not selected to figure on the list of works destined to become Crown possessions, perhaps because of the financial difficulties faced by the Royal Treasury at the time.

The presence of *The Astronomer* in the Louvre since the 1980s thus takes on particular significance, one enjoyed by few other

major works in the museum. How can we interpret such singular import? As a well-merited turn of the tables, retaliation for the shortcomings and incompetence of the ancien régime? A symbol of the fragility of cultural heritage, bandied about from sale to sale and finally reaching safe haven in the museum? A remarkable episode in the changing appreciation of the "Delft sphinx," testifying to a period when the master's works could still be purchased and, what is perhaps even more noteworthy, reminding us of an age when it was possible to fail to buy them without causing a scandal in the press?

The history of *The Astronomer* of the Louvre takes us back to a time when Vermeer did not figure in the pantheon of great artists in the West (and even less so in that of the rest of the world—we need only reflect on the emotion provoked today by the sojourn of a Vermeer painting in Japan). It reminds us of the constructed character of the favor which is now so unrestrainedly accorded to dead artists—an undeniable phenomenon, yet one which is continually forgotten by a public in search of icons.

BLAISE DUCOS

97

Georges de La Tour

French, 1593–1652

The Card-Sharp with the Ace of Diamonds, 17th century

Oil on canvas
41 11/16 × 57½ inches (106 × 146 cm)
Signed at bottom in middle: *Georgius De La Tour fecit*
Department of Paintings, RF 1972-8

HISTORY: Discovered in Paris by the tennis player and collector Pierre Landry in ca. 1925–1930; acquired by the Louvre in 1972.

BIBLIOGRAPHY: Philip Conisbee, ed., *Georges de La Tour and His World*, exhibition catalogue, National Gallery of Art, Washington, D.C., and Kimbell Art Museum, Fort Worth, Texas, 1996–1997; Jean-Pierre Cuzin and Pierre Rosenberg, eds., *Georges de La Tour*, exhibition catalogue, Galeries nationales du Grand Palais, Paris, 1997; Jean-Pierre Cuzin and Dimitri Salmon, *Georges de La Tour. Histoire d'une redécouverte*, Paris, collection "Découvertes Gallimard," Réunion des Musées nationaux, Paris, 1997.

Fig. 1. Georges de La Tour, *The Card-Sharp with the Ace of Clubs*, Kimbell Art Museum, Fort Worth, Texas.

Today Georges de La Tour is the seventeenth-century French painter best known to the general public. He is more popular than Poussin, and whenever one of his rare masterpieces appears on the market—only about sixty paintings are known—museums all over the world fight to obtain it. Yet less than a century ago his name meant virtually nothing, even to painting specialists. It was only in 1914, at the very beginning of the First World War, that the German art historian Hermann Voss devoted a short study to La Tour. For the first time, Voss attributed to the artist a number of pictures in French museums which until then had been thought to be by various other painters ranging from Velázquez to Le Nain.

The intriguing aspect of La Tour's pictures is the lighting—usually emanating from a candle or a lantern—which highlights the serene, silent, and profoundly humane figures and seems to make them almost rise out of their nocturnal environment. At the beginning of the twentieth century, the public was not only moved by the intense spirituality of La Tour's work, but felt a natural sympathy for the simple shapes he depicted, forms which appeared to have much in common with the geometrical values of the painting of the time. In 1934 an innovative exhibition in

Paris focused on these "painters of Reality," and this time the Le Nain brothers, the main representatives of the movement, were joined and even surpassed by Georges de La Tour. It was also realized on this occasion that, in addition to his "nocturnal" paintings, the still mysterious painter had produced "diurnal" pictures bathed in daylight. La Tour's beautifully written signature can indeed be found on both diurnal and nocturnal works. The masterpieces of the diurnal type are *The Fortune Teller* from the Metropolitan Museum of New York and *The Card-Sharp* from the Louvre.

The action of *The Card-Sharp* takes place in a tavern, a "place of perdition." Three people sit around a table playing cards. On the right a young man is portrayed in profile; richly dressed and obviously from a good family, he is quite clearly about to become the victim of the older man sitting opposite, shown withdrawing an ace of diamonds from under his belt. The cheat is depicted against the light; he looks out cunningly and almost seems to be involving the viewer in his dishonesty. A courtesan seated between the two men and facing the viewer appears to be acting in collusion with the servant, who proffers a glass of wine.

Although this genre painting appears to depict a scene from everyday life, it bears a moral similar to the parable of the Prodigal Son: the game of cards, the wine, and venal love are all assembled here to bring about the ruin of naïve youth. This type of scene first appeared in the art of Caravaggio, an artist of genius who initiated a realist movement characterized by the use of violent and dramatic lighting to set off the depiction of figures taken from the populace. The Caravaggio movement of the early seventeenth century attracted many painters from all over Europe to Rome. We do not know if La Tour ever made the journey to Italy, but it is clear that even in his native Lorraine he knew of and reflected upon this veracious and often violent art. But the paintings he produced in this vein had their own mysterious, profound meaning, combined with a strange, troubling sense of poetry—characteristics which were, and have remained, quite distinctive in the history of art.

The Kimbell Art Museum of Fort Worth, Texas, has another version of this composition titled *The Card-Sharp with the Ace of Clubs* (fig. 1), which was executed before the Louvre example. When La Tour painted the latter he made a number of changes, notably the three "negative" figures placed tightly together on the left, isolating their victim on the right.

SYLVAIN LAVEISSIÈRE

98
Jean Regnaud
French, known active 1679–1697

The Victory at Saint-Gothard, ca. 1686

Bronze
30½ inches (77.5 cm) in diameter
Department of Sculptures, RF 4751

HISTORY: Medallion commissioned in 1686 for the Place des Victoires; acquired by the State for the Louvre in 2006, sponsored by Elior.

BIBLIOGRAPHY: Geneviève Bresc-Bautier, "La Victoire de Saint-Gothard, médallion de la place des Victoires (1686)," in *Revue du Louvre,* October 2007, pp. 15–18.

Fig. 1. The Place des Victoires.

The Louvre's acquisition of this magnificent medallion—since declared a "national treasure"—has led to a significant change in the appreciation of Jean Regnaud. Before, the sculptor had been just a name on a contract, an artist known only for his participation in the Place des Victoires project in Paris, whereas this great masterpiece evokes the grandiose decoration commissioned by a courtesan in honor of King Louis XIV.

The medallion comes from a lighting column originally in the Place des Victoires. François, Duc de La Feuillade, was behind the construction of this grand square, which he decided to have built next to his private mansion to pay homage to the king who had made him Marechal of France. The oval Place des Victoires was lined with townhouses designed by Jules Hardouin-Mansart and was marked in the center with a royal monument. The royal square centered on a statue honoring Louis XIV was the first in a long series built or planned in provincial towns—including Dijon, Rennes, Aix, Marseille, Toulouse, and Lyon—and was constructed before another Parisian royal square, the Place Vendôme.

The Dutch sculptor Martin Van den Bogaert, known as Desjardins (1637–1694), was made responsible for all the sculptural decoration of the monument commissioned in December 1681. Shortly after this date he ordered the statue to be cast; it represented the king standing and being crowned by Victory. It was placed on a high marble pedestal surrounded by a bronze decoration commissioned in April 1681. To make this urban project even more magnificent and to provide lighting for the square,

La Feuillade ordered the ornament engraver Berain to install four lampposts made of three columns each bearing large lanterns (fig. 1). The columns were made of different precious marbles, and the project stipulated that six medallions commemorating the glorious exploits of the king were to be placed on each column group. On 12 August 1686, La Feuillade concluded a contract with the sculptor Jean Regnaud and the founder Pierre Le Nègre for the execution of twenty-four bronze medallions, modeled after drawings by the painter Pierre Mignard, a friend of Desjardins. Only eleven medallions were made since the project was abandoned after La Feuillade died in 1691.

The medallion of *The Victory at Saint-Gothard* is one of the most surprising of the series. It celebrates a minor victory for Louis XIV. In 1664, faced with the threat of the Ottomans, who were beginning to seriously threaten central Europe, the king sent a detachment of 6,000 men with La Feuillade as second-in-command. Three armies—those of the Emperor, the Empire, and the League—came together to put a stop to the Turks' advance. The battle took place on 1 August 1664, not far from the Hungarian monastery of Saint-Gothard. The king had followed the campaign's progress with great enthusiasm and was delighted with the courage shown by the French army. It was one of the first victories that La Feuillade chose to celebrate more than twenty years later, for he considered himself responsible for it. The medallion commemorates the event in allegorical form. The winged figure of Victory stands holding a large palm while she tramples underfoot trophies depicting oriental elements,

including turbans and scimitars, a curved bow, and a flag with Turkish crescents.

The medallions were executed after drawings by Mignard. This was a period when Charles Le Brun's star was waning at court, while Mignard was on the rise and was soon to be named First Painter to the King in 1690. The merit for the quality of the casting and chiseling must go to the caster Le Nègre, who had previously worked at Versailles. But we should not underestimate the role played by Jean Regnaud. The medallions by Mignard and Regnaud reveal the complementary nature of painting and sculpture, for if Mignard designed the composition in two dimensions, it was Regnaud who organized the third dimension, the smooth modeling, and the subtle gradation which gives movement and cohesion to the piece. The *Victory* is a very sculptural figure: the large outspread wings stand out against the smooth, flat background; the classical drapery shows graceful movement, and the face has a slight smile; the subdued turning of the figure gives a particular dynamism to the composition. The body, especially the breasts, can be distinguished beneath the wind-blown drapery.

Jean Regnaud did not receive the attention he deserved until very recently, probably as a result of a series of misunderstandings. On the 1686 contract, the notary mistakenly called him Arnould, although Regnaud signed with his own name at the bottom of the document. Moreover, we know that at the beginning of his career he adopted a name linked with his origins—a common practice among sculptors—and was thus known as Jean de Champagne, or "Sciampagna," in its Italian form. In 1679 he was admitted to the French Academy in Rome, and during his training executed the stucco decoration for the high altar of the Church of La Trinité-des-Monts, statues for the noviciate of the Jesuits and for the Gesu Church, and a bust of Louis XIV. Upon his return to Paris he began executing the medallions for the Place des Victoires and also made a number of statues that have since disappeared. After working for the Cardinal of Rohan at Saverne, he went to Brest, where he took up a post as sculptor for the execution of sculpture on Navy vessels. His nomination to this post was probably owing to his friendship with Berrain, the designer of the lampposts. Regnaud could not have worked in Brest for very long, however, since we know that he was already there by 1691, but that he died on 18 April 1697. The post-mortem inventory of his affairs indicates that he had a profound knowledge and appreciation of contemporary Italian culture. In addition to a large number of drawings, his collection included architectural designs and engravings and clay, wax, and plaster models, several of which were after Bernini, Mocchi, and Algardi.

The medallions of the Place des Victoires constitute a major work of French classicism. This ensemble in praise of the king is the equal in sculpture to the paintings of the Galerie des Glaces at Versailles. The medallion of the *Victory at Saint Gothard* provides a historiographic landmark for the reign of Louis XIV and is a major step in the rediscovery of the sculptor Jean Regnaud.

GENEVIÈVE BRESC-BAUTIER

99
Jean-Siméon Chardin
French, 1699–1779

The House of Cards, ca. 1735

Oil on canvas
30⁵⁄₁₆ × 26¾ inches (77 × 68 cm)
Department of Paintings, MI 1032

HISTORY: Bequeathed by Louis La Caze to the Musée du Louvre, 1869.

BIBLIOGRAPHY: Pierre Rosenberg and Renaud Temperini, *Chardin suivi du catalogue des oeuvres*, Paris, 1999, p. 238, no. 104; Sophie Eloy in Guillaume Faroult, ed., *La Collection La Caze. Chefs d'oeuvre des peintures des XVIIe et XVIIIe siècles*, Paris, 2007, CD-ROM, pp. 486–487.

Like the painting *Portrait of a Woman Holding a Booklet*, now attributed to Guillaume Voiriot (plate 101), *The House of Cards* comes from the Collection of Louis La Caze (1798–1869), a nineteenth-century art lover and collector renowned for his rediscovery of eighteenth-century French painting at a time when it was discredited and almost forgotten. During his lifetime, Jean-Siméon Chardin was a celebrated artist, much admired by even the most demanding of critics, including the philosopher Denis Diderot, but after his death his work was rapidly forgotten. Perhaps the down-to-earth subjects Chardin painted —predominantly still lifes and scenes from everyday life—had come to be thought trivial and secondary. In the early nineteenth century, very few of his pictures were exhibited in the Louvre, although some of his major works lay stacked away in the museum storerooms.

In the 1840s, thanks in part to the growing importance of Realism in painting—a movement whose most eminent representative was Gustave Courbet—Chardin came back into favor and once again the public gradually began to take an interest in him. In 1848 the critic and art historian Clément de Ris enthused over the rediscovery of "two great French painters of the eighteenth century, Watteau and Chardin, each of whom personifies a certain genre of painting, fantasy in the case of Watteau, reality in that of Chardin."

The picture from the La Caze Collection, dated to about 1735, is one of Chardin's first attempts to paint genre scenes of the lives of children in the tradition of seventeenth-century Dutch painting. When he undertook the painting of this very experimental work—which in our view cannot be classed as a masterpiece—Chardin's objective was to transform the ideal of classical beauty. By adopting a life-size format, in itself an ambitious decision, together with a simple composition favoring straight lines and a sober structure, he was striving to reveal the unpretentious but natural beauty of everyday life.

GUILLAUME FAROULT

100

Jean-Siméon Chardin
French, 1699–1779

*Child with a Top (Portrait of Auguste Gabriel Godefroy,
1728–1813)*, ca. 1738

Oil on canvas
26⅜ × 30 inches (67 × 76.2 cm)
Signed and dated: *Chardin* (date illegible)
Department of Paintings, RF 1705
Minneapolis only

HISTORY: Probably exhibited at the Salon of 1738 (no. 116); undoubtedly commissioned by Charles Godefroy (died in 1748), the father of the sitter; remained in possession of the sitter's family throughout the eighteenth and nineteenth centuries; acquired by the Louvre in 1907.

BIBLIOGRAPHY: Pierre Rosenberg and Renaud Temperini, *Chardin suivi du catalogue des oeuvres*, Paris, 1999, p. 242, no. 112; Pierre Rosenberg, *Chardin 1699–1779*, exhibition catalogue, Paris, Galeries Nationales du Grand Palais, 1979, pp. 239–241, no. 75.

Chardin exhibited this painting in 1738 at one of the very first Salons, the important art exhibition regularly held in Paris, which provided eighteenth-century artists with the possibility of making their works known to as wide a public as possible. The composition achieved considerable celebrity thanks to the engraving made of it by François-Bernard Lépicié in 1742. However, it was only in the nineteenth century that the painting was recognized as a masterpiece of the artist and of eighteenth-century French painting in general. In 1845, at a time when Chardin was completely unknown to the general public, a version of *Child with a Top* was sold for the notably high price of 605 francs at the sale of the collection of the Marquis de Cypierre (1784–1844), who was one of the first great discoverers of eighteenth-century painting. The most important critics of the day waxed lyrical over the work; the great art historian Théophile Thoré (1807–1869), for example, used these words to describe it in 1860: "this most delicate of paintings, clear in its flesh tints, deliciously light in its ensemble."

Tired as they were of the allegorical or mythological works that were soon to be stigmatized under the pejorative label of *art pompier*, contemporary commentators saw in Chardin the incarnation of a new ideal of perfection, an ideal of exact observation—in short, of "realism." This explains why the portrait of the young Auguste Gabriel Godefroy, the son of a prosperous jeweler and art lover, goes beyond the simple, factual dimension of genre painting. There is tenderness in Chardin's observation of the child's pensive attitude as he turns away from his books and irksome lessons to play quietly with a *toton* (the small unobtrusive top spinning on the table). The rendering of the clothes and accessories is precise but escapes the anecdotal; the different objects are represented in their entirety. In fact, they appear so real that in 1763 Denis Diderot was prompted to make this famous remark to the painter: "Oh Chardin! It's not white, red, or black that you grind on your palette: it is the very substance of objects, it is air and light that you take onto the tip of your brush and place on the canvas."

The composition of the painting is perfect, with predominance given to straight lines such as the edges of the table and the colored bands of the tapestry, which in turn serve to enhance the soft roundness of childhood and the delicate poetry of the boy's absorbed expression. At the time when they were painted, the sobriety of Chardin's portraits did not correspond with what contemporaries considered "great" history painting—painting essentially inspired by literature. But a century later, it was precisely because of this sobriety, with its perfectly rendered geometry, that Chardin's compositions—and this portrait in particular—came to be considered masterpieces of a silent and modest reality, one that was plebeian and no longer elitist. This simplicity allied with the faultlessly clear geometric arrangement of the shapes is the hallmark of Chardin's style. If we compare *Child with a Top* with the rest of the artist's production we realize that the painting has a supplementary element of poetry which might explain the masterpiece status it has enjoyed for over a century. In the contemplative and perfectly ordered world of Chardin, the little top implants a disturbing element as it progresses gracefully and hesitantly across the table, mischievously introducing imbalance and slight uncertainty. The absorbed gaze of the child settles on it, creating a fissure and opening a window onto the vast world of childhood dreams.

GUILLAUME FAROULT

101

Guillaume Voiriot

French, 1712–1799

Portrait of a Woman Holding a Booklet

Oil on canvas
31½ × 25⅝ inches (80 × 65 cm)
Department of Paintings, MI 1132

HISTORY: Bequeathed by Louis La Caze to the Musée du Louvre, 1869.

BIBLIOGRAPHY: Guillaume Faroult, *La Collection La Caze. Chefs d'oeuvre des peintures des XVIIe et XVIIIe siècles*, Musée du Louvre, Paris, 2007, p. 202, and CD-ROM, pp. 700–702.

This painting is today almost totally forgotten, yet in the nineteenth century it was considered one of the masterpieces of the Louvre's collection of portraits. It entered the Louvre in 1869 as part of a group of 583 paintings bequeathed by the collector and philanthropist Louis La Caze (1798–1869), an extraordinary man who devoted his entire life to collecting paintings in old styles which at the time were neglected by the Louvre. In this way he built up a magnificent collection of eighteenth-century French paintings, including major works by Jean-Antoine Watteau (1684–1721), Jean-Honoré Fragonard (1732–1806), and Jean-Siméon Chardin (1699–1779). After the French Revolution, all of these masters fell into oblivion, and only gradually came back into favor during the first half of the nineteenth century. Chardin, a specialist in unpretentious still-life paintings and the representation of intimate scenes of bourgeois life, was rediscovered from the 1840s onward, a period that coincided with the rise of the Realist school of painting, of which Gustave Courbet was to be the most eminent representative.

The *Portrait of a Woman Holding a Booklet* was first exhibited in 1848, when it was already in the possession of Louis La Caze. The painting was attributed to Chardin by La Caze on the grounds that it was probably the lost portrait of *Madame Lenoir Holding a Booklet*, which the painter had shown in the Salon of 1743, but which had since been lost. For those who rediscovered it in the nineteenth century, this painting combined several notable features: on the one hand it was surrounded by the aura of an unknown work by a forgotten master who had suddenly become famous again, and on the other it had undeniable intrinsic aesthetic qualities, including the refined but simple composition, the delicately harmonious combination of warm and cool colors—brown, white, and blue—and, above all, the slightly melancholic beauty of the model. The painting thus possessed the qualities and that small dose of mystery necessary for a masterpiece. But the subjective notion of what constitutes a masterpiece is a most fragile one. Indeed, while the painting was attributed to Chardin, it became very famous and was even considered the artist's finest portrait. But in 1881 Edmond de Goncourt, the great writer and leading specialist of the eighteenth century, proved that the La Caze painting could not be identified as Chardin's *Portrait of Madame Lenoir*. The traditional attribution was thus rejected, and the painting gradually fell into obscurity again.

An exhibition devoted to the Louis La Caze Collection was recently held at the Louvre, and for this occasion a detailed study of the painting was carried out. The sitter still remains unidentified, but the painting is now attributed to the French portraitist Guillaume Voiriot (recently rediscovered by art historians, in much the same way as Chardin himself was rediscovered 150 years earlier). Voiriot was in fact influenced by the sober composition of Chardin's portraits, and the *Portrait of a Woman Holding a Booklet* is one of his most striking works. The work is thus once again attracting the attention it so fully deserves.

GUILLAUME FAROULT

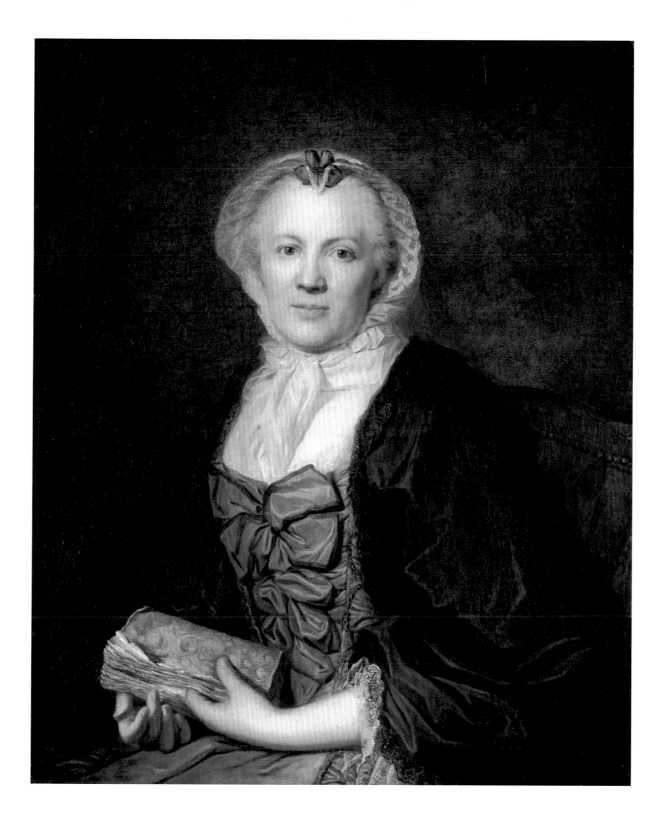

102

Franz Xaver Messerschmidt
Austrian, 1736–1783

Character head, between 1777 and 1783

Lead
16¼ × 8¼ × 8¼ inches (38.7 × 21 × 21 cm)
Incised on the right shoulder: *18*
Department of Sculptures, RF 4724

HISTORY: Part of Dr. Richard Beer-Hofmann's Collection, Vienna, confiscated by the Nazis during the Second World War. After 1939, exhibited at the Historiches Museum of Vienna. Returned to Dr. Hofmann's heirs in 2003. Acquired by the Louvre at Sotheby's sale, New York, January 27, 2005, no. 12 (with the support of the Société des Amis du Louvre and the Fonds du Patrimoine).

BIBLIOGRAPHY: Michael Krapf, ed., *Franz Xaver Messerschmidt 1736–1783*, exhibition catalogue, Barockmuseum of the Österreichische Galerie Belvedere, Vienna, 2002; Guilhem Scherf, "Une *Tête de caractère* de Messerschmidt au Louvre," in *La revue des Musées de France. Revue du Louvre 2*, April 2005, pp. 15–16; Robert Rosenblum, Sébastien Allard, Guilhem Scherf, et al., *Citizens and Kings: Portraits in the Age of Revolution 1760–1830*, exhibition catalogue, Paris and London, 2007.

 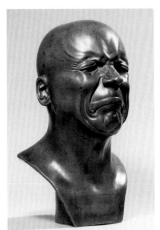

Fig. 1. Side view. Fig. 2. Three-quarter view.

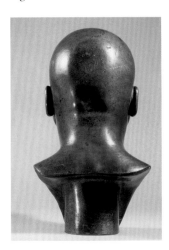

Fig. 3. Back view.

In 1793 an exhibition was held in Vienna of sixty-nine heads in alabaster and metal (lead and tin) created by Franz Xaver Messerschmidt, an artist who had died ten years before. The sculptor had once enjoyed a few brief moments of glory as a professor at the Imperial Academy of Vienna and as a portraitist —in an extremely traditional and grandiose style—to the Austrian royal family. In 1774, mental illness forced him to abandon his teaching responsibilities, and in 1777 he left Austria for Bratislava, where he lived as a recluse until his death. It was during this last period of activity that he created one of the most extraordinary series in the history of sculpture, the "Character heads." They were first called by this name at the 1793 exhibition; each was also given a title for the exhibition—the Louvre head, for example, was called *The Ill-Humored man* (*der Missmutige*)—and provided with a number incised into the bust. Each bust was also engraved with a label, the traces of which can just be made out below the neck. After the exhibition the heads were gradually dispersed, and over the years they were acquired by various institutions.

While living as a recluse in Bratislava, Messerschmidt started to believe that he was being persecuted and that he was in conflict with ghosts. He felt particularly tormented by the spirit of proportion, who wrenched and twisted the muscles of his face. In order to overcome his persecutor, the artist decided to reproduce the grimaces he was forced to make. In the words of Messerschmidt's fellow countryman Nicolai, "All these heads were his own self-portrait. . . . He looked at himself every half minute in the mirror and with the greatest precision made the faces he needed."[1] While living in Vienna, Messerschmidt had moved in circles that took an interest in magic and had made the acquaintance of Dr. Franz Anton Mesmer. The latter had developed a theory concerning the existence of a cosmic fluid which, he believed, would ensure good health if allowed to circulate freely through the body. Mesmer also believed that this fluid could be captured by magnets; it is possible that the strap placed over the lips of the Louvre *Character head* represents one such magnet.

Since the rediscovery of the sculptor and his strange personality by psychoanalysts in the 1930s,[2] the popularity of the

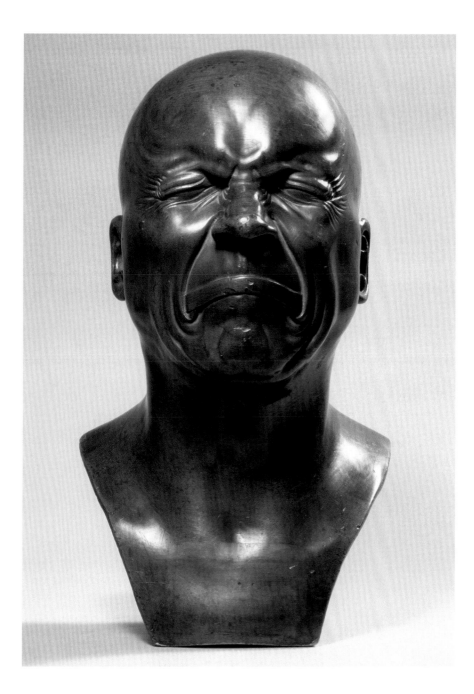

Character heads has never waned. They have been interpreted as the outward expression of the melancholic genius of the artist[3] and have been linked with a tormented aspect of the Age of Enlightenment, marked by spiritual tensions and research into the anatomy of the human face. They are carved in an extremely purist style, the forms are simplified, the surface beautifully polished and chased (figs. 1–3). Today Messerschmidt's *Character heads* have attained the status of masterpieces among both specialists and the general public.

GUILHEM SCHERF

NOTES

1. Quoted in M. Bückling, *Die phantastichen Köpfe des Franz-Xaver Messerschmidt*, exhibition catalogue, Liebieghaus, Frankfurt am Main, 2006, p. 320.

2. E. Kris, "Ein geisteskranker Bildhauer (Die Charakterköpfe des Franz Xaver Messerschmidt)," in *Imago, Zeitschfrift für psychoanalytische Psychologie, ihre Grenzgebiete und Anwendungen* 19, 1933, pp. 384–411.

3. R. and M. Wittkower, *Les enfants de Saturne. Psychologie et comportement des artistes, de l'Antiquité à la Révolution française*, London, 1963, trans. Paris, 1991.

103
John Martin
British, 1789–1854

Pandemonium, 1841

Oil on canvas
48⁷⁄₁₆ × 72⁷⁄₁₆ inches (123 × 184 cm)
Signed and dated in the lower right: "J. Martin 1841"
Department of Paintings, RF 2006-21

HISTORY: Acquired by the Musée du Louvre in 2006.

BIBLIOGRAPHY: Olivier Meslay, "John Martin ou le *Cauchemar de l'infini*," in *La Revue des musées de France. Revue du Louvre* 2, 2007, pp. 6–8.

The acquisition in 2006 of *Pandemonium* has not only significantly enriched the Louvre's collection of British paintings (which previously included none of John Martin's works) but has extended the museum's range of representations of beauty in European art. The painter John Martin was an eminent figure in the fantasy art movement—one of the important components of English painting from the 1780s to the middle of the nineteenth century—which included such singular artists as Henry Fuseli (1741–1825), William Blake (1757–1827), and Richard Dadd (1817–1886).

Following the publication in 1757 of "A Philosophical Enquiry into the Origin of Our Ideas of the Sublime and Beautiful" by the Irish philosopher Edmund Burke (1729–1797), British artists adopted the notion of the terrifying and terrorizing "sublime" in their attempt to transform the ideal of classical, harmonious, and serene beauty inherited from the Renaissance. Numerous representations of nightmares were painted by English artists in the late eighteenth century. By the 1810s John Martin had already taken up his own specialty—fantasy landscapes depicting the terrible fury of the elements, as revealed in floods, hurricanes, and other disasters. *Pandemonium* is typical of his paintings and is one of his most ambitious compositions inspired by a literary work. The painting illustrates a famous passage taken from *Paradise Lost*, the celebrated epic poem by John Milton (1608–1674) relating the conflict between God and the fallen angel Satan. Here, with one puff of air the prince of the devils conjures up a vast capital for his empire, "Pandemonium"—the

Fig. 1. Detail of frame.

Greek expression for the place of all devils. The painting portrays a gigantic imaginary building, in front of which the infinite multitude of the infernal army stretches out under a stormy sky. Amid torrents of lava and fire, Satan's troops advance toward their master, who stands to the right. Martin used a very dark, earthy palette, slightly streaked with bright red, and employed dense, opaque paint to accumulate coarse areas of thick matter. His intention was not to please but rather to provoke a powerful reaction of awe. In order to reinforce the impression of an opulent underworld, he designed a magnificently gilded frame, decorated with twisting serpents and terrifying dragons (fig. 1), which almost seem to erupt from the canvas and invade the spectator's space.

GUILLAUME FAROULT

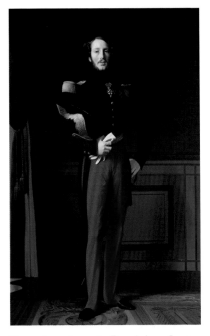

Fig. 1. Jean-Auguste-Dominique Ingres,
Portrait of Ferdinand-Philippe, Duke of Orléans,
Château de Versailles.

104

Jean-Auguste-Dominique Ingres

French, 1780–1867

Portrait of Ferdinand-Philippe-Louis-Charles-Henri
de Bourbon-Orléans, Duke of Orléans (1810–1842)

Oil on canvas
62³⁄₁₆ × 48 inches (158 × 122 cm)
Signed, lower left: *J. Ingres Pin.ᵗ Paris 1842*
Inscription, on the right: FERDINAND PHILIPPE D'ORLÉANS /
DUC D'ORLÉANS / PRINCE ROYAL / AVRIL 1842
Department of Paintings, RF 2005-13

HISTORY: Commissioned by the Duke of Orléans in 1840; delivered to
the sitter on 7 May 1842; in his collection until his death on 13 July
1842; collection of his widow and then by descent until its sale in 1986;
acquired by AXA and given to the Louvre in 2005.

BIBLIOGRAPHY: *Portraits by Ingres: Image of an Epoch*, exhibition catalogue,
London, Washington, D.C., New York, 1999–2000; Vincent Pomarède,
Ingres, exhibition catalogue, Paris, 2006, no. 108, pp. 277–285.

Portraits by Ingres constitute an excellent example of the
difficulties encountered when trying to define the notion
of a masterpiece. All of his portraits were commissions and there-
fore painted in a commercial or social context. Ingres himself
was never very interested in this kind of work and constantly
complained about it. As he confided to one of his best friends,
the engraver Jacques-Edouard Gatteaux: "Between the two of us
. . . although I fully appreciate the honor of being the only artist
the prince wants to be painted by, I am now obliged to do yet
another portrait! You know how distant I now feel from this kind
of painting. . . ."[1]

The art of portrait-painting does not therefore appear to
have been an artistic priority for the master, except in the early
years of his career. His ambition was to be recognized as a his-
tory painter. He considered all the great pictures he painted
for the Salon—including the *Apotheosis of Homer* (Louvre), *The
Martyrdom of Saint-Symphorien* (Autun Cathedral), and *The Vow
of Louis XIII* (Montauban Cathedral)—as aesthetic manifestos,
and in his capacity as man and artist he undertook them with
the greatest of enthusiasm.

Yet what has now come to be most admired by the public and
by art historians is not his history painting but his portraiture—

both drawn and painted—and it is his genius in this domain
which is now acclaimed, rather than his achievements in other
fields. It is true that the sensual nudes that Ingres continued to
paint throughout his life, from *La Grande Odalisque* (Louvre) to
The Turkish Bath (Louvre), continue to be unanimously admired,
but nothing can be compared with the universal admiration and
fascination for his portraits.

Acquired by the Louvre in 2005, the portrait of Ferdinand-
Philippe-Louis-Charles-Henri de Bourbon-Orléans, Duke of
Orléans and son of King Louis-Philippe, depicts one of the most
engaging political figures of the nineteenth century, a refined and
open-minded prince who was much loved by his countrymen.
The Duke of Orléans was born in Palermo, Sicily, where his
parents had taken up exile after being obliged to leave France at
the outbreak of the French Revolution. When his father came
to the throne in 1830 the young prince immediately started
taking an active part in royal duties. He succeeded in calming
the revolts in Lyon in a humane way, he contributed to the fight
against cholera during the epidemic of 1831, and his courage as
a soldier was without question. He was a great lover of literature
and music and an extraordinary collector whose tastes were
varied but sure. He took interest in all modern artistic trends
and purchased works by both Ingres and Delacroix.

The prince asked Ingres to paint his portrait in 1840, while
the latter was still Director of the Académie de France in Rome.
Ingres, however, only agreed to accept this prestigious commis-
sion upon his return to France in the autumn of 1841. He

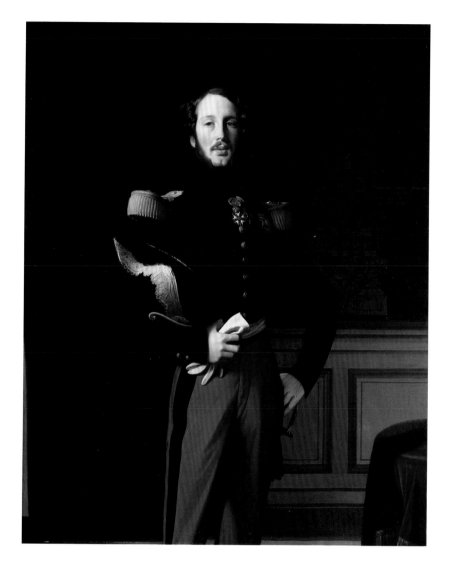

worked on the portrait during the winter of that year, continu-
ally complaining, "ever since I painted the portraits of Bertin
and Molé, everybody wants one. I've now refused or managed
to avoid taking on six of them, because I can't stand the work."[2]
The Duke of Orléans granted him seven sittings, and the work
was finally delivered in May 1742 for the sum of 15,000 francs.
The composition is sober and elegant. The Duke stands in the
salon of his apartment in the Tuileries palace, dressed in the uni-
form of the General Lieutenant of Cavalry. The painter decided
on a tight framing and chose to represent the prince only down
to the knees and in a range of different shades of red and black.

The painting was admired from the very beginning, but it
was to become an almost sacred icon just a few weeks later,
when the dramatic news broke that the Duke of Orléans had
died, killed in an accident on the road to Neuilly on 13 July
1842. In view of the fact that the painting was subsequently
widely diffused throughout France, it seems all the more apposite
that the Duke's portrait be presented at an exhibition designed

to explore the notion of the "masterpiece." Indeed, immediately
after the death of the prince—who was heir presumptive to the
throne at the time—the royal family, as well as the government
and several French towns, asked the painter to execute copies of
the portrait (fig. 1) in a wide variety of formats, sizes, and picto-
rial styles.

Ingres's image of the Duke thus became famous and was
henceforth considered a masterpiece, not only on account of the
virtuosity of the pictorial execution, but because of the devotion
felt for the prince, resulting from the exceptionally wide distri-
bution of the portrait.

VINCENT POMARÈDE

NOTES
1. Letter by Ingres to Gatteaux, 6 August 1840, in H. Delaborde, *Ingres, sa vie,
ses travaux, sa doctrine, d'après les notes manuscrites et les lettres du maître*, Paris, 1870,
pp. 258–259.
2. Letter from Ingres to Gilibert, 2 October 1841, no. 43, in D.and M.-J. Ternois,
Lettres d'Ingres à Gilibert, Paris, 2005, p. 312.

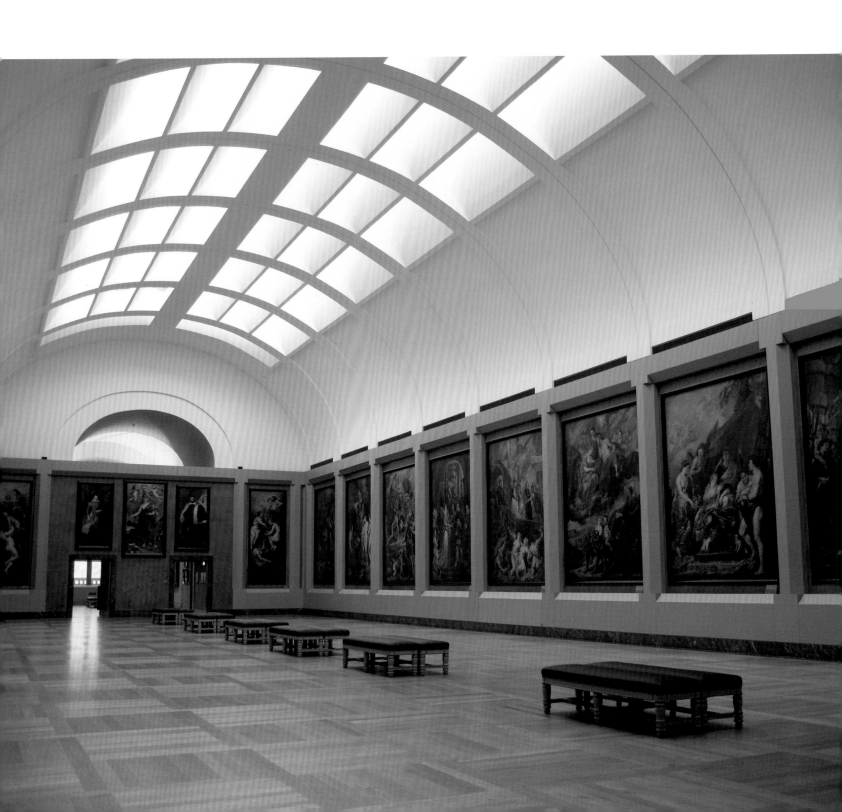

Afterword: The Masterpiece and The Louvre
An Interview with Henri Loyrette

You have said that the Louvre is not a museum of masterpieces.
Indeed, the Louvre is not a museum of masterpieces. This idea emerged at a conference recently organized at the Louvre on the subject of museum collections and their development and on the policies guiding the acquisition of new works. During this conference I took part in a discussion in which a most interesting comment was made by Katherine Reid, who at the time was Director of the Cleveland Museum of Art. She compared the Cleveland Museum with the Musée du Louvre, noting that "the big difference between the Cleveland Museum and the Louvre is that the Cleveland collection is a veritable collection of masterpieces," a collection of absolutely singular and admirable works drawn from all domains. She was quite right. The Louvre collection, on the other hand, cannot be described in the same way; it does of course include many masterpieces, but at the Louvre they are surrounded and supported by other works that explain them, throw light on them, and give information on the context in which they were created. If we compare the Louvre with the Cleveland Museum or the Kimbell Art Museum in Fort Worth— museums which have both purchased the most admirable and often unique works—we realize that what constitutes the particular wealth of the Musée du Louvre is not simply the masterpieces it possesses—for of course the Louvre contains many—but all the other works in the museum which contribute to our understanding and interpretation of the masterpieces.

The essence of a masterpiece is that quality which distinguishes it from its environment, which enables it to transcend passing fashions, which ensures that it surpasses the works of the other artists of any given period. The feature which so struck Katherine Reid, and which indeed is so remarkable about the Louvre, is the tremendous depth and comprehensiveness of the collections, including as they do the layers of substrata accumulated over time. Baudelaire wrote of the "immense palimpsest of memory," and we can apply the same metaphor to the Louvre collections, to the many works which for various reasons have entered the Louvre over the ages, and which together constitute a rich ensemble of successive and superposed layers. We know that the notion of a masterpiece is a changing one, and that the works we now admire as masterpieces were not always considered as such in the past; the fact that the Louvre collections are so amazingly voluminous and comprehensive means that we can constantly make new rediscoveries.

How would you define a masterpiece?
There are many ways of defining a masterpiece. In its most literal sense, the term *masterpiece* designates a work which is absolutely exceptional, the quintessence of all the skill and savoir faire of an artist or craftsman. In this respect the notion of the masterpiece is intimately linked with the concept of virtuosity. Historically, the term masterpiece or *chef d'oeuvre* referred to the work, the tour de force which a craftsman had to produce before he began his career, the work which confirmed

his skill, his mastery, his *maîtrise*. For us today, a masterpiece is a work which, because of its own particular force, its singularity, and its beauty stands out from "the common lot," and which can be clearly distinguished among the other works of a given period or a given artist. The notion of a masterpiece is therefore fairly broad. We can speak of an artist's masterpiece, and we can also speak of the masterpieces of a collection.

So the concept of a masterpiece is a changing one?
Yes, it is a concept which inevitably evolves. The masterpiece is by nature an isolated work; in the production of an artist or period, it is an individual work. This concept is an old one and corresponds to a time when artists produced their works in a kind of personal seclusion. But since the emergence in the nineteenth century of the more modern notion of "work in progress," of works which gradually evolve, of suites and series, it has become more difficult to distinguish the individual masterpiece. I would, for example, be unable to select the masterpieces among Monet's cathedrals or among Degas's nudes. In fact, the notion of the individual masterpiece ceases to be valid once one begins to consider the series as a whole and to reflect on the variation and the continual renewal of the same theme; in this case it is the series as a whole, or the continuity of the development that should perhaps be considered as the masterpiece. But this would mean that we no longer have the idea of a truly singular work. The masterpiece notion also inevitably includes the concept of quality: there are certain of Monet's paintings of the façade of the Rouen Cathedral (fig. 1) that we appreciate more or less than others, but it would be extremely difficult to say which, among the series of five at the Musée d'Orsay, is

Fig. 1. Claude Monet (French, 1840–1926), *Rouen Cathedral in Full Sunlight: Harmony in Blue and Gold*, 1893, oil on canvas, 42⅛ × 28¹¹⁄₁₆ inches, Musée d'Orsay, RF 2002.

the masterpiece. In the same way, it is difficult to distinguish an individual masterpiece from the second half of Monet's career. We should perhaps consider the great water lily frescoes of the Orangerie as a masterpiece; they were conceived as a sort of quintessence of Monet's reflections over the years concerning the *Nymphéas*.

So how can this idea be applied to contemporary art? Can there be an interaction between the museum masterpieces and contemporary art?
I think it is important to remember that a profound change occurred during the nineteenth century—when the first museums appeared—for the emergence of museums led to a virtual sanctification of the masterpiece notion. Henceforth, masterpieces were made by museums. Previously, people had talked of remarkable works that belonged to this or that collection, but these extraordinary works could not necessarily be seen by the general public. Once they became generally visible, these works achieved a new status. And today there is an increasing tendency to distinguish masterpieces, to set them apart from less outstanding works. Museum guides, for example, are produced with the express intent of focusing on the masterpieces and the important sections of the museum, and thus implicitly on the most notable works. Since the nineteenth century, artists have no longer worked for King or Church; they now create for museums, and

thus inevitably position themselves in relation to the masterpieces of the past. Henceforth, an artist's ambition—that force which in a way motivates all his production—is to have his works displayed in a museum. Artists now see themselves both as successors to the artists of the past who have already achieved recognition and also in comparison with them.

Could you name a work of contemporary art that you consider a masterpiece?
Although this notion of masterpiece no longer corresponds to the reality of art today, there are of course contemporary art masterpieces. The Rothko Chapel and works by Cy Twombly at Houston, the Buren Columns in the Palais-Royal in Paris, the sculptures by Richard Serra at the Guggenheim in Bilbao, and many others are, I am sure, all masterpieces. When one studies the history of art, and in particular that of the twentieth century right up to the present, one is struck by the lack of vision shown by historians of contemporary art. This is true of Focillon, and it is true of even more recent critics. It is difficult to recognize the masterpiece and to distinguish it among the immense worldwide panorama of artists and their works. But if I consider what I have seen personally, if I think about what I like and what I know, still limiting myself to the context of series, I would reply that yes, there are masterpieces in the domain of contemporary art. For example, in the Jasper Johns exhibition that I recently saw at the Metropolitan Museum in New York, I would not select one work, but rather two series of works as masterpieces of Johns's career: both the variations on the American flag and his variations on targets. However, I would be more skeptical regarding his later periods. And I would say the same about Rauschenberg and Richter; in the case of these artists, it is perhaps easier to distinguish periods that one particularly likes. It is also very difficult to choose between paintings of the same quality (even if one has a personal preference for some of them). Once again we are considering here not individual works, but rather a more open type of production developed over a long period. For example, in my opinion it is extremely difficult to select one masterpiece from the whole creative evolution of Pierre Soulages's production. This is not to say that all of his works are of the same quality, but they are all the reflection of the artist's intense thought process conducted over a long period of time, and it is difficult to distinguish any one work in particular.

Which is your favorite masterpiece in the Louvre?
I think it is important to distinguish here between one's personal and intimate choices on the one hand, and on the other a more objective notion of the masterpiece. The objective selection of what is a masterpiece implies—especially for a museum curator—the recognition of outstanding works by great masters, for which one does not have necessarily any special personal attraction. It would, for example, be impossible to deny that the Marie de Medici cycle by Rubens (see page 198) constitutes a masterpiece; it is quite obviously one of the artist's great masterpieces. Of course one can like Rubens to a greater or lesser extent, one can be passionately attached to his paintings or one can be more reserved in one's appreciation. Personally, it is a series which I originally did not like at all and which I am now gradually discovering (fig. 2). All of us—visitors, curators, and critics alike—can evolve in our perception of an artist and of his masterpieces. We

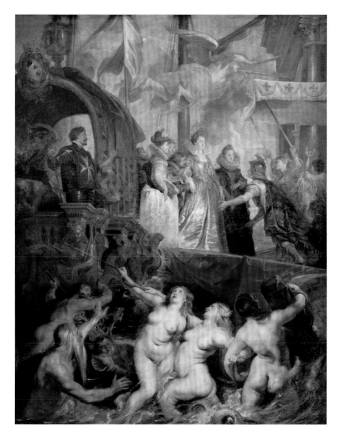

Fig. 2. Peter Paul Rubens (Flemish, 1577–1640), *The Disembarkation of Marie de Medici at the Port of Marseilles, November 3, 1600*, oil on canvas, 155⅛ × 116⅛ inches, Musée du Louvre, Department of Paintings, INV 1774.

have also seen how certain works of an artist can be rediscovered and appreciated afresh. Just a few years ago, for example, the young Cézanne was considered as a kind of Cézanne-before-Cézanne; the works of his early period were not highly thought of, and certainly no masterpiece was designated among them. But today the *Portrait of Achille Emperaire*, or the *Madeleine*, or other works of equal force and distinction dating from the 1860s are considered masterpieces. Similarly, the works produced by Degas in his later period were not always appreciated at their full worth; they were considered as the production of an artist in decline who, to repeat the often-used explanation, was handicapped by his worsening eyesight.

And then there is the more subjective and personal notion of the masterpiece, one that is intimately linked with one's personal history. There are certain masterpieces which have been with me all my life. I am thinking, for example, of Ingres's portraits of the Rivière family (fig. 3), three works which I first saw when I was very young and for which I have always had a kind of continually renewed interest. One of the distinguishing characteristics of masterpieces is that they are not fleeting loves. We either get to know them progressively and come to appreciate them very slowly, as I came to appreciate Rubens's Marie de Medici cycle in spite of my initial dislike and reticence, or we discover them during childhood and, in this case, continually come back to look at them again and to meditate on them—such works are always in our minds.

I have been speaking about the masterpiece as a personal experience, but it would be pretentious to decide what the public should consider masterpieces. There are some works about which there is no doubt—the *Mona Lisa* is unquestionably a masterpiece—and there are others which result from personal choice. I remember an experience I had very recently in the Uffizi Museum in Florence, a museum I know well, for when I lived in Rome I used to visit Florence very frequently. I went back to the museum again about four or five years ago and saw the *Venus of Urbino* by Titian (fig. 4)—a masterpiece. I had always recognized that it was a masterpiece, but for me it remained a rather distant work. It would have been ridiculous for me to deny that the painting was a masterpiece—all the more so since it has been admired by so many painters (including Goya

Fig. 3. Jean-Auguste-Dominique Ingres (French, 1780–1867), *Mademoiselle Caroline Rivière (1793–1807)*, 1806, oil on canvas, 39⅜ × 27½ inches, Musée du Louvre, Department of Paintings, MI 1447.

Fig. 4. Titian (Italian, ca. 1488–1576), *Venus of Urbino*, 1538, oil on canvas, 46⅞ × 65 inches, Uffizi Gallery, Florence, Italy.

and Manet) whom I so love and admire. The objective quality of this work's status was therefore totally established, but for me it represented a kind of obligatory masterpiece, one that I had not sufficiently reflected on or integrated. I remember so well that hot, summer day; I remember how I entered the small room where the *Venus* was hanging, I remember all the surrounding noise, and I remember seeing the painting for the first time. I had often seen this painting, I had even taken the time to look at it, but it was only on that summer day that I really saw it for the first time. It was as though the painting at last revealed itself to me, as though Titian had painted it just for me. I believe in this kind of maturation. Great works of art are known to us through the images we see of them. We curators are extremely lucky in that we have the great opportunity to see such works again and again, not only in our own museum, but in other museums, and this maturation, which sometimes occurs on a very personal level, can suddenly lead to the acceptance of the obvious. It is a masterpiece—yes, of course, it is a masterpiece—but now we are able to explain why it is a masterpiece, we are able to appropriate it and understand it. It is a quite marvelous process.

So the notion of masterpiece includes a dimension which is outside one's personal, subjective viewpoint, a kind of official obvious consecration. If we go to the Louvre, for example, we will have no problem at all in identifying the masterpieces of the great masters. And then, on the other hand, the notion of a masterpiece depends also on the personal preparation of the individual, as well as the contribution made by art critics, and on all that is done by curators to ensure that those works which are little seen and hardly looked at might be drawn out of the great confusion surrounding the great masters. I remember how I discovered Vilhelm Hammershoi, an artist who was totally unknown to me before I saw his works in Denmark. I was immediately struck by this artist and decided to organize an exhibition of his works at the Musée d'Orsay, for I immediately understood that he was a great artist, and that he had produced a number of real masterpieces. This viewpoint was subsequently endorsed by the international community, by the critics and the public at large. There are also other more peripheral notions which determine what one might consider a masterpiece: the popularity of an artist or, on the contrary, his eclipse, the way in which taste changes, the fact that we appreciate and interpret those masterpieces which really mean something to us personally—in contrast to the sacred icons displayed in museums—in terms of our own personal history and in terms of the times in which we live. And there are certain artists who are more in harmony with our period than others. We see this today—painters like Poussin, Ingres, Degas, and Manet are quite clearly contemporary painters for me. From this point of view the Musée du Louvre is a museum of contemporary art in the same way as the Centre Pompidou, bearing in mind that our viewing and interpretation are filtered through our twenty-first-century eyes. But we must also speak of sculpture and archaeology; we must speak of the distinction between "high" and "low" art, between what on the one hand is spoken of in almost hushed tones as Grand Art and, on the other, what covers more modest works. Increasingly, this lack of differentiation—which is a deliberate, well thought-out, and meditated choice—encourages a wider and less academic viewing of classical art, which relativizes both artists and genres.

What in your opinion is special about the masterpieces of the Louvre?
In a collection like that of the Louvre, an artist's masterpiece can be clearly distinguished from the rest of his production, since the museum often possesses numerous examples. The case of Poussin illustrates this point; the Louvre contains more than thirty paintings by Poussin, and this enables the viewer not only to comprehend how the artist evolved, but also to see which works are more successful than others, which paintings mean more to us, and which appear to be of

greater interest than others. Moreover, Poussin's paintings are surrounded by those of other artists of the same period, artists who worked with him, who worked on the same subjects and in similar styles. At the Louvre, we can compare how different but similar artists treated the same subject.

The same is true of archaeological works; when one walks through the rooms of the Louvre devoted to the Archaic Greek period and considers the works by unknown artists, one has no problem distinguishing the more important works from the others: they emerge clearly and surpass the others in beauty and force as, for example, *The Lady of Auxerre* (plate 68) stands out among a production which is necessarily of varying quality. What is important to keep in mind is that the masterpiece is in a way revealed by the context in which it is seen, by the great profusion of works, a profusion which is one of the most distinctive features of the Louvre. When there are no works with which to compare, no works to use as a yardstick, it becomes much more difficult to understand the uniqueness of a masterpiece.

At the Musée d'Orsay we have often been reproached for giving so much importance to academic art in relation to Impressionism. Critics ask why we hang the *Birth of Venus* by Paul Baudry near the *Olympia* by Manet (fig. 5). But there were two very good reasons for doing this. First of all, historically, the *Birth of Venus* is an important work, one which marked its period. And if we want to understand why, at the Salon of 1863, *Olympia*, with all its revolutionary and explosive beauty, suddenly created such a sensation, we need only see it displayed next to the picture that the public of the time considered a masterpiece. It was indeed at the same Salon that Baudry's painting was immediately applauded as a masterpiece, as were works by Bouguereau. This story reveals how futile the masterpiece concept can be; it also indicates how the quite exceptional, extraordinary, and unceasing force of the *Olympia* becomes all the clearer when it is placed next to works which in their time were esteemed far superior. This way of surrounding a masterpiece with other works to emphasize its intensity and innovating force becomes even more perceptible

when the artist and his production are confronted with their own period. The same kind of choice was made in the Cour Puget of the Louvre; here Jean-Baptiste Debay's bronze *Spirit of the hunt* (fig. 6) is placed next to Barye's *Lion and serpent* (plate 1), with the result is that the Debay group seems little more than an oversized trinket beside the *Lion and serpent*, which seems to vibrate with revolutionary force! Yet the two works were exhibited at the same Salon and were equally admired by the critics and the public. We could of course make the same point for works from all domains. And this possibility of comparing different works constitutes one of the very strong points of the Louvre, one which it is essential to exploit.

Fig. 6. Jean-Baptiste Debay, called Debay the Younger (French, 1802–1862), *The Spirit of the hunt*, 1838, melted bronze with sand, Musée du Louvre, Department of Sculptures, RF 149.

And then we have what I shall call the underground life of certain masterpieces, something which can be profoundly moving. I refer here to those works and those artists who lie buried away and completely forgotten and then suddenly reappear, thanks to the acute eye of one or more observers. Such was the case of both Johannes Vermeer (plate 96) and Georges de La Tour (plate 97); for many, many years these artists almost totally disappeared and then were suddenly "reinvented." But if their works survived those long years of obscurity, they must have had some absolutely extraordinary force.

What about the masterpieces in other museums? Are there masterpieces in these museums that have a particular meaning for you?
Of course, there are masterpieces everywhere. The number of great paintings and sculptures in the Metropolitan Museum, the Dresden Gallery, the National Gallery in Washington, the National Gallery of London, and many other museums throughout the world is enormous. But what distinguishes the Louvre is that it is the only museum which possesses that unique icon, the *Mona Lisa*, a universally acclaimed *chef d'oeuvre*, which is moreover intimately linked with the Louvre collection.

Do you think that the notion of the masterpiece is of importance to today's public?
For a museum like the Louvre, it is a way of helping the public, the ever-increasing number of visitors who do not always have the necessary background. The way in which works are installed, the way in which pictures are hung and in which some works are exhibited in individual showcases all help the visitor. I have just described how the positioning of the bronze groups by Debay and Barye side by side makes these works much more explicit to the public.

Today, the positioning of works in museums is increasingly designed to favor outstanding works; this differs substantially from the way in which works were exhibited during the nineteenth-century Paris Salons and in museums in general, when no distinction at all was made between the different paintings displayed. The spectators were then faced with a mix of works packed together as closely as possible. It was almost impossible for them—with perhaps the sole exception of the most aware professionals—to distinguish the important works from the others. Today museums are organized to focus on the more outstanding works. If we look at how pictures have been hung at the Musée du Louvre over the last twenty to thirty years, we realize that the positioning has

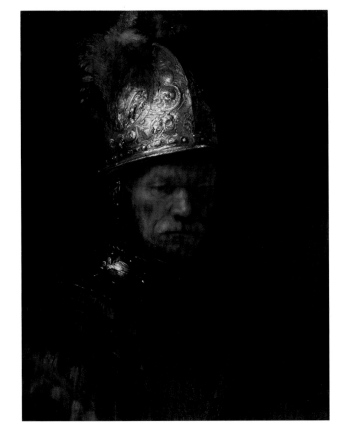

changed, that those pictures which once had pride of place have been replaced by others. And this is absolutely justified. The works which were once considered masterpieces have disappeared; they have either quite simply been forgotten, or have not passed the test of time, or—and this is an important issue—controversy over their attribution, their authenticity, or their state of conservation has provoked doubts concerning their intrinsic qualities. A painting previously attributed to Rembrandt illustrates this point; the *Man with the Golden Helmet* (fig. 7) was once unanimously considered a great masterpiece and was widely reproduced. But as soon as it was no longer considered a Rembrandt, it lost its privileged status as a masterpiece and was quickly relegated to the ranks of secondary works. Yet the painting itself has not changed at all and remains as beautiful as it has always been. The popularity and success enjoyed previously by the painting admittedly might have been somewhat excessive, but then so is the scorn now heaped on the work.

The same can be said for those antiquities which were restored during the sixteenth, seventeenth, and eighteenth centuries, and which were for so long held in disdain by the departments of antiquities. Today the presentation of these works in the Salle du Manège of the Louvre enables us to see them differently. From the sixteenth to the eighteenth century, these antiquities were restored and completed, and then as a result of a change in taste in the following centuries, they came to be considered as "impure."

Fig. 7. Formerly attributed to Rembrandt Harmensz. van Rijn (Dutch, 1606–1669), *Man with the Golden Helmet*, ca. 1650, oil on canvas, 26⅜ × 19¹¹⁄₁₆ inches, Gemäldegalerie, Staatliche Museen zu Berlin.

Today, we see them as constituting a lesson in the history of art, for in just one work of art we can trace the superposed efforts of different periods (see plates 36 and 70). These masterpieces are made of the profuse accumulated sediment of memory and time. Artists themselves have also contributed to the enrichment of masterpieces by reinterpreting them. We can no longer see Titian's *Venus of Urbino* simply as an individual and remarkable work in that great artist's production; today, we view and appreciate the painting through the eyes of Goya, through those of Manet, and through those of all the artists who have reinterpreted the painting. And so it is through and because of all these superposed alluvial sediments that the masterpiece in all its infinite richness is revealed.

Henri Loyrette is the President Director of the Musée du Louvre. He was interviewed in May 2008.

Checklist of the Exhibition

Egyptian Antiquities

1. Vase
Egypt, Nagada I period,
ca. 3800–3500 B.C.
Basalt
11 × 4¾ inches (28 × 12.1 cm)
Department of Egyptian Antiquities,
E 23449
Plate 10

2. Head of Amenhotep III
Egypt, New Kingdom, 18th Dynasty,
1391–1353 B.C.
Granodiorite
12¹³⁄₁₆ × 11¹³⁄₁₆ × 9⅞ inches (32.5 ×
30 × 25.3 cm)
Department of Egyptian Antiquities,
A 25
Plate 29

3. Statue fragment of a woman
Egypt, Ptolemaic period, 2nd–
3rd century B.C.
Porphyry
11 × 4⅜ × 4⅛ inches (28 × 11.2 ×
10.5 cm)
Department of Egyptian Antiquities,
AF 12417
Plate 70

4. The Blue Head
20th-century forgery in the style
of the late 18th Dynasty
Blue glass
3½ inches (9 cm) high
Department of Egyptian Antiquities,
E 11658
Plate 66

Greek, Etruscan, and Roman Antiquities

5. The Chalkodamas *aryballos*
Sparta, late 7th century–first third
of 6th century B.C.
Argian production
Bronze
1⅝ × 1⅜ inches (4 × 3.6 cm); weight:
2.5 oz. (70 g)
Department of Greek, Etruscan, and
Roman Antiquities, Br 2918
Plate 12

6. Female statuette known as
The Lady of Auxerre
Crete, second half of the
7th century B.C.
Limestone
29½ inches (75 cm) high

Department of Greek, Etruscan,
and Roman Antiquities, Ma 3098
Plate 68

7. Lévy *oinochoe*
Greek, ca. 630 B.C.
Clay
15½ inches (39.5 cm)
Department of Greek, Etruscan, and
Roman Antiquities, E 658
Atlanta only
Plate 30

8. *Oinochoe*
Greek, ca. 625–600 B.C.
Clay
12 × 8⅝ inches (30.5 × 22 cm)
Department of Greek, Etruscan,
and Roman Antiquities, A 312
Atlanta only
Plate 31

9. *Oinochoe*
Greek, ca. 600–580 B.C.
Clay
14 × 8¾ inches (34.5 × 22.2 cm)
Department of Greek, Etruscan,
and Roman Antiquities, A 314
Atlanta only
Plate 32

10. *Oinochoe*
Greek, ca. 580–570 B.C.
Clay
13⅜ × 8⅝ inches (34 × 22 cm)
Department of Greek, Etruscan,
and Roman Antiquities, A 319
Atlanta only
Plate 33

11. Dish from the Boscoreale Treasure
First half of 1st century A.D.
Partially gilt silver
2⅝ × 8⅞ inches (6.7 × 22.7 cm);
weight: 2 lb. (934.7 g)
Department of Greek, Etruscan,
and Roman Antiquities, Bj 1969
Plate 14

12. Roman copy of the statue type
known as the "Leaning Aphrodite"
Roman, 1st or 2nd century A.D.
After a lost Greek original by the
sculptor Alkamenes, ca. 420 B.C.
Marble
46½ inches (118 cm) high
Department of Greek, Etruscan,
and Roman Antiquities, INV Ma 414
Plate 34

13. Roman copy of the statue type known as the "Leaning Aphrodite"
Roman, 1st or 2nd century A.D. After a lost Greek original by the sculptor Alkamenes, ca. 420 B.C.
Marble
48⅜ inches (123 cm) high
Department of Greek, Etruscan, and Roman Antiquities, Ma 420
Plate 35

14. *Eros*, known as *The Winged Genius* or *The Genius Borghese*
Roman, 1st–2nd century A.D.
Marble
39¹³⁄₁₆ inches (101 cm) high without plinth
Department of Greek, Etruscan, and Roman Antiquities, cat. Ma 545
Plate 36

15. Israel Rouchomowsky
Russian, active late 19th century
Tiara of Säitapharnèse
Gold
6⅞ × 7⅛ inches (17.5 × 18 cm); weight: 15.6 oz. (443 g)
Department of Greek, Etruscan, and Roman Antiquities, Bj 2357
Plate 65

Near Eastern Antiquities

16. Cylinder seal: The sun-god rising
Mesopotamia, beginning of the Akkadian period,
ca. 2330–2284 B.C.
Serpentine
1⅜ × 1 inch (4 × 2.6 cm)
Department of Near Eastern Antiquities, AO 2261
Plate 25

17. Fragmentary bas-relief dedicated to the female divinity Nin-sun
Mesopotamia, Neo-Sumerian period, ca. 2119–2004 B.C.
Diorite
5½ × 2⅜ inches (14 × 6 cm)
Department of Near Eastern Antiquities, AO 2761
Plate 67

18. Cylinder seal: Contest scenes
Mesopotamia, Isin-Larsa period, 2000–1800 B.C.
Hematite
¾ × ⅜ inch (1.9 × 1.1 cm)
Department of Near Eastern Antiquities, AO 6250
Plate 27

19. Cylinder seal: Contest scenes
Mesopotamia, end of Akkadian period, reign of King Shar-kali-sharri, ca. 2217–2193 B.C.
Diorite
1½ × 1 inch (3.9 × 2.6 cm)
Department of Near Eastern Antiquities, AO 22303
Plate 28

20. Cylinder seal: Contest scenes
Mesopotamia, beginning of the Akkadian period, ca. 2330–2284 B.C.
Green porphyry
1⅜ × ⅞ inch (3.5 × 2.4 cm)
Department of Near Eastern Antiquities, AO 22307
Plate 26

21. Statuette of a worshipper bearing an offering
Susa, Iran, Middle Elamite period, 12th century B.C. (?)
Gold alloy (statuette) and copper (plinth)
2⅞ inches (7.5 cm) high
Department of Near Eastern Antiquities, Sb 2758
Atlanta only
Plate 11

22. Stele of the scribe Tarhunpiyas
Southeastern Turkey, late 7th century B.C.
Basalt
29⅜ × 11⅛ × 6⅛ inches (74.6 × 28.3 × 15.6 cm)
Department of Near Eastern Antiquities, AO 19222
Plate 69

23. Weight shaped like an anklebone
Ionia (present-day Turkey), third quarter of 6th century B.C.
Bronze
10¹³⁄₁₆ × 15⅜ × 9⅜ inches (27.5 × 39 × 24 cm); weight 206½ lb. (93.7 kg)
Department of Near Eastern Antiquities, Sb 2719
Atlanta only
Plate 13

Islamic Art

24. Ahmad al-Dhakî (al-Mawsilî)
Basin in the name of Sultan Ayyubide al-'Adil II Abû Bakr
Syria, ca. 1238–1240
Hammered copper alloy inlaid with silver, gold, and black paste
7½ × 18⅜ inches (19 × 47.2 cm)

Department of Islamic Arts, OA 5991
Minneapolis only
Plate 17

25. Muhammad ibn Al-Zayn
Basin known as the *Baptistère de St. Louis*
Egypt or Syria, second quarter of the 14th century
Hammered copper alloy inlaid with engraved silver, gold, and black paste
8¾ × 19¾ inches (22.2 × 50.2 cm)
Department of Islamic Arts, LP 16
Atlanta only
Plate 18

26. Peacock dish
Iznik, Turkey, ca. 1550
Stonepaste with underglaze painting over a slip coating
3⅛ × 14¾ inches (8 × 37.5 cm)
Department of Islamic Arts, K 3449
Plate 37

27. Dish with floral spray
Iznik, Turkey, ca. 1550–1560
Stonepaste with underglaze painting over a slip coating
3⅛ × 14¾ inches (8 × 37.5 cm)
Department of Islamic Arts, INV 27701
Plate 38

28. Dish with floral spray
Iznik, Turkey, late 16th–early 17th century
Stonepaste with underglaze painting over a slip coating; traces of gilding
2³⁄₁₆ × 11⅜ inches (5.5 × 29 cm)
Department of Islamic Arts, INV 10148
Plate 39

Graphic Arts

29. Antonio Pisanello
Italian, ca. 1395–1455?
Young boy with lowered head, seen from above
Pen and ink over a black chalk preparatory drawing
6½ × 8⅛ inches (16.5 × 20.6 cm)
Department of Graphic Arts, INV 2299
Atlanta only
Plate 74

30. Antonio Pisanello
Italian, ca. 1395–1455?
Man seen from behind, draped in a cape and seated on a bench
Pen and ink over a metalpoint preparatory drawing

10¹⁵⁄₁₆ × 7¹¹⁄₁₆ inches (27.7 × 19.5 cm)
Department of Graphic Arts, INV 2332 verso
Atlanta only
Plate 75

31. Antonio Pisanello
Italian, ca. 1395–1455?
Profile of a young woman to the left
Pen and ink over a black chalk preparatory drawing
9¹¹⁄₁₆ × 6¾ inches (24.6 × 17.2 cm)
Department of Graphic Arts, INV 2342 verso
Minneapolis only
Plate 76

32. Workshop of Pisanello
Profile of a young woman to the right
Pen and ink over a black chalk preparatory drawing, with a light red chalk wash
9⅝ × 7³⁄₁₆ inches (24.5 × 18.2 cm)
Department of Graphic Arts, INV 2343
Atlanta only
Plate 77

33. Antonio Pisanello
Italian, ca. 1395–1455?
Harnessed horse, seen from behind
Pen and ink over a black chalk preparatory drawing
8¹¹⁄₁₆ × 6⁵⁄₁₆ inches (22.1 × 16 cm)
Department of Graphic Arts, INV 2378
Atlanta only
Plate 78

34. Antonio Pisanello
Italian, ca. 1395–1455?
Two harnessed horses' heads and details of a horse's snout
Pen and ink over a black chalk preparatory drawing
11⁷⁄₁₆ × 7¼ inches (29.1 × 18.4 cm)
Department of Graphic Arts, INV 2354
Minneapolis only
Plate 79

35. Antonio Pisanello
Italian, ca. 1395–1455?
Two harnessed horses, one seen from the front, the other from behind
Pen and ink, gray and brown wash, and white highlights over a black chalk (or metalpoint) preparatory drawing
7¹³⁄₁₆ × 6½ inches (19.9 × 16.5 cm)
Department of Graphic Arts, INV 2468
Atlanta only
Plate 80

36. Antonio Pisanello
Italian, ca. 1395–1455?
Four egrets in flight
Pen and ink
6½ × 9¾ inches (16.5 × 24.7 cm)
Department of Graphic Arts,
INV 2469
Atlanta only
Plate 81

37. Antonio Pisanello
Italian, ca. 1395–1455?
Fourteen white herons
Pen and ink with green wash,
on parchment
7⅛ × 10⅝ inches (18.1 × 27 cm)
Department of Graphic Arts,
INV 2472
Minneapolis only
Plate 82

38. Antonio Pisanello
Italian, ca. 1395–1455?
Seven seated monkeys. A peacock in profile to the left
Pen and ink; some red chalk wash
10³⁄₁₆ × 7³⁄₁₆ inches (25.9 × 18.2 cm)
Department of Graphic Arts,
INV 2389
Atlanta only
Plate 83

39. Antonio Pisanello
Italian, ca. 1395–1455?
Dead peewit with spread wings
Watercolor, white gouache partly
oxidized, and pen and ink over a
metalpoint preparatory drawing
6³⁄₁₆ × 11⅜ inches (15.7 × 28.9 cm)
Department of Graphic Arts,
INV 2465
Atlanta only
Plate 84

40. Antonio Pisanello
Italian, ca. 1395–1455?
Three views of a male titmouse
Watercolor, pen and ink, and partly
oxidized white highlights on
parchment
4⅝ × 6⅛ inches (11.8 × 15.5 cm)
Department of Graphic Arts,
INV 2476
Atlanta only
Plate 85

41. Antonio Pisanello
Italian, ca. 1395–1455?
Hunting hawk hooded and perched on a gloved left hand
Pen and ink, brown wash and
watercolor, and white highlights over
a black chalk preparatory drawing
9⅜ × 5⁵⁄₁₆ inches (23.7 × 15.1 cm)

Department of Graphic Arts,
INV 2453
Minneapolis only
Plate 86

42. Antonio Pisanello
Italian, ca. 1395–1455?
Three studies of a cat's head. Eight studies of plants
Metalpoint on parchment
3¾ × 12 inches (9.5 × 30.5 cm)
Department of Graphic Arts,
INV 2381
Atlanta only
Plate 87

43. Workshop of Pisanello
Two studies of a cat's head. Light sketch of a fox in profile
Pen and ink with brown wash over
a black chalk preparatory drawing
9⅞ × 7 inches (25.1 × 17.9 cm)
Department of Graphic Arts,
INV 2418
Atlanta only
Plate 88

44. Anonymous Lombard artist
Lombardy, late 14th century
Three hunting dogs
Pen and ink, watercolor, and white
highlights on parchment
10 × 6¹¹⁄₁₆ inches (25.3 × 17 cm)
Department of Graphic Arts,
INV 2568
Atlanta only
Plate 89

45. Antonio Pisanello, after a
Lombard model sheet
Italian, ca. 1395–1455?
Three hunting dogs
Pen and ink with brown wash over
a black chalk preparatory drawing
10¹¹⁄₁₆ × 7¹¹⁄₁₆ inches (27.2 × 19.5 cm)
Department of Graphic Arts,
INV 2547
Plate 90

46. Antonio Pisanello
Italian, ca. 1395–1455?
Profile of a greyhound standing to the right
Watercolor and pen and ink over a
black chalk preparatory drawing
7¼ × 9⅝ inches (18.3 × 24.5 cm)
Department of Graphic Arts,
INV 2433
Minneapolis only
Plate 91

47. Antonio Pisanello
Italian, ca. 1395–1455?
Four views of a dormouse
Black chalk, pen and ink, pink wash,
and oxidized white highlights over a
black chalk preparatory drawing
10¹⁄₁₆ × 7⅛ inches (25.5 × 18.1 cm)
Department of Graphic Arts,
INV 2387
Minneapolis only
Plate 92

48. Antonio Pisanello
Italian, ca. 1395–1455?
Design for a tapestry with an emblematic tree and the Catalan motto "Guarden les Forces"
Pen and ink with brown wash over
a black chalk preparatory drawing
8⅜ × 11³⁄₁₆ inches (21.2 × 28.4 cm)
Department of Graphic Arts,
INV 2538
Atlanta only
Plate 93

49. Anonymous Artist
French, end of 14th century
The Bearing of the Cross
Block-book incunabula, woodcut
10½ × 15⅜ inches (26.7 × 39 cm)
Department of Graphic Arts,
Collection Edmond de Rothschild,
1 LR
Atlanta only
Plate 51

50. Anonymous Artist
German, 15th century
The Death of the Virgin, ca. 1460
Woodcut print with hand coloring
7⅞ × 10¹³⁄₁₆ inches (20.2 × 27.4 cm)
Department of Graphic Arts,
Collection Edmond de Rothschild,
4 LR
Atlanta only
Plate 52

51. Martin Schongauer
German, ca. 1450–1491
Carrying the Cross, 1475–1480
Engraving with burin
11³⁄₁₆ × 16¹³⁄₁₆ inches (28.5 × 42.7 cm)
Department of Graphic Arts,
Collection Edmond de Rothschild,
204 LR
Atlanta only
Plate 54

52. Tommaso d'Antonio, called
Maso Finiguerra
Italian, 1426–1464
The Baptism of Christ, ca. 1460
Niello print, unique impression
3½ × 2¹³⁄₁₆ inches (8.9 × 7.1 cm)

Department of Graphic Arts,
Collection Edmond de Rothschild,
137 Ni
Atlanta only
Plate 53

53. Antonio Pollaiuolo
Italian, ca. 1432–1498
The combat of the nude men,
ca. 1470–1480(?)
Engraving with burin in the broad
manner
15¹³⁄₁₆ × 23⅜ inches (40.2 × 60 cm)
Department of Graphic Arts,
Collection Edmond de Rothschild,
6813 LR
Atlanta only
Plate 55

54. Workshop of the Master of the
Arms of Cologne
Pietà, ca. 1480
Stipple engraving, burin and punches,
very lightly colored, unique
impression
10 × 7⁵⁄₁₆ inches (25.3 × 18.5 cm)
Department of Graphic Arts,
Collection Edmond de Rothschild,
45 LR
Atlanta only
Plate 56

55. Leonardo da Vinci
Italian, 1452–1519
Drapery study
Tempera on linen
12⁹⁄₁₆ × 8⁹⁄₁₆ inches (31.9 × 21.8 cm)
Department of Graphic Arts,
RF 41905
Atlanta only
Plate 40

56. Cristofano di Michele Martini,
called Cristofano Robetta
Italian, 1462–reported active to 1535
Allegory of the power of Love, ca. 1510
Engraving with burin
12⅛ × 11⅜ inches (30.9 × 28.9 cm)
Department of Graphic Arts,
Collection Edmond de Rothschild,
3834 LR
Atlanta only
Plate 57

57. Albrecht Dürer
German, 1471–1528
Melencolia I, 1514
Engraving with burin
9⅜ × 7⁵⁄₁₆ inches (24 × 18.6 cm)
Department of Graphic Arts,
Collection Edmond de Rothschild,
574 LR
Atlanta only
Plate 59

58. Albrecht Dürer
German, 1471–1528
Knight, Death, and the Devil, 1513
Engraving with burin
9⅝ × 7⅜ inches (24.4 × 18.9 cm)
Department of Graphic Arts,
Collection Edmond de Rothschild,
594 LR
Atlanta only
Plate 58

59. Michelangelo Buonarroti
Italian, 1475–1564
"Ideal Head" of a woman, early 1520s
Red chalk
12⅜ × 9½ inches (31.5 × 24.1 cm)
Department of Graphic Arts,
INV 12299
Atlanta only
Plate 41

60. Michelangelo Buonarroti
Italian, 1475–1564
Head of a satyr in profile, 1520–1525
Pen and ink for the satyr's head; red
chalk for the female head underneath
10⅞ × 8⅜ inches (27.7 × 21.3 cm)
Department of Graphic Arts,
INV 684
Atlanta only
Plate 42

61. Michelangelo Buonarroti
Italian, 1475–1564
*Virgin and Child with Saint Anne,
study of a male nude, head in profile*
Pen and ink, brown wash, and
black chalk
12¾ × 10¼ inches (32.4 × 26 cm)
Department of Graphic Arts,
INV 685
Minneapolis only
Plate 44

62. Giulio Clovio
Italian, 1498–1578
Bust of Cleopatra, copy after
Michelangelo
Black chalk and stumping
9¹³⁄₁₆ × 7¾ inches (25 × 19.7 cm)
Department of Graphic Arts,
INV 733
Atlanta only
Plate 43

63. Jacopo Ligozzi
Italian, 1547–1627
Allegory of Sloth, ca. 1590
Pen and brown ink, brown wash,
and gold highlights on paper covered
with beige wash
11¹⁵⁄₁₆ × 7¹³⁄₁₆ inches (30.3 × 19.8 cm)

Department of Graphic Arts,
INV 5037
Atlanta only
Plate 47

64. Jacopo Ligozzi
Italian, 1547–1627
Allegory of Lust, ca. 1590
Pen and ink, brown wash, and gold
highlights on paper covered with
brown wash
11⅞ × 7¹³⁄₁₆ inches (30.1 × 19.8 cm)
Department of Graphic Arts,
INV 5032
Minneapolis only
Plate 48

65. Bartolomeo Passarotti
Italian, 1529–1592
Jupiter seated on clouds
Pen and ink over a black chalk
preparatory drawing
17⅜ × 15 inches (44.1 × 38.1 cm)
Department of Graphic Arts,
INV 8463
Minneapolis only
Plate 45

66. Bartolomeo Passarotti
Italian, 1529–1592
Homer and the sailors
Pen and ink over a black chalk
preparatory drawing
20�5⁄₁₆ × 14¹⁵⁄₁₆ inches (51.6 × 37.9 cm)
Department of Graphic Arts,
INV 8469
Minneapolis only
Plate 46

67. Rembrandt Harmensz. van Rijn
Dutch, 1606–1669
The Three Crosses, 1653
Etching with dry-point and burin,
third state
15¼ × 17⅞ inches (38.8 × 45.6 cm)
Department of Graphic Arts,
2518 LR
Atlanta only
Plate 60

68. Jean-François Janinet
French, 1752–1814
After François Boucher
French, 1703–1770
The Toilet of Venus, 1783
Engraving with aquatint and mixed
technique, printed in colors from
several plates
19⁵⁄₁₆ × 15⅛ inches (49.1 × 38.5 cm)
Department of Graphic Arts,
Collection Edmond de Rothschild,
6431 LR
Atlanta only
Plate 61

69. Philibert Louis Debucourt
French, 1755–1832
The Wedding in the Château, 1789
Etching and aquatint, impression
printed in black, hand-colored with
watercolors
14⅛ × 10¼ inches (35.8 × 26.1 cm)
Department of Graphic Arts,
Collection Edmond de Rothschild,
6144 LR
Plate 62

70. Alexandre-Isidore Leroy de Barde
French, 1777–1828
Exotic shells, 1804
Watercolor and gouache on paper
glued onto canvas
49 × 31¹¹⁄₁₆ inches (124.5 × 80.5 cm)
Department of Graphic Arts,
INV 23689
Plate 49

71. Alexandre-Isidore Leroy de Barde
French, 1777–1828
Crystalized minerals, 1814
Watercolor and gouache on paper
glued onto canvas
49⅝ × 31½ inches (126 × 80 cm)
Department of Graphic Arts,
INV 23690
Plate 50

Decorative Arts

72. The Alpais ciborium
Limoges, France, ca. 1200
Copper: stamped, champlevé,
enameled, engraved, chased,
and gilded
Enamel: lapis, medium and lavender
blue, turquoise, dark and light green,
yellow, red, and white. Glass
cabochons and enameled beads
11¹³⁄₁₆ × 6⅝ inches (30.1 × 16.8 cm)
Department of Decorative Arts,
MRR 98
Plate 15

73. Saint Matthew
Limoges, France, ca. 1220–1230
Copper: champlevé, enameled,
engraved, chased, and gilded
Appliqué figure in copper: repoussé,
engraved, chased, and gilded
Enamel: dark blue, lapis blue, medium
blue, turquoise, white, green, yellow,
and red. Eyes inset with dark blue
enamel beads; blue and turquoise
enamel beads. Blue and dark red glass
cabochons
11⅜ × 5½ inches (29 × 14 cm)
Department of Decorative Arts,
MR 2650
Plate 16

74. Leather box
Italy?, 15th century
Embossed leather
7⅜ × 9 × 5⁵⁄₁₆ inches (18.7 × 23 ×
13.5 cm)
Department of Decorative Arts,
OA 5557
Plate 64

75. Incense boat
Aachen, Germany, last quarter of the
19th century
Lapis, gold, silver gilt, gilt brass,
enamel, emeralds, rubies, and pearls
7⅛ × 8½ × 4⅜ inches (18 × 21.5 ×
11.2 cm)
Department of Decorative Arts,
OA 5556
Plate 63

76. Attributed to Jean-Baptiste-Jules
Klagmann
French, 1810–1867
Ewer, Paris, ca. 1848
Cast and chased silver worked in
repoussé
39¾ × 18⅛ inches (101 × 46 cm)
Department of Decorative Arts,
OA 11741
Plate 24

Paintings

77. Lorenzo Lotto
Italian, ca. 1480–1556
Christ Carrying the Cross, 1526
Oil on canvas
26 × 23⅝ inches (66 × 60 cm)
Department of Paintings, RF 1982-50
Plate 95

78. Georges de La Tour
French, 1593–1652
*The Card-Sharp with the Ace of
Diamonds*, 17th century
Oil on canvas
41¹¹⁄₁₆ × 57½ inches (106 × 146 cm)
Department of Paintings, RF 1972-8
Plate 97

79. Bartolomé Esteban Murillo
Spanish, 1617–1682
Christ at the Column with Saint Peter
Paint on obsidian
13¼ × 12 inches (33.7 × 30.7 cm)
Department of Paintings, INV 932
Atlanta only
Plate 19

80. Johannes Vermeer
Dutch, 1632–1675
The Astronomer, 1668
Oil on canvas
19¹¹⁄₁₆ × 17¾ inches (50 × 45 cm)
Department of Paintings, RF 1983-28
Plate 96

81. Jean-Siméon Chardin
French, 1699–1779
The House of Cards, ca. 1735
Oil on canvas
30⁵⁄₁₆ × 26¾ inches (77 × 68 cm)
Department of Paintings, MI 1032
Atlanta only
Plate 99

82. Guillaume Voiriot
French, 1712–1799
Portrait of a Woman Holding a Booklet
Oil on canvas
31½ × 25⅝ inches (80 × 65 cm)
Department of Paintings, MI 1132
Plate 101

83. François Boucher
French, 1703–1770
Rinaldo and Armida, 1734
Oil on canvas
53⅜ × 66¹⁵⁄₁₆ inches (135 × 170 cm)
Department of Paintings, INV 2720
Plate 22

84. Jean-Siméon Chardin
French, 1699–1779
Child with a Top (Portrait of Auguste Gabriel Godefroy, 1728–1813), 1738
Oil on canvas
26⅜ × 30 inches (67 × 76.2 cm)
Department of Paintings, RF 1705
Minneapolis only
Plate 100

85. Théodore Géricault
French, 1791–1824
Study for The Raft of the Medusa, 1819
Oil on canvas
14¾ × 18⅛ inches (37.5 × 46 cm)
Department of Paintings, RF 2229
Plate 23

86. John Martin
British, 1789–1854
Pandemonium, 1841
Oil on canvas
48⁷⁄₁₆ × 72⁷⁄₁₆ inches (123 × 184 cm)
Department of Paintings, RF 2006-21
Plate 103

87. Jean-Auguste-Dominique Ingres
French, 1780–1867
Portrait of Ferdinand-Philippe-Louis-Charles-Henri de Bourbon-Orléans, Duke of Orléans (1810–1842)

Oil on canvas
62³⁄₁₆ × 48 inches (158 × 122 cm)
Department of Paintings, RF 2005-13
Plate 104

Sculpture

88. Capital: Daniel in the Lions' Den; acanthus leaves
Aquitaine (?) and Île-de-France, 6th century and first half of 12th century
Marble
19½ × 20⅞ × 20⅛ inches (49.5 × 53 × 51 cm)
Department of Sculptures, RF 457
Plate 71

89. Workshop of the Master of Mussy
South Champagne or North Burgundy
Head of Christ crowned, ca. 1300
Tonnerre stone (limestone), identified in 2007, minute traces of polychromy
18¹¹⁄₁₆ × 13 × 11 inches (47.5 × 33 × 28 cm)
Department of Sculptures, RF 3526
Plate 72

90. Workshop of the Master of Mussy
South Champagne or North Burgundy
Head of a chevalier in armor, ca. 1300
Tonnerre stone (limestone), identified in 2007
13⁵⁄₁₆ × 8½ × 7¾ inches (33.8 × 21.6 × 19.7 cm)
Department of Sculptures, RF 4217
Plate 73

91. Attributed to Desiderio da Settignano
Italian, ca. 1430–1464
Saint John the Baptist, ca. 1455
Marble bust
19¾ × 15 × 8⅝ inches (50.2 × 38.2 × 22 cm)
Department of Sculptures, RF 679
Plate 94

92. Pierre Hutinot
French, 1616–1679
Time revealing Truth and the Love of the Arts, 1667
Marble
32⁵⁄₁₆ × 26⅜ inches (82 × 67 cm)
Department of Sculptures, MR 2730
Plate 20

93. Jean Regnaud
French, known active 1679–1697
The Victory at Saint Gothard, ca. 1686
Bronze
30½ inches (77.5 cm) in diameter
Department of Sculptures, RF 4751
Plate 98

94. François Barois
French, 1656–1726
The Death of Cleopatra, 1700
Marble
19⅛ × 39⅞ × 11⅝ inches (48.5 × 101.5 × 29.5 cm)
Department of Sculptures, MR 1756
Plate 21

95. Franz Xaver Messerschmidt
Austrian, 1736–1783
Character head, between 1777 and 1783
Lead
16¼ × 8¼ × 8¼ inches (38.7 × 21 × 21 cm)
Department of Sculptures, RF 4724
Plate 102

96. Antoine-Louis Barye
French, 1795–1875
Lion and serpent, also known as *The Lion of the Tuileries*, 1832–1833
Bronze, cast by Jean-Honoré Gonon (1780–1850) and Sons
53⅛ × 70⁵⁄₁₆ × 37¹³⁄₁₆ inches (135 × 178 × 96 cm)
Department of Sculptures, LP 1184
Plate 1

97. Antoine-Louis Barye
French, 1795–1875
Lion and serpent, 1832
Bronze foundry model
4¾ × 6¹³⁄₁₆ × 4⅛ inches (12 × 17.3 × 10.4 cm)
Department of Sculptures, OA 5740
Plate 2

98. Antoine-Louis Barye
French, 1795–1875
Lion and serpent, mid-19th century
Bronze chief model with patina
6⅞ × 8⅛ × 3¹³⁄₁₆ inches (17.5 × 20.6 × 9.7 cm)
Department of Sculptures, OA 5743
Plate 3

99. Antoine-Louis Barye
French, 1795–1875
Lion and serpent, mid-19th century
Bronze model with patina
9¼ × 13¾ × 6¹¹⁄₁₆ inches (23.5 × 34.9 × 17 cm)
Department of Sculptures, OA 5741
Plate 4

100. Antoine-Louis Barye
French, 1795–1875
Lion and serpent, mid-19th century
Bronze with yellow-brown patina
6⅞ × 8⅛ × 3¹³⁄₁₆ inches (17.5 × 20.6 × 9.7 cm)
Department of Sculptures, OA 5742
Plate 5

101. Antoine-Louis Barye
French, 1795–1875
Lion and serpent, mid-19th century
Bronze with brown patina on oval base
5¹⁄₁₆ × 6⅞ × 4½ inches (12.9 × 17.5 × 11.4 cm)
Department of Sculptures, OA 5744
Plate 6

102. Antoine-Louis Barye
French, 1795–1875
Lion and serpent, 1852
Patinated plaster reduction
5¾ × 4⁵⁄₁₆ × 4⁵⁄₁₆ inches (14.6 × 11 × 11 cm)
Department of Sculptures, RF 1569
Plate 7

103. Antoine-Louis Barye
French, 1795–1875
Panther attacking a deer, mid-19th century
Patinated plaster model with wax additions
14⅞ × 23⅜ × 9⁵⁄₁₆ inches (37.8 × 59.4 × 23.7 cm)
Department of Sculptures, RF 1572
Plate 8

104. Antoine-Louis Barye
French, 1795–1875
Bull attacked by a lion, mid-19th century
Terracotta sketch
8¹³⁄₁₆ × 13⅛ × 7⁵⁄₁₆ inches (22.4 × 33.3 × 18.5 cm)
Department of Sculptures, RF 2593
Plate 9

Notes on Contributors

Guillemette Andreu has a doctorate in Egyptology from the Sorbonne University and is a former member of the French Institute of Oriental Archaeology of Cairo. She is a curator at the Louvre, where she has been head of the Department of Egyptian Antiquities since 2007. A specialist in Egyptian civilization, she was curator of the exhibitions *Les Artistes de Pharaon. Deir el-Médineh et la Vallée des Rois* (2002–2003) and *L'homme égyptien d'après les chefs-d'œuvre du Louvre* (2005).

Elisabeth Antoine is a graduate of the Ecole Normale Supérieure and has the *agrégation* in history. Since 2005 she has been a curator in the Department of Decorative Arts at the Louvre, with responsibility for the Gothic collections. She previously spent ten years as curator at the National Museum of the Middle Ages in Paris, where she created a medieval garden around the museum and organized the exhibition *Sur la terre comme au ciel. Jardins d'Occident à la fin du Moyen Âge* (2002). She has also published *La tapisserie du Jugement dernier* (2007). She teaches at the Ecole du Louvre.

Marc Bascou, principal curator of the French Heritage Collections, was named director of the Department of Decorative Arts at the Louvre in 2004. He holds degrees from the University of Paris in both art history and international law. He began his career in 1977 working on the project of the Musée d'Orsay, which opened in 1986. He joined the Direction des Musées de France in 2002 as head of the Department of Collections, dealing with acquisitions, loans, and export licenses for works of art.

Nicolas Bel, a curator in the Department of Near Eastern Antiquities at the Louvre since 2007, is participating in the improvement of the museum's Roman collections from the Eastern Mediterranean. He lectures on ancient Near Eastern art history and archaeology at the Ecole du Louvre.

Agnès Benoit is a senior curator in the Department of Near Eastern Antiquities at the Louvre. Since 1986 she has had responsibility for works from ancient Iran, and her major area of interest is the relationships between the Elamite and Trans-Elamite civilizations and Central Asia during the third millennium B.C., when the development of new towns gave birth to the vast Oxus civilization, also known as BMAC (Bactria-Margiana Archaeological Complex). Since 1994 she

has taught at the Ecole du Louvre and is the author of the textbook *Art et archéologie: les civilisations du Proche-Orient ancien*, published in 2003 and revised in 2007. She holds degrees in both philosophy and French literature.

Marc Bormand is senior curator in the Department of Sculptures at the Louvre, where he has been in charge of Italian sculpture of the Middle Ages and the Renaissance since 2000. He was previously curator in the field of contemporary art at the Inspection Générale des Musées (1985–1993) and then at the Musée National d'Art Moderne, Centre National d'Art et de Culture Georges Pompidou (1994–1999). He was a co-curator of several exhibitions, including *Collages. Collections des musées de province* (1990–1991), *Face à l'histoire.1933–1996. L'artiste moderne devant l'évènement historique* (1997), *Les Della Robbia. Sculptures en terre cuite émaillée de la Renaissance italienne* (2002–2003), and *Desiderio da Settignano. Sculpteur de la Renaissance florentine* (2006–2007).

David A. Brenneman, managing curator for *Louvre Atlanta*, has been the Frances B. Bunzl Family Curator of European Art at the High Museum of Art since 1995 and Chief Curator since 2001. In September 2006 he was appointed Director of Collections and Exhibitions while still retaining his responsibilities as Chief Curator and Curator of European Art. He has organized numerous exhibitions, including *Toulouse-Lautrec: Posters and Prints from the Collection of Irene and Howard Stein* (1997), *Monet & Bazille: A Collaboration* (1999), *Degas & America: the Early Collectors* (2001), *Monet: A View from the River* (2001), *Paris in the Age of Impressionism* (2002), and *Van Gogh to Mondrian: Modern Art from the Kröller-Müller Museum* (2004). Brenneman holds a B.A. degree from Pennsylvania State University and a Ph.D. from Brown University. Before arriving at the High, he was assistant curator of paintings at the Yale Center for British Art.

Geneviève Bresc-Bautier became a curator in the Department of Sculptures at the Louvre in 1976 and has directed the department as principal curator since 2004. Her areas of expertise include sixteenth- and seventeenth-century French sculpture (particularly the work of Jacques Sarazin), French bronze sculpture, and terracotta sculpture from the Maine region of France. She is the author of publications on the history of the Louvre and the statuary in the Tuileries gardens. A specialist in Sicilian art, she is a former member of the Ecole Française in Rome.

Annabelle Collinet has been a design engineer in the Department of Islamic Arts at the Louvre since 2005. She is responsible for the study and publication of the department's collection of metalworks and is contributing to the planning of the department's new exhibition rooms. She is also a ceramologist for the excavations conducted on the Nishapur site in eastern Iran.

Anne Coulié, a graduate of the Ecole Normale Supérieure, has the *agrégation* in classics and is a former member of the Ecole Française of Athens (1993–1996). She has a doctorate in the history of the art and archaeology of ancient Greece and is qualified by the University of Paris to direct research. In 2005 she became senior curator in the Department of Greek, Etruscan, and Roman Antiquities, where she is responsible for the ancient Greek geometric, orientalizing, and black-figure vases. She is a specialist in Archaic Greek pottery and published the book *La céramique thasienne à figures noires* (2002). She is currently working on Thasos, the Cyclades, and eastern Greece during the Orientalizing Period.

Françoise Demange was previously curator at the Museum of Fine Arts of Orléans and since 1991 has been principal curator in the Department of Near Eastern Antiquities at the Louvre. She has responsibility for the archaeological collections of Mesopotamia and antiquities associated with the Parthian Dynasty and the Sassanid Empire. She has organized several important exhibitions, including *Les Perses sassanides: Fastes d'un empire oublié (224–642)* (2006) and *Glass, Gilding, and Grand Design: Art of Sassanian Iran* (2007). Since 2005 Demange has been in charge of a scientific collaboration between the Louvre and the Yemeni General Authority for Antiquities and Museums.

Sophie Descamps-Lequime is a senior curator in the Department of Greek, Etruscan, and Roman Antiquities and has been in charge of the department's collection of bronzes since 1984. She is working on the art of northern Greece and recently edited the proceedings of the Louvre symposium *Couleur et Peinture dans le monde grec antique* (2007). In collaboration with Marc Etienne, she was a co-curator with Martine Denoyelle of *The Eye of Josephine*, an exhibition of the Empress Josephine's collection of antiquities held at the High Museum, Atlanta, in 2007–2008. She teaches at the Ecole du Louvre.

Anne Dion-Tenenbaum entered the Department of Decorative Arts at the Louvre in 1987 and is now a senior curator. She is a specialist in the decorative arts of the first half of the nineteenth century. She organized the exhibitions *Un âge d'or des arts décoratifs, 1814–1848* (1991), *L'orfèvre de Napoléon, Martin-Guillaume Biennais* (2003), and *Marie d'Orléans, princesse romantique* (2008).

Blaise Ducos has been the curator of the Louvre's collection of seventeenth- and eighteenth-century Dutch and Flemish paintings since 2005. He took his master's degree at the Sorbonne with a thesis on the Netherlandish painters' presence in Cologne in the sixteenth century. Having completed the Ecole du Louvre, he is now working on the Flemish master Frans Pourbus the Younger (1569–1622). In 2002, he spent two months at the Gemäldegalerie in Dresden as part of his curatorial training at the Institut National du Patrimoine. In 2005 he was the Focillon Fellow at the Yale University Department of the History of Art, and in 2007 was hosted in Munich at the Zentral Institut für Kunstgeschichte. Ducos has organized an exhibition on the Dutch landscapist Frans Post (2005–2006), participated in the Cincinnati exhibition catalogue *Rembrandt: Three Faces of the Master* (2008), and is preparing an exhibition in Japan of seventeenth-century paintings from the Louvre (2009).

Marc Etienne has been a curator at the Louvre since 1992 and curator of the papyrus section of the Department of Egyptian Antiquities since 1994. He is a specialist in Egyptian religion, in particular the cult of Osiris and the study of magical texts. He has contributed articles to a number of exhibition catalogues, including *Pharaohs of the Sun: Akhenaten, Nefertiti, & Tutankhamen* (1999), *Cleopatra of Egypt: From History to Myth* (2000), and *La mort n'est pas une fin. Pratiques funéraires en Egypte d'Alexandre à Cléopâtre* (2002). Since 1985 he has taken part in excavations in France and Egypt, including the sites of the Valley of the Queens in Luxor, the Temple of Montu in El Toud, and the tomb of Akhethetep in Sakkara.

Guillaume Faroult has been a curator in the Department of Paintings at the Louvre since 2001, with responsibility since 2006 for the collections of British and American paintings. He was the curator in charge of the exhibition *1869. Watteau et Chardin entrent au Louvre; La collection La Caze* (2007–2008) and co-organizer of the exhibition *Mélancolie. Génie et Folie*

en Occident (2006). He is the author of articles and essays on eighteenth-century French painting and recently published a book in the Solo Collection on the *Verrou* by Fragonard (2007).

Gwenaëlle Fellinger is a curator in the Department of Islamic Arts at the Louvre and within the the new department is in charge of restoration and conservation. She is also responsible for the Iranian collections of the sixteenth to nineteenth centuries. She studied history at the Sorbonne and art history at the Ecole du Louvre and is a qualified library and museum curator. She is at present preparing a dissertation on Islamic portable objects in the French Royal collections of the Valois (ca. 1360–1515) under the supervision of Christian Prigent.

Varena Forcione is a curatorial research associate who has worked in the Louvre's Department of Graphic Arts. She has participated in the preparation of thirteen exhibitions and in the writing of the accompanying exhibition catalogues. She began with *Le siècle de Titien* (1993) at the Grand Palais and has contributed more recently to the exhibitions *Leonard de Vinci, dessins et manuscrits* (2003), *Leonard de Vinci* (2004), and *The King's Drawings* (2006).

Cécile Giroire is a curator in the Department of Greek, Etruscan, and Roman Antiquities at the Louvre and since October 2003 has been in charge of Roman mosaics, silverware, metalware, and bone and ivory objects. She co-organized the exhibition *Roman Art from the Louvre* (2007–2008).

Pascal Torres Guardiola is the curator of the Chalcography Collection and the Cabinet of Baron Edmond de Rothschild in the Department of Graphic Arts at the Louvre and a member of the Real Academia de Nobles y Bellas Artes de San Luis in Saragossa, Spain. He is the author of *Barcelone, la Passion de la Liberté* (1992), *El Cercle Maillol, les avantgardes barcelonines i l'Institut Francés de Barcelona sota el franquisme* (1994), *La Peinture en Espagne du XVème au XXème siècle* (1999), and *Van Dyck graveur, l'art du portrait* (2008). He contributed to the compilation of the *Dictionnaire de la Pornographie* (2005) and has published numerous articles on painting and the graphic arts. He has organized several exhibitions at the Louvre, including *Mémoires du Visible* (2003), *Les Arts graphiques sous le règne de Louis XVI et la Terreur* (2005), *Zoran Music, Nous ne sommes pas les derniers* (2005), and *Seicento, gravures italiennes du XVIIème siècle* (2007).

Stéphanie Lardez, who holds a master's degree in art history, works in the Department of Paintings. She is a specialist in Renaissance art and has worked under Jean Habert, senior curator in charge of the museum's collections of sixteenth-century Venetian paintings.

Sylvain Laveissière is principal curator at the Louvre, with responsibility for seventeenth-, eighteenth-, and early nineteenth-century French paintings. He is a former member of the French Academy in Rome (1978–1980) and was a Focillon Fellow at Yale University. He organized the exhibitions *Le Classicisme français* (1985), *Géricault* (1991), *Autour de Poussin* (1994–1995), *Prud'hon* (1997–1998), *Le Sacre de Napoléon peint par David* (2004–2005), and *Jacques Stella* (2006–2007).

Isabelle Leroy-Jay Lemaistre is senior curator in the Department of Sculptures at the Louvre. She has lectured on nineteenth-century sculpture at Princeton University. She was a co-curator of the exhibition *Masterpieces from the Louvre, French Bronzes and Paintings from the Renaissance to Rodin* (1988). Since 1995 Lemaistre has been a member of the Administration Council of the Musée Rodin. She teaches at the Ecole du Louvre and has contributed to many publications, including *La Sculpture romantique* (1992) and *Napoléon et le Louvre* (2004).

Pierre-Yves Le Pogam has been a curator in the Department of Sculptures at the Louvre since 2004, with responsibility for the medieval French collections. He is an archivist and palaeographer, has a doctorate in history and art history, and is a former member of the Ecole Française of Rome. He was previously curator of the National Museum of the Middle Ages in Paris and has written on the history of architecture and sculpture, as well as the iconography, everyday life, and craftwork of the Middle Ages in the West—with particular emphasis on the thirteenth to fifteenth centuries.

Jean-Luc Martinez is senior curator and head of the Department of Greek, Etruscan, and Roman Antiquities at the Louvre. He has the *agrégation* in history and as a member of the Ecole Française of Athens (1993–1996) took part in excavations at both Delos and Delphi. He became a curator in 1997, responsible for ancient Greek sculptures, and he has worked on the reinstallation of the museum rooms around the *Venus de Milo*, a project due to be completed in 2010.

He organized the exhibition *La Grèce classique au Louvre : chefs-d'œuvres des Ve et IVe siècles avant J.C.* (2006) and, with Alain Pasquier, *Praxitèle* (2007). He has written on the history of the Louvre collections and on Greek sculpture: *La Dame d'Auxerre* (2000), *Les Antiques du Louvre. Une histoire du goût d'Henri IV à Napoléon Ier* (2004), and *Les Antiques du musée Napoléon. Edition illustrée et commentée des volumes V et VI de l'inventaire du Louvre de 1810* (2004), and co-wrote with Alain Pasquier *100 chefs-d'œuvre de la sculpture grecque au Louvre* (2007).

Olivier Meslay is a senior curator at the Louvre and a lecturer at the Ecole du Louvre. Since 2006 he has been in charge of the scientific and cultural aspects of the Louvre-Lens project. He joined the Louvre in 1993 as curator in the Department of Paintings, with special responsibility for the Anglo-Saxon and Spanish collections. In 2001–2002 he was a Clark Fellow in the United States, and from 2002 to 2006 he coordinated the *Louvre Atlanta* project. He has organized several exhibitions on English art: *D'outre-Manche, l'art britannique dans les collections publiques françaises* (1994), *Constable, le choix de Lucian Freud* (2002), *L'art anglais dans les collections de l'Institut de France* (2004), *Artistes américains et le Louvre* (2006), and *Hogarth* (2006).

Catherine Metzger has been a curator in the Department of Greek, Etruscan, and Roman Antiquities as a specialist in late Antiquity, with particular interest in Palaeo-Christian art. At the Louvre she was responsible for the collections of Greek and Roman jewelry. She is co-author of the catalogue *From Hannibal to Saint Augustine. Ancient Art of North Africa from the Musée du Louvre* (1994).

Marie-Emmanuelle Meyohas is a graduate in restoration from the Istituto Centrale del Restauro in Rome. She restores artworks in the French public collections, particularly in the Department of Greek, Etruscan, and Roman Antiquities at the Louvre.

Geneviève Pierrat-Bonnefois has been a curator in the Department of Egyptian Antiquities since 1981. She combines her interest in the archaeology of everyday objects—especially pottery, glass, and faience—with her wish to increase the general public's knowledge and love of Egyptian antiquities. In 2005 she co-organized a Louvre exhibition on ancient faiences that revolutionized how this area was viewed. She directed the Louvre excavations at Tôd (Upper Egypt) from 1988 to 1991.

Vincent Pomarède has a degree in art and archaeology from the Panthéon Sorbonne University and is a graduate of the Ecole du Louvre. He also trained at the Ecole Nationale d'Administration (ENA) and the Ecole Nationale du Patrimoine. He entered the Department of Paintings at the Louvre in 1991, where he was in charge of nineteenth-century paintings. In 2000 he was appointed director of the Lyons Museum of Fine Arts, and in 2003 he became head of the Department of Paintings at the Louvre. Pomarède is a specialist in the Romantic period and French landscape painting. He has organized many exhibitions, including *Romanticismo, il nuovo sentimento della natura* (1993), *Achille-Etna Michallon* (1994), *Delacroix, les dernières années* (1998), *Paysages d'Italie* (2001), *Théodore Chassériau. Un autre romantisme* (2002), *L'école de Barbizon* (2002), *La Collection Winthrop au Fogg Art Museum de l'Université d'Harvard* (2003), *Corot* (2005), and *Ingres* (2006). He has written a number of works on Etienne Moreau-Nélaton (1988), *La Joconde* (1988), and the paintings of the Louvre (*1001 peintures au Louvre*, 2005). He is at work on a book on French landscape painting between 1750 and 1850.

Guilhem Scherf, senior curator in the Department of Sculptures, at the Louvre since 1985, is a specialist in eighteenth-century sculpture. He was a Focillon Fellow at Yale University. He has overseen several exhibitions and was largely responsible for compiling the accompanying catalogues: *Clodion, 1738–1814* (1992); *Augustin Pajou, Royal Sculptor 1730–1809* (1997); with James David Draper, *Playing with Fire: European Terracotta Models, 1740–1840* (2004); with Gilles Grandjean, *Pierre Julien 1731–1804* (2004); and *Citizens and Kings: Portraits in the Age of Revolution 1760–1830* (2007). He is the author of *Houdon at the Louvre. Masterworks of the Enlightenment* (2008). He has headed international scholarly colloquia and written articles on such subjects as collectors, the aesthetics of the bas-relief, the *Grands Hommes de la France* series, and drawings by sculptors.

Carel van Tuyll van Serooskerken has headed the Louvre's Department of Graphic Arts since 2004. After five years at the Istituto Universitario Olandese di Storia dell'Arte in Florence, he was made chief curator of the Teyler Museum in Haarlem. He wrote the catalogue *The Italian Drawings of the XVth and XVIth Centuries in the Teyler Museum*, 2000. Besides his publications on the Italian School, such as the exhibition catalogues *Guercino (1591–1666): Drawings from Dutch Collections* (1991) and (with several others) *The Drawings of Annibale Carracci* (1999), he

co-authored *Rembrandt dessinateur. Chefs d'œuvre des collections en France* (2006). In 2004 he was the Edmund J. Safra Visiting Professor at the Center for Advanced Study in the Visual Arts at the National Gallery of Art, Washington.

Matthias Waschek was appointed Director of the Pulitzer Foundation for the Arts in September 2003. For the twelve years before that, he was Head of Academic Programs at the Louvre. Waschek has published articles on French painting, decorative arts, and nineteenth-century art theory; his doctoral research focused on Emile Bernard and Symbolism. He has also written on historiographic subjects and on aspects of perception of paintings in seventeenth-century Europe. He has taught at Sciences Po, Université de La Rochelle, and the Ecole du Louvre, as well as the Paris branch of Parson's School of Design.

Christel Winling is a documentalist in the Department of Graphic Arts at the Louvre. Since 2002, he has worked with the Edmond de Rothschild Collection and the Chalcography Collection of the Louvre, where he regularly contributes to the writing of catalogues and to other publications and works on the conservation and development of the collections.

Index

Photo Credits